VENICE
CANALETTO AND HIS RIVALS

VENICE
CANALETTO
AND HIS RIVALS

CHARLES BEDDINGTON
WITH A CONTRIBUTION BY AMANDA BRADLEY

NATIONAL GALLERY COMPANY, LONDON
DISTRIBUTED BY YALE UNIVERSITY PRESS

Published to accompany the exhibition
Venice: Canaletto and his Rivals
The National Gallery, London, 13 October 2010–16 January 2011
National Gallery of Art, Washington, 20 February–30 May 2011

The exhibition in London is sponsored by Credit Suisse.

The exhibition in Washington is made possible by the Bracco Foundation, which promotes cultural, scientific, and artistic expressions to improve the quality of life.

The exhibition in Washington is also made possible through the generous support of the Anna-Maria and Stephen Kellen Foundation.

National Gallery publications generate valuable revenue for the Gallery to ensure that future generations are able to enjoy the paintings as we do today.

First published in Great Britain in 2010 by National Gallery Company Limited
St Vincent House, 30 Orange Street London WC2H 7HH
www.nationalgallery.co.uk

ISBN 978 1 85709 418 3 hardback 1018492
ISBN 978 1 85709 417 6 paperback 1018491

British Library Cataloguing-in-Publication Data.
A catalogue record is available from the British Library.
Library of Congress Control Number: 2009937849

Publishing Director Louise Rice
Publishing Manager Sara Purdy
Project Editor Jan Green
Editors Johanna Stephenson and Philippa Baker
Picture researcher Maria Ranauro
Production Jane Hyne and Penny Le Tissier
Designed by Libanus Press
Printed in Belgium by Die Keure, Bruges, by arrangement with Mercatorfonds, Brussels

Front cover: Canaletto (1697–1768), *The Entrance to the Grand Canal, looking West, with Santa Maria della Salute*, about 1729 (plate 14, detail)

Back cover: Francesco Guardi (1712–1793), *The Piazza San Marco during the Feast of the Ascension*, about 1777 (plate 59, detail)

Page 1: Francesco Guardi (1712–1793), *San Giorgio Maggiore and the Giudecca*, about 1780 (plate 63, detail)

Page 2: Canaletto (1697–1768), *The Molo from the Bacino di San Marco on Ascension Day*, about 1733–4 (plate 16, detail)

Pages 10–11: Bernardo Bellotto (1722–1780), *The Entrance to the Grand Canal, looking East, with Santa Maria della Salute*, about 1743 (plate 47, detail)

Pages 54–5: Canaletto (1697–1768), *A Regatta on the Grand Canal*, about 1733–4 (plate 17, detail)

Page 153: Canaletto (1697–1768), *The Bacino di San Marco*, about 1738–9 (plate 22, detail)

Contents

Sponsor's Foreword

As Partner of the National Gallery, Credit Suisse is delighted to support *Venice: Canaletto and His Rivals*.

This exhibition is the first time that Canaletto's Venetian paintings have been directly juxtaposed against those of his contemporaries and rivals to highlight their different characteristics and styles. In recognition of the importance of English patrons to Canaletto's career, it is fitting that this exhibition should be shown in London, a city he visited on several occasions (1746–50, 1751–3 and 1754–6) and portrayed with great distinction.

There is no doubt that Canaletto dominated topographical painting in eighteenth-century Venice, and is most admired for his skill and precision in design and his ability to suffuse his work with light and air. As this exhibition demonstrates, some of the characteristics we find in his work were inspired by his forebears, such as the Dutch artist Gaspar van Wittel (called Gaspare Vanvitelli) or his contemporaries such as Luca Carlevarijs and Michele Marieschi. As we follow Canaletto's career we also learn more about the other, less well known, but highly talented Venetian artists of this period, such as Bernardo Bellotto, Antonio Joli and Francesco Guardi.

This unique exhibition comprises approximately 55 major loans from public and private collections in the UK, Europe and North America. It also features many of Canaletto's greatest masterpieces in Britain, including *The Riva degli Schiavoni, looking West* (Sir John Soane's Museum, London), *The Stonemason's Yard* (The National Gallery, London) and four of his finest works from the Royal Collection.

At a time when there was fierce competition for patronage, Canaletto understood the need to distinguish himself from his rivals. Credit Suisse also aims to differentiate itself by earning the trust and confidence of our clients.

We hope you enjoy your visit and the opportunity to see so many major Venetian paintings of this period at the same time.

Fawzi Kyriakos-Saad
CEO, Europe, Middle East and Africa

CREDIT SUISSE

Partner of the National Gallery

Directors' Foreword

This exhibition presents some of the greatest paintings ever made of one of the most beautiful cities in the world. But Charles Beddington, an outstanding expert on Venetian view painting, has also devised it to bring the pleasures of connoisseurship to the public. As soon as two artists paint the same view we become more aware of what belongs to their personality rather than to their subject; it is much the same when two actors recite the same speech. And that personality, that personal style, is the quality that is the connoisseur's concern (and pleasure) to assess. It may manifest itself in colour combinations or tonal preferences, in the way that features are abbreviated, in the shorthand selected for broken water, in the way that a brush loaded with white sweeps the soft clouds into place, or in the manipulation of linear perspective.

Central to the exhibition is Canaletto. His greatness as an artist may be self-evident but seen next to the artists whose example he emulated and surpassed, seen next to those who copied or imitated him, it is even more apparent. Perhaps his versatility can be best acknowledged by surveying the range of art that took its inspiration from his paintings.

The exhibition will appeal at many levels but no one will leave it without marvelling at the variety of Venetian view painting as well as the variety of Canaletto. The great demand for views of celebrated buildings and crowded popular ceremonies seems to have stimulated an alternative taste for paintings of the ordinary, if picturesque, corners of the city and for the empty Lagoon with its decaying and depopulated small islands. A proper relish for the latter was perhaps conditioned by the former. In any case, an exhibition such as this helps us to question as well as to enjoy these and other developments in the history of art.

The exhibition has been organised by the National Gallery, London, and the National Gallery of Art, Washington. The National Gallery, London, gratefully acknowledges the generous support of Credit Suisse, without which the exhibition would not have been possible.

The National Gallery of Art in Washington is especially grateful to Diana Bracco and the Bracco Foundation, promoting cultural, scientific, and artistic expressions to improve the quality of life. We also would like to thank the Anna-Maria and Stephen Kellen Foundation, whose commitment to the Gallery's exhibition programme is greatly appreciated.

We are most grateful to our lenders, both private collectors and museums in the United States and Europe, for their generosity in helping us bring together such an ambitious exhibition. It is our hope that *Venice: Canaletto and His Rivals* will provide visitors in London and Washington with the opportunity to become acquainted with a brilliant period in the history of art.

Nicholas Penny Earl A. Powell III
The National Gallery, London National Gallery of Art, Washington

Acknowledgements

I have been the beneficiary of more support, help and kindness over the years of preparation of this exhibition than I can adequately acknowledge in a few words. My first debt is to those without whom it would never have taken place. Charles Saumarez Smith, former Director of the National Gallery, and Dawson Carr, Curator of Spanish and Later Italian Paintings, embraced the project at its outset, and Nicholas Penny brought a fresh eye and a keen appreciation of view painting when he assumed the position of Director in 2008. I shall remain eternally grateful to them for taking a chance on a guest curator from neither an academic nor a museum background. Among the many who helped make the exhibition a reality in London, I would like to thank especially Jo Kent, Stephen Dunn, Scott Nethersole and Juliet Chippindale. Special thanks are due to a former member of The National Gallery's staff, David Bomford, whose great knowledge of Venetian view painting was indispensable as the exhibition developed. The late Philip Conisbee performed a similar role in Washington, and the exhibition and its catalogue are poorer without his contribution.

I am very grateful to the National Gallery of Art and its Director, Earl A. Powell III, for staging the exhibition in America. I thank the many members of staff who worked on the exhibition, but most particularly D. Dodge Thompson, Ann Bigley Robertson, and Hillary Krell Lord in the Department of Exhibitions; David Alan Brown and David Essex in the Department of Italian Paintings; Michelle Fondas, Exhibition Registrar; Mark A. Leithauser and his colleagues in the Design Office, especially Gordon Anson and Donna Kirk; Susan M. Arensberg and Margaret Doyle in Exhibitions Programs; Conservator Michael Pierce; Deborah Ziska and Anabeth Guthrie in the Press and Information Office; Christine Myers and Patricia Donovan in Development; and Caroline Weaver in the Publishing Office. For their generous advice, I thank Andrew Robison, Department of Prints and Drawings; Oliver Tostmann, Mellon Curatorial Fellow; educator Eric Denker; and visiting scholar Juergen Schulz. Thanks are especially due to Linda Cena of the Bracco Foundation for her steadfast encouragement of our project.

Many people have helped to provide the loans which make the exhibition what it is, notably Irina Artemieva, Alex Bell, Roberto Contini, Simon Dickinson, Everett Fahy, Gabriele Finaldi, Ivan Gaskell, Jonathan Green, Derek Johns, David Ker, Tim Knox, David Landau, Stéphane Loire, Otto Naumann, Christopher Ridgway, Jo Rishel, Vincent Pomarède, Giandomenico Romanelli, David Scrase, George Shackelford, Desmond Shawe-Taylor, Marco Voena, Eric Zafran and Miguel Zugaza Miranda. Those lenders who prefer to remain anonymous are owed a particular debt of gratitude for agreeing to denude their walls for several months, making it possible to show a number of paintings rarely (and in two cases never before) seen in public.

I owe an immense debt, as much personal as anything else, to the late J.G. Links, one of the most inspiring people I have been fortunate to know. I wish he were here to see this exhibition, which he would have enjoyed more than anyone. The study of Venetian view painting is not a large field and it has benefited much from those who have laboured to present it to a wide audience in Italy, notably Dario Succi, Giuseppe Pavanello, the late Alessandro Bettagno, Bozena Kowalczyk, and the most recent addition to their number, Alberto Craievich, who has been of invaluable assistance over certain specific problems. A tribute is also due to the crucial work done by those who have uncovered new documentation, above all Federico Montecuccoli degli Erri, who has published much new information as well as providing a model interpretation thereof.

In this book, Jan Green and her colleagues at the National Gallery Company have made my words into a visually exciting experience, befitting the subject matter. I am grateful to Dr David Maskell and Dr Emanuela Tandello for translations of French and Italian texts.

And finally, my greatest gratitude is to my wife Amanda, not only for her contribution to the text, but for living with Canaletto during the years of preparation, and for so much else besides.

CB

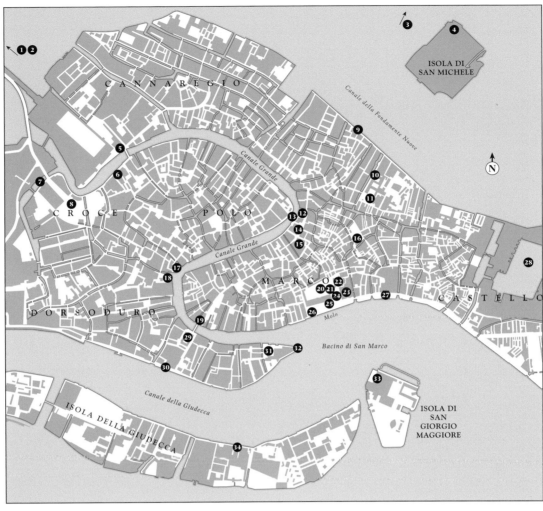

Fig. 1 Map of Venice showing the locations of the views

0		500 yards
0		500 metres

Arsenale 28

Basilica di San Marco 22

Ca' Foscari 18

Campanile di San Marco 21

Campo San Bartolomeo 14

Campo San Salvador 15

Campo Santa Maria Formosa 16

Campo Santi Giovanni e Paolo 11

Campo San Vidal 19

Canale di Santa Chiara 7

Fondaco dei Tedeschi 12

Fondamenta Nuove 9

Isola della Madonnetta 1

Libreria Sansoviniana
(Library of San Marco) 25

Murano 3

Palazzo Balbi 17

Palazzo Ducale (Doge's Palace) 23

Piazza San Marco 20

Piazzale Roma 8

Piazzetta di San Marco 24

Punta della Dogana
(Customs House Point) 32

Redentore 34

Rialto Bridge 13

Rio dei Mendicanti 10

Riva degli Schiavoni 27

San Giorgio Maggiore 33

San Michele in Isola 4

San Simeone Piccolo 6

Santa Maria degli Scalzi 5

Santa Maria della Carità 29

Santa Maria della Salute 31

Torre di Malghera 2

Zattere 30

Zecca (Mint) 26

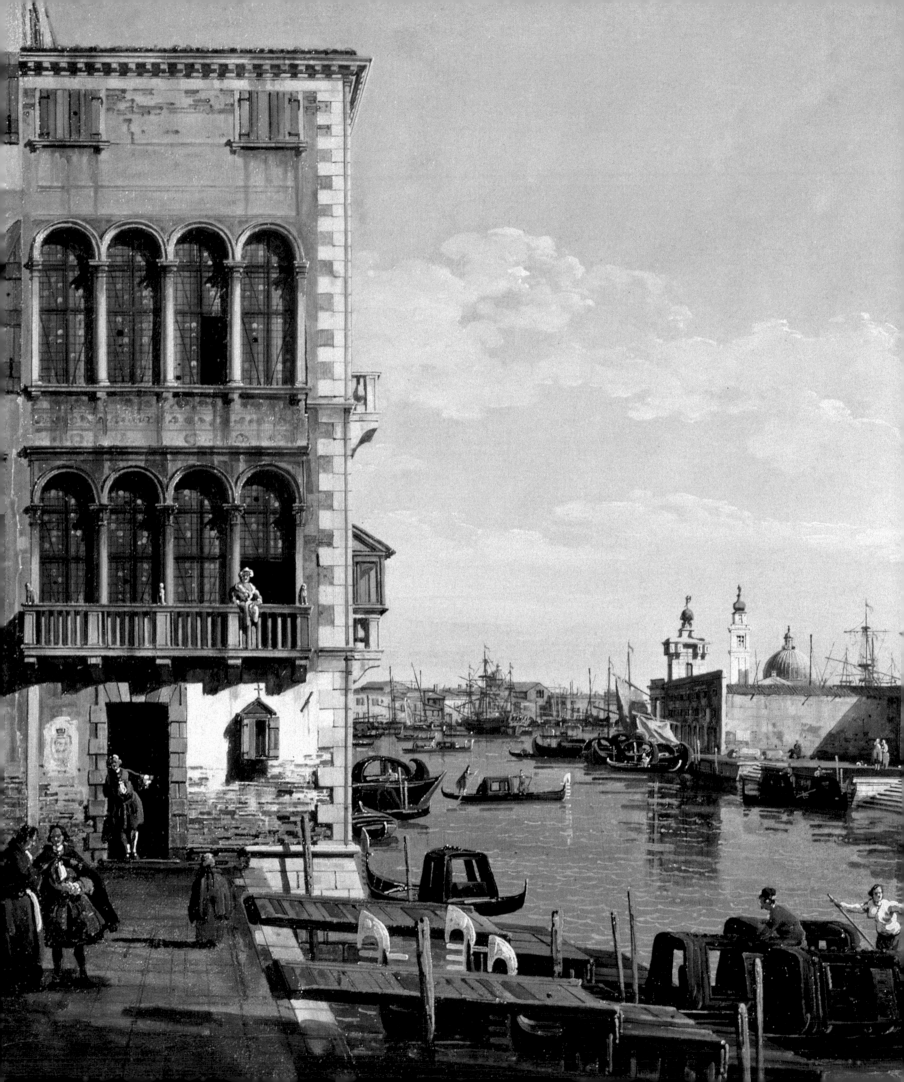

Venetian View Painting
in the Eighteenth Century

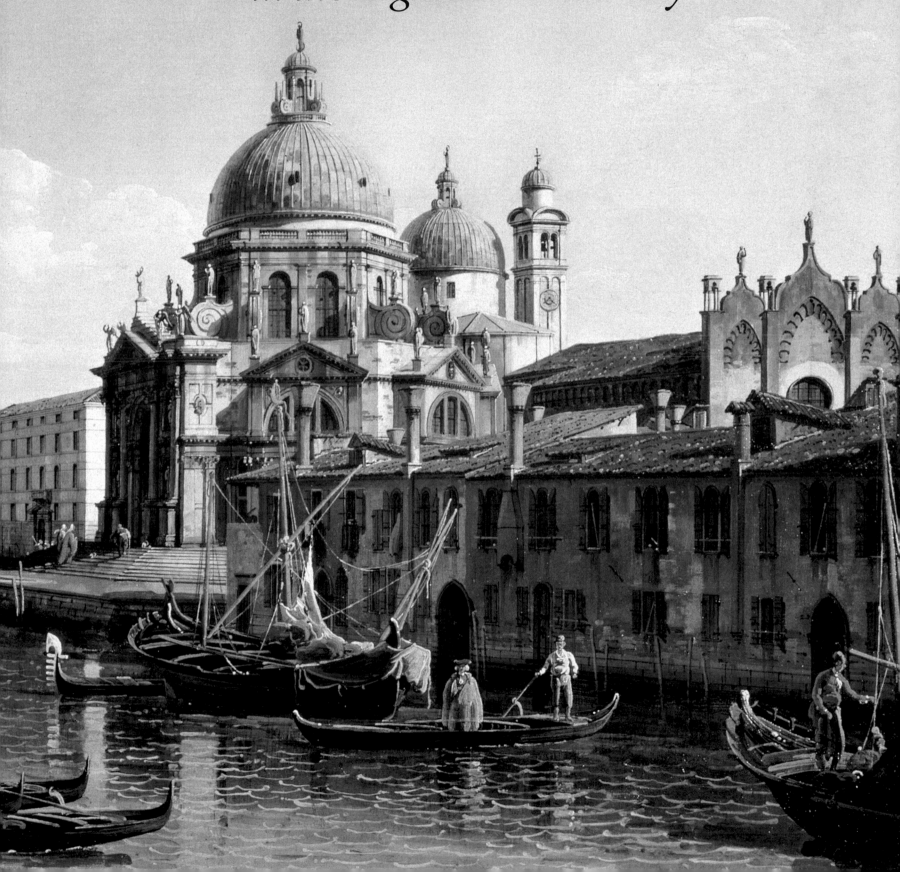

Venetian View Painting in the Eighteenth Century

CHARLES BEDDINGTON

The genre of *vedutismo* – view painting – is a specifically eighteenth-century phenomenon, and in Venice the age of the *veduta* fits neatly within the parameters of the century. The first dated Venetian view by Gaspare Vanvitelli is of 1697 (plate 1) and the first datable views by Luca Carlevarijs are of 1703, while the death of Francesco Guardi in 1793 and the fall of the Venetian Republic in 1797 mark the end of the production of this type of painting. Views of Italian cities of earlier dates are by no means unknown. Indeed, such paintings as Gentile Bellini's *Procession in the Piazza San Marco* (fig. 2) and Vittore Carpaccio's *The True Cross healing a Possessed Man*, both executed in the years around 1500 for the Scuola Grande di San Giovanni Evangelista as parts of a series of large canvases of *Miracles of the True Cross* (all now in the Gallerie dell'Accademia, Venice), form important Venetian precedents. So do, in the seventeenth century, a group of canvases by the German-born Joseph (Giuseppe) Heintz the Younger (Augsburg about 1600–Venice 1678), such as *The Procession on the Feast of the Redentore*, signed and dated 1648 (Museo Correr, Venice), and *The Piazzetta on Ascension Day* (fig. 3).[1] These, however, are isolated examples. In the eight-

eenth century Venice produced a real 'school' of view painters in a way that only Naples can be said to have rivalled, but the view painters of Naples were no match in quality, creativity or variety for those of Venice.

View painting as a genre in Italy was very much the creation of Gaspare Vanvitelli (Amersfoort 1652/3–Rome 1736). Born Gaspar van Wittel and trained, crucially, in the Netherlands, Vanvitelli was already in his early twenties when he went to live in Rome in about 1674. There he was producing drawings and gouaches of his adoptive home by 1680, and painting views in oils by 1682. Although he remained based in Rome, apart from a few years in Naples, Vanvitelli also travelled in Northern Italy and expanded his repertoire to include Florence, Bologna, Verona, Venice, Lake Maggiore and Vaprio d'Adda; he may possibly even have visited Messina, of which several views are known. He worked from carefully executed drawings, which are often large and very detailed, and seems to have prided himself on his ability to paint a view even several decades after he had last seen it, which makes it particularly difficult to judge how many of his views of a particular place would have been

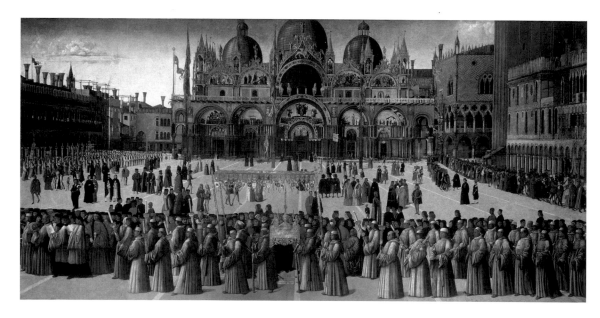

Fig. 2 Gentile Bellini
(active about 1460;
died 1507)
Procession in the Piazza San Marco, 1496
Oil on canvas, 367 × 745 cm
Gallerie dell'Accademia, Venice

known to its inhabitants. Vanvitelli's undated works can be dated fairly accurately on stylistic grounds, since his work after 1710 shows a progressive diminution in refinement and increasingly pale colouration. This may well be due in large part to problems with his eyesight, since as early as 1696 he had become known as '*Gaspare dagli Occhiali*' ('Gaspare of the Spectacles') on account of the thick glasses he was obliged to wear, his cataracts causing him loss of perception of contrast and colour.[2]

Vanvitelli's visit to Venice is generally thought to have taken place in 1695 and it was to result in some forty views over the following decades. Almost all show the Bacino di San Marco and the buildings bordering it, no fewer than 11 being frontal views of the Molo from the Bacino. Encompassing the foremost civic and religious buildings of the city, the view is that experienced by a visitor approaching the preferred point of arrival on the Molo. Although he is

usually most comfortable working on a fairly small scale, with numerous figures, Vanvitelli's earliest dated Venetian view of 1697, mentioned above (fig. 7; plate 1), is an unusually large canvas and one of his masterpieces. The tone is light, in contrast to much Venetian painting of the seventeenth century, the palette dominated by light blues, with scattered dashes of bright red. Vanvitelli's technical dexterity is displayed throughout. Fundamental to his achievement are his skills as a draughtsman: he transferred onto canvas with great conviction the drawings he had made on the spot. A large compositional study, used for most of the waterfront shown in the painting, is a fortunate survival, although in poor condition, in the unrivalled collection of the artist's graphic work in the Biblioteca Nazionale Vittorio Emanuele in Rome.[3] That must have been augmented by other more focused drawings to provide the wealth of detail included in the painting. The drawing also confirms that

Vanvitelli was the first of a distinguished line of painters of views of Venice to take liberties with his subject matter in order to enhance the visual effect: while only one of San Marco's domes is shown in the drawing, three are visible in the painting. Another irregularity is the depiction of the six large windows of the upper storey of the Doge's Palace; in reality only the two on the right have Gothic tracery, and they are set distinctly lower than the others. Rather than the artist's error this is more likely to be an intentional correction of the façade's imperfect symmetry.

Vanvitelli's dexterity with the brush is shown in his capture of the shimmering translucence of the water, punctuated by multicoloured reflections and with flicks of white where it is broken by gondoliers' oars and the prows of boats. In this, and in the attention to effects of light in general, the painting retains the stamp of the painter's northern training, making it to some extent a southern equivalent of the Dutch cityscapes of Jan van der Heyden (Gorinchem 1637–Amsterdam 1712) and Gerrit Berckheyde (Haarlem 1638–98).[4] As in their work the atmosphere is placid, despite the plentiful anecdotal detail of townsfolk going about their everyday business, including gondoliers with a barge full of cattle and a *sandolo* with chickens and vegetables at lower left, and at lower right a couple enjoying a romantic outing in a gondola (figs 4–6). A possible criticism of Vanvitelli's style is that a similar atmosphere pervades all his Italian views, but here he heralds the beginning of the golden age of Venetian *vedutismo* with a fanfare.

Figs 4–7 Gaspar van Wittel, called Gaspare Vanvitelli (1652/3–1736) *The Molo from the Bacino di San Marco*, 1697 Details of plate 1

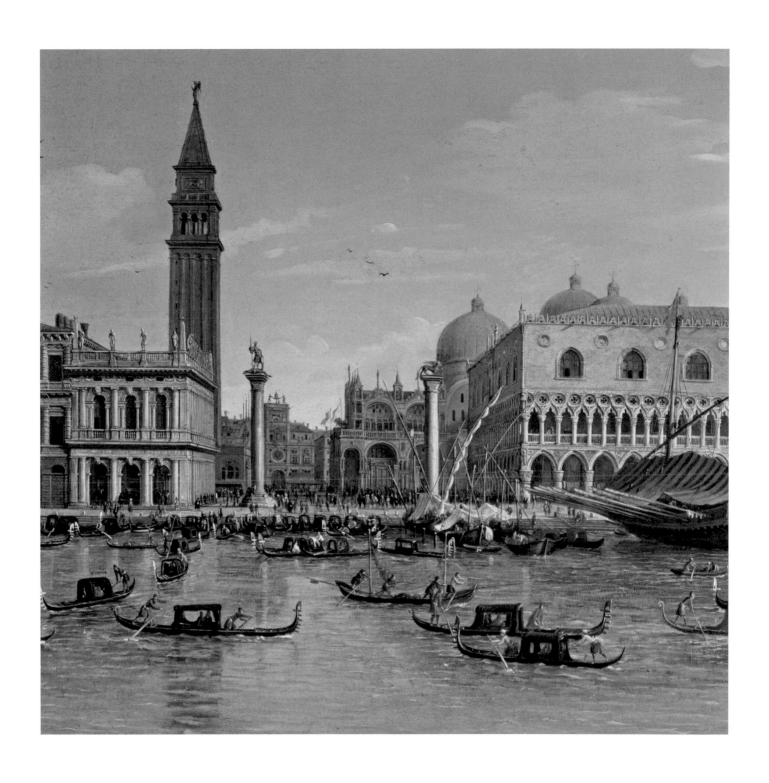

View paintings functioned at least primarily as reminders of the appearance of cities and in Italy tended to be of little interest to natives of those cities, to whom the actual view was available on a daily basis. Bernardo Bellotto was to encounter a very different attitude in the courts of Northern Europe after his emigration in 1747, but in Italy Vanvitelli was the last view painter able to rely predominantly on local patrons. There is no evidence, however, of any of his Venetian views having remained in Venice. The Prado painting (plate 1), for instance, was already in Spain by 1746. Five paintings by Vanvitelli are recorded in the Venetian collection of Giorgio Bergonzi in 1709, but none of those was of Venice, two being of the Colosseum, one of Naples and two of imaginary views. It is thus impossible to be sure how Vanvitelli's influence was transmitted to subsequent Venetian *vedutisti*.

It was, however, very much in the wake of Vanvitelli's visit to Venice that a local painter began to turn his mind to the execution of views. Luca Carlevarijs (1663–1730) had been born in Udine but, orphaned before his seventh birthday, had lived in Venice since September 1679. Little is known of the first four decades of his life. P.A. Orlandi, in his *Abecedario pittorico* of 1704, states that he 'had no real master, but studied here and there',[5] and the few works datable before the end of the seventeenth century are undistinguished landscapes revealing the strong influence of Northern painters active in the Veneto. He is, however, described in a publication of 1700 as a painter of 'architecture and perspective', and he emerges in the first years of the new century as a painter of *capricci* and *vedute ideate* (imaginary assemblages of actual and invented elements such as classical ruins in landscapes), for which there was always a much stronger local market than for views. Those were to remain a significant part of the output of most of the subsequent painters of views, as well as specialists such as Marco Ricci (Belluno 1676–Venice 1730).

The first visual evidence of Carlevarijs's interest in the appearance of the city is provided by the publication in 1703, when he was already forty years old, of his great series of 103 engravings of Venetian views entitled *Le Fabriche, e Vedute di Venetia* (see figs 56, 59). That had an enormous success and influence, being used as a compositional sourcebook by Venetian view painters for several following decades.[6] Also dating from the same moment are the earliest of his painted views, although by the end of the first decade of the century he had already executed many of his masterpieces, including those now at Birmingham (see fig. 17; plate 2); in the J. Paul Getty Museum, Los Angeles (plate 3); in the Rijksmuseum, Amsterdam; at Frederiksborg Castle, Hillerød; and in the Lehman Collection in the Metropolitan Museum of Art, New York.[7] With works such as these he established in Venice a genre of painting which was to grow with the appetite of the market as the century progressed until it became the pre-eminent genre for which eighteenth-century Venetian painting is known. Carlevarijs was to remain the unrivalled master of Venetian *vedutismo* until the early 1720s.

His depiction of *The Molo from the Bacino di San Marco on Ascension Day* (fig. 8; plate 3) is dated 1710. While the view is much the same as that in Vanvitelli's of 1697 (fig. 7; plate 1), Carlevarijs's treatment of it is very different. Evidence of direct links between the two artists is scarce indeed, although Carlevarijs did paint a view of the Piazza San Pietro in Rome which is clearly based on a Vanvitelli prototype.[8] Carlevarijs's painting of the Molo is of even larger size than Vanvitelli's, his favoured scale being much larger than the Dutchman's. Vanvitelli's vision of Venice as a tranquil jewel set between summery skies and translucent water is replaced by a Venice of pomp and bustle. Carlevarijs's viewpoint is not from the convenient Island of San Giorgio Maggiore but much closer, so that watercraft – the *Bucintoro*, the *Fusta*, a three-master, galleys, barges, gondolas and *sandolos* – fill the foreground to the point that water is barely visible.[9] The architectural element is here particularly planar, resembling a theatrical backdrop for the busy foreground. All transferred and assembled from individual drawings, the foreground elements seem somewhat frozen, and, as often in Carlevarijs's work, contrast with the whirling drama of the cloud formations. In paintings such as this Carlevarijs introduced to the repertoire of view painting the depiction of festivals and special occasions. Vanvitelli had shown no interest in these, and in Carlevarijs's work they represent a response to the newly developing markets, heralding the advent of the foreign patronage which was to determine much of the course of Venetian view painting beyond the middle of the eighteenth century. For foreign visitors they held an obvious appeal, and they were to provide the subject matter for many of the most opulent view paintings of the following decades.

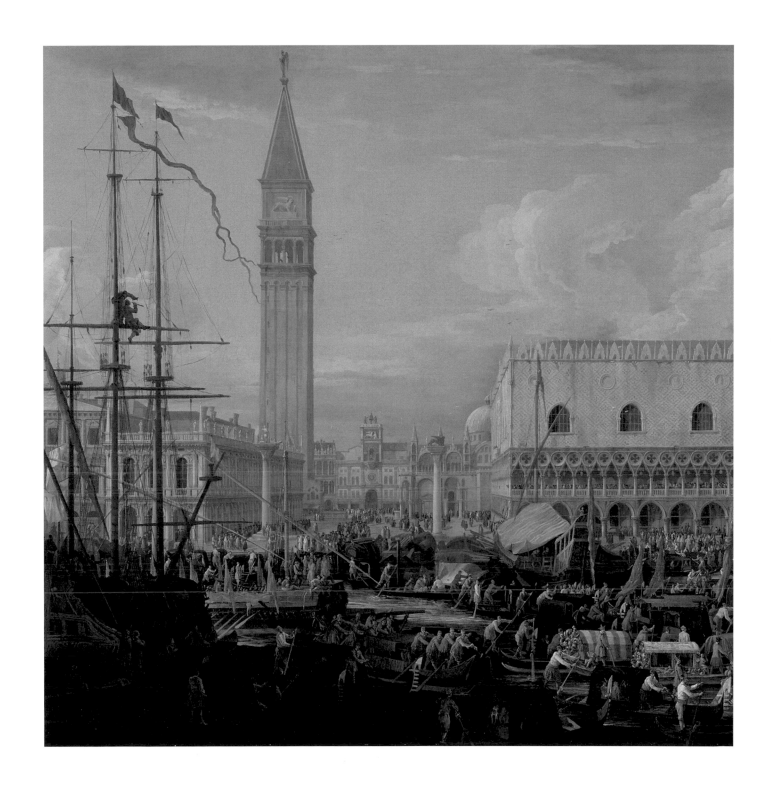

Fig. 8 Luca Carlevarijs (1663–1730)
The Molo from the Bacino di San Marco on Ascension Day, 1710
Detail of plate 3

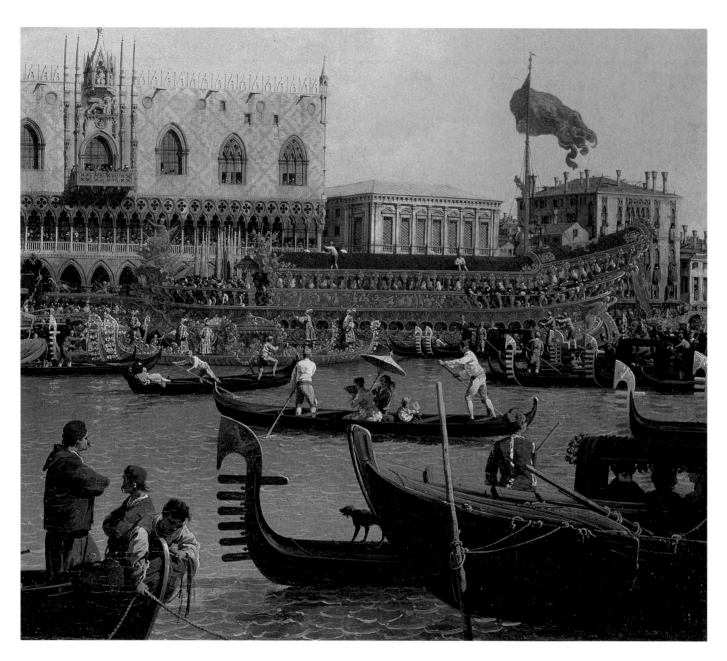

The *Bucintoro* leaving, and returning to, the Molo on Ascension Day were among the most spectacular moments in the Venetian ceremonial year, and were to provide the subject matter for many of Canaletto's grandest productions from the late 1720s until 1746 (figs 9, 10; and see plates 16 and 24), as well as being covered by Bellotto (fig. 11; plate 42) and Francesco Guardi. Paintings showing the ceremonial receptions of visiting foreign ambassadors in front of the Doge's Palace naturally held an irresistible appeal for the foreign visitors represented therein. Carlevarijs established the standard composition for this subject in his first 'festival' paintings (see fig. 17; plate 2), and this was to be followed by Canaletto (see fig. 16; plate 13). He also established the standard composition for depictions of regattas or gondola races on the Grand Canal, seen from Palazzo Foscari at the *volta del Canal*, the bend where the canal turns north-eastwards towards the Rialto Bridge and where the races began and ended (see plate 4); this was also followed by Canaletto (plate 17), as well as by Guardi (plate 60).

Carlevarijs's *The Piazza San Marco, looking East* (fig. 14;

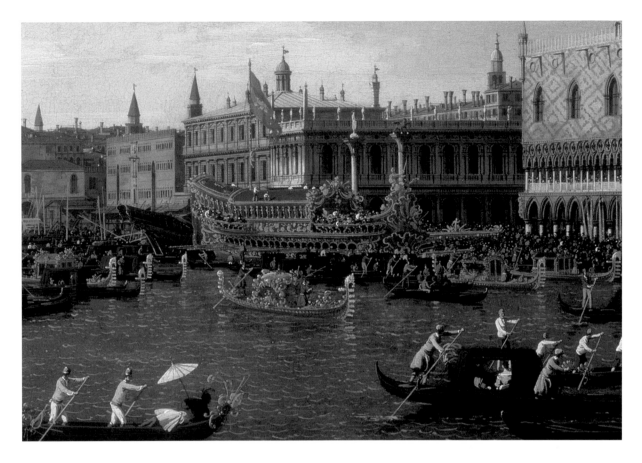

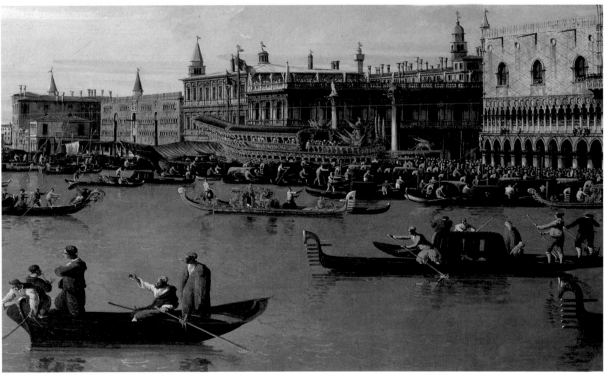

plate 5) probably dates from only a few years later than the Getty *Ascension Day*. This view, looking down the square towards the Basilica of San Marco, curiously never tempted Vanvitelli; it has, however, always been the most popular of the many which Venice offers to painters, engravers and photographers alike. Here it is atypically off-centre, focusing as much on the lower part of the Campanile as on the façade of the Basilica of San Marco. The figurative element was always of far greater concern to Carlevarijs than it was to Vanvitelli, or indeed to the majority of his successors. In paintings such as this the balance which Carlevarijs attained between the figures and their setting is tipped in favour of the townsfolk, their setting becoming to some degree a theatrical backdrop as in the Molo view, despite the strong – and very decorative – receding diagonals. There are hundreds of figures, those in the foreground of considerable size, and they represent the full, colourful range of the populace, many of them appropriately in carnival costume. Each is characterised individually and posed in such a way as to interact naturalistically with its companions in a group, the variety and conviction of their types and poses only made possible through an attentive study of the townsfolk themselves. While there are 86 drawings of buildings for *Le Fabriche, e Vedute di Venetia* in the British Museum and a number of drawings of shipping and boats are known, the majority of Carlevarijs's surviving preparatory studies are of figures. There are 51 sheets in the British Museum, 38 in the Museo Correr, Venice, and 32 in the Victoria and Albert Museum. Equally unprecedented are the 43 oil sketches of figures also in the Victoria and Albert Museum. Many of the figures in these drawings and oil sketches were used in paintings, sometimes recurring in works of widely differing dates, indicating that Carlevarijs retained them in his studio for use as a pattern book, a practice without parallel in the methods of other view painters. Thus one of the most striking figures in the oil sketches, a masked lady in a pink dress holding a fan (fig. 12), who features prominently in the left foreground of *The Piazza San Marco* (fig. 14), had made earlier appearances in the galley in the right foreground of *The Molo from the Bacino di San Marco on Ascension Day* (fig. 13; plate 3), as well as in the right foreground of *The Piazza San Marco* in the Lehman Collection at the Metropolitan Museum of Art. The Kiplin Hall painting (plate 5) gives a vivid impression of the colourfulness of everyday life in the square, which had been described by an English visitor at the beginning of the seventeenth century as 'a market place of the world'.[10] One result of this method of assembling the component parts of the crowd from a pattern book is, however, a tendency towards firmness of outline and rigidity, contributing to a lack of atmosphere. As often in Carlevarijs's paintings, the focus on the line of large figures across the foreground also creates a somewhat frieze-like effect, and, as in the Molo view, the heavy, massing clouds seem out of tune with the placid scene below.

The beginning of the 1720s saw the advance to the next stage in the development of Venetian view painting, and in many ways its most decisive moment, in the emergence and rapid rise to pre-eminence of a young painter of exceptional intuitive gifts in his response to natural phenomena, and

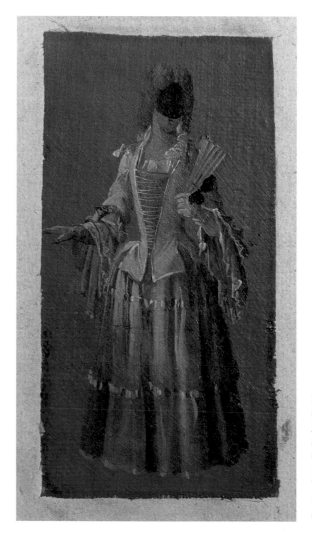

Fig. 12 Luca Carlevarijs (1663–1730)
Lady with Fan and Mask, about 1700
Oil sketch, 17.2 x 93 cm
Victoria and Albert Museum, London
(P.72-1938)

Fig. 13 Luca Carlevarijs
(1663–1730)
*The Molo from the Bacino di San
Marco on Ascension Day*, 1710
Detail of plate 3

Fig. 14 Luca Carlevarijs
(1663–1730)
*The Piazza San Marco, looking
East*, about 1710–15
Detail of plate 5

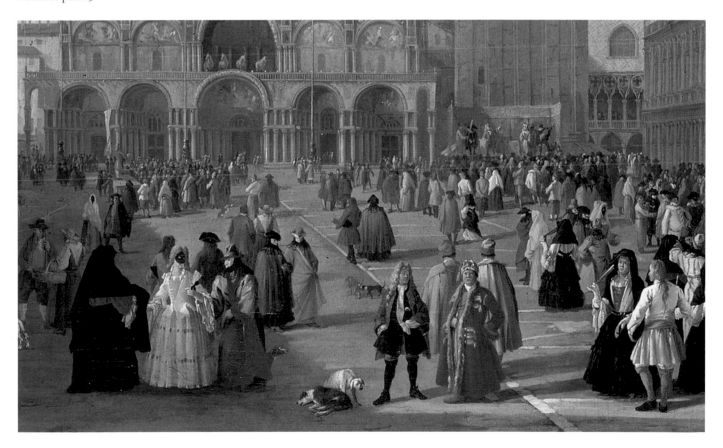

more than adequate technical ability to render these in paint. This was Giovanni Antonio Canal, known as Canaletto (Venice 1697–1768), whose only known training was as a painter of theatrical scenery and was received from his father, Bernardo Canal (Venice 1664?–1744). Bernardo remains a shadowy figure, although he was elected Prior of the Collegio dei Pittori in 1739 and recently a not inconsiderable number of view paintings have been convincingly established as his work. These are in a style most closely related to that of his near contemporary, and Carlevarijs's one true disciple, Johan Richter (Stockholm 1665–Venice 1745), who arrived in Venice sometime between 1697 and 1710 and remained there for the rest of his life, producing *vedute* and *capricci*, and often an individual blend of the two (see p. 68 and plate 6). Many of Bernardo's compositions are borrowed from his son's creations, and there is little evidence of influence in the opposite direction.

Sources from Canaletto's lifetime, above all the renowned Parisian connoisseur and writer Pierre-Jean Mariette, tell us that Canaletto went to Rome in his youth and in or around 1719 gave up working for the theatre in favour of drawing and painting views from nature, especially the ruins of the ancient city. This is demonstrably true, as the last record of the artist assisting his father in the painting of scenography is for productions of operas performed in Rome during the carnival of 1720. Furthermore, a series of 23 drawings of Rome survives, 22 of them in the British Museum and one (with a provenance from the painter's great-nieces) at Darmstadt, all apparently signed and one, showing *The Arch of Constantine*, dated 'August 10 1720'.[11] There is also a possibility that the young artist's new interest in view painting was given an additional stimulus by a meeting with Vanvitelli, who was certainly in Rome at the time.[12] Among Canaletto's earliest Venetian views are a group of paintings which are reminiscent of Vanvitelli's work in their small scale and tiny, spiky figures.[13] One of those, a view of *The Piazza San Marco, looking South*,[14] which is also markedly Vanvitellian in its pale colouring, dominated by beige and light blue, is taken from the third window to the left of the Torre dell'Orologio. There are two paintings by Vanvitelli from a similar, unusual viewpoint, but Canaletto is unlikely to have known either since both were probably already in Spain.[15] Vanvitelli could, however, have shown him his impressive preparatory drawing, which has survived, and,

indeed, the coincidence is difficult to explain in any other way.[16]

While Canaletto's beginnings might well be considered inauspicious, only about three years after his return from Rome he was able to produce a masterpiece of the calibre of *The Piazza San Marco, looking East* (fig. 15; plate 10), presumably painted for Joseph Wenzel von Liechtenstein and datable to 1723 from the documented state of advancement of the laying of the new pavement of the Piazza, designed by Andrea Tirali, which is shown in progress. While Carlevarijs's painting of the same view is supremely decorative, colourful and fundamentally linear, Canaletto's painting is comparatively dark, and the figures and details of buildings alike are subordinated to the moody atmosphere created by the turbulent sky and the casting of a large section of the foreground into shadow. While Carlevarijs's figures betray their origins as individual figure studies, Canaletto seems rarely to have felt the need to make such studies and his figures blend into their surroundings. In Canaletto's painting detail is suggested rather than delineated, the paint being thickly applied and producing a rough surface; in this he reveals his training as a painter of scenography, which is by its nature executed broadly in such a way as to 'tell' at an appropriate distance. The mood of the sky and that of the square below are as unified as the tone. What separates Canaletto from Carlevarijs is, above all, his observation of elements such as effects of sunlight, cloud formations, atmospheric perspective, and townsfolk going about their everyday lives, and an ability to capture these in paint in a way that makes his precursors' work seem comparatively mechanical and archaic. Everything is conceived in terms of the way that it is defined by light and it is this revolutionary vision, already – and indeed most – evident when the artist was still in his twenties, that is the basis of his achievement.

Although happy to repeat figures, Carlevarijs rarely repeated a composition, and this character trait, unexpected in a genre which might be thought to invite repetition, became with Canaletto a veritable aversion to doing the same thing twice. This is clearly demonstrated by the various depictions by both painters of the ceremonial receptions of foreign ambassadors. In his renditions of some subjects, however, Canaletto had no qualms about using his rival's composition and one imagines that he relished the manner in which he was able to outclass an artist of more than twice

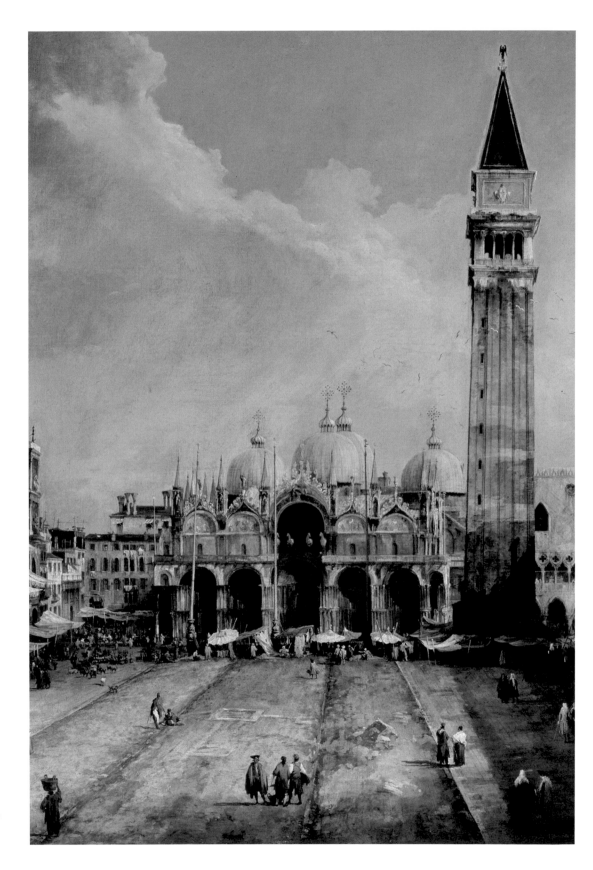

Fig. 15 Canaletto (1697–1768)
The Piazza San Marco, looking East,
about 1723
Detail of plate 10

his own age. His depiction of *The Reception of the French Ambassador Jacques-Vincent Languet, Comte de Gergy, at the Doge's Palace, 4 November 1726* (fig. 16; plate 13) is one of his most spectacular productions of the 1720s. A comparison with *The Reception of the British Ambassador Charles Montagu, 4th Earl of Manchester at the Doge's Palace, 22 September 1707* (fig. 17; plate 2) painted two decades earlier during Carlevarijs's prime, illustrates all the differences between the approaches and accomplishments of the two artists (the two paintings are of almost identical width). Foremost among these are Canaletto's unification of all the various elements into a convincing whole. The figures, despite their considerable number and the skill with which the painter's brush has articulated each one, are integrated into the scene rather than being spread across the fore-ground. Each one is imbued with vibrancy and movement, while in Carlevarijs's painting all seem comparatively static and 'staged'. Both skies are turbulent, but while Carlevarijs's contrasts with the mood of the scene below, in Canaletto's painting the two are inextricably linked, a cloud casting a shadow over the far end of the Doge's Palace. Aided by a viewpoint both lower and further away, Canaletto is able to give a far more convincing impression of the solid bulk of this unique building, which here appropriately dominates its surroundings.

There are signs that Carlevarijs attempted to update his style to compete with his young competitor, learning from him, for instance, subtleties of atmospheric perspective, but progressive paralysis ended Carlevarijs's career in 1728, two years before his death in 1730. In any case, already by the mid-1720s Canaletto's star had eclipsed that of Carlevarijs, and this situation was clearly evident to the Veronese figure painter and adviser Alessandro Marchesini (1663–1738), who in July 1725 wrote to the collector Stefano Conti of Lucca urging him not to commission more paintings from Luca Carlevarijs, but to turn to 'signor Antonio Canale, who astounds everyone in this county who sees his work, which is similar that of Carlevarijs, but you can see the sun shining in it'.[17] This eloquently expresses how Canaletto imbues his scenes with light and atmosphere, although, as J.G. Links has pointed out, actual sunlight was only to become a dominant feature of his work several years later, whenceforth it was to remain so until the mid-1750s. For it was at the end of the 1720s that the artist realised (or was advised) that what his clients wanted were views of Venice bathed in summer sun; the moodiness and drama of his earlier works vanishes, to be replaced by a new tranquillity. The lightening of Canaletto's palette echoes the recent development of Giambattista Tiepolo (1696–1770), his senior by one year, away from the tenebrism of Giovanni Battista Piazzetta.[18] Also from this time on, and here surely for commercial reasons, Canaletto's large paintings are outnumbered by comparatively small ones, which could be shipped abroad far more conveniently to the foreigners who had ordered them on their visits to Venice. These changes are already fully apparent in a group of views on copper plates painted in 1727–30, of which nine survive, and which are his only works on this support, as well as in *The Entrance to the Grand Canal, looking West, with Santa Maria della Salute* (plate 14), which, with its pendant, was received by their Irish patron, Hugh Howard of Shelton Abbey outside Arklow, County Wicklow, in August 1730.

The 1730s are the great decade of Canaletto's production of Venetian views, painted in his mature style, generally regarded as his most 'characteristic'. It is also the period when his relationship with Joseph Smith (about 1674–1770) was at its peak. Smith, an English merchant banker who had settled in Venice around 1700 and who was to serve as British Consul in the years 1744 to 1760, had played a significant part in the painter's career since the early 1720s as a patron. Although he was still active in that role in 1750, from the late 1720s through the 1730s he was even more useful as an agent in securing and processing commissions from British visitors to Venice, the Howard views being the first for which he is known to have been involved in this capacity.[19] Smith's enthusiasm for Canaletto's work was to be the making of the artist's fortune. Apart from his activity as patron and agent, he was also instrumental in the publication in 1735 of the first edition of Antonio Visentini's *Prospectus Magni Canalis Venetiarum*, a book of 14 engravings after Venetian views by Canaletto in Smith's own collection (including engravings of plates 16 and 17). The most celebrated of all Venetian publications of this kind, it boosted Canaletto's fame internationally, helping to disseminate his compositions and no doubt also serving to attract still more commissions. A second edition with 24 additional plates was issued in 1742. When Canaletto's own etchings were published after 1744, the title plate included a dedication to Smith.

Canaletto was much less reluctant than his predecessors

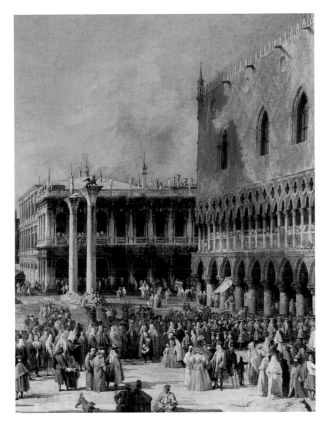

Fig. 16 Canaletto (1697–1768)
The Reception of the French Ambassador Jacques-Vincent Languet,
Comte de Gergy, at the Doge's Palace, 4 November 1726, about 1727
Detail of plate 13

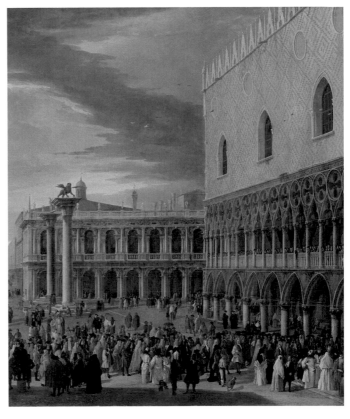

Fig. 17 Luca Carlevarijs (1663–1730)
The Reception of the British Ambassador Charles Montagu, 4th Earl of
Manchester, at the Doge's Palace, 22 September 1707, about 1707–8
Detail of plate 2

to wander from the beaten track in search of visually striking subject matter. An early and particularly brilliant example of his transformation into visual poetry of a relatively humble Venetian backwater is the unique view of *The Rio dei Mendicanti, looking South* (plate 9) – part of the same set of paintings of around 1723 as *The Piazza San Marco, looking East* (see fig. 15; plate 10) – with its raggedy-apparelled townsfolk, boatbuilder's yard and washing line. The celebrated *'Stonemason's Yard'* (plate 11) of about 1725 also shows a view which was then an out of the way cul-de-sac, although it is very much better known today, as the Campo San Vidal in the foreground is now the approach to the Accademia Bridge. Here again, no other painting of the view is known.

This inclination to investigate fresh subject matter became a necessity when Canaletto received the two largest commissions of his career, both for series of Venetian views, both executed in the 1730s, and both obtained through Joseph Smith. The first of these, received in 1731 or 1732, was from John Russell, 4th Duke of Bedford, payments from whom are recorded in 1733, 1735 and 1736. This was for 24 canvases, two large and 22 in a now standard smaller format, all of which remain in the possession of the duke's descendants, now at Woburn Abbey. Canaletto subsequently received a commission for 20 views in the smaller format from Charles Spencer, 3rd Duke of Marlborough, who was the Duke of Bedford's brother-in-law, and the painter evidently strove to keep the duplication of subjects to a minimum. The Marlborough series was scattered in the late 1950s and all its components remain in private collections (see plates 20 and 21). In these two series the subject matter

which comprised the repertoire of Venetian view painting was by necessity extended to envelope many parts of the city that had never been painted before.

Canaletto's supreme achievement in this style is a painting showing the most familiar buildings from an unprecedented angle, *The Riva degli Schiavoni, looking West* (fig. 18; plate 19), an incomplete payment for which – 100 *zecchini* of a total price of 120 – was made on 23 February 1736. It was commissioned by Field Marshal Johann Matthias von der Schulenburg (1661–1747), who was, with Joseph Smith, the greatest foreign patron of painters and collector of paintings resident in Venice in the eighteenth century. Schulenburg, a Saxon mercenary whose brilliant defence of Corfu against superior Turkish forces in 1715–16 had made him a Venetian hero, had subsequently settled in Venice, where he had begun to form his immense collection in 1724 at the age of 63. Although he began almost at once to ship his purchases back to his estates in Germany, the size of the canvas clearly presented none of the problems for him that it did in the case of views intended for shipping to Great Britain. The result, the most copied of all Canaletto's views, epitomises Canaletto's style at this stage in his development.

The painter is here at his most placid, the calm atmosphere, light tonality and warm sunlight being far removed from his style of the mid-1720s. The brushwork is supremely confident and precise, and there is a wealth of detail, far more in fact than the eye would assimilate before the view itself. A formula for representing ripples on the water has been established, and the sky is punctuated by carefully placed clouds which somewhat resemble floating drifts of cotton wool. There is a heightened emphasis on solidity, with much use of black to delineate the outlines and details of the buildings. The palette is dominated by blues and browns, with vivid local reds and yellows in the clothing. The painting is a masterclass in the balancing of a composition, and in the differentiation of the textures of materials, the artist's deft brushwork describing and distinguishing sailcloth, cloth, wood, stone, stucco, tiles and foliage. The figures are quite large and, although their movement is gentle throughout, there is a convincing impression of a captured moment. Peter Ackroyd has recently written:

> In the drawings and paintings of Venetian life, from those of Jacopo Bellini in the middle of the 15th century

to those of Francesco Guardi in the latter part of the 18th century, the setting and architecture of the city take precedence over the activities of its inhabitants. The physical space, and the stone face, are pre-eminent. Who can remember any of the human figures in Canaletto?[20]

While the general observation is clearly correct, the last sentence is most unfair to Canaletto, who of all the Venetian view painters took the most trouble to give every single one of the figures enlivening his scenes its own character and individuality. This is even more true of the dogs which clearly held a special place in the bachelor artist's affections.

The achievements of the Venetian view painters of the eighteenth century, and notably Canaletto, are often attributed in part to their use of the camera obscura, an ancestor of the photographic camera. This consists of a wooden box with a small hole in the side, through which an image is projected upside down on to a sheet of paper.[21] A portable example in the Museo Correr in Venice is traditionally believed to have been owned by Canaletto, although the evidence is slight,[22] and there are several eighteenth-century references to artists' use of them, contemporaries evidently being attracted by the idea of a new scientific method of capturing visual data.[23] Michele Marieschi, ostensibly one of the more spontaneous of view painters, was portrayed in a caricature by Antonio Maria Zanetti the Elder with a camera obscura as his 'attribute' (fig. 19).[24] Perhaps most surprisingly, Francesco Guardi was described by the diarist Pietro Gradenigo in his early, and only, reference to the artist, of 1764, as being very successful through his use of the 'camera optica'.[25] Canaletto certainly employed the camera obscura, and passed this practice on to Bellotto. It could be used in the making of *scaraboti*, perspectival diagrams which served as points of departure for compositions for which there was no easily accessible precedent. A drawing in Darmstadt of the Piazzetta is a rare example of a straightforward image, with a single vanishing point, created in this way.[26] It could also be

Fig. 18 Canaletto (1697–1768)
The Riva degli Schiavoni, looking West, about 1735–6
Detail of plate 19

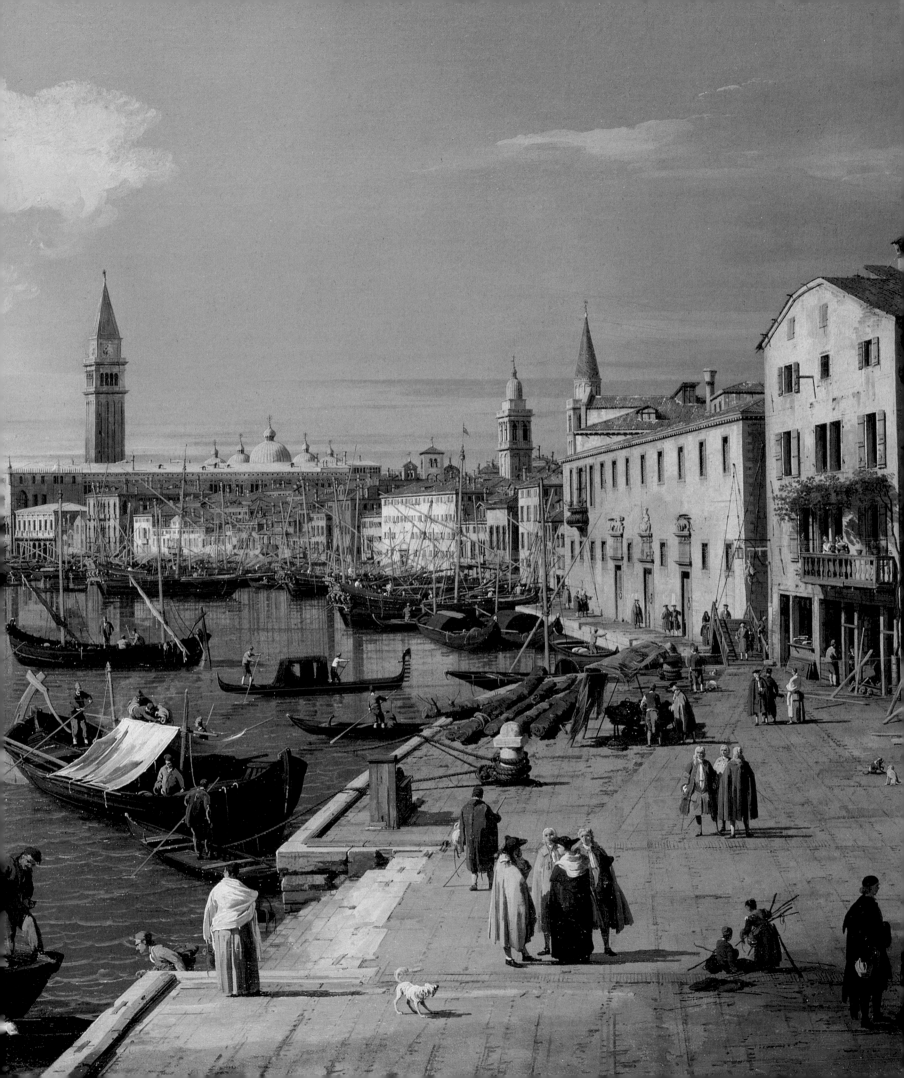

used to help create compositions with multiple vanishing points. Those would then have been followed by more specific drawings of sections of the composition, for which the camera obscura could also be employed. It was of less use for the numerous compositions involving unattainable viewpoints, for instance above the Grand Canal or high above the Bacino di San Marco (see plate 22), or in situations where there was insufficient distance between the artist and his subject for it to be contained in the viewfinder. A mechanical device such as the camera obscura was usually of limited help, as the viewpoint would often be adjusted for the painting in its final form, with some details suppressed and others added. Its limitations were remarked upon by the art critic Antonio Maria Zanetti the Younger (1706–78), who observed that

> Canal [i.e. Canaletto] taught through example the proper use of the camera ottica: and likewise to recognise the defects that such use brings to a painting, when the artist trusts entirely the perspective that he can see through such a device, in particular the colour of atmosphere, and is thus unable to deftly remove what may offend the sense.[27]

In the case of the Darmstadt drawing, which the artist inscribed 'the year 1732 the Month of July for [a painting sent to] England',[28] the resultant work is part of the series for the 4th Duke of Bedford, now at Woburn Abbey,[29] so that the ways in which the composition has been transformed can be clearly seen. An extreme example is *The Piazza San Marco, looking South and West* (plate 15; fig. 20) in the Wadsworth Atheneum, which may have been painted for Schulenburg and delivered in March or April 1731.[30] While a superlative representation of the square, this was hardly intended to be topographically accurate. Indeed, it is a visual catalogue of the sort of distortions which Canaletto and his fellow *vedutisti* were wont to introduce for visual effect. The Campanile has been drastically truncated to fit into the picture plane, and the bays of the Procuratie Nuove have been reduced in number by about a third. Most surprising is the satisfactory assimilation of contradictory vanishing points, as the façade of the Procuratie Vecchie on the far right would have to be behind the viewer's back for him to attain the view down the Piazzetta presented on the left. The more startlingly distorted views by Michele Marieschi may

well have been inspired by experimentation with wide-angle lenses (see figs 23 and 25; plate 39).

The mood of Canaletto's work changes in the late 1730s, cold light replacing the warm sunshine which pervades his earlier production, and it retains this character until around 1742, when the sunshine returns to stay. The style produced its own masterpieces in the frosty panoramic view of *The Bacino di San Marco* (plate 22) and *The Grand Canal with San Simeone Piccolo and the Scalzi* (plate 25), which are unequalled in their translucence and precision. The Boston painting (plate 22) is a particularly good example of the artist's ability to paint from unattainable viewpoints, which must have tested his imaginative abilities to their extreme, since the Campanile, the only high vantage point which Venice offers, was of no assistance here, and the first manned flight of a hot air balloon did not take place until 1783. It is very detailed; indeed, such is the wealth of detail incorporated in the

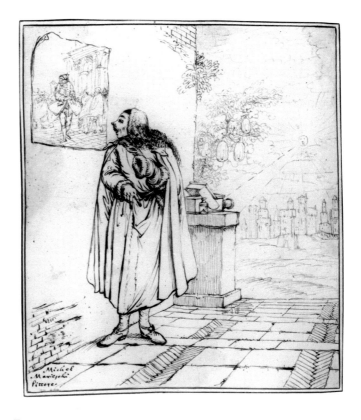

Fig. 19 Antonio Maria Zanetti the Elder (1680–1757)
Michele Marieschi con la camera ottica, about 1740–1
Pen and brown ink with bistre, on traces of black pencil, 23.1 x 20 cm
Fondazione Giorgio Cini, Gabinetto dei Disegni e delle Stampe, Venice (36726, f. 76)

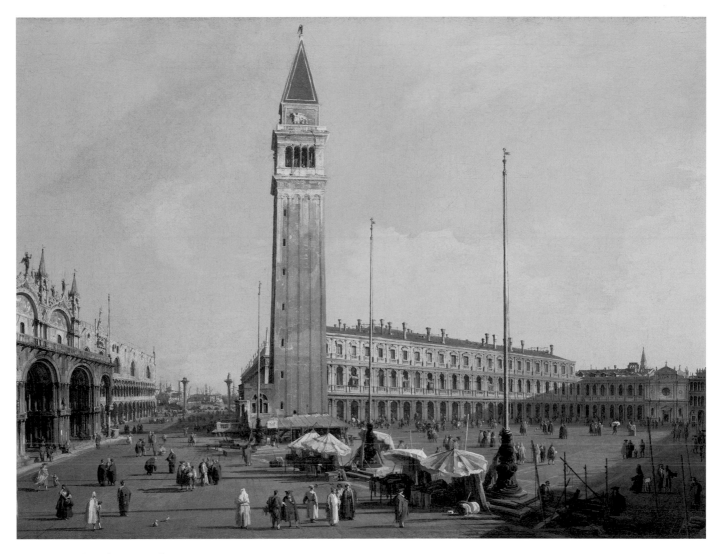

Fig. 20 Canaletto (1697–1768)
The Piazza San Marco, looking South and West, about 1731
Detail of plate 15

painting that even the forms of the buildings in the Castello district shown just to the left of the island of San Giorgio are precisely defined. The Bacino is punctuated by a veritable encyclopaedia of the types of craft to be seen in Venetian waters, including English, French and Danish as well as Venetian shipping. Everything is held together by the crystalline light, here more wintry than in any other painting by Canaletto, and the surface, which is fairly rough for a work of this date, enhances this effect.

In contrast to the leading view painters of Rome and Naples, the majority of those in Venice were natives of the city. The only one of Canaletto's near-contemporaries to pose a real threat to his domination of the field was Michele Marieschi (Venice 1710–43). Like Canaletto, he had a background in scenography. The vivacity of his brushwork suggests that he painted quite quickly, and this would seem to be born out by the relatively large oeuvre which he produced in a short career. In general his highly individual style is a brighter, more vividly coloured variant of Canaletto's in this period, dominated by light blues and shades of brown, and punctuated by small areas of strong red. It is also more animated, with a busier formula for the water, and shows less concern with conveying the solidity of buildings. The thickness of his paint and his broader brushwork, with individual strokes clearly visible, recall Canaletto's work at a time when Marieschi was still in his

early teens.[31] Marieschi followed Canaletto in working mainly on canvases of fairly small dimensions. Inevitably the eight exceptions provide the masterpieces. These include *The Bacino di San Marco* (fig. 21; plate 41), which shows the painter at his most Canalettesque. Indeed, it was believed to be the work of Canaletto by its second owner, James Harris (1709–80), father of the 1st Earl of Malmesbury, when he was bequeathed it, simply described as a 'large view of Venice', in 1750;[32] this was despite his ownership of other paintings by both Canaletto and Marieschi, and its true authorship was first recognised only in 1958.

Although Marieschi's highly distinctive touch and rich texturing are evident throughout, the composition and palette reveal so strongly a knowledge of Canaletto's similarly panoramic and only slightly larger view now in Boston that it must have been painted in conscious emulation of that. Marieschi's approach to painting is so

Fig. 21 Michele Marieschi (1710–1743) *The Bacino di San Marco*, about 1739–40. Detail of plate 41

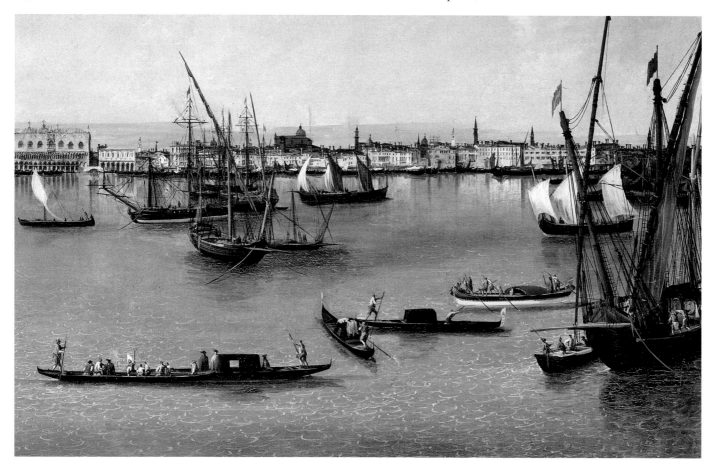

spontaneous and vivacious that it comes as no surprise to discover that large areas of the painting were transformed during the process of its creation, to an extent without known parallel in Venetian view painting. The shipping, initially much more dominant, was largely repainted on a smaller scale, closer to that of the Canaletto painting. This is fully apparent with the use of infrared reflectography (see fig. 22), and is evident to some extent to the unaided eye. Such significant *pentimenti* are often the hallmark of artists who compose directly onto canvas without the aid of preparatory drawings, and indeed, in striking contrast to Canaletto, no drawings by Marieschi are known.[33] He did, however, publish in 1741 a book of 22 engravings of his own compositions, *Magnificentiores Selectioresque Urbis Venetiarum Prospectus*. Like Visentini's book of engravings after Canaletto, this was clearly intended to disseminate

Marieschi's work to a wide audience and to serve as a pattern book. Many of Marieschi's paintings are variants of the compositions of its plates.

One characteristic of Marieschi's style which sets it apart from Canaletto's work is his fondness for striking compositions using unexpected viewpoints and involving varying degrees of distortion. A good example is *The Entrance to the Grand Canal, looking East, with Santa Maria della Salute* (fig. 23; plate 36), whose dramatic effect is due to the striking foreshortening of the church of Santa Maria della Salute and the distortion of the right angle between the quays in the foreground, both of which emphasise the unusually low viewpoint. Further distortion is evident in the buildings lining the far side of the Grand Canal, which bend round until they are almost parallel with the picture plane. The result is a composition which makes a Canaletto painting of

Fig. 22 Detail from infrared reflectogram of plate 41

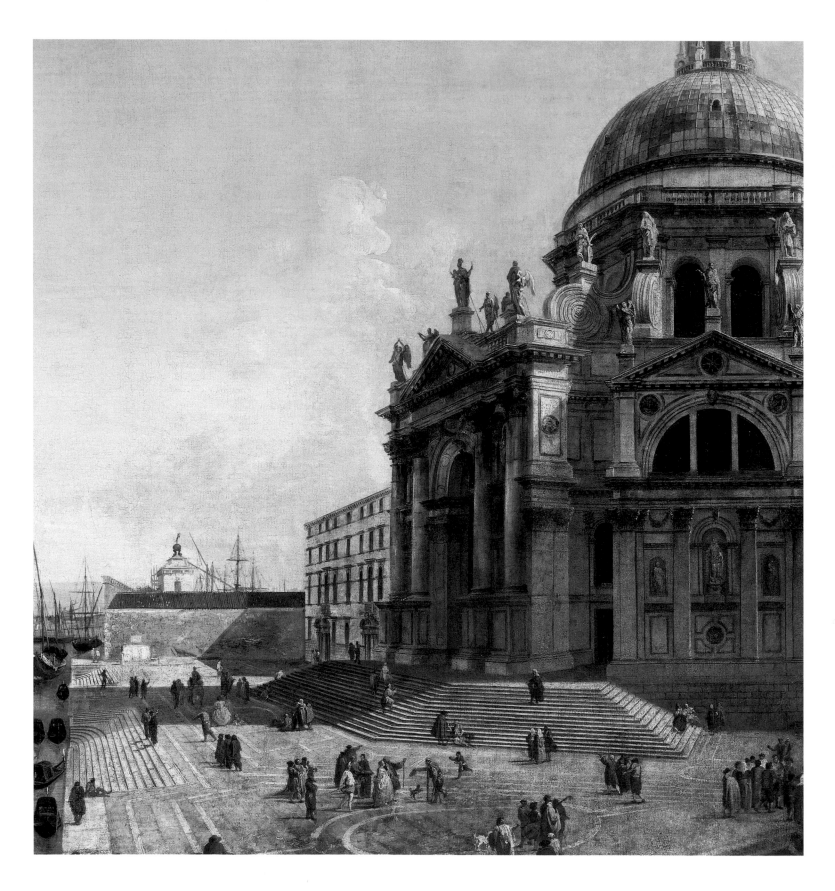

Facing:
Fig. 23 Michele
Marieschi (1710–1743)
*The Entrance to the Grand
Canal, looking East, with
Santa Maria della Salute,*
about 1735
Detail of plate 36

Fig. 24 Canaletto
(1697–1768)
*The Entrance to the Grand
Canal, looking East, with Santa
Maria della Salute,* about
1742–4
Detail of plate 29

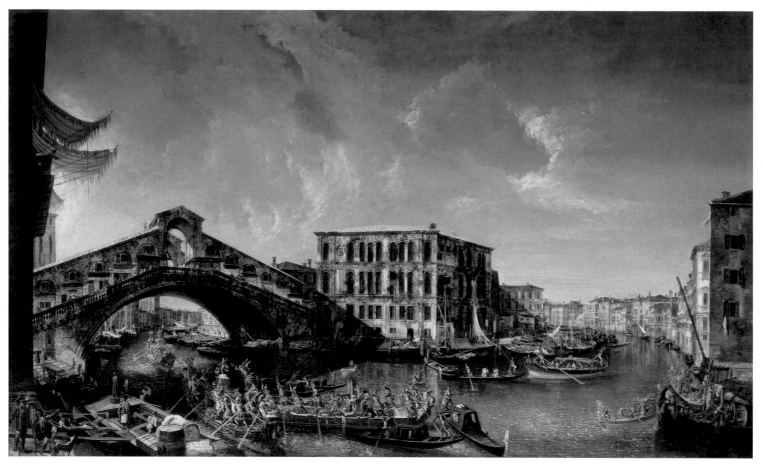

Fig. 25 Michele Marieschi (1710–1743)
The Grand Canal with the Rialto Bridge from the North and the Arrival of the new Patriarch Antonio Correr, 7 February 1735, 1735
Oil on canvas, 123.15 x 208.3 cm
Osterley Park, The National Trust. The Lady Mildred Fitzgerald Bequest

the same subject, which is of similar date and similar size, seem comparatively staid, despite its distinctly more subtle technique (fig. 24; plate 29).

An equally arresting composition is *The Grand Canal with the Rialto Bridge from the North and the Arrival of the new Patriarch Antonio Correr, 7 February 1735* (fig. 25), in which the canal is distorted into a dramatic U-bend in a way antici-pated only by Canaletto's *The Piazza San Marco, looking South and West* (plate 15). Following a practice not uncommon in Venetian workshops of the period, Marieschi delegated the execution of the staffage (the figurative element) in this painting to a specialist figure painter, Gaspare Diziani (Belluno 1689–Venice 1767), who was to perform the same function for Antonio Joli in his pair of views of *The Formal Entrance of the Apostolic Nuncio Monsignor Giovanni Francesco*

Stoppani, 17 April 1741 (plates 34, 35). On other occasions the staffage in Marieschi views was often provided by Francesco Simonini (Parma 1686–Florence or Venice about 1753) or Giovanni Antonio Guardi (Vienna 1699–Venice 1760). This painting is one of two large masterpieces executed by Marieschi for Schulenburg, who acquired no fewer than 12 paintings from him. Marieschi would seem to have very directly lured the old soldier's affections away from Canaletto, since Schulenburg's commissions to Marieschi follow immediately his last commission to Canaletto, despite the unsurpassed quality of the painting which Canaletto had just supplied to him (plate 19). No doubt financial concerns played their part in Schulenburg's decision, as on 20 April 1737 Marieschi received for this painting, the more expensive of the two, 55 zecchini 'and

two silver medals',[34] while Canaletto had charged more than 120 zecchini for his.[35] Works such as this suggest that Canaletto may well have had cause to feel relieved by Marieschi's death in 1743, shortly after his 32nd birthday.

Another occasional competitor to Canaletto around this date is Giovanni Battista Cimaroli (Salò, near Brescia 1687–Venice 1771). Cimaroli was predominantly a painter of landscapes and in that capacity contributed the backgrounds to two paintings of Allegorical Tombs executed largely by Canaletto in the mid-1720s.[36] His activity as a view painter has only recently begun to be assessed, and one of his views, of *Dolo on the Brenta* (Staatsgalerie, Stuttgart), remains incorrectly attributed to Canaletto.[37] *The Piazza San Marco with the Populace chasing Bulls in Celebration of the Visit of Frederick Christian of Saxony, 16 February 1740* (figs 26, 73; plate 33) is possibly the painter's finest view painting, the previously unpublished prototype of a composition hitherto known only from derivative versions.[38] The rare staging of a bull-baiting spectacle in the Piazza San Marco was a subject well suited to Cimaroli's abilities, and shows him providing a worthy alternative to the more decorative type of large canvases produced by Canaletto with varying degrees of

studio assistance in the 1740s.[39] The painting remained in Venice until 1836, when it was purchased there by Richard, 2nd Marquess of Westminster (1795–1869), inevitably as the work of Canaletto; this suggests that it may be a relatively rare example of a Venetian view commissioned by a local, to whom it would have been of greater interest than other Venetian views as a record of a notable historical event.

Canaletto's 'cold' period, around 1738 to 1742, coincides with the emergence in his studio of his nephew Bernardo Bellotto (Venice 1722–Warsaw 1780). Bellotto was more than capable of assimilating the lessons to be learned from his bachelor uncle and took full advantage of the best training a view painter ever received. Remarkably precocious, he was only 16 years old when he was enrolled in the Venetian painters' guild in 1738, and by about 1740 he could imitate his uncle's style with extraordinary dexterity. The later stages of his training involved the production of his own versions of accessible paintings by Canaletto – recent works in the studio awaiting dispatch to their patrons, and earlier examples in Joseph Smith's house on the Grand Canal – including fairly comprehensive coverage of the more successful compositions. While many of the results were

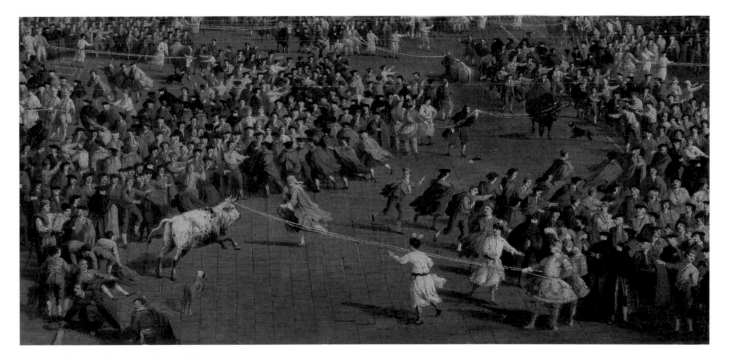

Fig. 26 Giovanni Battista Cimaroli (1687–1771)
The Piazza San Marco with the Populace chasing Bulls in Celebration of the Visit of Friedrich Christian of Saxony, 16 February 1740, 1740
Detail of plate 33

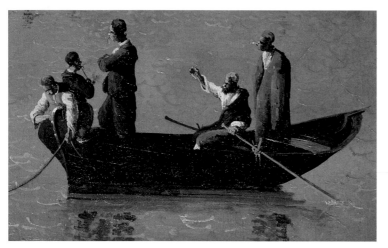

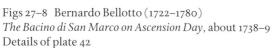

Figs 27–8 Bernardo Bellotto (1722–1780)
The Bacino di San Marco on Ascension Day, about 1738–9
Details of plate 42

Figs 29–30 Canaletto (1697–1768)
The Molo from the Bacino di San Marco on Ascension Day, about 1733–4
Details of plate 16

presumably sold under the name of the better-known artist, Bellotto's distinct artistic personality is clearly expressed from the start, as he was never shy of seeking to 'improve' on his models. *The Bacino di San Marco on Ascension Day* (see fig. 11; plate 42) is a very early work by Bellotto, painted around 1739 when he was only about 17 years old. This follows Canaletto less closely than most, the boats and figures deriving from two different prototypes. The barge in the left corner and the rowing boat in the left foreground (figs 27–8) are taken, the latter in reverse, along with all their figures, from the older artist's view of *The Molo from the Bacino di San Marco on Ascension Day* (figs 29–30; plate 16) then in Smith's collection. In all other respects Bellotto's composition is close to that of a Canaletto drawing in the Royal Collection.[40]

It differs from that, however, in the clouds, which are in their general layout close to those in Canaletto's painting of about 1739 (of much smaller dimensions) in the Museu Nacional d'Art de Catalunya, Barcelona (fig. 33; plate 24).

Bellotto's youthful inexperience is evident in the inelegance and awkward twisting of the figures; the bulky, faceted limbs of many of the larger ones make them seem hewn from tree trunks. The impression is given that he would happily have avoided painting faces altogether, single round dots of paint being used to represent noses even in the most prominent figures. While Canaletto was particularly adept at painting dogs, which provide many of the most charming details in his paintings (figs 34, 35), his nephew was not. In the gondola at lower right (which is not present

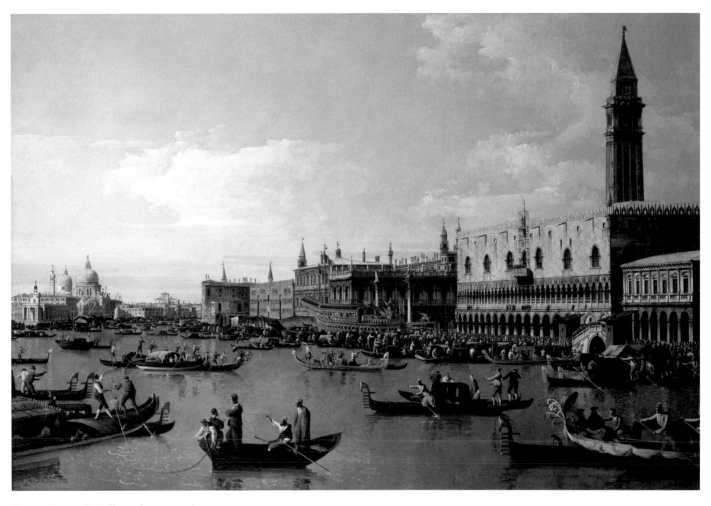

Fig. 31 Bernardo Bellotto (1722–1780)
The Bacino di San Marco on Ascension Day, about 1738–9
Plate 42

Fig. 32 Canaletto (1697–1768)
The Molo from the Bacino di San Marco on Ascension Day, about 1733–4
Plate 16

Fig. 33 Canaletto (1697–1768)
The Bacino di San Marco on Ascension Day, about 1739
Plate 24

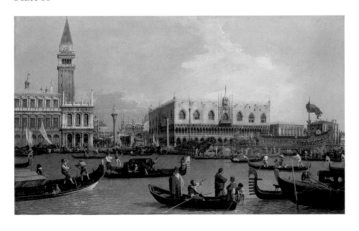

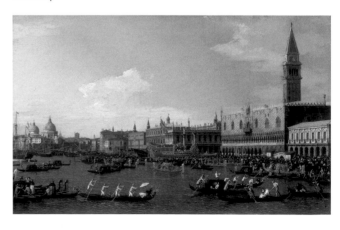

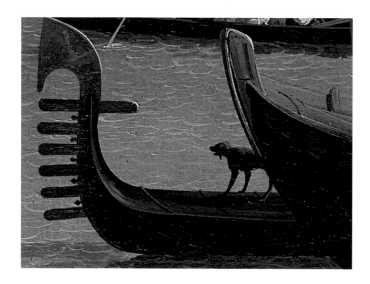

in Canaletto's drawing and is one of several vessels which appear perilously close to their neighbours) is a dog (fig. 36) which recurs in similarly simian form in other paintings, including *The Arsenale* (plate 45). Bellotto has obvious difficulties in painting boats in water – in all of his early productions boats appear to glide over the surface of the water rather than sit in it. In other respects, however, the painting anticipates his mature style, revealing a distinct personal aesthetic. The paint is applied more broadly and thickly than in contemporary work by Canaletto, giving the painting a more richly textured – and in the foreground even crusty – surface. While Canaletto's clouds are soft, with something of the appearance of hovering bunches of cotton wool, Bellotto's more closely resemble scraped icing sugar; the lowest part of the sky is composed of thin horizontal bands of differing tones. Bellotto's particular love of black is evident, and there are stronger contrasts of light and shade than in Canaletto's work. The palette in general is dominated by pale greys and blues, with localised reds, and the painter's favoured shades of grey-blue and lilac in the clothing. The resulting effect is overcast, Canaletto's warm sunlight having been replaced by a colder, even wintry, light (this was to remain a characteristic of Bellotto's style for the rest of his career, although it is obviously less appropriate in the Italian views than it was to be in his later work at Königstein in Saxony, and Warsaw). The formula for the water, with ripples in extended and interlocking 'W' shapes, gives way in the middle ground to a lighter, more translucent surface, which allows more play with reflections and throws into relief the dark shapes of boats upon it. The reflections themselves are often executed in very short parallel strokes. Other distinguishing features of Bellotto's early modus

Fig. 34 Canaletto (1697–1768)
The Reception of the French Ambassador Jacques-Vincent Languet, Comte de Gergy, at the Doge's Palace, 4 November 1726, about 1727
Detail of plate 13

Fig. 35 Canaletto (1697–1768)
The Molo from the Bacino di San Marco on Ascension Day, about 1733–4
Detail of plate 16

Fig. 36 Bernardo Bellotto (1722–1780)
The Bacino di San Marco on Ascension Day, about 1738–9
Detail of plate 42

Fig. 37 Bernardo
Bellotto (1722–1780)
*The Campo Santa
Maria Formosa,*
about 1742
Plate 44

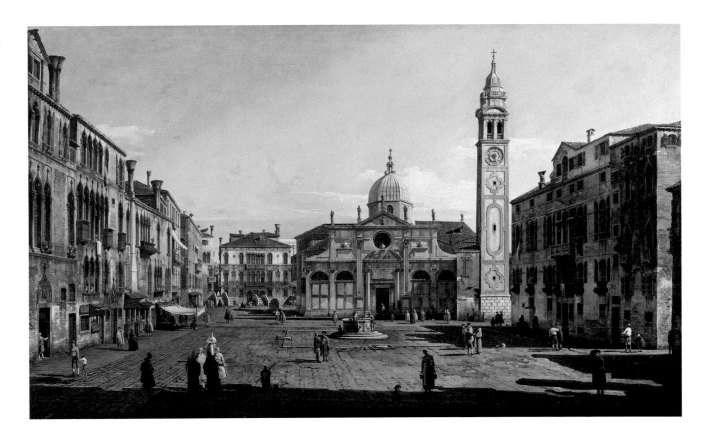

Fig. 38 Canaletto
(1697–1768)
*The Campo Santa
Maria Formosa,*
about 1733–4
Plate 18

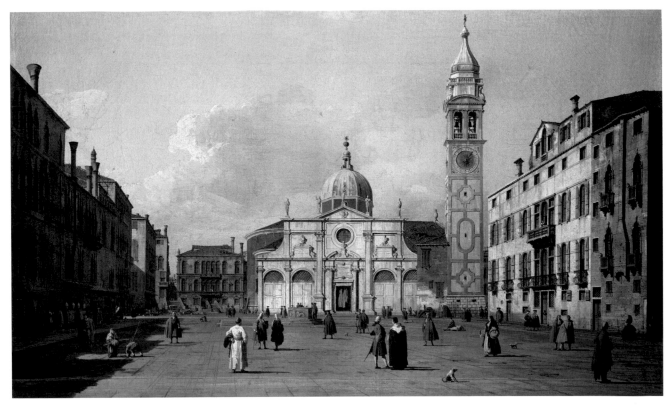

operandi are the execution of the sky in diagonal strokes
descending towards the left, and the use of light-catching
incised straight lines as the edges of buildings and their
reflections.

While *The Bacino di San Marco on Ascension Day* is a
remarkable achievement for such a young painter, *The
Campo Santa Maria Formosa* (fig. 37; plate 44), of only about
three years later, shows how far Bellotto progressed in his
development of a personal manner in a relatively short time,
the handling showing far greater confidence in all areas.
Three paintings by Canaletto of this composition are known
(see fig. 38, plate 18), of which Bellotto would have seen his
uncle paint at least one.[41] Bellotto's versions of Canaletto
compositions are often larger than the prototypes, and,
although Bellotto's first treatment of the subject, of about
1739,[42] is only slightly larger than Canaletto's three, the
dimensions of this painting are significantly greater. The
larger scale helped Bellotto to enhance the monumentality
of the buildings, to which end his more forceful application
of shadow also contributes considerably. The shadow cast
across the whole width of the foreground is a device often
employed by him to lead the eye into the painting. The
painter's understanding of natural phenomena is shown in
details such as the reverse shadow cast by the gentleman
towards lower left, the result of sunlight reflecting off the
wall of the house behind him. His command of the descrip-
tion and differentiation of textures is apparent throughout,
including his distinctive and masterful treatment of old
stucco on brick. The figures demonstrate Bellotto's search
for a figure style distinct from that of his uncle, here still
going through a distinctly mannered phase. The dwarf-like
female figure seen from behind and holding sticks, in the left
foreground, is a frequently recurring motif around this
date.[43] While in general figures diminish in size and signifi-
cance in Venetian view painting as the century progresses,
Bellotto always had ambitions as a figure painter, and in his
later work in Northern Europe the trend is in reverse, the
figurative element becoming more important in a number
of paintings of the 1760s than it ever was before.

A composition which was particularly popular in the
Canaletto studio for a short period in the early 1740s is *The
Entrance to the Grand Canal, looking East from the Campiello
del Traghetto di Santa Maria Zobenigo, with Santa Maria
della Salute*. Many of the differences in approach between

Figs 39–41 Bernardo Bellotto (1722–1780)
The Campo Santa Maria Formosa, about 1742
Details of plate 44

Fig. 42 Bernardo Bellotto (1722–1780)
*The Entrance to the Grand Canal, looking East, with Santa Maria della
Salute*, about 1743
Detail of plate 47

Fig. 43 Canaletto (1697–1768)
*The Entrance to the Grand Canal, looking East, with Santa Maria della
Salute*, about 1741
Detail of plate 26

Bellotto and his uncle in the early 1740s are demonstrated
by a comparison between Bellotto's rendition of about
1743 (plate 47) and Canaletto's, datable on stylistic grounds
to around 1741, in the Fitzwilliam Museum, Cambridge
(plate 26). In Bellotto's version the buildings have a solidity
and monumentality which belies the painting's small scale,
the cold light unifies the scene, there is more convincing
transparency and recession in the water, and the blacks are
differentiated from one another by subtle gradations of
tone (figs 42, 43; figs 44, 45). This composition was to
become one of the most popular Venetian views among
derivative painters of the following decades, no doubt
largely because another version by Bellotto (also in the
Fitzwilliam Museum) seems to have remained accessible in
Venice. It is therefore somewhat surprising that this painting
should be the only one known of this subject by Canaletto,

while there are no fewer than four by Bellotto.[44]

Bellotto is only known to have had one pupil during his
early years in Venice, his slightly younger brother Pietro
Bellotti (Venice 1725–France about 1800), from whom he
received payment for board and training between 5
November 1741 and 25 July 1742.[45] A recently identified
painting by Pietro of the same composition is a particularly
fine example of his work during his brief career in Venice
before he emigrated to France at about the age of 23 (fig. 46;
plate 50). While he must surely have been brought up in the
Canaletto studio, and this painting reveals in certain details
a knowledge of at least three of his brother's versions of the
composition, his approach to the subject is surprisingly
individual and un-Canalettesque. This is most apparent
in the light palette, dominated by the light brown of the
buildings and the brilliantly translucent turquoise blue of the

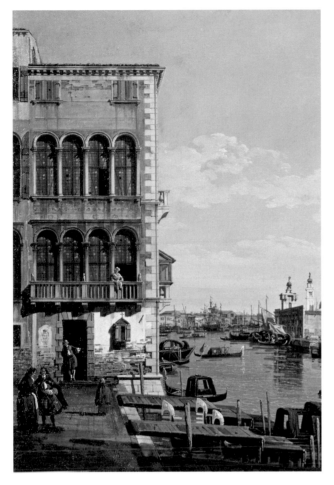

Fig. 44 Bernardo Bellotto (1722–1780)
The Entrance to the Grand Canal, looking East, with Santa Maria della Salute, about 1743
Detail of plate 47

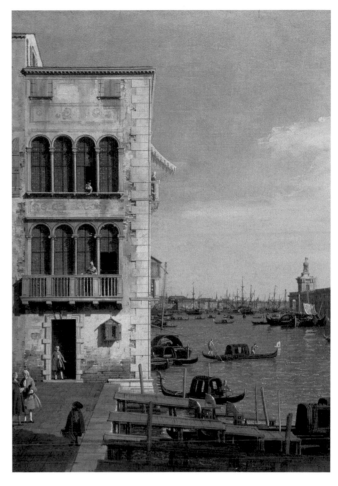

Fig. 45 Canaletto (1697–1768)
The Entrance to the Grand Canal, looking East, with Santa Maria della Salute, about 1741
Detail of plate 26

water – with vivid accents of red and blue in the figures, and very limited use of black, which anticipates that of several nineteenth-century painters – and in the lighting from the left rather than the right, as in Canaletto's version and all those by Bellotto, so that little apart from the lower corners is in shadow. Other characteristics of Bellotti's style are the inclusion of more sky and the extension of the composition to the left. There are innumerable other differences of detail, notably the omission of the masts between the dome of San Giorgio Maggiore and the Seminario Patriarcale, and of the ship moored in the Bacino. A real impression of the vast expanse of the Bacino is given, the Riva degli Schiavoni not being brought forward and round to close off the view.

The period around 1740 is in many ways the apex of the history of Venetian view painting. By this date Canaletto's Venetian views were widely circulated among the Whig aristocracy. In June 1741 Frances, Countess of Hertford, could write to her friend Henrietta, Countess of Pomfret:

I have (in imagination) attended you to the doge's palace at Venice, the front of which I am acquainted and charmed with, from a large picture that Sir Hugh Smithson has of it, painted by Canaletti. Lord Brooke also has some views of that city painted by the same master.

Much can be learned about the market for view paintings in Venice at the end of the 1730s and beginning of the 1740s from the collecting activities of Henry Howard (1694–1758),

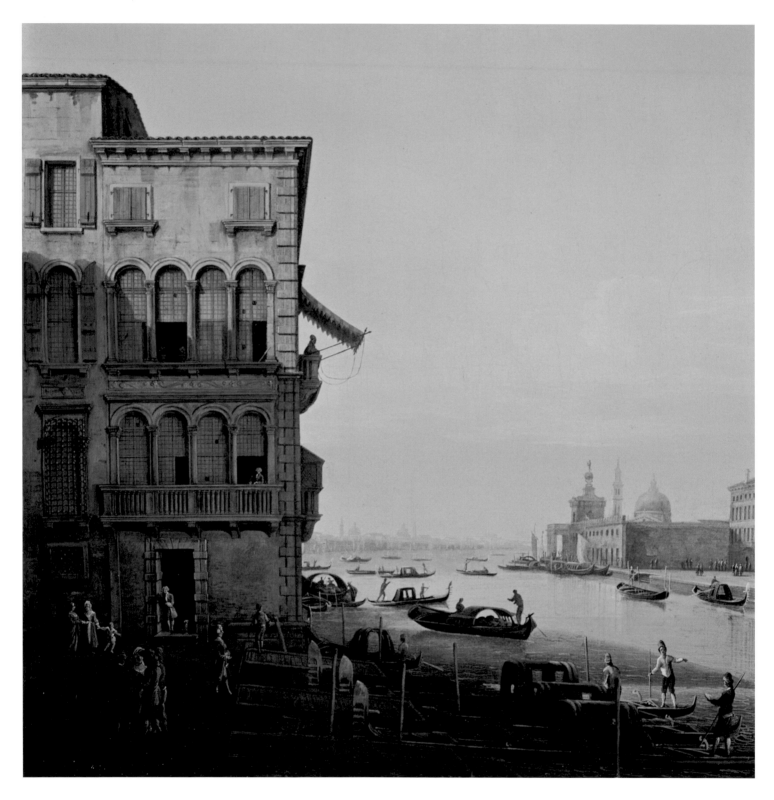

Fig. 46 Pietro Bellotti (1725–about 1800)
The Entrance to the Grand Canal, looking East, with Santa Maria della Salute, about 1743–4
Detail of plate 50

who succeeded as 4th Earl of Carlisle in 1738, and whose wife was the half-sister of the 4th Duke of Bedford and sister-in-law of the 3rd Duke of Marlborough, Canaletto's great patrons of the early and mid-1730s. He was in Venice on the Grand Tour from November 1738 for a few months, when he presumably commissioned the large number of view paintings delivered to Castle Howard in the following years. The collection was to remain there intact until 1895 but has since been almost entirely dispersed, and, in some cases, destroyed. It included a surprisingly disparate group of five large canvases by Canaletto, of which the surviving elements are the Boston *Bacino di San Marco* of about 1738–9 (plate 22) and the pair showing *The Entrance to the Grand Canal and Santa Maria della Salute from the Molo* (plate 27) and *The Piazza San Marco and the Piazzetta, looking South East* (plate 28) in the National Gallery of Art, Washington, which must date from around 1743. There were also fifteen paintings by Bellotto, three large and twelve small, of which the large *Bacino di San Marco on Ascension Day* (plate 42) and three small canvases are the only Venetian views remaining at Castle Howard.[46] Six perished in the fire in the house in 1940, but the large pair, sold in 1895, is now in the Louvre (Donation Hélène et Victor Lyon). Like Schulenburg, the other recipient of one of Canaletto's outstanding master-pieces of the 1730s, Carlisle also turned to Marieschi, acquiring from him no fewer than eighteen Venetian views, all of a standard fairly small size. Thus both patrons acquired more paintings from Marieschi than they ever had from Canaletto. Here again the reasons may well have been economic. The connoisseur-dealer Antonio Maria Zanetti the Elder, who seems to have been responsible for securing Marieschi this commission, reminds Carlisle in a letter of 1740 that the painter, whom he does not name, but who is 'as able as Canaletto, to whom nowadays one pays only for the name and the renown', only charges six pounds for views of the type which had recently arrived at Castle Howard.

The War of the Austrian Succession, which had broken out in December 1740, moved to Italy in 1741 and after escalating in 1744, continued there until the conclusion of peace in October 1748. That, while not preventing travel, inevitably dampened the enthusiasm of many potential travellers on the Grand Tour. Canaletto, who had for several years been showing a desire to expand his horizons beyond the painting of views of Venice, which had occupied his time

so completely through the previous decade, left for England in 1746. He was to remain there for nine years, apart from an eight-month return to Venice in 1750–1 (of which the only fruit we know is, paradoxically, the large pair of London views now in the Royal Collection). The departure of Bernardo Bellotto for Northern Europe in 1747 and of his brother Pietro Bellotti to Toulouse before mid-1748, neither of whom ever returned to their native city, completed the exodus of the family from Venice, leaving no painter of any real merit to supply whatever remained of the market for view paintings.

The simultaneous departure of the leading protagonists must, however, have given a considerable boost to imitators and copyists. These probably included former Canaletto studio assistants, and there is evidence that Joseph Smith himself helped to develop this market. Sir Matthew Fetherstonhaugh, 1st Baronet (1714–74), who had purchased Uppark in West Sussex in 1747, was in Italy in 1750–1. Keen to decorate his new home, in 1751 he commissioned in Rome nine portraits and two personifications from Pompeo Batoni and six landscapes from Joseph Vernet, and in Naples five Neapolitan views from Tommaso Ruiz, before arriving in Venice in time for Ascension Day. There he met Joseph Smith, who shipped to him between 1753 and 1755 tables, china and paintings which he had commissioned or purchased. The paintings (for some of which he paid Smith on 13 February 1753, followed by 'Duty on Pictures' on 16 May 1754) included a set of eight 'Canaletti'. Clearly provided in Canaletto's absence, these are highly competent copies of Venetian views by Canaletto owned by Smith, and their author may well have been a Canaletto studio assistant; other similar works by the same hand are known.[47]

Canaletto's definitive return to Venice in 1755 prompted a further stylistic change towards greater sobriety, darker tonality, and a tendency for the size of canvases to reduce still further.[48] Clouds are tinged with pink, highlights are rendered in dots of paint and background figures ever diminish in significance, eventually dissolving into tiny calligraphic swirls and dots. The painter's ability to create striking new compositions continued unabated, a fine example being the typically small view of *The Piazza San Marco from the Western Arcade* (plate 31). The highlights of this final phase in Canaletto's career are among the few larger products of this period, a set of four paintings

Fig. 47 Canaletto (1697–1768)
The Grand Canal looking South-East from the Campo Santa Sofia to the Rialto Bridge, between 1758 and 1762
Detail of plate 32

the two daylight views may be seen as a culmination of the development towards hard outlines and precise detail. Sir Michael Levey, that most eloquent of apologists for Canaletto, wrote of the late paintings, with particular reference to the Streit *Grand Canal*, that they

> become triumphs of conscious exactness, down to the precise placing of each paving stone and ripple, with an effect more of mosaic than of paint used in any obviously 'free', painterly way. Canaletto has compelled the untidy reality of the assembled bobbling gondolas and other boats at the right here, as well as the bustling activity of rolling barrels or bales along the adjoining quay, to be frozen into deliberate, intricate patterns, with no loss of artistic vitality – only of 'naturalism'.[50]

During the last decade of his life Canaletto had a new rival, who was to outlive him by 25 years and to provide a glorious last chapter in the history of Venetian view painting. Francesco Guardi (Venice 1712–93) was only 15 years younger than Canaletto, but was even older than Luca Carlevarijs when he found his calling; like Carlevarijs, he would hardly be remembered for his earlier work in other genres. He had begun his career as a specialist figure painter, like his father and elder brother Giovanni Antonio, whose work of this type overshadowed his. Francesco's earliest datable outings in his newly chosen genre are of 1758, when he was already in his mid-forties. He may well have first decided to try his hand at view painting a few years earlier, quite possibly being among the copyists probably employed by Smith to produce paintings based on prints after, and by, Canaletto in order to meet the demand while the latter was still in England.[51] New responsibilities incurred by his marriage in 1757 may have encouraged this change of direction, as may the death of his brother in 1760, although by then Francesco seems to have already moved out of the family studio. Pietro Gradenigo's interesting comments of 1764 about Guardi, to which reference has already been made above (p. 26), include the description of him as 'a good pupil of the renowned Canaletto'.[52] This should probably not be taken literally, but may be understood as reflecting contemporaries' understanding of his stylistic links with the older artist. That Guardi was considered to be something of an authority on Canaletto's work is implied by his presence in 1789 on a tribunal at the Accademia called to adjudicate whether

executed for Sigismund Streit (1687–1775), a native of Berlin who had settled in 1709 in Venice, where he had made a fortune as a merchant. Like Schulenburg, Streit was a bachelor. His commission was very specific, the resulting paintings being intended as a gift for the secondary school in Berlin which he had attended in his youth, the Gymnasium zum Grauen Kloster, to which they were dispatched in 1763 and to which they still belong (now on long-term loan to the Berlin Gemäldegalerie). Two depict night festivals, the other two *The Campo di Rialto*, the centre of commerce and banking, and *The Grand Canal looking South-East from the Campo Santa Sofia to the Rialto Bridge* (plate 32), which includes Streit's home prominently on the left (fig. 47).[49] Here again the compositions are new and striking, and

paintings offered for sale by a dealer were correctly attributed to Canaletto; the conclusion was that they were products of the 'school of Marieschi'. Guardi certainly shows a willingness to borrow compositions from Canaletto throughout his career, an example probably of the 1760s being a view of Santa Maria Zobenigo based on one of Visentini's prints after Canaletto published in 1742.[53]

The chronology of Guardi's view paintings is notoriously difficult, the only dated example being a version of 1758 of *The Festival of Giovedì Grasso in the Piazzetta* (plate 52).[54] The dated version formed part of a group of five views by Guardi acquired by Sir Brook Bridges (1733–91), who was in Italy in 1757–60.[55] Although the details of his stay in Venice are not known, Bridges is recorded in June 1757 in Padua, which he may be presumed to have visited from Venice. He was accompanied on that occasion by John Murray, the British Resident, and by Joseph Smith, the British Consul, whose presence suggests that he may have played a similar role in Bridges' transaction with Guardi as he had for earlier British visitors over commissions to Canaletto. *The Giudecca Canal and the Zattere* (fig. 48; plate 53) was also painted for Bridges and is thus securely datable around 1758. An original composition, this reveals an artistic sensibility already at this early stage highly individual and in striking contrast to that of Canaletto's later work. While the painting's scale, light tonality and bright palette are closest to the older artist's work of the early and mid-1730s (see, for instance plates 20 and 21), these qualities and the sense of movement throughout recall more strongly the style of Marieschi, whose manner had been kept alive after his death in 1743 by his pupil Francesco Albotto (1721–57). The buildings have none of the structural solidity, firm outlines and strong tonal contrasts characteristic of Canaletto's mature style, and their peripheral contribution is more closely paralleled in certain paintings by Canaletto of the early 1720s, such as *San Cristoforo, San Michele and Murano from the Fondamenta Nuove* (plate 7).[56] Here, as in that painting, light and atmosphere are the true subject of the painting, and it is this aspect of Canaletto's first style, abandoned in the mid-1720s, which the last of the great Venetian view painters was to make his own and which was to characterise the final stage in the development of the genre.[57]

In setting himself up as a view painter Guardi clearly hoped to attract a similar clientele to that which had been

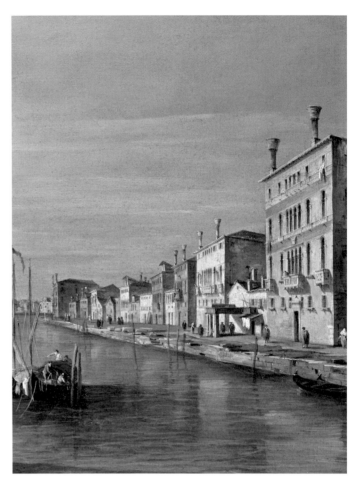

Fig. 48 Francesco Guardi (1712–1793)
The Giudecca Canal and the Zattere, about 1758
Detail of plate 53

the basis of Canaletto's international fame. Times had changed, however, and while many of Guardi's paintings can be established as having been produced for visiting foreign aristocrats such as Sir Brook Bridges, when Canaletto died in 1768 he had none of the trappings of success that one might expect. His apartment, which may have been the one in which he was born, contained a small single bed and a sparse wardrobe, while he was able to bequeath to his three sisters no more than 283 ducats, 6 grossi in cash, which has been estimated as the equivalent of about £80, and a small property which he had bought as an investment in 1751 for 2,150 ducats, around £600.[58] The most obvious explanation for this is that he was no longer enjoying the volume of commissions which he had previously received through Joseph Smith. It is also possible that Smith had done very

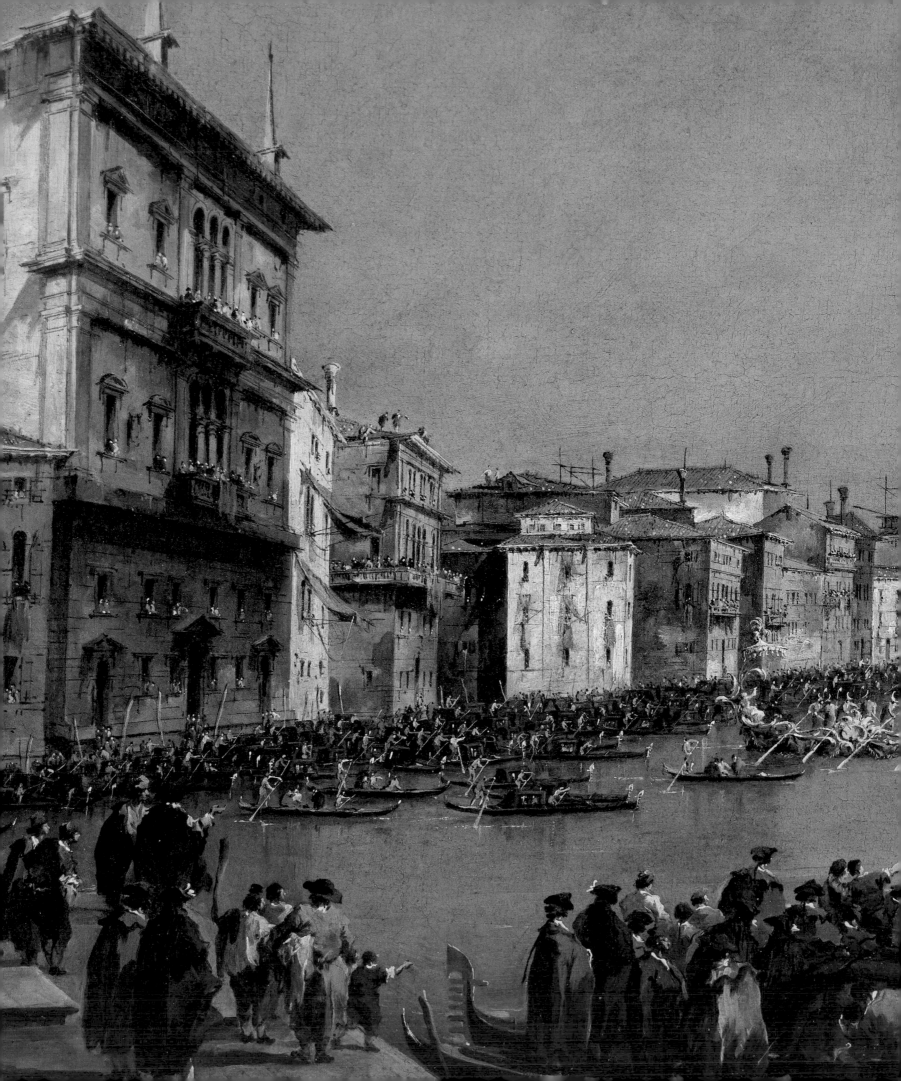

much better out of their business arrangement than Canaletto had. Horace Walpole noted in June 1783 that 'Mr Smith engaged him to work for many years at a very low price, & sold his works to the English at much higher rates'.[59] Francesco Guardi, with occasional assistance probably from his brother Nicolò (1715–86) and certainly later from his son Giacomo (1764–1835), was obliged to seek different types of patronage in order to make a living. This may account in part for the widely ranging quality of his paintings, as well as their great variety of both size and style.[60]

Many of Guardi's greatest achievements date from the 1770s. *A Regatta on the Grand Canal* (fig. 49; plate 60), datable around 1777, shows very different concerns from Canaletto's depiction of the same subject (fig. 50; plate 17). The older painter's solid buildings and precisely drawn, richly coloured figures have been replaced by a vision filtered through a haze of summer sunshine, every detail animated by the uniquely feathery flicks of Guardi's brush and the figures in a fully rococo sensibility. The dominant interest in atmosphere and light already apparent in the paintings of 1758 for Bridges has here matured to the point that light seems to threaten to dissolve the very buildings. In this respect Guardi's stylistic progression is the opposite of Canaletto's. The domination of nature over the works of man anticipates important developments in the art of the following century. It emphasises the fragility of the city rather than its permanence, appropriately enough, as the Most Serene Republic came to an inglorious end four years after Guardi's death with the invasion of Napoleon's troops in 1797.

Guardi is at his most poetic when the human element is at its most marginal, out on the Lagoon. Canaletto's view of *The Torre di Malghera* (fig. 53; plate 30) was painted shortly after his return to Venice from London in 1755, and is based on an earlier graphic prototype, his own engraving of the subject made in the early 1740s (fig. 52). Its subject is the imposing structure of the abandoned medieval tower, and this focus is repeated in Bellotto's recently rediscovered variation on the same theme (fig. 54; plate 48). In Guardi's exquisite rendering (fig. 51; plate 57), however, it is the mood

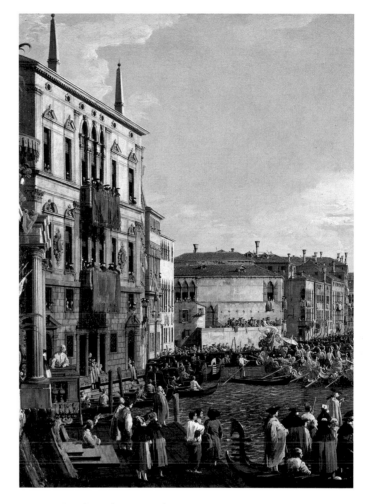

Fig. 50 Canaletto (1697–1768)
A Regatta on the Grand Canal, about 1733–4
Detail of plate 17

which has become the theme, as local fishermen go about their business in this quiet backwater. It comes as a considerable surprise to learn that the composition is taken from a drawing by Canaletto, which is followed with remarkable precision in all but the smallest details.[61] Even here the comparison serves to astonish the viewer with how two painters from the same cultural background could respond so differently to subject matter which could hardly be more identical.

Fig. 49 Francesco Guardi (1712–1793)
A Regatta on the Grand Canal, about 1777
Detail of plate 60

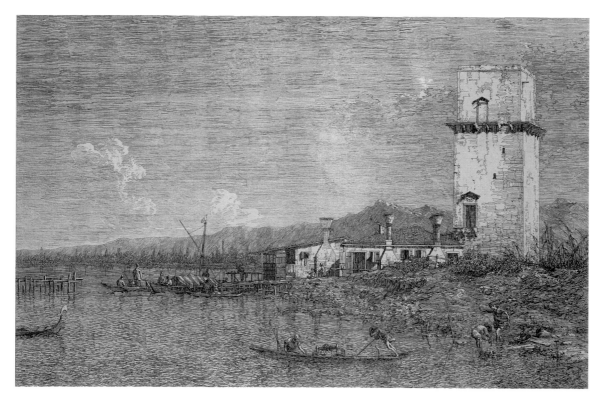

Fig. 51 Francesco Guardi
(1712–1793)
*The Lagoon with the Torre di
Malghera*, probably 1770s
Plate 57

Fig. 52 Canaletto (1697–1768)
The Torre di Malghera,
about 1735–46
Etching (state 2 of 3),
29.5 x 42.7 cm (plate)
National Gallery of Art,
Washington. Gift of W. G. Russell
Allen (1941.1.172)

Facing above:
Fig. 53 Canaletto (1697–1768)
The Torre di Malghera, about 1756
Detail of plate 30

Facing below:
Fig. 54 Bernardo Bellotto
(1722–1780)
The Torre di Malghera, about 1744
Detail of plate 48

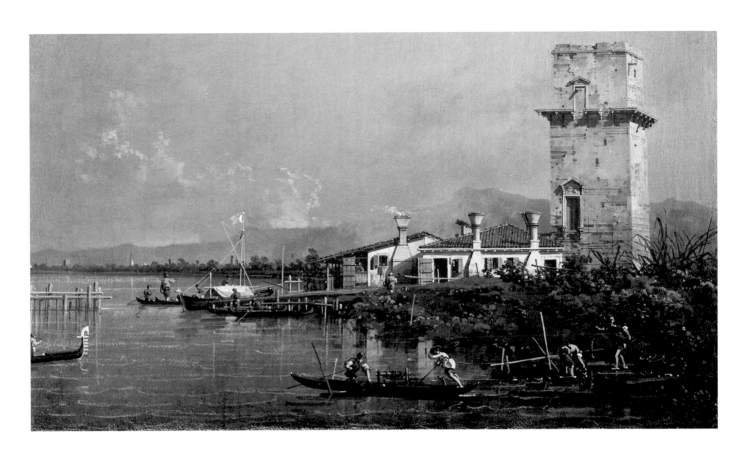

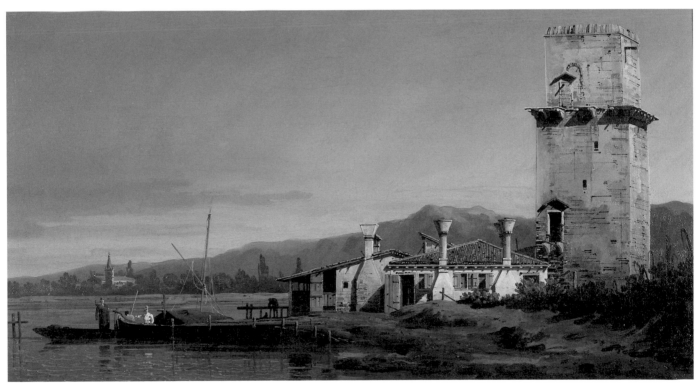

NOTES

1 While the Museo Correr painting is large (115 x 205 cm), that at Springfield anticipates the smaller scale of the majority of Venetian views from about 1730 onwards.

2 He is described as '*Gasparo dalli Ochiali*' in inscriptions on the backs of two pendant paintings of 1696 (Briganti 1996, nos 194 and 219).

3 Briganti 1996, p. 407, no. D340, illus. p. 409.

4 For Jan van der Heyden see, for instance, Greenwich and Amsterdam 2006–7. For both artists see, for example, The Hague and Washington 2008–9, nos 3–12 (Berckheyde) and 21–5 (van der Heyden).

5 Orlandi 1704, p. 226.

6 It certainly fulfilled the primary intended function specified in the dedicatory inscription, 'to familiarise foreign countries with the splendours of Venice' ('*Il maggior motivo … è stato il soṁo desiderio di rendere più facili alla notizia de Paesi stranieri le Venete Magnificenze*').

7 For the Rijksmuseum and Frederiksborg paintings, and two from the Lehman set, see, for instance, Treviso 2008–9, nos 10, 11, 14 and 15. For the Lehman set see, for instance, San Diego 2001, nos 3–6.

8 D. Succi in Padua 1994, pp. 42–3, fig. 5.

9 For the *Bucintoro*, see 'Ascension Day', p. 169; for the *Fusta*, see 'The Molo', p. 162.

10 Thomas Coryate, quoted in Fenlon 2009, p. 131.

11 All under Constable 1962, no. 713. The date on *The Arch of Constantine* was first noticed by Hugo Chapman in Venice 2001, no. 3.

12 Vanvitelli attended meetings of the general assembly of the Accademia di San Luca in Rome on 20 April and 10 November 1719, and 1 January, 7 January, 17 April, 9 June and 4 August 1720 (see Rome and Venice 2002–3, p. 71).

13 These include Venice 2001, nos 45–7.

14 Private collection, Rome; Links 1998a, p. 7, no. 48*, pls 244, 245 and 247, and colour frontispiece.

15 Briganti 1996, nos 285–6; Rome and Venice 2002–3, no. 59, illus. in colour (the illustration in the Venice edition is far superior). An unpublished painting by Canaletto of similar date and showing the left part of the composition, but seen through the arch of the Torre dell'Orologio, is in a private collection, Monte Carlo.

16 Biblioteca Nazionale Centrale Vittorio Emanuele, Rome; Briganti 1996, no. D339; Rome and Venice 2002–3, no. D 15, illus. in colour.

17 '*signor Antonio Canale, che fa in questo paese stodire universalmente ognuno che vede le sue opere, che consiste sul ordine di Carlevari ma vi si vede lucer entro il sole*'; for a transcription of the whole letter, see Venice 2001, p. 227, no. 1.

18 A similar development can be seen a century earlier in the paintings of Guercino, who suppressed his own aesthetic inclinations in order to keep in tune with contemporary taste; see Mahon 1947, pp. 1ff.

19 The great collector Carl Gustav Tessin, then Swedish Ambassador in Vienna, described Canaletto in a letter of 16 June 1736 as '*étant engagé pour 4 ans à ne travailler que pour un marchand anglois, nommé Smitt*' (Bettagno and Magrini 2002, p. 81).

20 Ackroyd 2009, p. 227.

21 According to Susan Sloman 'rather sophisticated types of camera obscura were being developed in the 1760s and 1770s, including reflex models that produced an image the right way up …' (Sloman 2002, p. 138).

22 It is inscribed 'A.CANAL', but is first recorded in 1901.

23 There has been much discussion of the use of the camera obscura in the age of the photographic camera, with its respect for topographical exactitude. The interest of Italian contemporaries, for whom works of the imagination were regarded as of a higher order, is somewhat paradoxical.

24 Fondazione Cini, Venice; Venice 1969, p. 107, no. 326, illus.; Montecuccoli and Pedrocco 1999, p. 67, fig. 13; Treviso 2008–9, illus. p. 14.

25 '*25 Aprile 1764. Francesco Guardi, Pittore della contrada de' S:ti Apostoli su le Fondamente Nove buon Scolaro del rinomato … Canaletto, essendo molto riuscito per via della Camera Optica dipingere sopra due non picciole Tele, ordinate dà un Forestiere Inglese, le vedute della Piazza di S. Marco verso la Chiesa, e l'Orologio, e del Ponte di Rialto, e sinistre Fabbriche verso Canareggio, oggi le rese esposte su laterali delle Procuratie Nove, mediante che si procacciò l'universale applauso*' ('25 April 1764. Francesco Guardi, a painter from the district of Santi Apostoli su le Fondamente Nuove, able pupil of the celebrated Canaletto, having mastered the use of the camera optica was commissioned by an English visitor to paint two canvases, by no means small, of the Piazza San Marco towards the Church, and the clock [tower], and of the Ponte di Rialto, and on the left the buildings towards Canareggio, views which are today exhibited on the side walls of the Procuratie Nuove, and for which he was widely acclaimed') (Gradenigo 1942, p. 106).

26 Hessisches Landesmuseum, Darmstadt; Constable 1962, 1, pl. 100, 11, no. 551; exhibited Rome 2005, no. 17, illus. in colour.

27 '*Insegno il Canal con l'esempio il vero uso della camera ottica; e a conoscere i difetti che recar suole a una pittura, quando l'artefice interamente si fida della prospettiva che in essa camera vede, e delle tinte spezialmente delle arie, e non sa levar destramente quanto può offendere il senso*' (Zanetti 1771, V, p. 463).

28 '*l'anno 1732 il Mese di Luio per ingiltera*'.

29 Constable 1962, 1, pl. 23; 11, no. 64.

30 See Binion 1990, pp. 137, 138, 234, 266 and 294.

31 This suggests that Marieschi may have been familiar with the few early works by Canaletto which had remained in Venice or the vicinity, notably the four large canvases owned in 1765 by Giovanni Berzi in Padua (see plate 7 and Venice 2001, nos 38–41).

32 Its first owner was the London dealer William Hayter.

33 Caravaggio is probably the foremost example of a painter who worked in this manner.

34 Binion 1990a, p. 153.

35 It may not be a coincidence that Tessin, in the same letter of exactly this moment, 16 June 1736, referred to in note 19, described Canaletto as

'*fantasque, bourru, baptisé, vendant un tableau de cabinet (car il n'en fait d'autres) jusqu'à 120 sequins*' ('a fantasist, an awkward character, baptised[?], selling a cabinet picture [for he doesn't do any others] for up to 120 zecchini').

36 *Allegorical Tomb of John, Lord Somers* by Canaletto, Cimaroli and Giovanni Battista Piazzetta (private collection, UK; Constable 1962, 1, pl. 94, 11, no. 516; exhibited New York 1989–90, no. 13, and London and Washington 1994–5, no. 135; and *Allegorical Tomb of Archbishop Tillotson* by Canaletto, Cimaroli and Giovanni Battista Pittoni (private collection, UK; Constable 1962, 1, pl. 94, 11, no. 517; exhibited New York 1989–90, no. 12).

37 See, for instance, New York 1989–90, no. 56.

38 The author intends to discuss this painting at greater length in a forthcoming article.

39 See p. 170.

40 Constable 1962, 1, pl. 118; 11, no. 643.

41 Of the others, one is in a private collection in the UK (Links 1998, p. 28, no. 280*, pl. 266) and the other in an Italian private collection (Constable 1962, 11, no. 280).

42 Exhibited Turin 2008, no. 11.

43 It may be compared, or rather contrasted, with the young girl carrying sticks seen from behind at lower right in Canaletto's *The Riva degli Schiavoni, looking West* (fig. 18; plate 19).

44 These include the very large version which emanated from Canaletto's studio in about 1743, presumably as the work of Canaletto himself, and which remained attributed to him until after its purchase by the J. Paul Getty Museum in 1991; it is now generally accepted that Bellotto was responsible – at least predominantly – for its execution (Constable 1962, 1, pl. 80; 11, no. 180; exhibited Venice and Houston 2001, no. 8). A small format version is in the Fitzwilliam Museum, and another, in the Otto Hirsch Collection, Frankfurt am Main, in 1925, is last recorded in the collection of Adolf Hitler (Kozakiewicz 1972, nos 7 and 8. I am grateful to Götz Morgenstern for pointing out the Hitler provenance).

45 Bernardo was the only member of his family to give his surname as Bellotto rather than Bellotti.

46 While Canaletto had hitherto generally provided patrons with groups of paintings consistent in style as well as quality, another patron who acquired a surprisingly disparate group of paintings around this time was Henry Fiennes Clinton, 9th Earl of Lincoln (1720–94), later 2nd Duke of Newcastle, who was in Venice from 5 June to 12 July 1741. That also included a particularly fine Canaletto Venetian view, now in the Norton Simon Museum (Constable 1962, no. 66) and a pair of paintings of which at least one is certainly by Bellotto (Constable 1962, nos 170[b]3 and 228[b]1), the two other components of the group being studio productions at best (Constable 1962, nos 28 and 94).

47 Four of the Uppark paintings were destroyed in the fire there on 30 August 1989 (Constable 1962, nos 184[b], under no. 196, 233[g] and 270[b]), but four survive in the private part of the house (Constable

1962, nos 161[b]1 and 251[d]2, and copies of nos 170 and 250).

48 Evidence of his return in this year, in the form of three documents establishing his presence in Venice on 12 December 1755, has only recently been published: see Montecuccoli degli Erri 2002, pp. 6–7.

49 For *The Night Festival at San Pietro di Castello on the Eve of the Feast Day of Saints Peter and Paul (28 June)* and *The Campo di Rialto*, see Treviso 2008–9, nos 45–6.

50 M. Levey, 'Canaletto as Artist of the Urban Scene', in New York 1989–90, p. 20.

51 The abilities of the Guardi brothers as copyists of figurative subjects by other artists were well known.

52 See note 25.

53 Sold at Christie's, New York, 26 January 2005, lot 76, and now in a European private collection; Succi 1993, pp. 38–9, fig. 26.

54 Last seen at Sotheby's, London, 14 December 2000, lot 91; D. Succi, 'Una eccezionale veduta datata di Francesco Guardi', in Gorizia 1987, pp. 47, 49 and 55, note 1, figs 22–5 (colour), where the date is incorrectly given as 1756; Succi 1993, pp. 27–8, figs 10–12 (colour).

55 Russell 1996.

56 It is no coincidence that many of Canaletto's paintings of the early 1720s were believed to be by Guardi in the nineteenth century, and some even through the twentieth century.

57 Guardi's response to Canaletto's earliest style may well derive from his youth. Canaletto's two huge and magnificent *capricci* of 1723 were painted for the Giovanelli brothers of Noventa Padovana, with whom Guardi's father had been intimately associated until his death in 1716. They subsequently employed Giovanni Antonio Guardi until 1729 and very probably Francesco himself after that.

58 The currency conversions are from J.G. Links, 'Canaletto: a Biographical Sketch', in New York 1989–90, p. 14.

59 Walpole 1928 edn, p. 79, quoted by Eglin 2001, p. 117.

60 The great connoisseur James Byam-Shaw observed that 'At his best, Francesco Guardi was inimitable, but occasionally, like Homer, he could be said to nod' (J. Byam Shaw, 'Guardi', in *The Dictionary of Art*, xx, London 1996, p. 745).

61 Constable 1976, 1, pl. 216; 11, no. 663*. Sold at Christie's, London, 1 July 1997, lot 77.

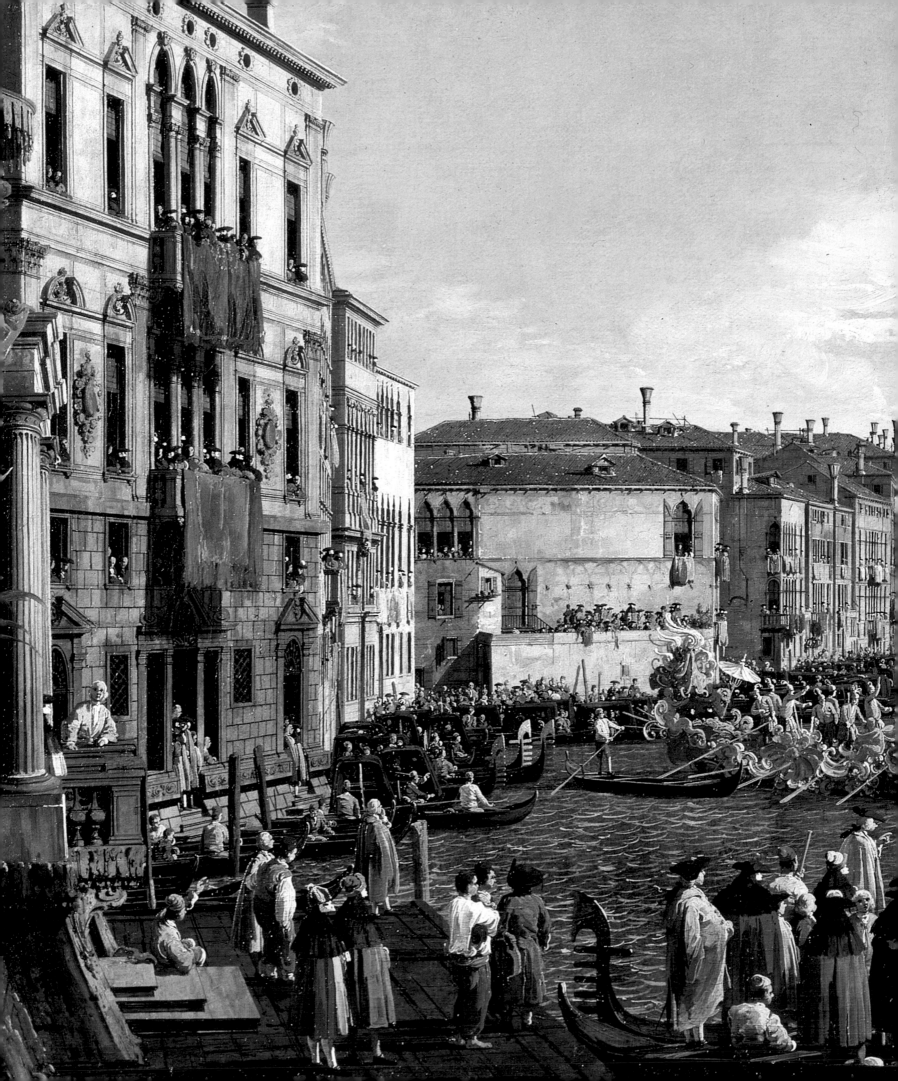

Artists' Biographies
and Plates

Gaspar van Wittel, called Gaspare Vanvitelli

(Amersfoort 1652/3 – Rome 1736)

Gaspar Adriaensz. van Wittel was born at Amersfoort, near Utrecht, where he was trained by Matthias Withoos, a painter of landscapes and still-life who had also made a small number of panoramic views of cities.[1] Like many Dutch artists of the period, Withoos had completed his training with a visit to Italy (1648–52) and van Wittel followed in his footsteps, arriving in Rome probably in 1674. Van Wittel, however, never returned north and is now generally known by his Italianised name Gaspare Vanvitelli. There he was to become the first specialist view painter, introducing to his adopted country the genre which was to enjoy such popularity in the following century.

Vanvitelli joined the Northern community in Rome, becoming a member of the *Schildersbent*, the association of Dutch and Flemish artists, by 3 January 1675. He initially found employment with Cornelis Meyer, a Dutch hydraulic engineer who had come to Rome for the Jubilee of 1675 and had been invited by Pope Clement X to investigate the possibility of extending the navigability of the Tiber from Rome to Perugia. Meyer's report of 1676 has survived, accompanied by 50 drawings identified by an inscription on the frontispiece as the work of Vanvitelli but lacking the quality and individual characteristics of the artist's mature work.[2]

Three engravings of views of Rome published in 1683 and 1685 follow drawings by Vanvitelli probably made around 1678, which are his first known venture into the field of view painting. Here for the first time are displayed some of the qualities which set the artist's work apart from earlier views of the city: his skills as a draughtsman, his mastery of the rules of perspective (both areas in which his initial training under Withoos may have been limited), and his instinct for striking compositions. Vanvitelli often repeated successful compositions many times, only changing details such as the figures, which are invariably small. Thus the composition of the engraving of the Piazza del Popolo[3] recurs as that of the artist's earliest dated gouache, of 1680,[4] and was to be reused for more than a dozen gouaches and oils, in the process entering the iconography of Roman view painting as the standard representation of the subject. Although Vanvitelli was already working in oils by 1682, gouache was initially his preferred medium, only six of the 28 dated views of the years 1680–5 being in oil. Only in 1686 do the dated oils outnumber the gouaches, and thereafter oils dominate the artist's production. All are characterised by a light tonality, a unifying use of light and a meticulous technique, paralleling the coeval views of Northern towns by such painters as Jan van der Heyden (1637–1712) and Gerrit Berckheyde (1638–98).

Vanvitelli's style shows only limited development, although the deterioration of his eyesight – by as early as 1696 he had become known as '*Gaspare dagli Occhiali*' on account of the thick spectacles he was obliged to wear – must have contributed to the decline in quality of his work in the last decades of his career. While there are a number of depictions of the Colosseum and of the Arch of Titus, Vanvitelli was less interested in ancient Rome than in the modern city, with its squares teeming with people (Piazza del Popolo, Piazza Navona and Piazza San Pietro) and the Tiber seen from various vantage points along its banks. More than half of his oeuvre consists of views of Rome and towns in the Roman *campagna*, such as Tivoli.

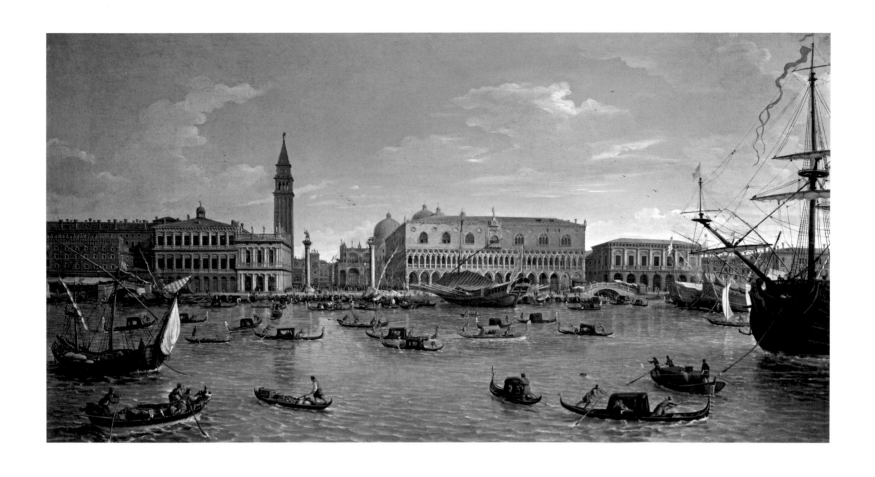

1

Gaspar van Wittel, called Gaspare Vanvitelli (1652/3–1736)
The Molo from the Bacino di San Marco, 1697

Oil on canvas, 98 x 174 cm
Museo Nacional del Prado, Madrid (P-475)

By the end of the seventeenth century he had created the repertoire of views of Rome which was to support him in his adopted city for the rest of his career, and which was to have such an influence on his successors.

Vanvitelli achieved academic recognition, being admitted to the Roman Accademia di San Luca in 1711. This was somewhat paradoxical, given the painter's foreign origins; Canaletto was to have to wait until 1763, only five years before his death, for similar acknowledgement in Venice. Vanvitelli was also more fortunate than any of his Italian successors in attracting the patronage of the Italian nobility. The support of Roman families such as the Colonna, who were already buying his work in the 1680s, and whose printed catalogue of 1783 lists no fewer than a hundred works as his,[5] meant that he had no need to catch the eye of visitors to the city. Vanvitelli's greatest foreign patron was the Spanish 9th Duque de Medinaceli, who commissioned no fewer than 37 views, but as Viceroy of Naples he was a resident (like Smith and Schulenburg in Venice) rather than a visitor.

Vanvitelli's subject matter was augmented from 1690 by views of other parts of Italy. His practice of working from carefully executed drawings meant that these were often produced at some distance of time and place from their subjects. His periods in Naples, including one of more than two years in 1699–1702, were particularly productive, and it was there that his son Luigi, the great architect, was born in 1700. A tour of Lombardy, including Lake Maggiore and Vaprio d'Adda, probably in 1690–1, provided new subject matter for paintings and was followed by a second, probably in 1694–5, which included visits to Florence, Bologna, Verona and Venice.[6] It is not known how long Vanvitelli spent in Venice, and only a handful of his characteristically exquisite drawings of it have survived.[7] He must have made many more, used in the execution of around forty paintings through into the 1720s.[8] Apart from three views of the Island of San Michele, all of these are taken from viewpoints only a few hundred yards apart, on or close to the Bacino, the part of the city which would be most immediately recognisable to non-inhabitants.

The date 1697 on *The Molo from the Bacino di San Marco* (plate 1) provides a certain *terminus ante quem* for the Venice visit, and is much the earliest of Vanvitelli's dated views of the city.[9] Its pendant, now in Barcelona, shows *The Piazza San Marco looking South*, one of two versions of that composition which are the painter's only depictions of this (or indeed any Venetian) piazza.[10] In these views of Venice Vanvitelli seems to have been inspired to overcome his usual discomfort at working on such a large scale; two of his other Bacino views are indeed even larger and among the very largest that he ever produced.[11]

While Vanvitelli's influence on his successors in Rome, including Hendrik Frans van Lint and Giovanni Paolo Panini, is easy to explain, it is less clear to what extent later painters in other cities that he portrayed may have been aware of his work. This is of particular interest in the case of Venice, where his importance as a precursor is indisputable, but where not a single one of his Venetian views is known to have remained and his role as an inspiration is difficult to define. Carlevarijs may have seen him at work, however, and certainly painted his own version of one of Vanvitelli's Roman views,[12] while Canaletto's apparent awareness of Vanvitelli's style, as well as at least one composition, suggests that the two artists may have met in Rome in 1719/20.[13]

Luca Carlevarijs

(Udine 1663 – Venice 1730)

Born in Udine, a Venetian possession since 1420, Carlevarijs was taken to Venice in 1679 by his sister Cassandra, who had looked after him since the deaths of their mother, when Luca was three, and their father, a minor painter, sculptor and architect, shortly before Luca's seventh birthday. They moved into a house on the Fondamenta del Carmine which Carlevarijs was to occupy for the rest of his life. Little is known about his first forty years. His contemporary, the art historian P.A. Orlandi (1660–1727), states that he 'had no real master, but studied here and there',[1] and there is no evidence that he ever left the Veneto. Only a handful of paintings dating from before the end of the seventeenth century are known, notably a pair of large upright land-scapes in the church of San Pantalon,[2] and three even larger landscapes with figures in the Ca' Zenobio.[3] These reveal a familiarity with the work of Northern painters active in the Veneto. By the turn of the century he must have been quite well known, however, as he is mentioned by Coronelli in 1700, as a celebrated painter of 'perspective and architecture' and of landscapes,[4] as well as by Orlandi.[5]

The first fixed point for Luca Carlevarijs as a *vedutista* is the publication in 1703 of his *Le fabriche, e vedute di Venetia disegnate, poste in prospettiva, et intagliate da Luca Carlevarijs*, a set of 103 engravings of Venetian views. Without precedent in their scope, compositional variety and convincing perspective, these were to serve as a pattern book for Venetian view painters for decades to follow. They were followed by a rapid escalation in Carlevarijs's abilities as a painter. His two greatest achievements in the realms of the imagination, *An Allegory of Peace (An Imaginary Port with a Roman Triumphal Arch)* and *An Allegory of War (A Sea Battle)* painted for the Villa Giovanelli at Noventa Padovana,[6] which have been interpreted plausibly as celebrating the Treaty of Karlowitz with the Ottomans (1699),[7] probably date from around 1705. *Capricci*, of greater appeal than views to local patrons, occupied much of the painter's time in the first decade of the eighteenth century, and continued to do so into the second.

In his paintings of views Carlevarijs restricted his subject matter almost exclusively to the area around the Bacino di San Marco and between it and the Piazza San Marco, which would have been most immediately recognisable to foreigners. This no doubt contributed to the speed with which he attracted and built up a Grand Tour clientele. One of his innovations proved of irre-sistible appeal to visiting dignitaries – views of the city incorporating formal receptions or regattas given in their honour and in which they themselves would feature. The earliest of these is that identified as *The Reception of the French Ambassador Joseph-Antoine Hennequin de Charmont at the Doge's Palace, 29 April 1703*, in the Terruzzi collec-tion.[8] Far more imposing, and revealing the rapid development of Carlevarijs's technical skills, are his variations of the composition, showing *The Reception of the French Ambassador, Abbot Henri-Charles-Arnauld de Pomponne at the Doge's Palace, 10 May 1706* (Rijksmuseum, Amsterdam)[9] and *The Reception of the British Ambassador Charles Montagu, 4th Earl of Manchester at the Doge's Palace, 22 September 1707* (plate 2), which fully demonstrate his ability to render the pomp of such occasions. The composition was to be repeated, again with variations, in 1726 (see below) and around 1727

in *The Reception of the French Ambassador Jacques-Vincent Languet, Comte de Gergy, at the Doge's Palace, 4 November 1726* (Musée National du Château de Fontainebleau).[10] This is small and of disappointing quality, and uniquely follows closely the example of the Rijksmuseum *Reception of the Abbot de Pomponne* of twenty years earlier. This last was taken by Canaletto as the starting point for his own depiction of the same event (plate 13).

In the second half of the first decade of the eighteenth century the painter was at the height of his powers. Another of his compositions which was to prove popular with later painters was that of *The Regatta on the Grand Canal in Honour of Frederick IV, King of Denmark and Norway, 4 March 1709*, in which the width of the canal is reduced to heighten the sense of festivity. The first version is generally presumed to be that painted for the King and now at Frederiksborg Castle, Hillerød,[11] although it did not arrive in Denmark until 1713.[12] A second version (plate 4), dated 1711, is by no means a slavish replica, and anticipates the lengths to which Canaletto would later go to differentiate different depictions of the same view. The subject of its pendant, *The Molo from the Bacino di San Marco on Ascension Day*, dated 1710 (plate 3), was, not surprisingly given its significance as the foremost of the city's festivals, to be one of the most enduring in the repertory of Venetian view painting.

Carlevarijs was already painting pure views of Venice by 1706, when he delivered three to the Lucchese collector Stefano Conti, who was to commission four important paintings from Canaletto twenty years later. A set of four small views by Carlevarijs in the Robert Lehman Collection at the Metropolitan Museum of Art, New York, includes one signed with initials and dated 'L[C]/[M]DCC/IX' (1709), the only known dated pure view by the artist.[13] The set includes versions of his festival paintings of around 1708 and 1711 (plates 2 and 3) without

the crowds, as well as a view of *The Piazza San Marco, looking East*, a subject which had been overlooked by Vanvitelli but which Carlevarijs was the first of a long line of Venetian painters to depict repeatedly. A bigger and more focused version of that (plate 5) originally formed part of a set of four larger paintings, of which three are of the same subjects as the earlier set but with the characteristic variations.[14] These were almost certainly executed after the set of 1709 and before December 1716, when the patron, Christopher Crowe of Kiplin Hall, Yorkshire, ended his term as British consul at Leghorn and returned home.

Three views painted for William Bateman, later the 1st Viscount Bateman, as souvenirs of his Grand Tour of 1718,[15] show that the painter retained his full powers until his mid-fifties, but many works of the 1720s show a decline. Carlevarijs must have felt disheartened to see so many of his patrons – the Counts Giovanelli, Joseph Smith, Stefano Conti and the Comte de Gergy – turning to the young Canaletto. One client who employed Carlevarijs in this late period, the Imperial Ambassador Count Giambattista Colloredo, had already commissioned or purchased three major Venetian views from Canaletto (for one of which see plate 12) but went to Carlevarijs for a depiction of his reception at the Doge's Palace, which took place on 3 April 1726 (Gemäldegalerie Alte Meister, Staatliche Kunstsammlungen, Dresden);[16] this was no doubt due to the older painter's lingering reputation for these, a type of *veduta* which Canaletto was not to embark upon until some months later (see plate 13). In his last commission, a set of four large views of around 1727 for Johann Matthias von der Schulenburg, who was not to become a major patron of Canaletto until the following decade, Carlevarijs attempted to keep up with the times by introducing atmospheric perspective.[17] The painter's career was ended by progressive paralysis in 1728,[18] two years before his death.

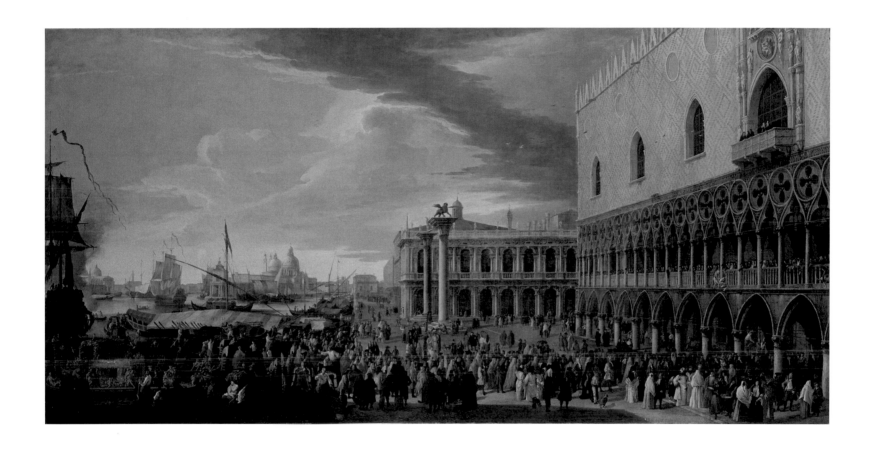

2

Luca Carlevarijs (1663–1730)
The Reception of the British Ambassador Charles Montagu, 4th Earl of Manchester, at the Doge's Palace,
22 September 1707, about 1707–8

Oil on canvas, 132 x 264 cm
Birmingham Museums & Art Gallery (1949P36)

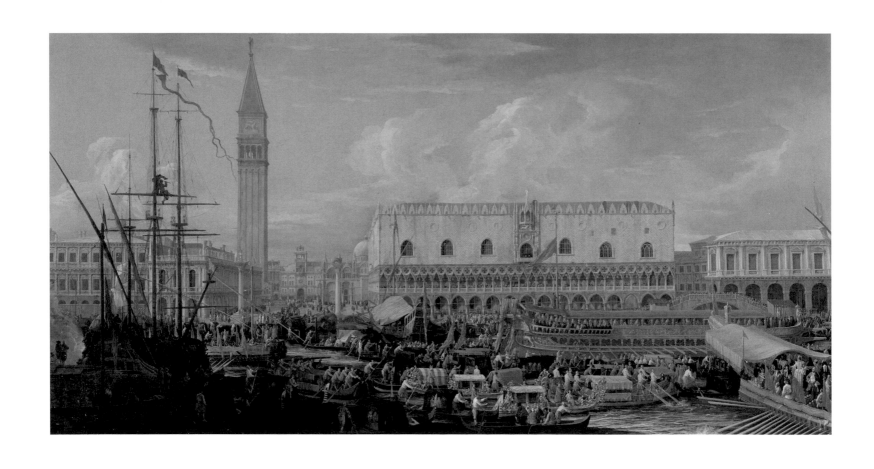

3

Luca Carlevarijs (1663–1730)
The Molo from the Bacino di San Marco on Ascension Day, 1710

Oil on canvas, 134.8 x 259.4 cm
The J. Paul Getty Museum, Los Angeles, CA (86.PA.600)

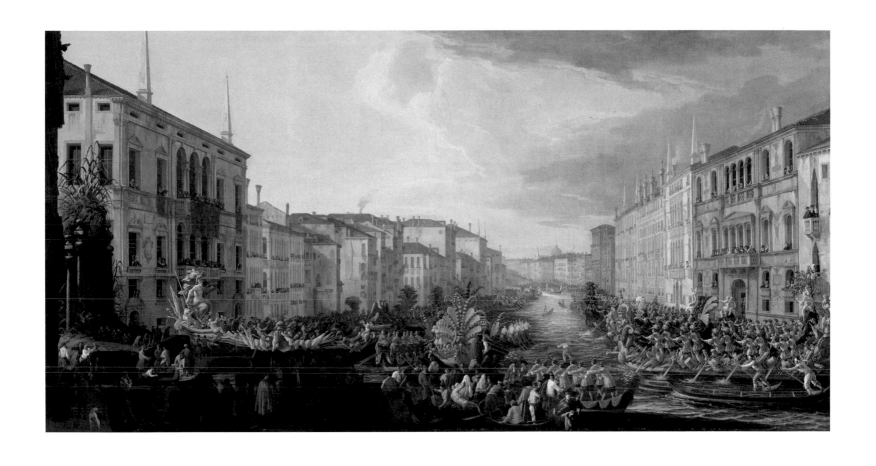

4

Luca Carlevarijs (1663–1730)
The Regatta on the Grand Canal in Honour of Frederick IV, King of Denmark and Norway, 4 March 1709, 1711

Oil on canvas, 134.9 x 259.7 cm
The J. Paul Getty Museum, Los Angeles, CA (86.PA.599)

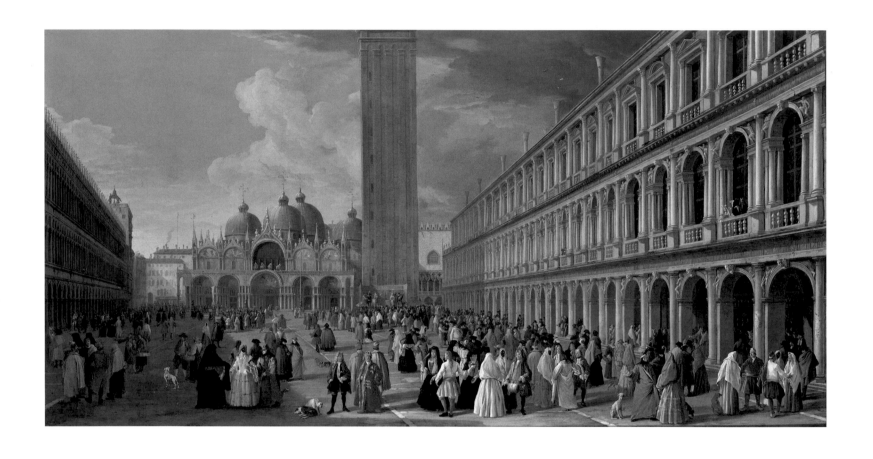

5 (*and detail facing*)

Luca Carlevarijs (1663–1730)
The Piazza San Marco, looking East, about 1710–15

Oil on canvas, 86 x 163.5 cm
Accepted by HM Government in lieu of inheritance tax and allocated to the Trustees of Kiplin Hall, North Yorkshire, 2007
Loaned from Kiplin Hall with agreement of the Museums, Libraries and Archives Council

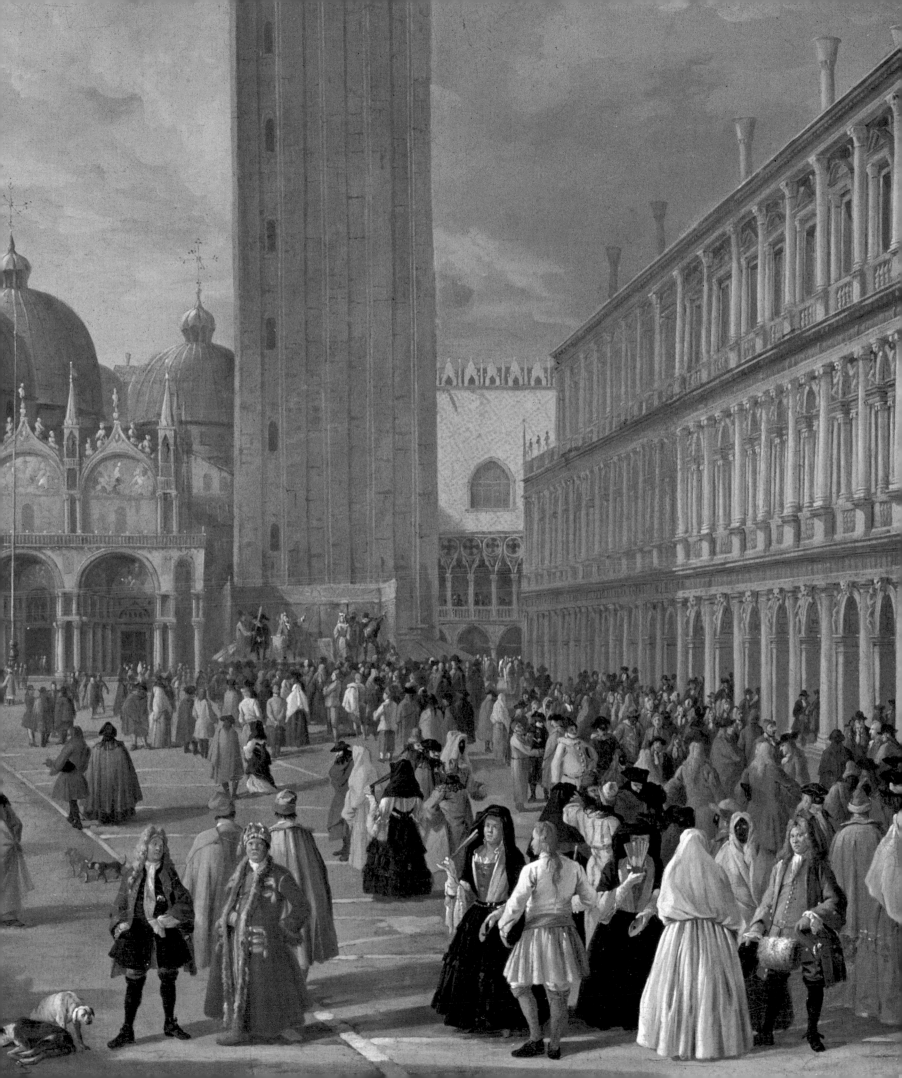

Johan Richter

(Stockholm 1665 – Venice 1745)

Johan Richter was unique among Italian view painters of the eighteenth century in being of Scandinavian origin. Born in Stockholm, he was the son of a goldsmith and came from a family of artists including his brothers David Richter the Younger (1664–1741), the miniaturist portrait painter and goldsmith Bengt (1670–1737), a medallist, and Christian (1676–1732), a portrait miniaturist and engraver who moved to England in 1702. Their cousin David Richter the Elder (1662–1735) was a portrait painter and engraver, and the pastellist Gustaf Lundberg (1695–1786) was their nephew. Richter was a pupil of Johan Sylvius (d. 1695), who had spent much of his career in Rome before returning to Sweden in 1686 to contribute to the decoration of Drottningholm Castle. Richter assisted him there, probably completing the ceiling of the Great Hall, which was unfinished at the time of Sylvius's death. Richter left Sweden in 1697, initially going to Stettin (now in Poland), which was part of the Swedish Empire until 1720. He may have gone immediately to Venice, but the earliest evidence of his activity there is a pair of Venetian views, *The Piazza San Marco and the Base of the Campanile* and *The Grand Canal with the Church of Santa Lucia*, last recorded in the collection of the art historian Osvald Sirén (1879–1966) in Stockholm, which are said to be signed and dated on the reverse 'Jean Richter Suezzese fece in Venezia l'anno 1717'.[1] These show his style already fully formed.

On 25 December 1717 the painter Antonio Balestra wrote to the Florentine collector Francesco Gabburri praising Richter's 'small paintings … accomplished with great love … showing particular propensity for a finished quality' and 'his genius' for view painting.[2] Richter is thus, with Luca Carlevarijs, one of the only two specialist view painters active in Venice before Canaletto,[3] and he remained there for the rest of his life. In Gabburri's inventory of 1722 of his own collection of drawings, he describes Richter as a pupil of Carlevarijs,[4] but there is no further record of a relationship between the two. In the same year the London diarist George Vertue describes him as 'a painter of Views very free and Masterly as some of his works here appear to be – that have been bought a[t] Venice'.[5] In a letter of 1736 the great Swedish collector Count Carl Gustav Tessin (1695–1770) stated that he had bought at Venice '*Deux Vues par Richter*'.[6]

Documentary evidence is otherwise scarce, although two further works were owned by Sigismund Streit, who described them as by 'the Swedish painter Richter' in his own catalogue of his possessions and bequeathed them with his Canaletti to the Gymnasium zum Grauen Kloster; one of them survives in the school's collection in Berlin.[7] A pair of views signed 'J.R.P.' is in a private collection in Piacenza.[8] The identification of a not inconsiderable oeuvre has been further aided by ten engravings by Bernard Vogel (Nuremberg 1683 – Augsburg 1737), published in Augsburg in 1730, after Venetian views by Richter.[9] Since Richter tended to repeat (with variations) his compositions, these engravings help to confirm the attribution not just of the paintings from which they are taken. Almost all of Richter's paintings are views of Venice. An altarpiece of *Saints Helena, Sebastian and* (?)*Silvester*, signed and dated 1730, in the parish church at Spinea makes one grateful that no other figurative work of this kind by the artist is known.[10] Unlike almost all of the other Venetian view painters of the eighteenth

6

Johan Richter (1665–1745)
The Entrance to the Grand Canal, looking East, with the Bridge of Boats for the Feast of the Madonna della Salute,
before 1728

Oil on canvas, 120.6 x 151.4 cm
Wadsworth Atheneum Museum of Art, Hartford, CT. The Ella Gallup Sumner and Mary Catlin Sumner Collection Fund (1939.268)

century he seems to have had little interest in pure *capricci*, although he shows less respect for topographical accuracy than most of his successors, and imaginary elements are often introduced in the foregrounds to produce an individual blend of view painting and *capriccio*.

Richter's style is intimately related to that of Carlevarijs, and the establishment of his oeuvre has involved to a large extent the separation of his work from that of the better-known painter, which remains an ongoing process.[11] Although Fiocco suggested that Richter may have been the innovator,[12] it is now generally assumed that Carlevarijs, the senior by two years, should be credited with this. Richter's compositions are very much of his own invention, and he anticipates Canaletto in showing none of Vanvitelli's and Carlevarijs's reluctance to adopt subjects away from the Piazza San Marco and Bacino area. Richter's figures are particularly distinctive. In contrast to his peers he shows a marked preference for attractive young women, often with their hair tied up,[13] who are probably not derived from pattern models like Carlevarijs's and are more freely painted and vivacious.[14] In views with water in the foreground, boats containing groups of figures are often shown prominently very near the bottom edge of the painting. There is a strong tendency to show buildings at an angle, and their height is often exaggerated in relation to their width, evident in all Richter's representations of the Basilica of San Marco. Everything beyond the foreground is subject to aerial perspective, so that whole views may seem to be seen through an often pink-tinged heat mist.

The Entrance to the Grand Canal, looking East, with the Bridge of Boats for the Feast of the Madonna della Salute (plate 6) is one of Richter's masterpieces and as such was not surprisingly long held to be the work of Carlevarijs, although that attribution was already challenged in the 1940s.[15] It was, indeed, described by Aldo Rizzi, in the only major monograph on the artist, as 'one of Carlevarijs's greatest achievements'.[16] While the dramatic, diagonal, rolling sweep of cloud recalls Carlevarijs, the painting displays all the hallmarks of Richter's style. It is a particularly good example of the way that the artist compresses buildings horizontally and heightens them, which is here applied both to the Palazzo Gritti and other buildings on the left, and to the Dogana and the church of San Giorgio Maggiore on the right. The subject, an unusual one in art despite its importance as a fixture in the Venetian theological calendar,[17] clearly held an appeal for the artist, who produced at least three other, very different representations of it.[18] The composition is equally unusual, particularly in its omission of the focal point of the subject, the church of Santa Maria della Salute; cusping along the right edge suggests, however, that it has not been cut on this side. The striking image which results is unlike anything in Carlevarijs's oeuvre, from which it also differs in its pastel colours, with mauve tints on the boats, the bridge, some buildings, the distant water and the lower part of the sky.

Richter's work is not easy to date, but this painting shows the campanile of San Giorgio Maggiore with the conical cap which was replaced between June 1726 and 1728 with one of onion-shaped form,[19] strongly suggesting that it was executed while Carlevarijs was still active. Richter was to perpetuate his atmospheric style as an alternative to Canaletto's more detailed manner of the 1730s and 1740s, through until 1745. The style of his contemporary Bernardo Canal (1664?–1744) is in many ways closer to that of Richter than to that of his own son, although his palette is always distinctly more subdued. The reasons for these stylistic affinities remain unexplored, although Canal certainly made use of Vogel's engravings after Richter.[20]

Giovanni Antonio Canal, called Canaletto

(Venice 1697–1768)

Canaletto[1] was born in the parish of San Lio in Venice, the second of five children, with an elder brother and three sisters.[2] The Canal family were proud to be 'cittadini originari', a class immediately below the patrician, and Canaletto was to use a coat of arms as a sort of signature on a number of drawings, etchings and paintings, mostly of the early 1740s. He is first recorded assisting his father, Bernardo Canal (Venice 1664?–1744),[3] in the production of stage scenery, and in this capacity was in Rome in 1719–20. Sources from Canaletto's lifetime, notably Pierre-Jean Mariette, tell us that it was on this, his only visit to Rome that he first developed the interest in view painting which was to make him one of the most celebrated artists in Europe. This is fully corroborated by the existing evidence, as there is no reference to any involvement in scenography after the carnival of 1720, while his first dated work, a drawing of *The Arch of Constantine*, is of 10 August,[4] and he was inscribed in the Venetian painters' guild before the year was out. Bernardo is usually not credited with any significant role in his son's development, as nothing is known of any activity outside the theatre before the 1720s,[5] and his known view paintings, which are of relatively undistinguished quality, are all assumed to derive from his son's. Canaletto is not, however, known to have received any training from anybody else.

The painter's development was rapid. His first oil paintings are relatively inauspicious and consist mainly of *capricci* betraying his background in stage scenery and painted somewhat in the manner of Marco Ricci.[6] By 1723, however, he was able to produce masterpieces of the calibre of the set of four for Johann Wenzel von Liechtenstein, which included *The Rio dei Mendicanti,*

looking South (plate 9) and *The Piazza San Marco, looking East* (plate 10).[7] His early production of *capricci* reached its apogee with an enormous and highly inventive pair executed for the Villa Giovanelli at Noventa Padovana, one of which is his earliest signed and dated work (1723);[8] these were to be his last *capricci* before the 1740s. By this time Canaletto was already working for Joseph Smith, whose role as patron, and later agent, was to be the dominant influence on the painter's career, executing for him a series of six views of the Piazza San Marco and the Piazzetta which included *The Entrance to the Grand Canal and Santa Maria della Salute from the Piazzetta* (plate 8).[9]

Canaletto's activity in the year 1725 is particularly well documented. On Saint Roch's day, 16 August, *The Campo Santi Giovanni e Paolo* (plate 12) was acquired by the Imperial Ambassador, Conte Giambattista Colloredo. While the early history of *The Campo San Vidal and Santa Maria della Carità ('The Stonemason's Yard')* (plate 11) is not known, it can be dated on topographical as well as stylistic grounds to the same moment;[10] indeed, the two paintings are the same size and it has been suggested that they were originally conceived as pendants. On 2 August the painter received from the Lucchese collector Stefano Conti the commission for two views, which were executed briskly between late August and 25 November; by then Conti had commissioned a second pair, which had been completed and full payment made (90 zecchini, including a 'bonus' of 10 zecchini) by 15 June 1726.[11] This was to be the last major commission Canaletto undertook for an Italian patron. In the second half of the 1720s he can be seen adapting his work to what would most appeal to foreign, especially British, visitors. Following the lead of Luca Carlevarijs, he

began to paint large representations of ceremonies, of which the first is *The Reception of the French Ambassador Jacques-Vincent Languet, Comte de Gergy, at the Doge's Palace, 4 November 1726* (plate 13).

At the same time Canaletto began working on a very much smaller scale, executing a group of views on copper plates (his only known use of this support), of which four pairs and one single plate survive, at Goodwood, Chatsworth, Holkham Hall, in a Belgian private collection and in the Musée des Beaux-Arts, Strasbourg.[12] All datable between 1727 and 1730, they are of familiar views and of easily transportable size (and support). The Irish impresario Owen McSwiny acted as an intermediary in at least some of the transactions between Canaletto and British visitors over these, a task which he seems to have found less than straightforward.[13] There can be no doubt that it was Joseph Smith who provided McSwiny with necessary assistance, and soon afterwards he adopted the role of arranging commissions himself (although never exclusively). This event heralded a decade in which the painter concerned himself solely with views of Venice. The first two commissions in which Smith's involvement is documented are both for pairs of views.[14] *The Entrance to the Grand Canal, looking West, with Santa Maria della Salute* (plate 14) and its pendant were received by their Irish patron, Hugh Howard of Shelton Abbey, on 22 August 1730.[15] A larger pair of the Molo, looking East and West, for Samuel Hill is documented to 1730–1.[16]

At some point around the mid-1720s Canaletto had begun for Smith's personal collection a series of 14 views,[17] which was completed resplendently around 1733/4 when the 12 of the Grand Canal were joined by two larger depictions of festivals, *The Molo from the Bacino di San Marco on Ascension Day* (plate 16) and *A Regatta on the Grand Canal* (plate 17). It was Antonio Visentini's engravings of this series which formed the first edition of his *Prospectus*

Magni Canalis Venetiarum, published in 1735, which was to make Canaletto's compositions known to a wide audience.[18] During the middle years of the 1730s the painter also produced two even larger series of Venetian views, for John Russell, 4th Duke of Bedford, including *The Campo Santa Maria Formosa* (plate 18), and for his brother-in-law Charles Spencer, 3rd Duke of Marlborough, of which *The Grand Canal, looking South-East along the Fondamenta di Santa Chiara* and *The Campo San Salvador* (plates 20 and 21) both formed part. All of a standard, fairly small size which was easy to ship, these are in the mature style which is generally regarded as the artist's most characteristic.[19] Their execution was interrupted by that of two much larger masterpieces, *The Feast Day of Saint Roch* (National Gallery, London),[20] probably of around 1735, of which the early history is unknown, and *The Riva degli Schiavoni, looking West* (plate 19), which certainly did not need to travel by sea to England, having been commissioned by Johann Matthias von der Schulenburg, who made a payment on 23 February 1736.

The years 1738–42, when Canaletto's scenes bathed in summer sunshine are replaced by a more wintry and analytical approach, saw the creation of *The Bacino di San Marco* (plate 22) and *The Grand Canal with San Simeone Piccolo and the Scalzi* (plate 25), as well as the two magnificent upright views of *The Corner of the Libreria Marciana and the Base of the Campanile from the North End of the Piazzetta* and *The Courtyard of the Doge's Palace with the Scala dei Giganti* at Alnwick Castle.[21] These must have been particularly busy years in the family studio, with Bernardo Canal still present, Pietro Bellotti being trained and, most significantly, Bernardo Bellotto emerging as a – probably annoyingly precocious – potent force. At the moment when Bellotto's career begins to diverge from his uncle's, *The Entrance to the Grand Canal and Santa Maria della Salute from the Molo* and *The Piazza San Marco and the Piazzetta,*

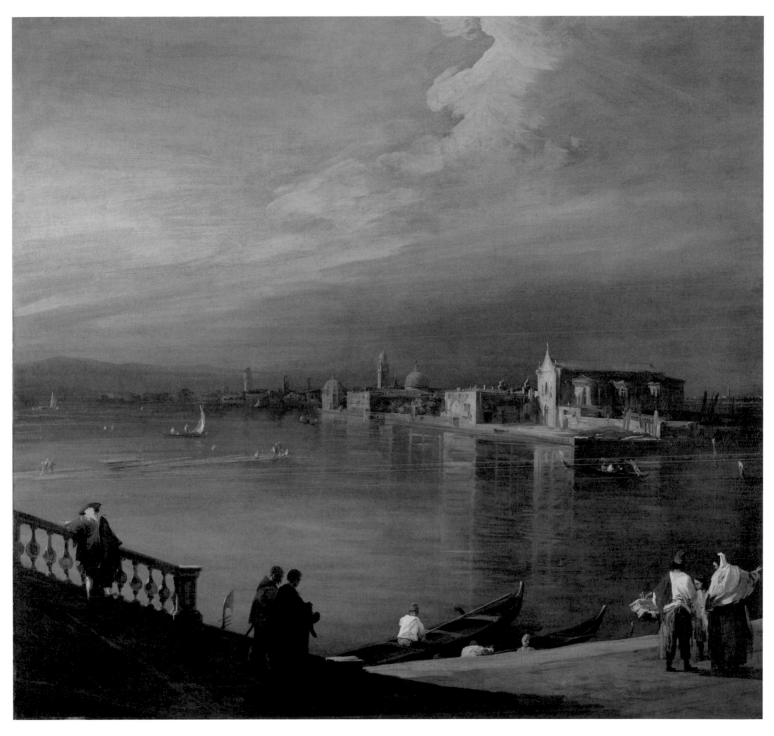

7

Canaletto (1697–1768)

San Cristoforo, San Michele and Murano from the Fondamenta Nuove, about 1722

Oil on canvas, 143.5 x 151.1 cm
Dallas Museum of Art, TX. Foundation for the Arts Collection, Mrs John B. O'Hara Fund (1984.51.FA)

looking South-East (plates 27 and 28), painted around 1743, show the warm sun returning. These are more than twenty paintings of 1742–4 to which Canaletto felt the need to append a signature, for the first time since the large *capriccio* of 1723. The reasons for this can only be surmised, but the most obvious explanation is that he felt threatened by his nephew's growing reputation.

Venetian views ceased to hold Canaletto's interest around this time, being supplemented by views of the mainland (visited with Bellotto in 1742) and of Rome (visited by Bellotto in the same year). He also diversified his activities into etching for the first time. A desire for new challenges may well have contributed to Canaletto's decision to transfer to England in May 1746, although the War of the Austrian Succession of 1740–8, which spread into Italy in 1741 and discouraged travel, must also have been a dominant factor (and it should be remembered that both his nephews emigrated shortly afterwards).[22] As far as we know, this was only the third time that Canaletto had left his native city, and it was to be by far the most significant. He remained in England for nine years, except for an eight-month return to Venice in 1750–1.

Despite the initial scepticism of the great London art-world diarist George Vertue,[23] Canaletto was extremely successful both in reinvigorating the interest of old patrons and in finding new ones. Although he was mainly occupied with executing views of England, and to a lesser extent *capricci*, he had no difficulty in painting in London a number of wholly convincing views of Venice.[24] These are distinguished by the use of a grey ground rather than the darker russet which was customary in Venice. Canaletto's success in England made it possible for him, on his temporary return to Venice in 1750, to invest money for (as far as we know) the only time in his life, on 8 March 1751 buying the lease of the Scuola dei Luganegheri on the Zattere for 2,150 ducats (an investment which he bequeathed to his three sisters). Paradoxically the main artistic fruit of this visit home was a pair of large views of London executed for Joseph Smith as a reminder of his native country; these were to be the last paintings commissioned from the artist by Smith.[25]

After his return to Venice, which took place in 1755, before 12 December,[26] Canaletto's style changed again, into its final form. Between 1758 and 1762 he executed for Sigismund Streit, a German merchant resident in Venice, his last major commission, a group of four Venetian views, two by daylight, including *The Grand Canal looking South-East from the Campo Santa Sofia to the Rialto Bridge* (plate 32),[27] and two, uniquely, nocturnal, including *The Night Festival at San Pietro di Castello on the Eve of the Feast Day of Saints Peter and Paul (28 June)*. A view of *The Piazzetta and Piazza San Marco from the Campo San Basso* (Los Angeles County Museum of Art), signed and dated 1763 on the reverse, rivals the Hartford view of the piazza of about 1731 (plate 15) in its distortions and use of multiple vanishing points.[28] A *Capriccio of a Colonnade opening onto the Courtyard of a Palace* (Gallerie dell'Accademia, Venice), signed and dated 1765, was to be much copied, as it was one of the very few works by the painter which remained available in Venice to later artists.[29] It was presented by Canaletto to the Venetian Academy as his *morceau de réception* following his election in September 1763.[30] He gained more belated official recognition in the same year when he was elected prior of the Collegio dei Pittori. In 1766 he signed and dated a superb, finished drawing now at Hamburg, proudly adding the inscription 'Aged 68 Without Spectacles'.[31]

Canaletto died at Corte Perin in the apartment in which he had spent much of his life,[32] and which may have been the one in which he was born. His posthumous inventory, which lists his assets in detail, reveals that he had very little indeed to show for his decades of hard work and fame.[33]

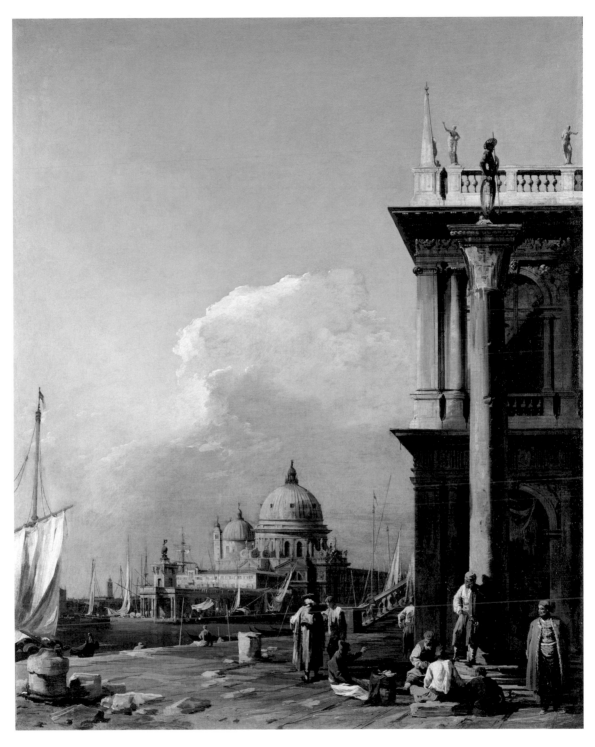

8

Canaletto (1697–1768)
The Entrance to the Grand Canal and Santa Maria della Salute from the Piazzetta, about 1723

Oil on canvas, 172.4 × 135.6 cm
Lent by Her Majesty The Queen (RCIN 405073)
London only

9
Canaletto (1697–1768)
The Rio dei Mendicanti, looking South, about 1723

Oil on canvas, 143 x 200 cm
Ca' Rezzonico, Museo del Settecento Veneziano, Venice

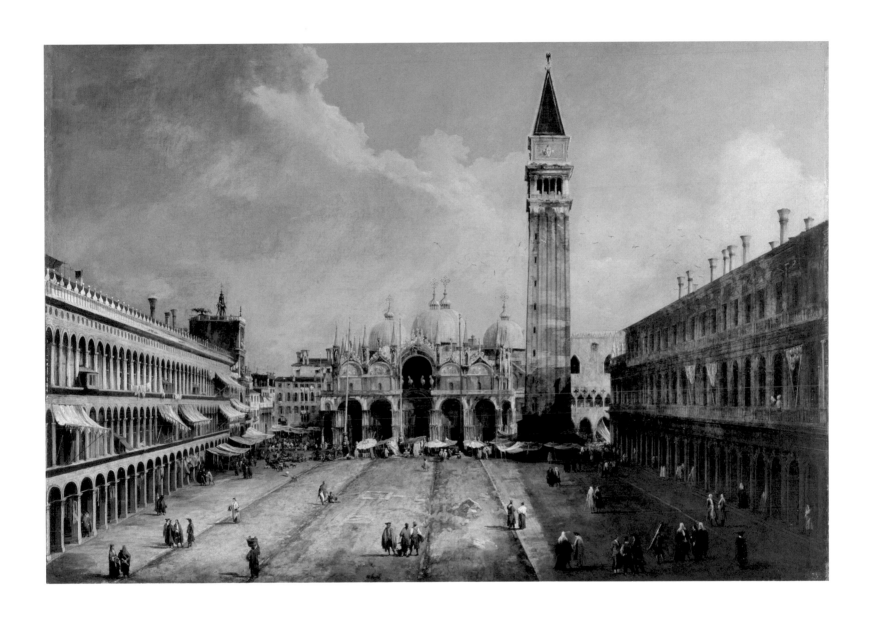

10

Canaletto (1697–1768)
The Piazza San Marco, looking East, about 1723

Oil on canvas, 141.5 x 204.5 cm
Museo Thyssen-Bornemisza, Madrid (75 [1956.1])

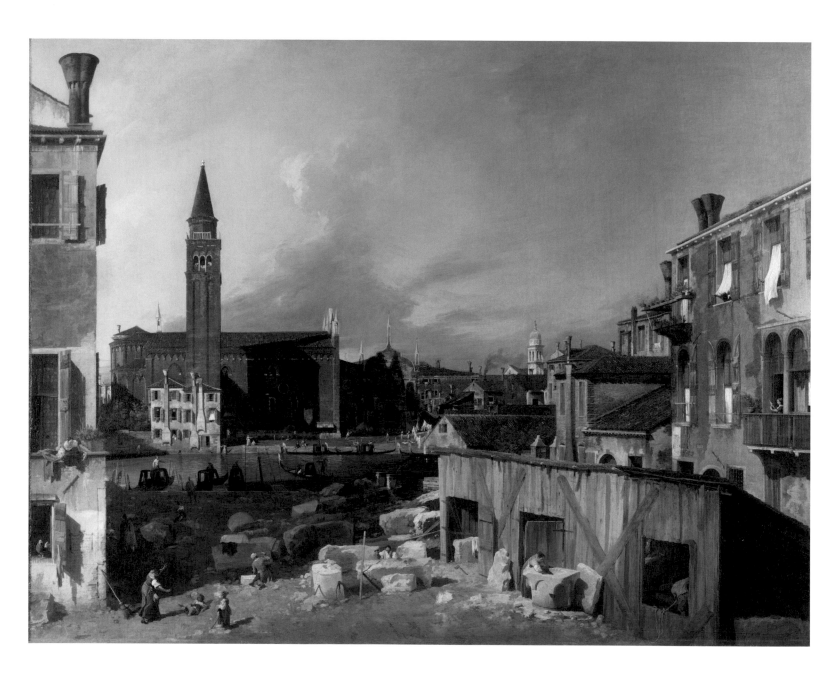

11
Canaletto (1697–1768)
Campo San Vidal and Santa Maria della Carità ('The Stonemason's Yard'), about 1725

Oil on canvas, 123.8 x 162.9 cm
The National Gallery, London. Sir George Beaumont Gift, 1823; passed to the National Gallery, 1828 (NG127)

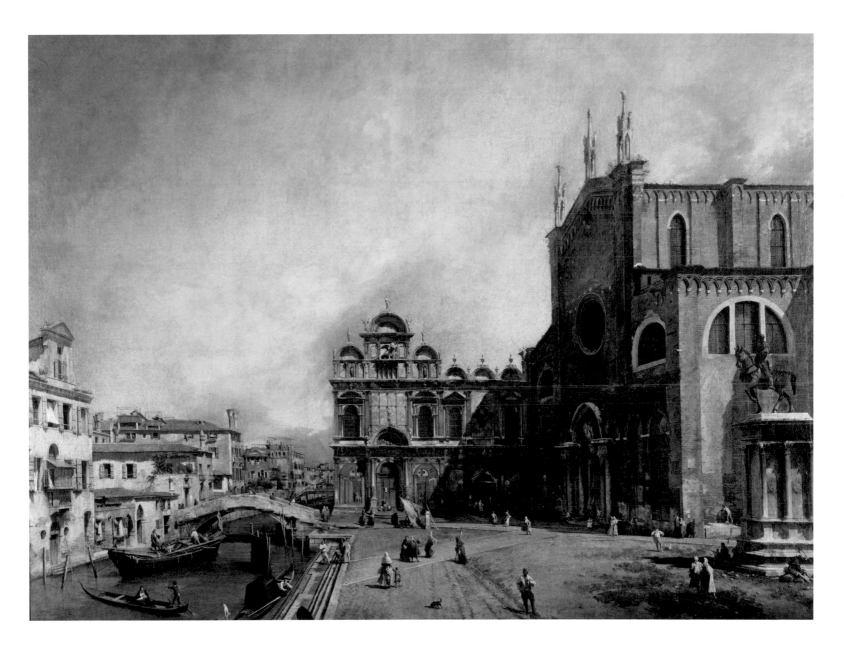

12

Canaletto (1697–1768)
The Campo Santi Giovanni e Paolo, about 1725

Oil on canvas, 125 x 165 cm
Gemäldegalerie Alte Meister, Staatliche Kunstsammlungen Dresden (3465)
Washington only

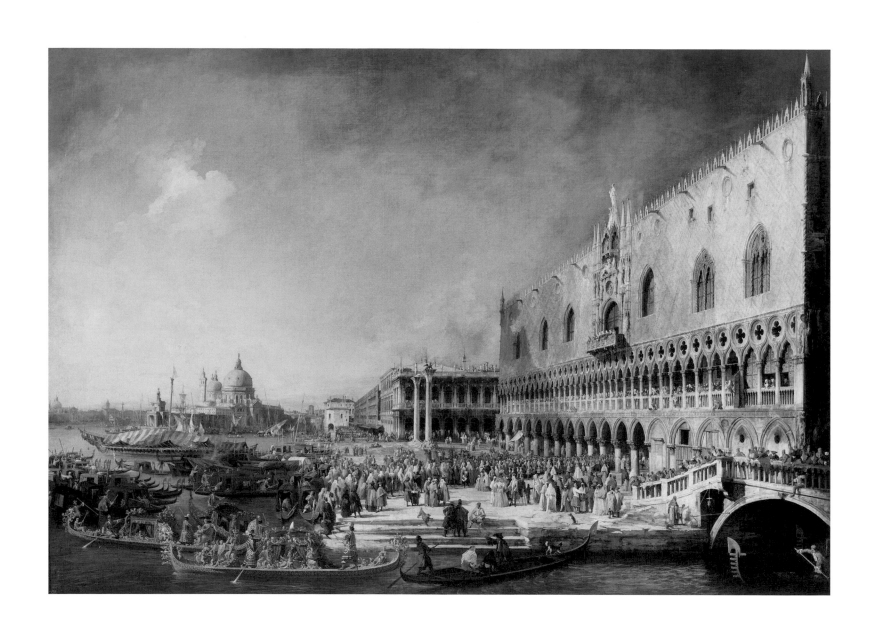

13 (*and detail facing*)

Canaletto (1697–1768)
The Reception of the French Ambassador Jacques-Vincent Languet, Comte de Gergy, at the Doge's Palace,
4 November 1726, about 1727

Oil on canvas, 181 × 259.5 cm
The State Hermitage Museum, St Petersburg (GE-175)

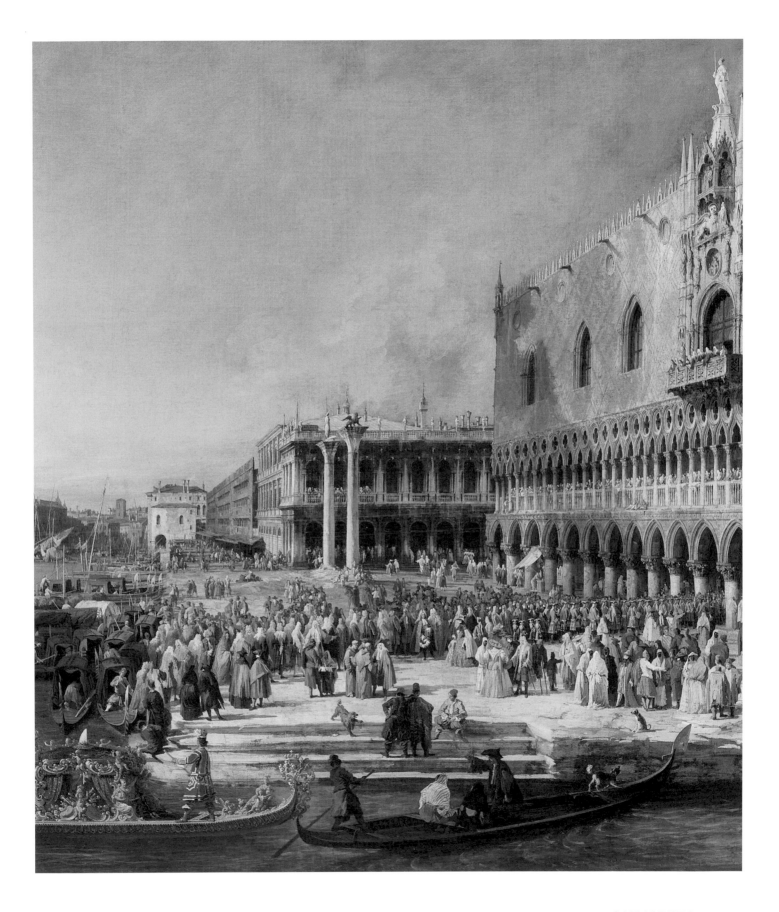

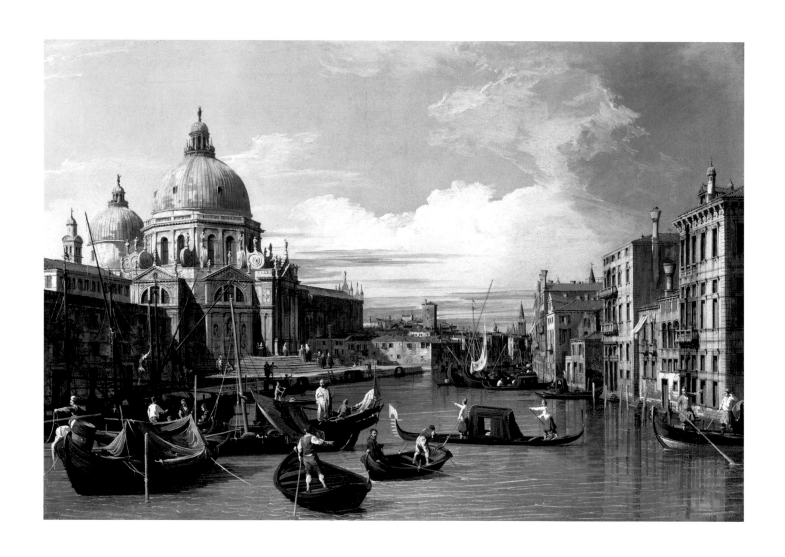

14

Canaletto (1697–1768)

The Entrance to the Grand Canal, looking West, with Santa Maria della Salute, about 1729

Oil on canvas, 49.5 × 73.7 cm

The Museum of Fine Arts, Houston, TX. The Robert Lee Blaffer Memorial Collection, gift of Sarah Campbell Blaffer (56.2)

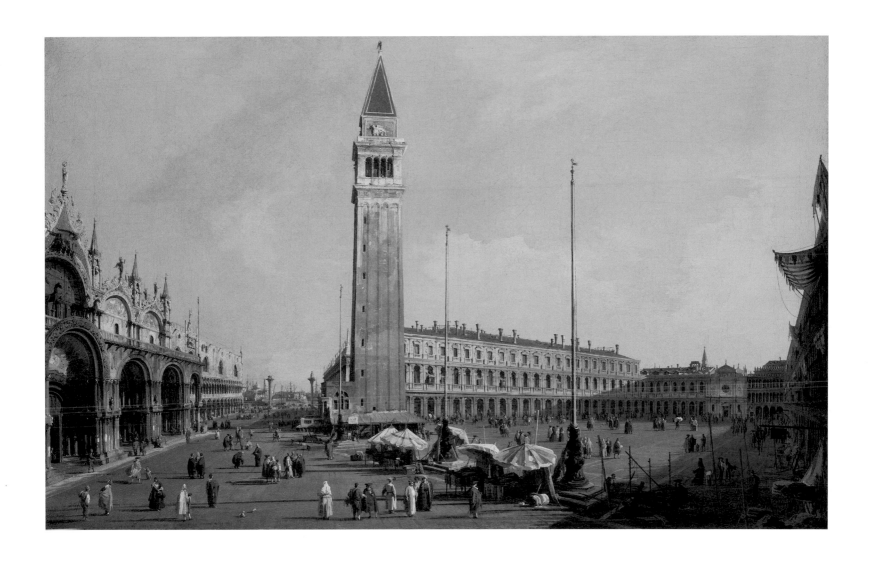

15

Canaletto (1697–1768)
The Piazza San Marco, looking South and West, about 1731

Oil on canvas, 66.3 x 103.5 cm
Wadsworth Atheneum Museum of Art, Hartford, CT. The Ella Gallup Sumner and Mary Catlin Sumner Collection Fund,
endowed by Mr and Mrs Thomas R. Cox, Jr (1947.2)

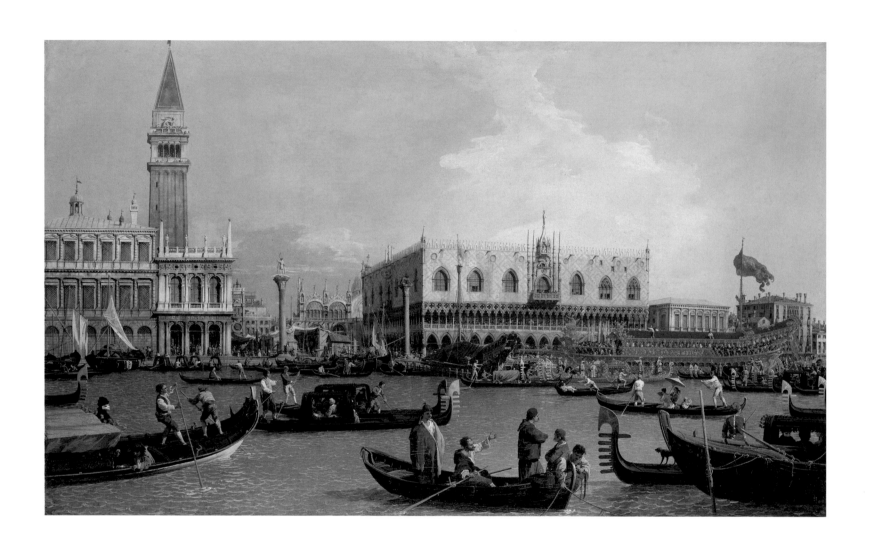

16

Canaletto (1697–1768)
The Molo from the Bacino di San Marco on Ascension Day, about 1733–4
Oil on canvas, 76.8 x 125.4 cm
Lent by Her Majesty The Queen (RCIN 404417)

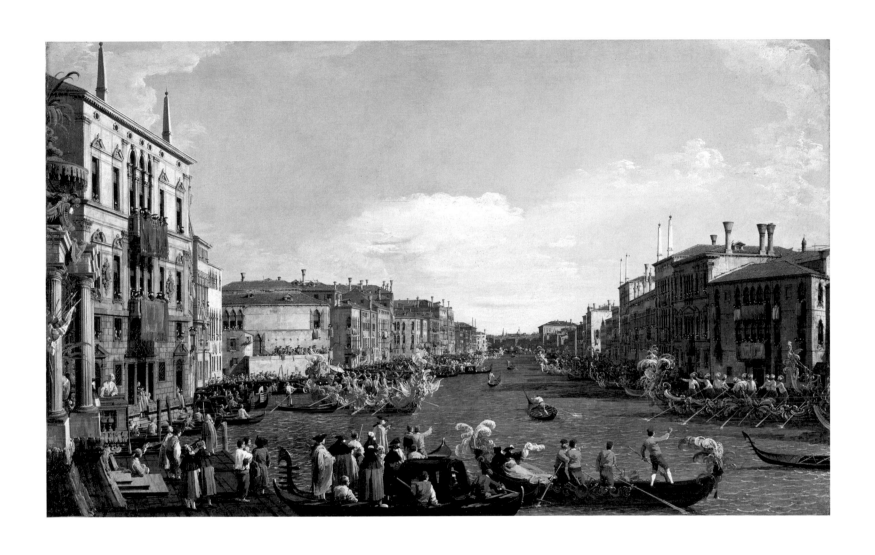

17

Canaletto (1697–1768)
A Regatta on the Grand Canal, about 1733–4

Oil on canvas, 77.2 x 125.7 cm
Lent by Her Majesty The Queen (RCIN 404416)

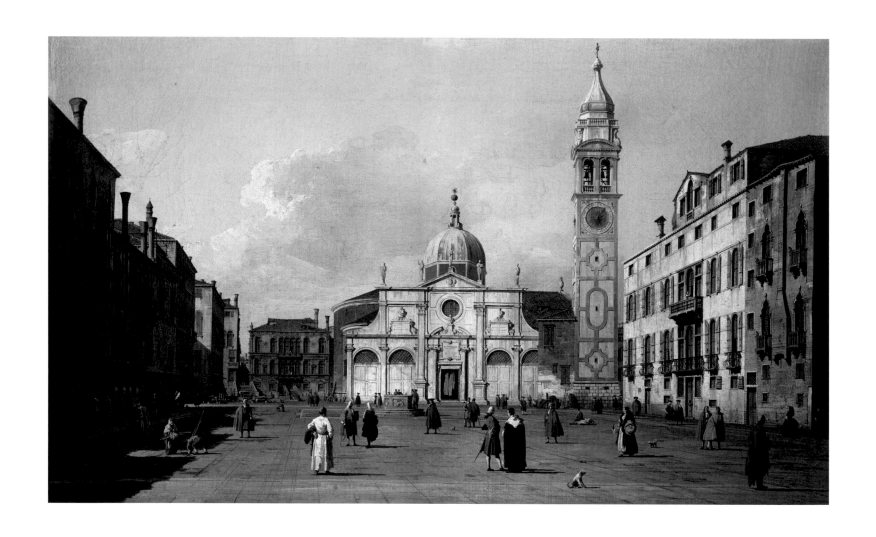

18

Canaletto (1697–1768)
The Campo Santa Maria Formosa, about 1733–4
Oil on canvas, 47 x 80 cm
Lent by His Grace the Duke of Bedford and the Trustees of the Bedford Estates
London only

84 CANALETTO

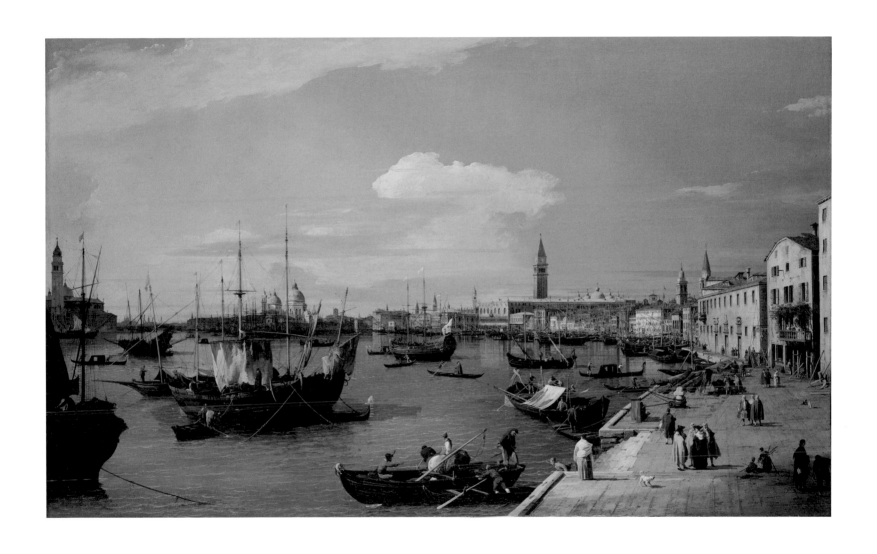

19
Canaletto (1697–1768)
The Riva degli Schiavoni, looking West, about 1735–6
Oil on canvas, 126.2 x 204.6 cm
The Trustees of Sir John Soane's Museum, London
London only

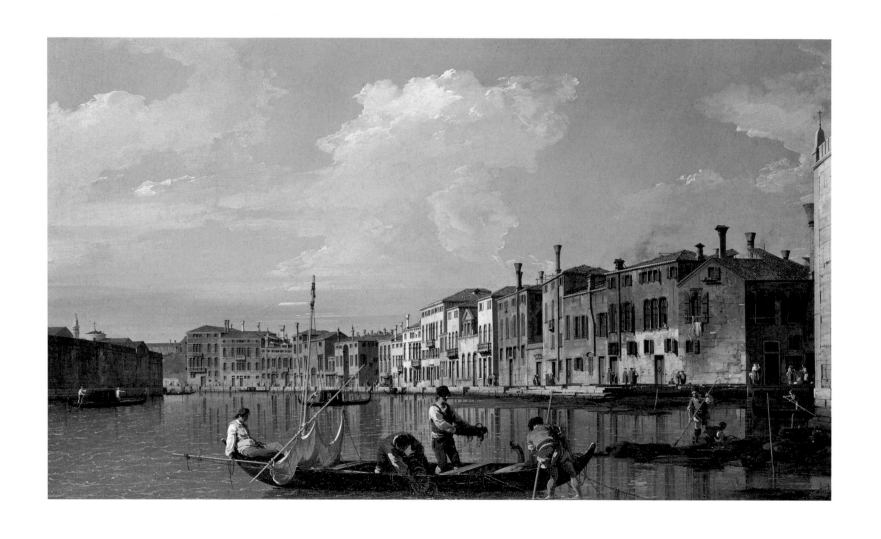

20

Canaletto (1697–1768)
The Grand Canal, looking South-East along the Fondamenta di Santa Chiara, about 1736
Oil on canvas, 47 x 77.7 cm
Private collection, London

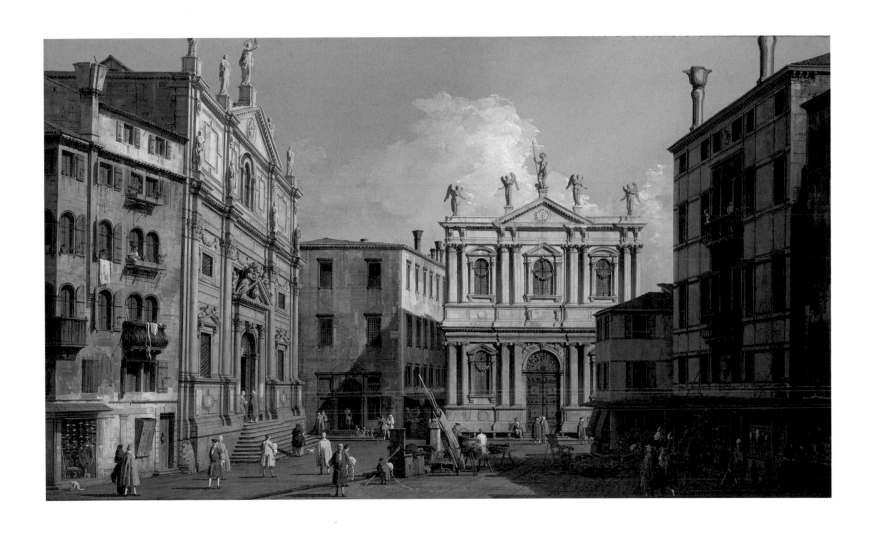

21

Canaletto (1697–1768)
The Campo San Salvador, about 1736
Oil on canvas, 46.8 x 77.5 cm
Private collection, London

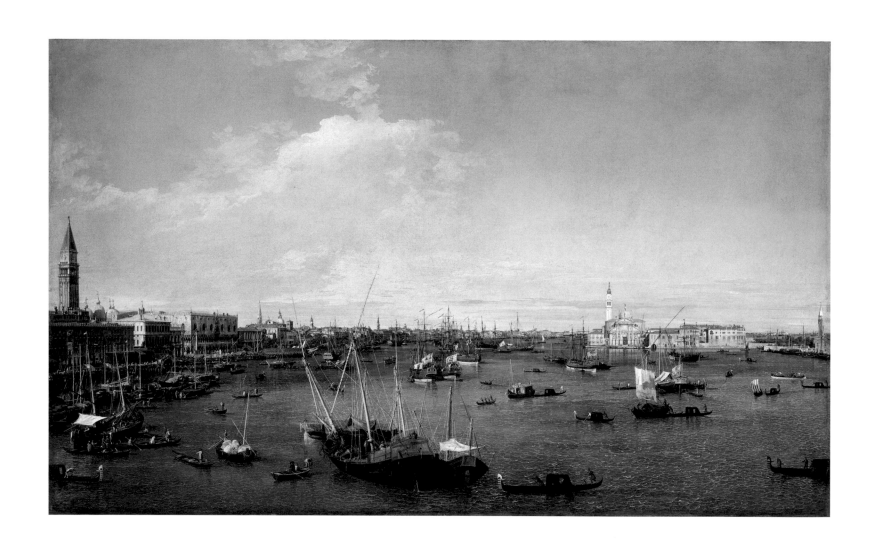

22 (*and detail facing*)

Canaletto (1697–1768)
The Bacino di San Marco, about 1738–9

Oil on canvas, 124.5 x 204.5 cm
Museum of Fine Arts, Boston, MA. Abbott Lawrence Fund, Seth K. Sweetser Fund, and Charles Edward French Fund, 1939 (39.290)

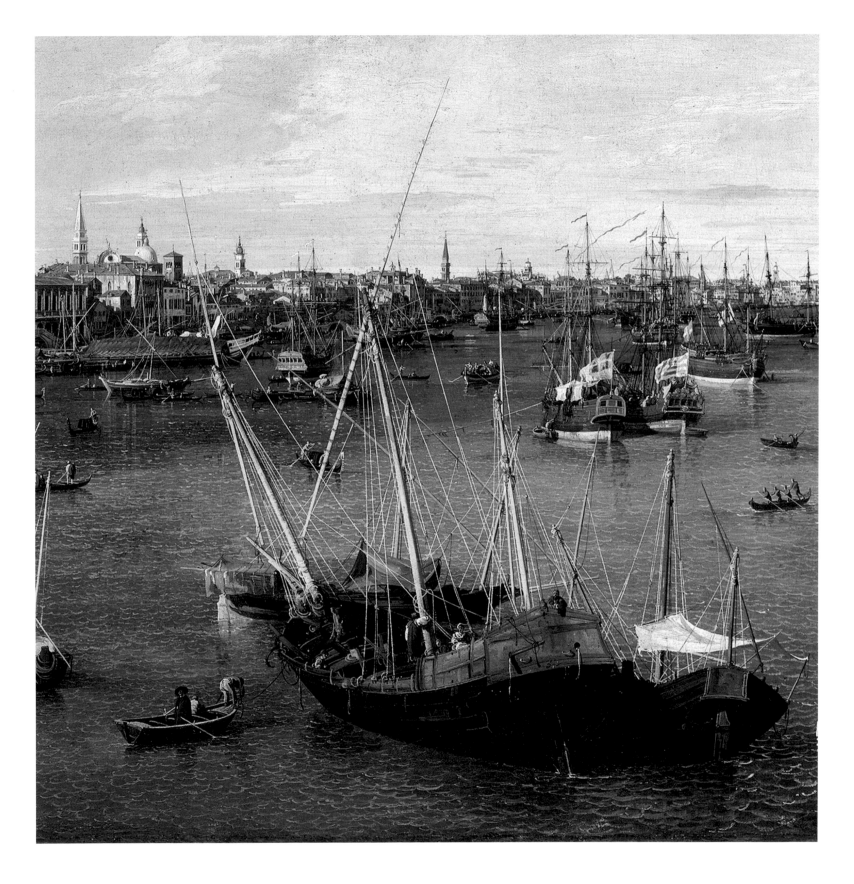

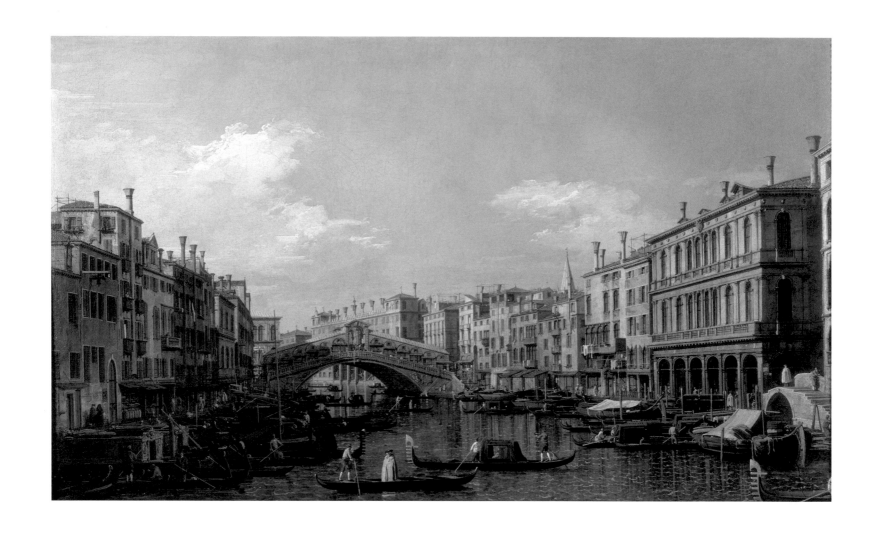

23
Canaletto (1697–1768)
The Grand Canal with the Rialto Bridge from the South, about 1740
Oil on canvas, 45 × 76 cm
Institut de France, Musée Jacquemart-André, Paris (MJAP-P 577-1)

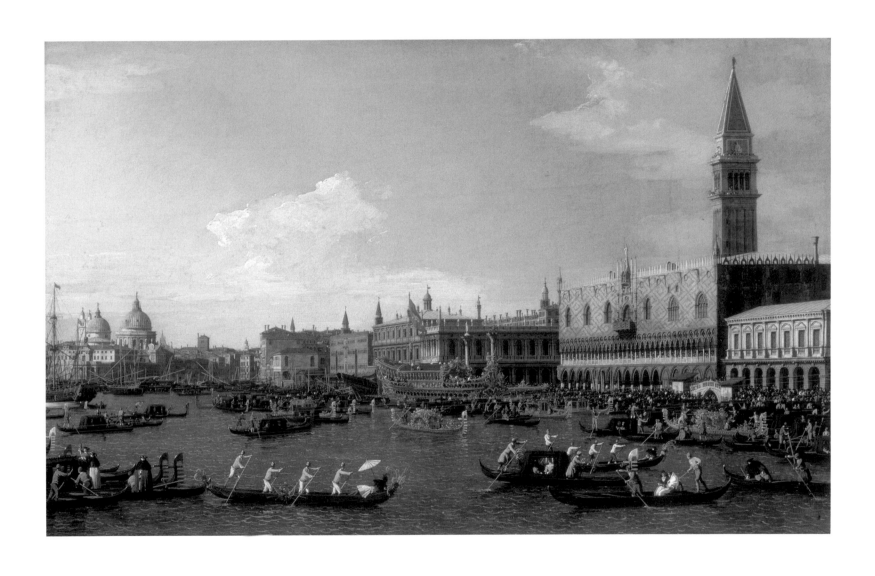

24
Canaletto (1697–1768)
The Bacino di San Marco on Ascension Day, about 1739
Oil on canvas, 57 x 93 cm
MNAC. Museu Nacional d'Art de Catalunya, Barcelona. On permanent loan from the Colección Thyssen-Bornemisza (MNAC 212851)

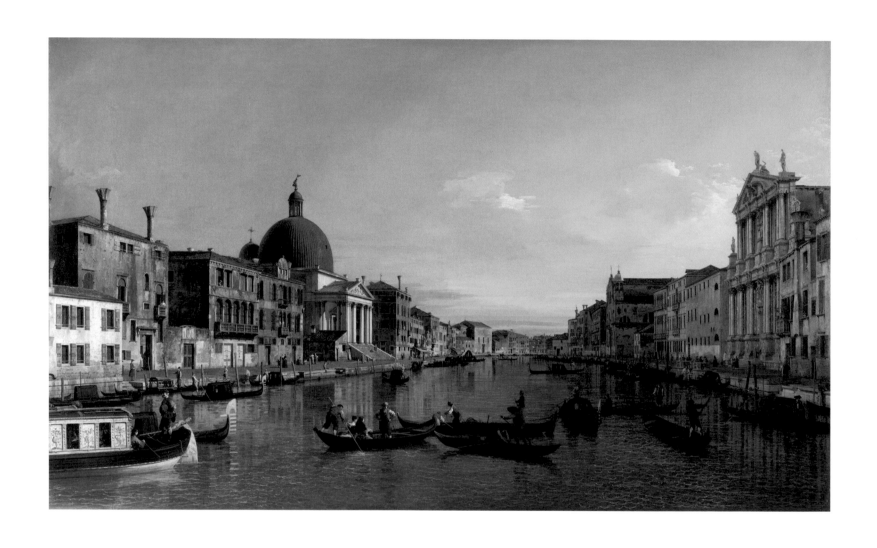

25

Canaletto (1697–1768)
The Grand Canal with San Simeone Piccolo and the Scalzi, about 1740
Oil on canvas, 124.5 x 204.6 cm
The National Gallery, London. Bequeathed by Lord Farnborough, 1838 (NG163)

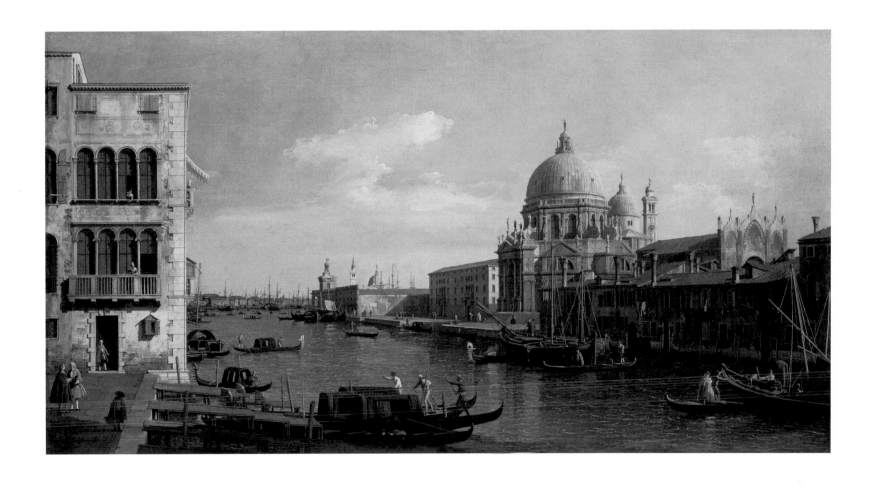

26

Canaletto (1697–1768)

The Entrance to the Grand Canal, looking East, with Santa Maria della Salute, about 1741

Oil on canvas, 54.6 x 101.6 cm
The Fitzwilliam Museum, Cambridge (PD.106-1992)

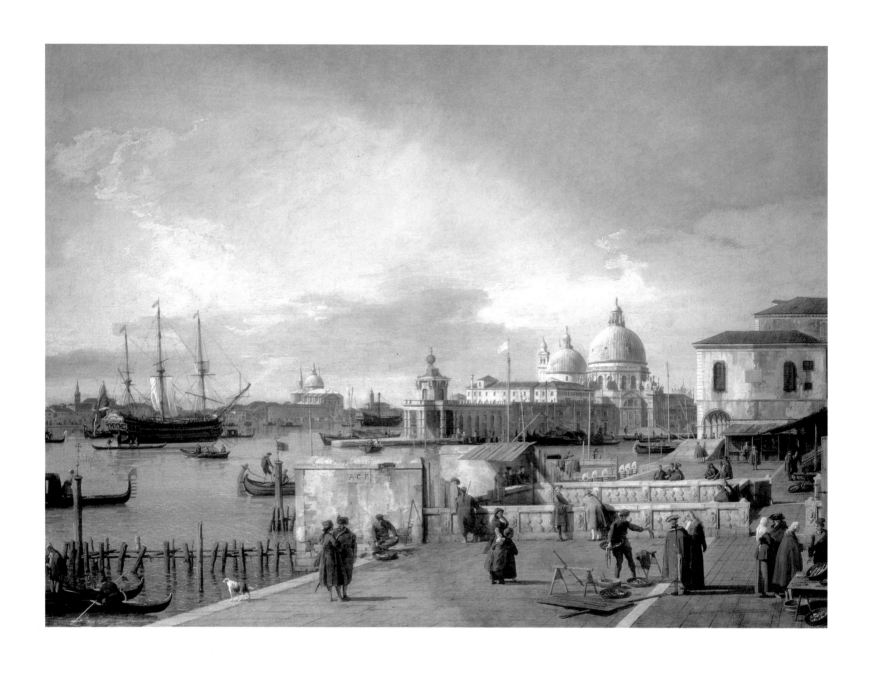

27

Canaletto (1697–1768)
The Entrance to the Grand Canal and Santa Maria della Salute from the Molo, about 1743
Oil on canvas, 114.5 x 153.5 cm
National Gallery of Art, Washington. Gift of Mrs Barbara Hutton (1945.15.4)
Washington only

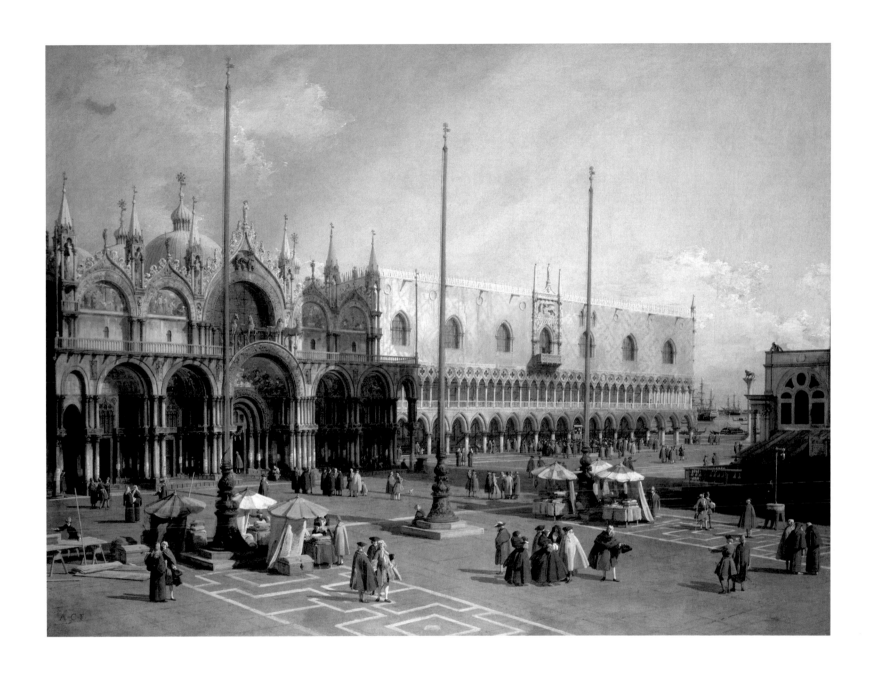

28

Canaletto (1697–1768)

The Piazza San Marco and the Piazzetta, looking South-East, about 1743

Oil on canvas, 114.6 x 153 cm
National Gallery of Art, Washington. Gift of Mrs Barbara Hutton (1945.15.3)
Washington only

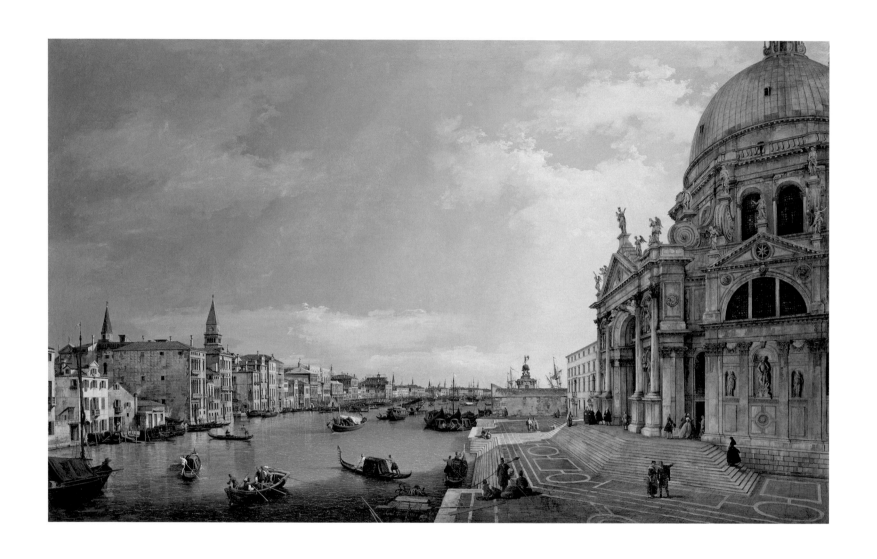

29

Canaletto (1697–1768)

The Entrance to the Grand Canal, looking East, with Santa Maria della Salute, about 1742–4

Oil on canvas, 127 x 203 cm
Lent by Her Majesty The Queen (RCIN 404397)
London only

96 CANALETTO

30
Canaletto (1697–1768)
The Torre di Malghera, about 1756
Oil on canvas, 31.5 x 46.2 cm
Private collection

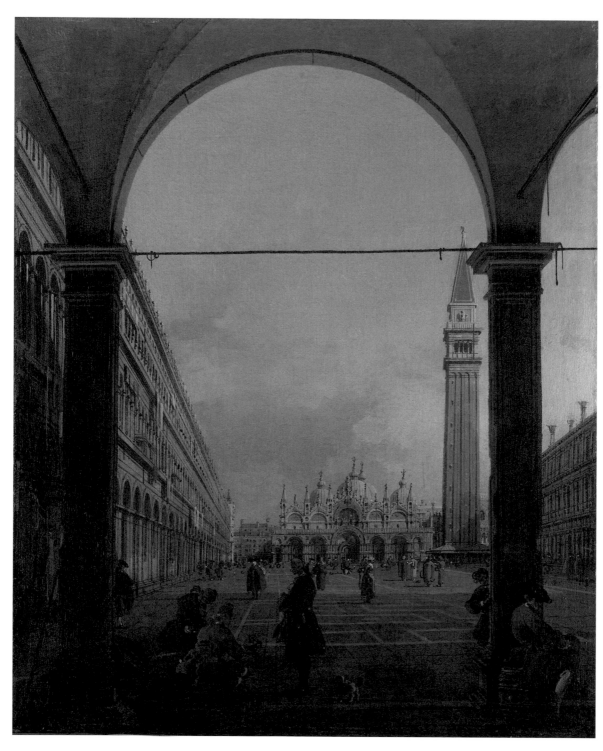

31
Canaletto (1697–1768)
The Piazza San Marco from the Western Arcade, about 1758
Oil on canvas, 46.4 x 37.8 cm
The National Gallery, London. Salting Bequest, 1910 (NG2515)

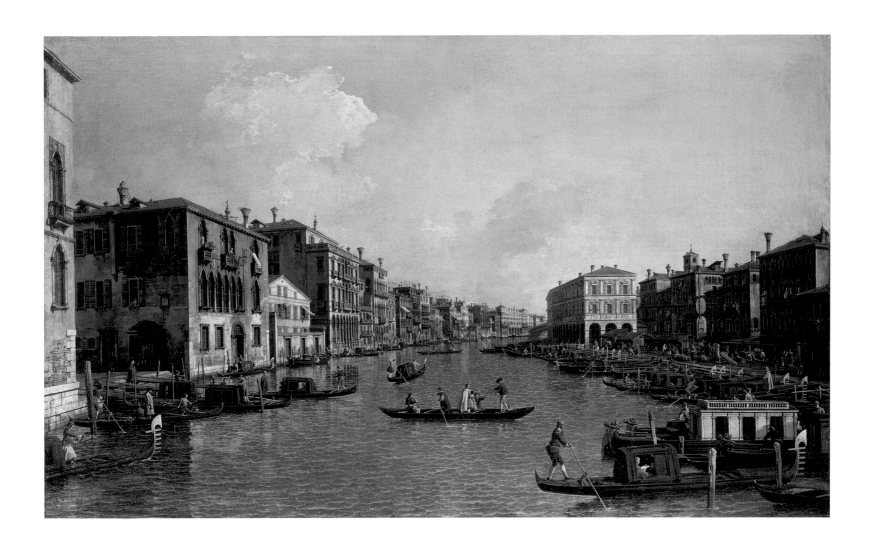

32

Canaletto (1697–1768)
The Grand Canal looking South-East from the Campo Santa Sofia to the Rialto
Bridge, between 1758 and 1762

Oil on canvas, 119 x 185 cm
Staatliche Museen zu Berlin, Gemäldegalerie, on loan from the Streitsche Stiftung (1653)
London only

Giovanni Battista Cimaroli

(Salò, near Brescia, 1687 – Venice 1771)

Born in the Lombard town of Salò, which was under Venetian control, Cimaroli was trained in Brescia and from 1711 in Bologna under the battle painter Antonio Calza, before settling and marrying Calza's sister-in-law in Venice in 1713 at the age of 26. By 1722 his reputation as a painter of landscape was such that he received the prestigious commission to collaborate with other carefully selected painters on no fewer than four of the 'Allegorical Tombs' commissioned by the Irish impresario Owen McSwiny, including both of those to which Canaletto contributed the architectural element, that of Lord Somers with figures by Giovanni Battista Piazzetta,[1] and that of Archbishop Tillotson with figures by Giovanni Battista Pittoni.[2] Few other details are known about Cimaroli's life, and the last mention of him still alive is of 1753.[3] In a letter of 16 June 1736 Count Carl Gustav Tessin lists him immediately after Canaletto, noting that 'he paints in the same taste, but has not yet arrived at the top of the ladder, moreover spoiled by the English, who have imagined that the smallest of his paintings is worth 30 zecchini'.[4]

Cimaroli was most active as a landscapist. His distinctive and elegant works in this genre have always been admired, and have ensured his inclusion in most general studies of eighteenth-century Venetian painting.[5] Two were owned by Johann Matthias von der Schulenberg and no fewer than six by Joseph Smith.[6] Cimaroli also painted a significant number of imaginary views of towns on the Brenta, including a pair acquired by Henry Howard, 4th Earl of Carlisle, presumably in 1738/9, and now in the Terruzzi Collection.[7] His significance as a view painter was, however, largely overlooked until quite recently. The

only attempt at a catalogue raisonné, now more than a decade out of date, only lists six Venetian views among the 71 paintings catalogued.[8] Quite a number more have emerged since then.[9] Several have been misattributed to Canaletto, notably a view of *Dolo on the Brenta* in the Staatsgalerie, Stuttgart, which was as recently as 1989–90 included in the great Canaletto exhibition in New York,[10] and a view of *The Grand Canal at the Entrance to the Cannaregio* in a Venetian private collection, of which Constable wrote: 'The greater part of the painting is undoubtedly by Canaletto; but some of the figures … may be by another hand'.[11] Paintings such as these establish Cimaroli, Canaletto's senior by ten years, as one of his few significant competitors during the 1730s and 1740s, and help to explain why Schulenburg commissioned from him a pair of views in 1736, the same year that he acquired the masterpieces by Canaletto (plate 19) and Marieschi (plate 37); he paid Cimaroli 50 zecchini,[12] the same sum received by Marieschi, while Canaletto's painting may seem relatively inexpensive at 120 zecchini.

Cimaroli's work was occasionally mistaken for Canaletto's (quite possibly deliberately), even by contemporaries. A painting in an Italian private collection of *The Piazza San Marco with the Populace chasing Bulls*, a subject perfectly suited to Cimaroli's decorative talents, was in the collection of Bouchier Cleeve (1715–60) at Foot's Cray Place, Kent, as the work of 'Canaletti and Chimeroli'.[13] Despite the unlikelihood of such a collaboration between the two artists,[14] this dual attribution was retained by Constable[15] and is still accepted in some quarters to this day.[16] A different type of attributional problem is presented by a larger variant of that painting, recently

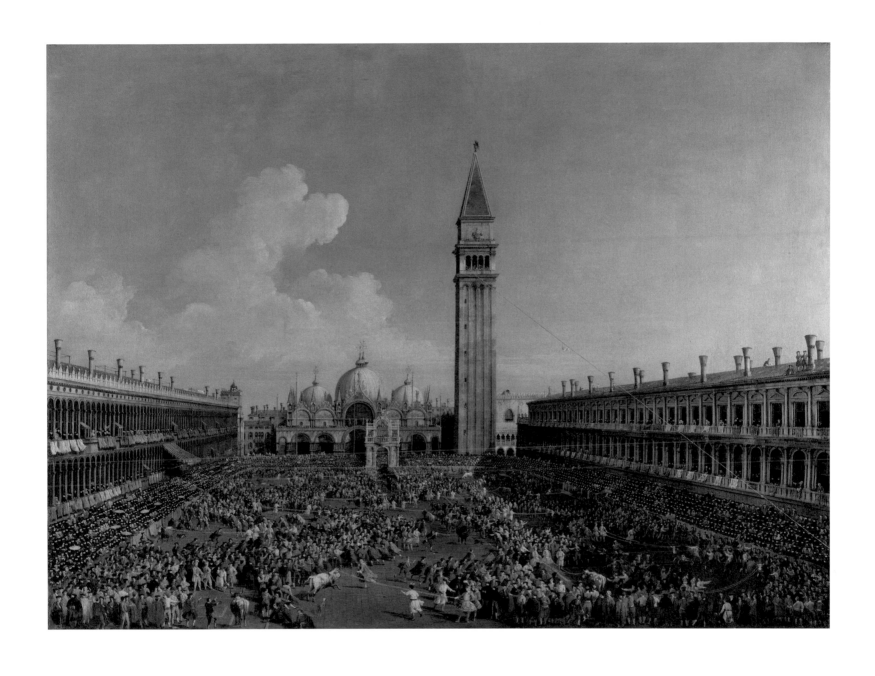

33

Giovanni Battista Cimaroli (1687–1771)
The Piazza San Marco with the Populace chasing Bulls in Celebration of the Visit of Friedrich Christian of Saxony,
16 February 1740, about 1740

Oil on canvas, 153 x 202.5 cm
Private collection, England

purchased for the Terruzzi Collection.[17] This shows a much grander occasion, specifically the populace chasing bulls on 16 February 1740 in celebration of the visit of Friedrich Christian of Saxony.[18] Also known from a smaller copy attributed to Giuseppe Bernardino Bison,[19] the composition is clearly Cimaroli's most impressive invention. Exhibited and published repeatedly as the work of Cimaroli,[20] the Terruzzi painting has been identified with that recorded by Cicogna in 1842:

> In recent times there was with the dealer Gaspare Craglietto a large painting by that painter [Canaletto] with the Bull Chasing of 1740 …; but the painting is no longer here, having been bought from its owner by a rich foreigner for a very high price. Craglietto, however, had a copy made of the same size, very like the original, and this is currently (1844) [sic] the property of the Abate Angelo Fornasieri in Venice.[21]

Discrepancies in quality between the Terruzzi painting and the smaller variant, as well as other works by Cimaroli, have been pointed out by Fabrizio Magani,[22] and might already have suggested that its origins may be explained by Cicogna's last sentence.[23] In any case it is not the painting purchased from Craglietto, which is here presented for the first time (plate 33), having passed by inheritance from the 'rich foreigner', Richard, 2nd Marquess of Westminster, who acquired it in 1836 as a souvenir of his visit to Venice of 2–10 March of that year. The identification is certain, as not only does the catalogue of the Marquess's collection of 1849 state that the painting was 'purchased at Venice, in 1836, of Captain Craglietti [sic]',[24] but the diaries of both the Marquess and Marchioness have passed by descent with it. The Marchioness's diary, which is particularly detailed, records the couple's visit in the afternoon of Saturday 5 March to Craglietto's house and their inspection of his 'large Canaletti, a very elaborate picture of St. Mark's Place, on the occasion of a fete given to a son of the K. of Poland, about 1740'. On Wednesday 9 March, the eve of their departure, the Marquess received a visit from 'the old Capt. Craglietti', when no doubt an agreement was reached.

The painting is a relatively rare example of a view which had remained in Venice into the nineteenth century, presumably because the subject gave it a particular appeal, and was inevitably attributed to Canaletto. Its re-emergence presents the opportunity, more than any other work by Cimaroli, to assess the level of competition he offered to similarly large and decorative works which emanated from the Canaletto studio in the 1740s.

Antonio Joli
(Modena about 1700 – Naples 1777)

While Canaletto only left the Veneto twice, albeit for protracted periods, his contemporary Joli was the most widely travelled of the Italian view painters of the eighteenth century. The historian Girolamo Tiraboschi (1731–94) tells us that after initial training under a local painter in his native Modena, he worked under Giovanni Paolo Panini (1691–1765) in Rome until 1725, when he returned home.[1] Joli's training was presumably as a painter of imaginary architecture with figures, and the association with Panini, also of Emilian origin, is very probable, as some of Joli's *capricci* are close enough in manner to Panini's to have been mistaken for his work.[2]

The first record of Joli's presence in Venice is at Ascension Day 1732, when an opera was performed with stage sets designed by him. Unlike Canaletto, who abandoned scenography when he became interested in view painting, for Joli this was to remain a regular occupation throughout his career. He designed the sets for two or three operatic productions in Venice each year from 1735 until Ascension Day 1742.[3] The first record of the artist as a painter of views dates from 28 September 1735, when Johann Matthias von der Schulenburg paid him 14 zecchini for a view of Verona; that was followed on 30 May 1736 by a payment of 16 zecchini for a view of Naples.[4] The only other documentary reference to work by Joli outside the theatre in this period is a letter of 16 June 1736 from Count Carl Gustav Tessin in Vienna, in which he says that the painter '*fait assés bien les vües et l'architecture*'.[5] His growing reputation is shown by his election as Prior of the College of Venetian Painters on 28 December 1739, and as one of its three Syndics two years later.

Joli seems to have returned to Rome, possibly only briefly, in the summer of 1740. His whereabouts for two years from Ascension Day 1742 are unknown, although he may have visited Dresden in search of employment. In 1744 he is first recorded in London designing scenery for the King's Theatre in Haymarket, and he was further active in this capacity in 1746 and 1748.[6] For its director John James Heidegger, Joli also produced one of his most delightful creations, the decoration of the entrance hall of 4 Maids of Honour Row, Richmond Green, Surrey.[7] After Heidegger's death on 5 September 1749 the artist moved to Madrid, where he remained until 1754, designing sets and adding views of Madrid and Aranjuez to his repertory, including a set of six for Joseph Henry of Straffan, Co. Kildare, one of which is dated 1754 on the reverse.[8]

On 13 October 1754 Joli returned to Venice, the start of an eight-year period free of scenographic obligations, and he was elected a founder member of the Accademia Veneziana di Pittura e Scultura on 13 February 1756. Later that year, however, he was to establish one of the most significant relationships of his career, with John Montagu, Lord Brudenell (1735–70), then on a particularly unhurried Grand Tour which lasted from 1754 until 1760. The painter seems to have visited Ischia with Brudenell in August,[9] and in November accompanied him on a tour of Sicily. He subsequently executed for his patron an unrivalled series of at least 38 views of Naples, Florence, Southern Italy, Sicily, Malta and Southern France, which passed by inheritance to the Dukes of Buccleuch and Queensberry and the Lords Montagu of Beaulieu, with whom much of it remains, eight canvases at Bowhill and sixteen at Beaulieu. Joli is recorded on

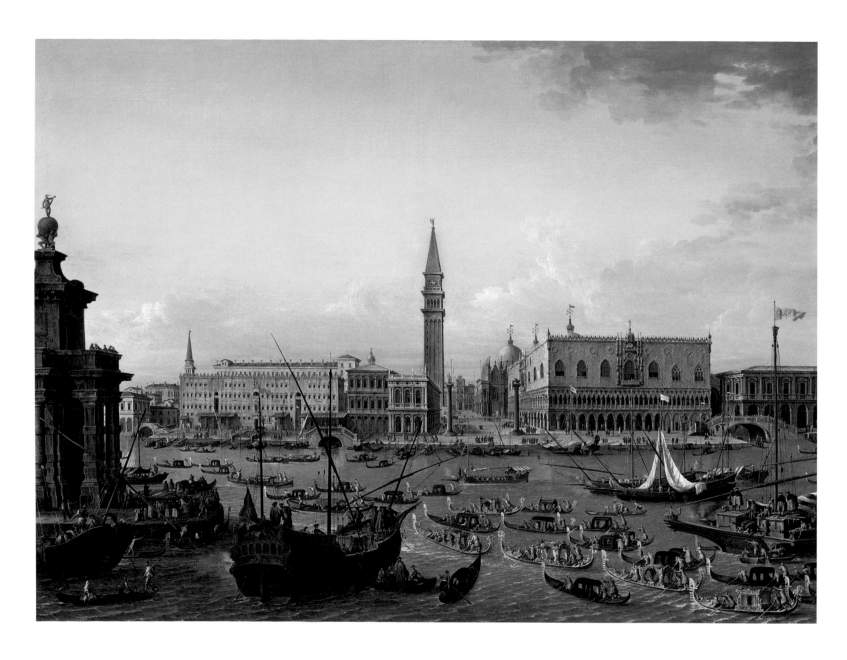

34

Antonio Joli (about 1700–1777)
The Bacino di San Marco and the Molo with the Formal Entrance of the Apostolic Nuncio Monsignor Giovanni Francesco Stoppani, 17 April 1741, about 1742

Oil on canvas, 160.7 x 221.6 cm
National Gallery of Art, Washington. Gift of Mrs Barbara Hutton (1945.15.2)

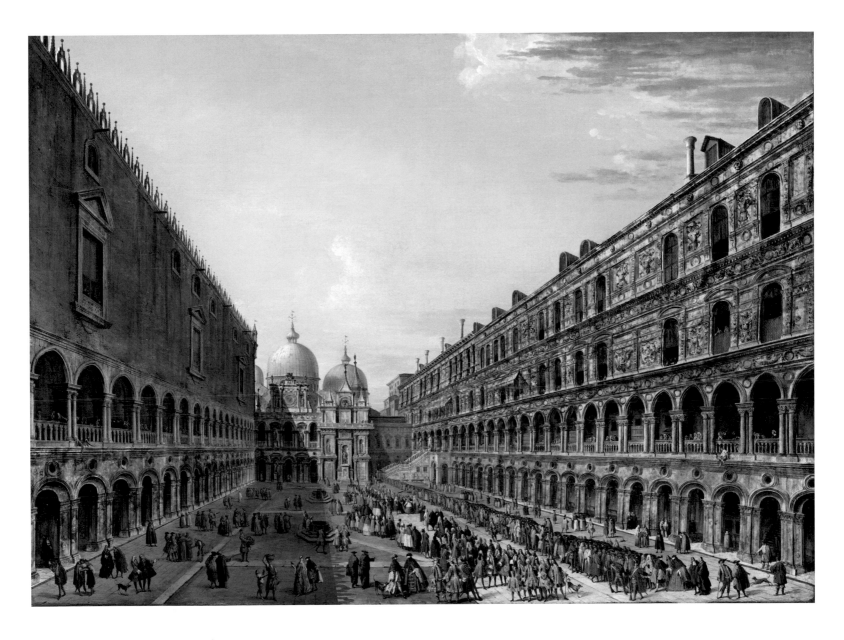

35 (*and detail overleaf*)

Antonio Joli (about 1700–1777)
The Courtyard of the Doge's Palace with the Apostolic Nuncio Monsignor Giovanni Francesco Stoppani
and Senators in Procession, 17 April 1741, about 1742
Oil on canvas, 160.7 x 221.6 cm
National Gallery of Art, Washington. Gift of Mrs Barbara Hutton (1945.15.1)
Washington only

21 April 1759 in Naples, quite possibly still working on Brudenell's Neapolitan views, which as a group constitute the definitive portrait of the city in the mid-eighteenth century. When Brudenell moved on to Venice, where he had arrived by 21 September 1758, and left on 24 February 1760, he was probably thus obliged to look elsewhere for local views, turning to Francesco Guardi, newly established in this field, from whom he commissioned eight (of which four remain at Bowhill) and others from the Master of the Langmatt Foundation Views (including views of Stra and the Brenta Canal). Although Joli is recorded in Venice on 28 December 1761, he was thereafter resident in Naples, in constant demand for sets for the Teatro San Carlo and for views of the city, which were to be his most influential legacy.

Joli's style is neither as robust as that of Canaletto nor as vivacious as that of Marieschi. His delicate, feathery touch is ideally suited to work on a fairly intimate scale and he was usually at his best when painting close to his subject. When the Prince of San Nicandro referred in 1762 to Joli's 'great expertise in painting, especially on a small scale …',[10] he may well have been thinking of such paintings as his recent series for Brudenell. The quality of his considerable output is very variable, partly because of his willingness to produce views while at some distance from their subjects, a practice he shared with Vanvitelli and Canaletto. Popular compositions, above all those of the Castel Sant'Angelo and of the Roman Forum, were repeated many times, including in Spain and England, with varying degrees of intervention by workshop assistants and a consequent loss of atmosphere.

Many of Joli's twenty-odd Venetian views show some of these weaknesses. Some were certainly painted in London, including three overdoors for the lavishly rococo 'French Room' in Chesterfield House,[11] and others very probably so, including one signed and inscribed with the names of Heidegger and his natural daughter.[12] Four others follow prints by Carlevarijs and Marieschi.[13] In the pair of very large views in Washington, however, Joli rose to the challenge of a particularly glamorous commission to produce two of the most imposing of all his works, their quality fully revealed by their recent cleaning (plates 34 and 35). These are first recorded, in 1836, as showing different moments during the formal reception of the Apostolic Nuncio Monsignor Giovanni Francesco Stoppani, which took place on 17 April 1741.[14] The presence of Antonio Gai's bronze gates of the Loggetta of the Campanile, erected in 1742, suggests that the two paintings were not completed until the year after the event.[15] Attributed in 1836 to Canaletto, and given to the National Gallery of Art in 1945 as such, they remained long in storage, their correct authorship being first suggested by Antonio Morassi in 1958 and confirmed by Dario Succi as recently as 1993.[16]

Joli usually painted his own figures, but these are generally very small. Succi is also responsible for the identification of all but the smallest figures in these paintings as the work of the Venetian specialist figure painter Gaspare Diziani (1689–1767), a unique instance of collaboration between the two artists. Joli has made every effort not to be upstaged by the vivacity of Diziani's contribution. Borrowing (but by no means slavishly copying) the composition of the view of the courtyard of the Doge's Palace from Marieschi's painting, which he must have seen in the collection of his old patron Johann Matthias von der Schulenburg (plate 37), he has also imitated the rich texturing created by Marieschi's distinctive brushwork.[17]

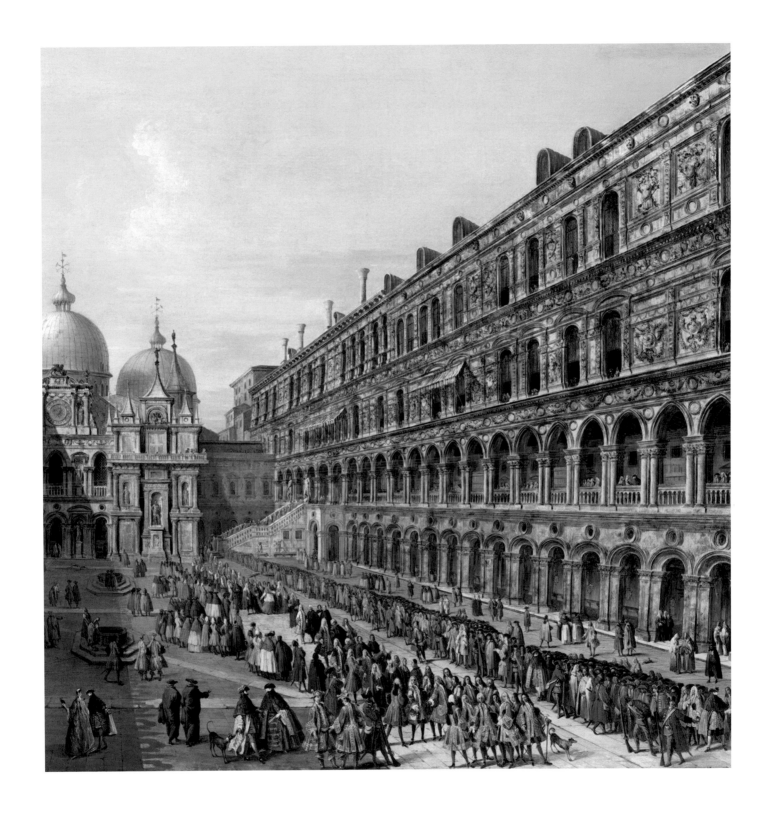

Michele Marieschi

(Venice 1710–1743)

The son of a minor craftsman who died when Michele, the eldest of eight children, was only ten years old, Marieschi came from a very humble background in the poorest area of Venice.[1] His artistic activity seems to have begun, like Canaletto's, in the field of scenography, and he is first recorded, on 3 January 1731, as an associate of Francesco Tasso, a designer of temporary structures for festivals. Pietro Guarienti tells us that the painter worked in Germany at an early stage in his career, although corroborating evidence is lacking.[2] This must have been before 1735, when Marieschi executed two drawings for engravings of the decorations, designed by Tasso, in the church of San Paterniano at Fano for the funeral of Maria Clementina Sobieska, wife of the Old Pretender. In 1736 he emerged, fully fledged, on the Venetian artistic scene, being inscribed in the Collegio dei Pittori and on 20 November receiving from Johann Matthias von der Schulenburg 50 zecchini – a handsome sum for a painting by an un-established artist – for a view of *The Courtyard of the Doge's Palace* (plate 37). This was followed on 20 April 1737 by an advance of 55 zecchini and two silver medals[3] for a depiction of *The Grand Canal with the Rialto Bridge from the North and the Arrival of the new Patriarch Antonio Correr, 7 February 1735* (fig. 25).[4]

On 26 August 1737 Marieschi was able to invest 155 zecchini with the Arte dei Lunganegheri for a term of not less than four years.[5] The money was invested in the name of his fiancée, Angela Fontana, whom he married in November. His father-in-law, Domenico Fontana, was a successful picture dealer and the couple seem to have lived in some comfort. An inscription on a document of 2 December relating to his wife's dowry would seem to

show that Marieschi was almost illiterate.[6] In 1741 he published *Magnificentiores Selectioresque Urbis Venetiarum Prospectus*, his great series of 22 engravings of Venetian views of his own composition. This was clearly intended to compete with Antonio Visentini's *Prospectus Magni Canalis Venetiarum* of 1735, which had done so much to disseminate Canaletto's compositions, the differences being that in Marieschi's case the engravings were by the painter himself, and that there are notable variations between his paintings and the prints. Marieschi's career was cut short at the age of 32, according to Guarienti because of his 'excessive application to work and study'.[7]

Marieschi was indeed prolific, given the brevity of his career, and was also a highly inventive painter of *capricci* (at a moment when Canaletto was not). Like Canaletto he divided his production of Venetian views between fairly small canvases and a few much larger ones, which, apart from the two for Schulenburg, include *The Entrance to the Grand Canal, looking East, with Santa Maria della Salute* (plate 36), *The Bacino di San Marco* (plate 41), *The Rialto Bridge from the Riva del Vin* (plate 39) and its pendant showing *The Grand Canal and the Riva del Vin*.[8] Marieschi was a competent, but not inspired, figure painter and more often than not he preferred to delegate the staffage in his views to specialised figure painters, including Gaspare Diziani (who was a witness at his wedding), Giovanni Antonio Guardi, Francesco Simonini, and Francesco Fontebasso (godfather to his third child).[9] Diziani, for instance, was responsible for the figures in *The Grand Canal with the Rialto Bridge from the North and the Arrival of the new Patriarch Antonio Correr, 7 February 1735* and in the pair in Russia, *The Rialto Bridge from the*

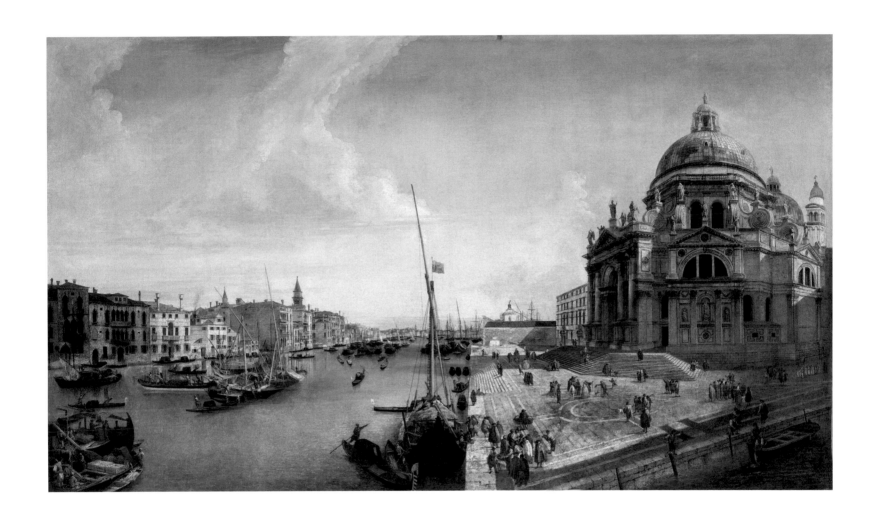

36 (*not exhibited*)

Michele Marieschi (1710–1743)

The Entrance to the Grand Canal, looking East, with Santa Maria della Salute, about 1735

Oil on canvas, 124 x 213 cm

Musée du Louvre, Paris (162)

Riva del Vin and *The Grand Canal and the Riva del Vin*.

Establishing a chronology of Marieschi's work is not easy, as his style had little time to develop. Some paintings can be dated from topographical details, and others from the circumstances of their acquisition. Henry Howard, 4th Earl of Carlisle, for instance, is first recorded in Venice in November 1738. He commissioned from Marieschi a series of 18 Venetian views of the same size, which, although dispersed, can almost all be identified from a contemporary list in Italian which survives at Castle Howard. It may be presumed to be these to which Antonio Maria Zanetti the Elder refers in a letter of 3 June 1740, in which he writes 'I am pleased that you have received the paintings … I believe that you have put them in your country house …'.[10] If so, all the components of the series should date from 1739 or the first months of 1740. A far wider range of dates is, however, suggested by all those who have offered opinions on the subject.[11]

Defining the limits of Marieschi's oeuvre has proved particularly controversial, with six major publications, five of them supposedly complete catalogues, published since 1988 by four different authors. Despite this, quite a number of paintings remain unpublished.[12] Attributions are complicated by the existence of a real disciple, Francesco Albotto (1721–57), who, according to Pierre-Jean Mariette, became known as 'the second Marieschi'.[13] He was living in Marieschi's house before his marriage in November 1737, and on 29 October 1744, a year after the death of his master, he married his widow; she died in 1751 at the age of 42. The only certain work by the painter, a view of *The Molo from the Bacino di San Marco* with a signature or inscription on the reverse recorded as 'F. Albotto F. in Cale di Ca' Loredan S. Luca' surfaced on the art market in 1972, and again in 2006.[14] This obviously forms the basis for all attributions to the painter, but some of the paintings assumed to be his are of significantly superior quality and thus much more difficult to differentiate from his master's. The views and *capricci* of the Master of the Langmatt Foundation Views are also closely related, often in specific compositions as well as in manner, to the work of Marieschi and Albotto.

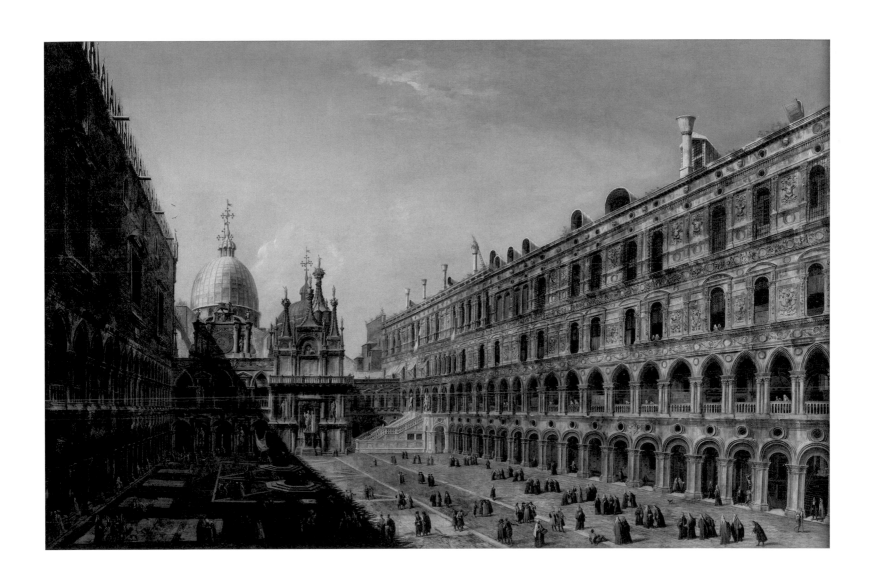

37
Michele Marieschi (1710–1743)
The Courtyard of the Doge's Palace, 1736
Oil on canvas, 118.5 x 180.7 cm
Private collection, Italy
London only

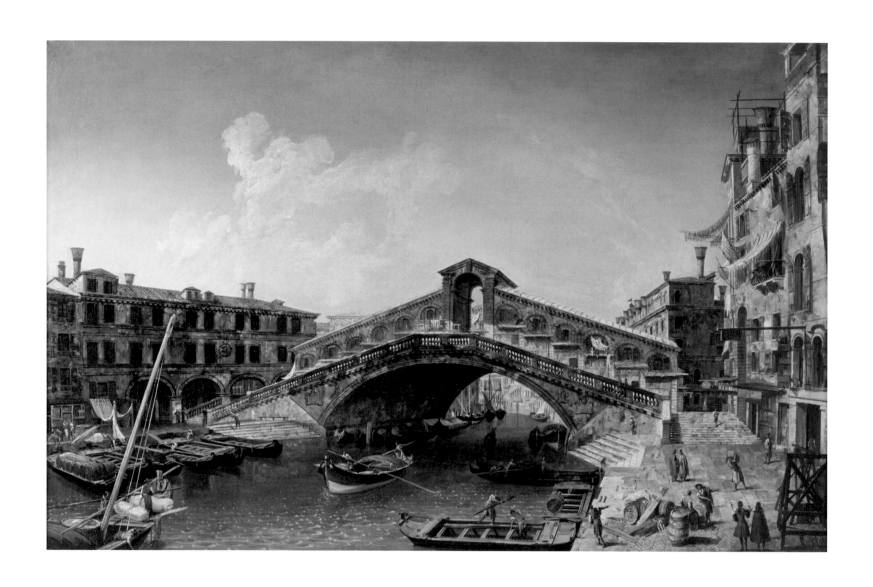

38

Michele Marieschi (1710–1743)
The Rialto Bridge from the South, about 1736
Oil on canvas, 55.9 x 85 cm
Philadelphia Museum of Art, PA. The John G. Johnson Collection, 1917 (298)
Washington only

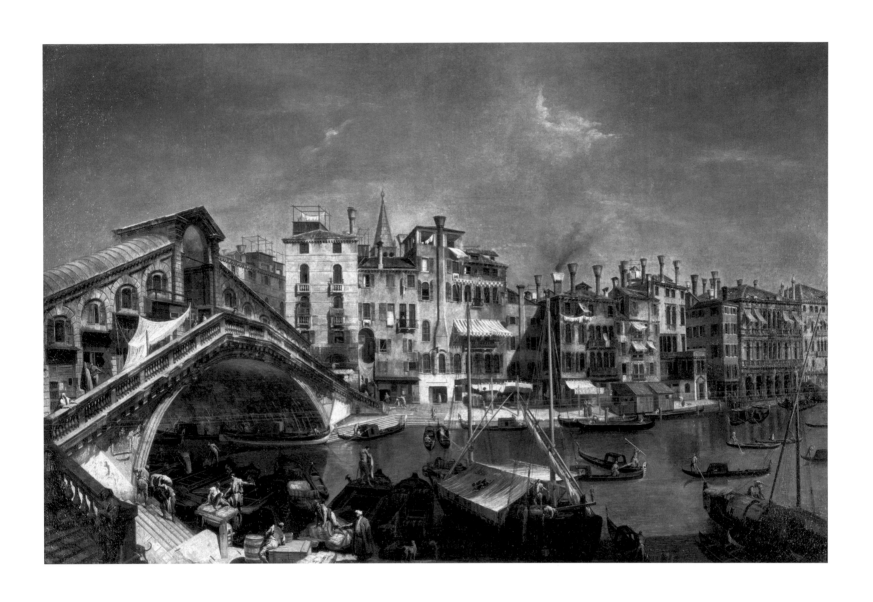

39

Michele Marieschi (1710–1743)
The Rialto Bridge from the Riva del Vin, about 1737
Oil on canvas, 131 x 196 cm
The State Hermitage Museum, St Petersburg (GE-176)

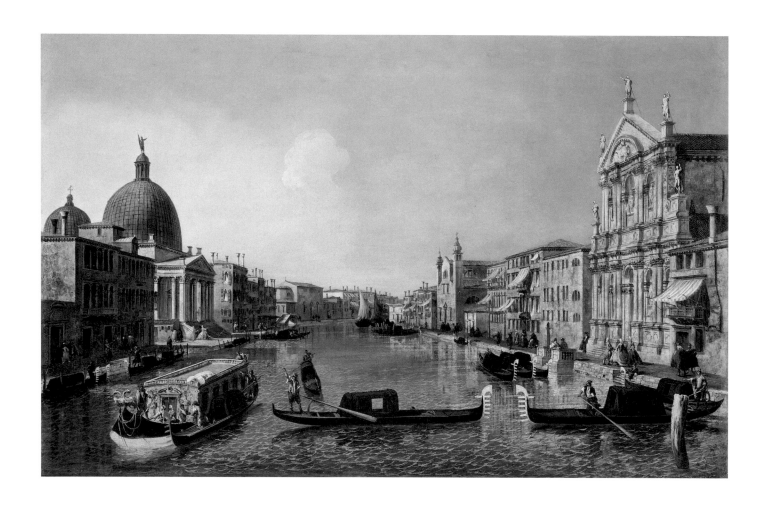

40

Michele Marieschi (1710–1743)
The Grand Canal with San Simeone Piccolo and the Scalzi, about 1742
Oil on canvas, 55.6 x 84.8 cm
Philadelphia Museum of Art, PA. Purchased with the W.P. Wilstach Fund, 1900 (w1900-1-14)
Washington only

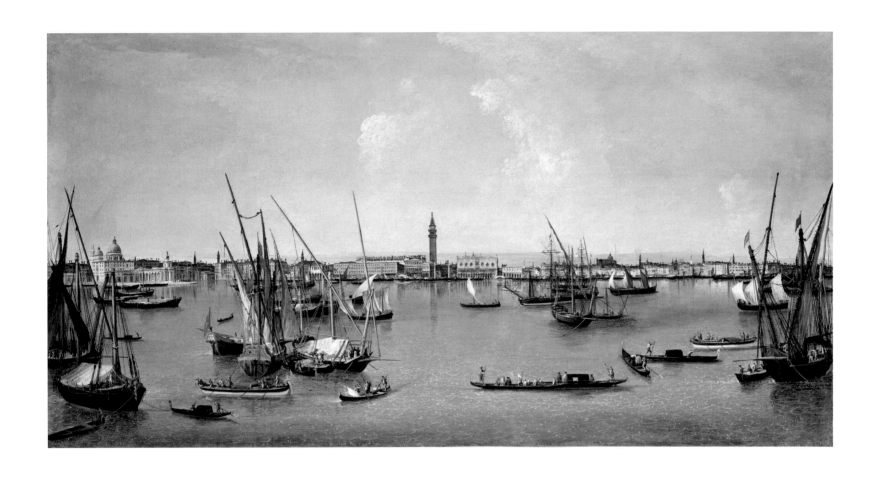

41

Michele Marieschi (1710–1743)
The Bacino di San Marco, about 1739–40
Oil on canvas, 95.2 x 178.7 cm
Private collection

Bernardo Bellotto

(Venice 1722 – Warsaw 1780)

In Bernardo Bellotto were combined an exceptional natural talent and all the fortunes of birth that an aspiring view painter could enjoy. Born on 20 May 1722, he was the son of Fiorenza Domenica Canal, the eldest of Canaletto's three sisters.[1] His bachelor uncle took him under his wing and began his training when Bellotto was still in his early teens; Canaletto's own first tentative ventures into the field of view painting were not made until he was about 23 years old. Bellotto responded by demonstrating a quite remarkable precocity. A highly proficient drawing of *The Grand Canal at the Entrance to the Canale di Santa Chiara, looking South-East along the Fondamenta di Santa Chiara*[2] is on the verso of two letters from Venice written by Bernardo and his elder brother, Michiel, to their father; Michiel's departure from Venice in June 1736 provides a convincing *terminus ante quem* for its execution, and indeed one of Canaletto's paintings of the same view, from a slightly different viewpoint, probably dates from that year (plate 20).

Bellotto was inscribed in the Venetian painter's guild in 1738, when he was only 16 years old. His earliest known painting, a view of *The Entrance to the Grand Canal, looking West, with Santa Maria della Salute* (currently with Cocoon Art, Milan)[3] may well precede that singular honour. That and a slightly later pendant view of *The Rialto Bridge from the North*[4] are recorded by James Harris, MP (1709–80), father of the 1st Earl of Malmesbury, in his own *Account of my Pictures* begun in 1739 as 'Four views of Venice' including 'two … by Antonio Bellotti [the artist's Christian name presumably mistaken for that of his uncle, Canaletto], one representing the Custom House; the other, the Rialto', for which he paid ten guineas. 'They

were painted all at Venice, & imported at my Request by Mr. Wm Hayter of London March 1743'.[5] These are the only Venetian views by Bellotto whose attribution is confirmed by a contemporary document.

The two paintings set the pattern for many of Bellotto's early works. They are based on works by Canaletto which the young artist would have known not only from Antonio Visentini's engravings, plates VI and VII of his *Prospectus Magni Canalis Venetarium* published in 1735, but also, no doubt, from the paintings themselves, which were among the relatively few earlier works by his uncle to have remained in Venice, having been retained by Canaletto's patron and agent Joseph Smith in his house on the Grand Canal, the Palazzo Mangilli-Valmarana.[6] Characteristically, Bellotto's versions are larger than the prototypes, and are more thickly painted. The colouration, predominantly in tones of beige and grey with prominent black lines, is already quite distinct from Canaletto's, and the older artist's sunshine has been replaced by more wintry light. The skies are applied largely in diagonal strokes descending to the left, a hallmark of Bellotto's technique. Any urge to criticise the signs of youthful inexperience which are certainly apparent should be overcome by wonder at the confidence with which the painter reinterprets his famous uncle's work in his own manner at such an early stage in his career.

Bellotto went on to cover most of the major Canaletto compositions, whether by choice or to help fulfil commissions received by his uncle. Some 55 Venetian views are now known, and, it should be remembered, a not insignificant number of *capricci* also date from within

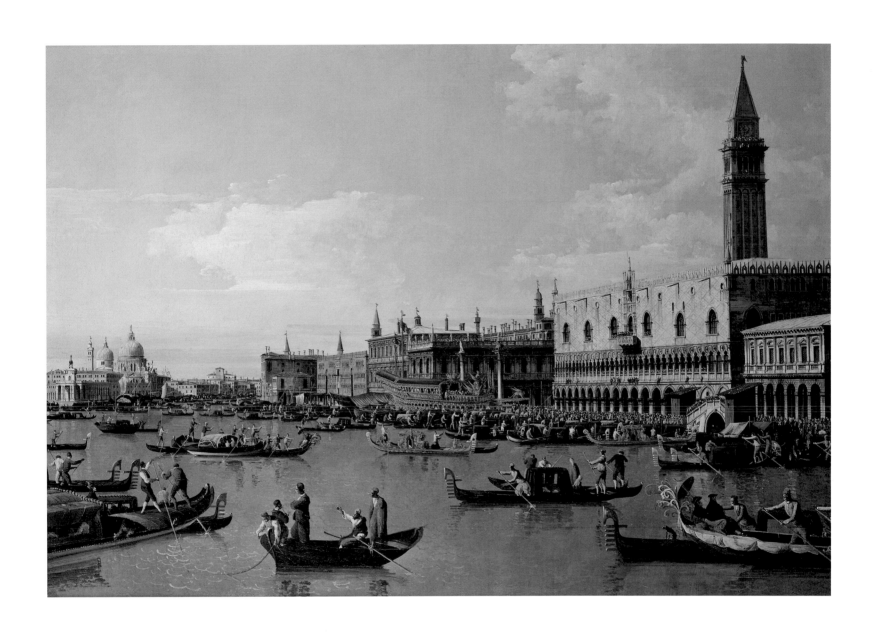

42

Bernardo Bellotto (1722–1780)
The Bacino di San Marco on Ascension Day, about 1739
Oil on canvas, 108 x 152.5 cm
From the Castle Howard Collection

Bellotto's Venetian period, the painter's industry resulting in a rapid honing of his skills. The presence of Henry Howard, 4th Earl of Carlisle, in Venice in November 1738 suggests that Bellotto's work for Castle Howard, consisting of probably no fewer than 15 canvases, three of them of substantial size, began during 1739, if not before the end of 1738; while six were destroyed by fire in the house in 1940,[7] four remain there (see plate 42),[8] two are in the Louvre[9] and three have been identified fairly convincingly with paintings in American private collections.[10] A drawing at Darmstadt of *The Campo Santi Giovanni e Paolo* signed and dated 8 December 1740[11] would seem to indicate that the closely related painting in the Museum of Fine Arts, Springfield, Massachusetts, should be dated to 1741.[12]

Another work datable by circumstantial evidence is *The Grand Canal from the Palazzo Foscari towards Santa Maria della Carità* (Nationalmuseum, Stockholm);[13] this includes, as Kowalczyk has pointed out,[14] a depiction of the figure of the young, handicapped Prince Frederick Christian of Saxony, who arrived supposedly incognito at Palazzo Foscari on 21 December 1739 for a six-month stay, which strongly suggests that the painting should be dated within 1740. This is considerably larger than Canaletto's prototype and is a notable demonstration of Bellotto's tendency to augment as much as possible the impression of monumentality. Perhaps his greatest interpretations of Canaletto compositions are *The Entrance to the Grand Canal and Santa Maria della Salute from the Piazzetta* (plate 43), inspired by his uncle's painting of twenty years earlier which he must have seen in Joseph Smith's collection (plate 8),[15] and *The Campo Santa Maria Formosa* (plate 44), both of about 1742.

In the early 1740s the painter already, occasionally, reveals an ability to create his own compositions, most notably those of *The Scuola di San Marco and the Rio dei*

Mendicanti (Gallerie dell'Accademia, Venice),[16] and *Santa Maria dei Miracoli and the Apse of Santa Maria Nuova* (Niedersächsisches Landesmuseum, Hanover),[17] both of around 1741. The pendants showing *The Arsenale* and *The Piazzetta, looking North* in the National Gallery of Canada, Ottawa (plates 45 and 46) are similarly compositions which were never painted by Canaletto. Despite that, and despite their being characteristic Bellotto masterpieces of about 1743, they were in the collection of Bouchier Cleeve at Foot's Cray Place, Kent, as the work of Canaletto, before the collector's death in 1760.[18] Contemporaries certainly had difficulty differentiating between the hands of the two painters, Pietro Guarienti writing in 1753 of Bellotto's Venetian views that '… those who wish to tell his works from his uncle's need a good deal of discernment'.[19]

Apart from the very early pair bought by James Harris in 1743 referred to above, the only evidence of Bellotto selling work under his own name while in his uncle's studio is a record in the accounts of Johann Matthias von der Schulenburg, whose secretary purchased for him in November 1740 four views, 'two of S. Marco and two of the Arsenal' by 'the nephew of Canaletto'.[20] If this indeed refers to Bernardo – and Pietro Bellotti was only 15 years old at the time – the paltry sum paid, 9 zecchini, tells its own story. By the time of his marriage on 5 November 1741 at the age of 19, Bellotto was housing and supporting his mother, who had been deserted by her husband, as well as his brother Pietro.

From 1742 Bellotto's career in Venice was interrupted – and his repertoire augmented – by visits to other Italian cities; in the spring of 1742 to Rome via Florence and Lucca; in 1744 to Milan, Gazzada and Vaprio d'Adda; in 1745 to Turin. All of these journeys resulted in important groups of views which presumably followed soon after the respective visits, thus helping to chart the fairly rapid

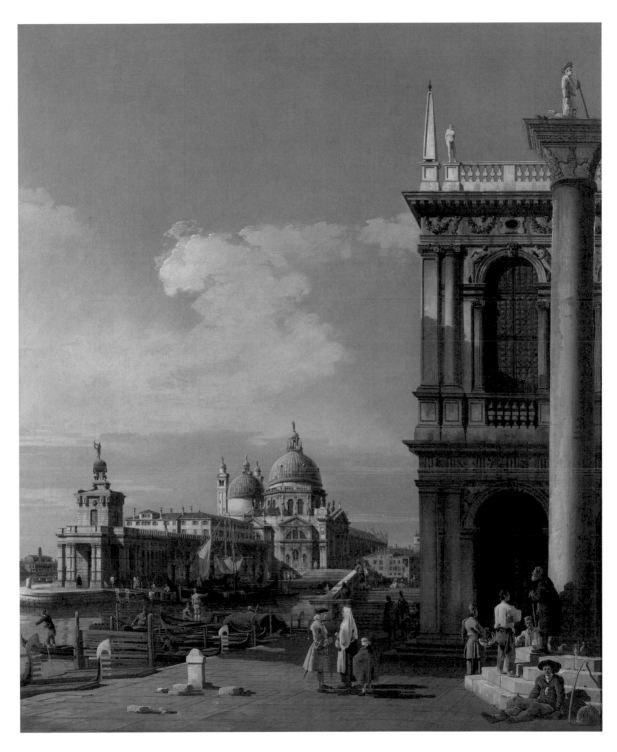

43

Bernardo Bellotto (1722–1780)
The Entrance to the Grand Canal and Santa Maria della Salute from the Piazzetta, about 1742
Oil on canvas, 150 x 122 cm,
Private collection

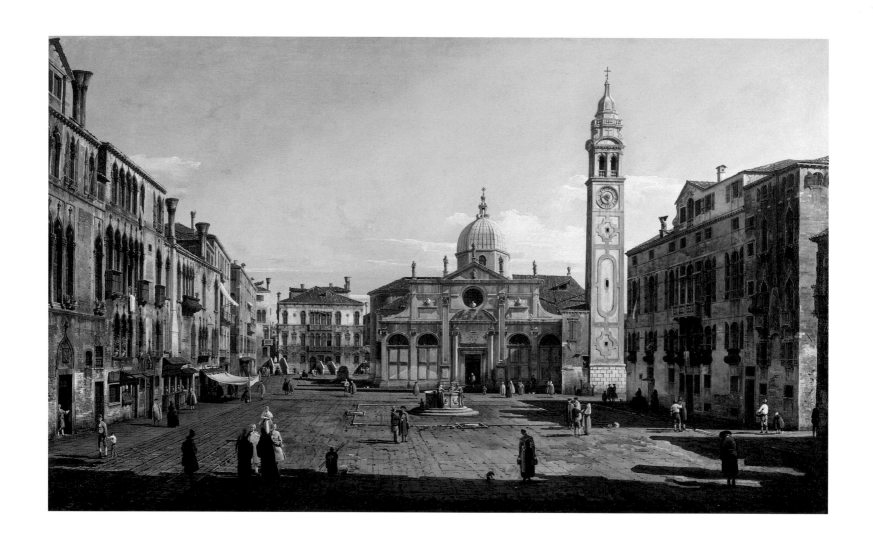

44

Bernardo Bellotto (1722–1780)
The Campo Santa Maria Formosa, about 1742
Oil on canvas, 92 x 150.5 cm
From a private European collection

development of the artist's style. Two of the quite numerous fruits of the Rome visit are known to have been exhibited in Venice on 16 August 1743, one of them almost certainly the view of *Santa Maria in Aracoeli and the Campidoglio* (Petworth House, National Trust).[21] The pair of large views of Turin which remain in the Galleria Sabauda there,[22] painted when Bellotto was 23 years old, show a degree of sophistication that he possibly never surpassed. Also of supreme beauty are the views of Verona at Powis Castle (National Trust) and on loan to the National Gallery of Scotland, Edinburgh, which are in the very large format (more than 132 x 230 cm), which was to become almost standard for the more important of the views he was to produce in Northern Europe.[23]

Bellotto should be considered one of the geniuses of European view painting for the work of his Venetian period alone. This came to an end with his departure for Dresden shortly after 5 April 1747, just before his 25th birthday, never to return. In fact his career had barely begun, as he was to enjoy more than three decades of highly productive employment in the great courts of Northern Europe, where he was to find in plentiful supply the wintry light which he had favoured from the outset.

During his initial eleven years in Dresden (1747–58) Bellotto painted for the Elector, who was also King Frederick Augustus II of Poland, a series of 25 views in the large format, 14 of Dresden itself and 11 of Pirna, which is his crowning achievement. His prodigious output during this period also included a second series of 21 views on the same scale, 13 of Dresden and 8 of Pirna, for the Prime Minister, Count Heinrich Brühl, and five views of the fortress of Königstein. He was thus producing one painting of the large format – and these are real masterpieces – every 12 weeks, alongside other, lesser commitments.

After the outbreak of the Seven Years War Bellotto moved to Vienna in 1759, Munich in 1761 and back to Dresden in 1762, before settling definitively in Warsaw in 1767. In 1770 his son and assistant Lorenzo (born 1742), by whom only one work signed as his work alone is known,[24] predeceased him.[25] A series of 26 views of Warsaw and the nearby palace of Wilanòw, most of which is in the Canaletto Room[26] of the Royal Castle in Warsaw, shows, even at this advanced stage in his career, Bellotto's intensely poetic response to his new surroundings.[27]

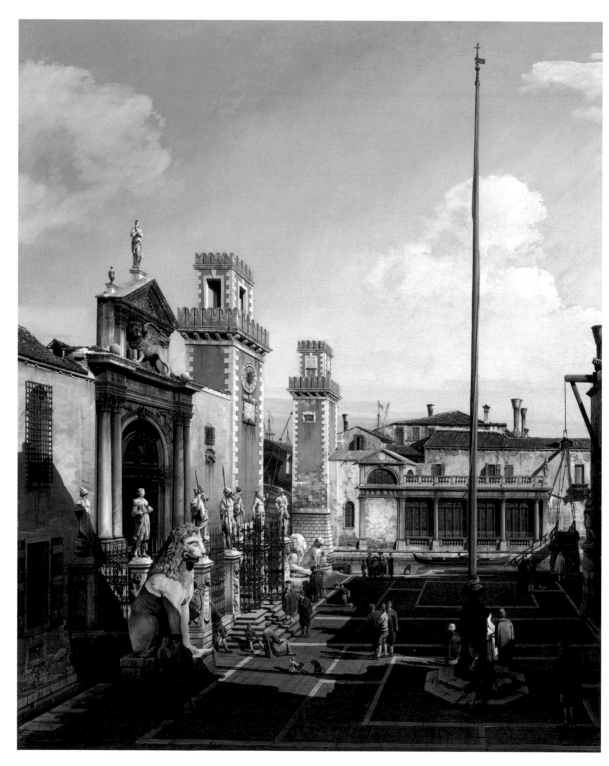

45

Bernardo Bellotto (1722–1780)
The Arsenale, about 1743
Oil on canvas, 151.1 x 121.5 cm
National Gallery of Canada, Ottawa. Purchased 1930 (3719)

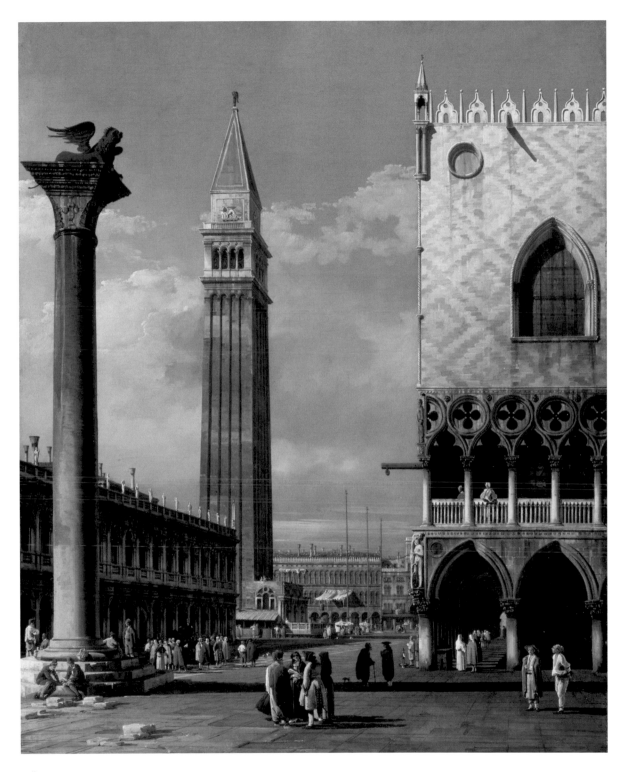

46

Bernardo Bellotto (1722–1780)
The Piazzetta, looking North, about 1743
Oil on canvas, 151.5 x 121.5 cm
National Gallery of Canada, Ottawa. Purchased 1930 (3720)

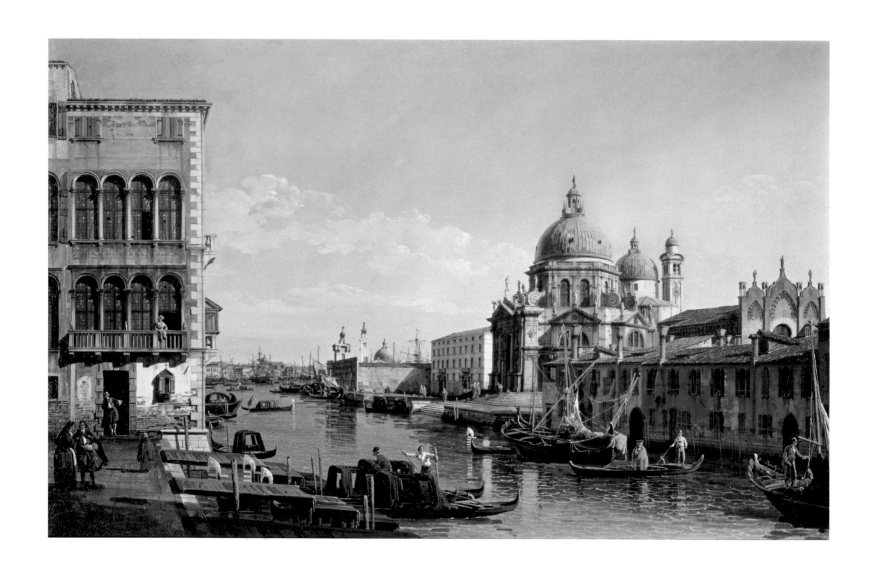

47

Bernardo Bellotto (1722–1780)
The Entrance to the Grand Canal, looking East, with Santa Maria della Salute, about 1743
Oil on canvas, 72 x 96.5 cm
Private collection / care of Richard Green Gallery

48
Bernardo Bellotto (1722–1780)
The Torre di Malghera, about 1744
Oil on canvas, 37.3 x 62.2 cm
Bristol's Museum, Galleries & Archives (K5269)

49

Bernardo Bellotto (1722–1780)
The Campo Santi Giovanni e Paolo, about 1745
Oil on canvas, 70.8 x 111 cm
National Gallery of Art, Washington. Widener Collection (1942.9.7)
Washington only

Pietro Bellotti

(Venice 1725 – France about 1800)

Of all the Venetian view painters of the eighteenth century whose reputations waned in the intervening centuries, Bellotti was forgotten the most completely and the longest. This is due above all to his having spent most of his career in the French provinces, working predominantly for a local clientele. His origins were as distinguished as any, as the nephew of Canaletto and younger brother of Bernardo Bellotto.[1] Furthermore, Pietro is the only known pupil of his elder brother during the latter's years in Venice, undertaking on 5 November 1741 to pay Bernardo 120 ducats a year for board and training, an arrangement which was terminated on 25 July 1742. Pietro would presumably have been an assistant in Canaletto's studio for several years before the date of these documents. The possibility that he accompanied his brother to Rome in the first half of 1742 is raised by the presence of his name on the back of one of Bernardo's drawings of Lucca in the British Museum.[2] He must have emigrated to France by 1748, since on 24 March 1749 the baptism took place in Toulouse of his first child by a French woman, whom he married the following day.

Several documents show that even soon after his arrival in France Bellotti was not averse to travel. In 1755 he applied for permission to practice his art in Nantes, where he is again mentioned in 1768. He was in Besançon in 1761 and Lille in 1778–9. Of particular interest is a handbill issued in Paris in 1754/5 with the following advertisement:

THE PLEASURES OF THE COURT: OR AN UNRIVALLED SPECTACLE. NOTICE FOR THE LOVERS OF FINE ARTS. Architectural and perspective painting which attains the highest degree of perfection. Signor CANALETTO, a Venetian painter, invites all those interested in the fine arts and painting to come to view his unrivalled spectacle, composed of the finest views in Europe, such as Venice, Rome, Florence, Milan, Turin, London, Versailles, Strasbourg, several sea ports and other examples of ancient and modern architecture, all painted in oils and of natural size, having seen and depicted them from nature on location, having made them realistic through the lightness and delicacy of his paintbrush, and having acquired a reputation everywhere he passes through. His intention was to show them only to those in the art world and connoisseurs, in order to gain their esteem and advice, but these art-lovers, realising the pleasure that all this might give to townspeople, persuaded him to display them to the public.

Signor CANALETTO hereby gives notice to those who are inspired to see his work, which will surely please them by the beauty, choice and variety of the subjects, that he will exhibit it at any time at the Foire, in Widow BERNARD's shop, entrance through the Porte de Tournon.

This exhibition has been seen by his Majesty, Monsieur le Dauphin, Madame la Dauphine and all the court, with great success and applause.

It can be conveyed to the houses of those who do him the honour of contacting him.

Signor Canaletto teaches drawing.

The price is 24 sous per person[3]

First republished in 1988,[4] this document was introduced into the Canaletto literature in the following year by J.G. Links, who was disinclined to accept it as referring to either Canaletto or to Bellotto.[5] The range of subject

matter is alone sufficient to identify this 'Canalety' as none other than Bellotti, as Giorgio Marini first suggested,[6] and Anne and Udolpho van de Sandt endorsed in their pioneering article on the painter.[7] A similar range is shown in the titles of his paintings exhibited at the Académie Royale in Toulouse at irregular intervals between 1755 and 1790, all lent by local collectors, and a set of no fewer than 17 small canvases is still in the collection of the marquis de Beaumont at the Château de Merville, near Toulouse, the majority with eighteenth-century inscriptions on the reverse identifying the artist as 'Bellotti'.[8]

As in the fairly scarce signatures on his paintings,[9] Pietro shows as little reticence as his brother in making full use of their uncle's name and fame, and his assertion that he had visited all the cities depicted is almost certainly far-fetched, as the majority of his known views can be readily identified as following graphic sources. Bellotti's claim to have travelled to London does, however, raise the possibility that he may have visited his uncle during his years there, and he was almost certainly in England at some point in the mid-1760s, since two particularly fine views of *Warwick Castle* [10] and *The Courtyard of the Royal Exchange, London*[11] do not seem to follow prints. The handbill was not the only occasion when Bellotti claimed to have attracted the interest of the French royal family, as one of two pendant *capricci* in the Mauritshuis is signed and inscribed 'BELLOTTI DIT CANALETI VENITIEN PEINTRE ROIAL'.[12]

Bellotti is last recorded with certainty in Toulouse in 1776. His final decades are swathed in obscurity until in 1805 the first curator of the Musée des Augustins in Toulouse, who had known him, stated that he had 'died a short time ago in France'.

50

Pietro Bellotti (1725–about 1800)
The Entrance to the Grand Canal, looking East, with Santa Maria della Salute, about 1743–4
Oil on canvas, 56.5 x 84 cm
Private collection, Canada

Francesco Tironi

(active in Venice in the last quarter of the eighteenth century)

As Lino Moretti has recently pointed out,[1] all that we know for certain about the life of Tironi is that in 1806 he had 'died too young a few years ago'.[2] He has been identified with a priest of that name who died on 28 February 1797 at the age of about 52, but that was hardly 'young' by Venetian standards of the day, and further evidence that this priest was also an artist is lacking. Another candidate is a Francesco Spiridione Tironi (1757–91), but his stated business was running a shop which sold account books and white paper.

Work by Tironi is rather more abundant. A set of engravings by Antonio Sandi (1733–1817) entitled *Twenty-Four Views of Islands in the Venetian Lagoon*, published in Venice at some point after 1779, follows drawings by Tironi, many of which survive.[3] These permit the attribution to him of a body of other drawings executed in the same distinctive and delicate style, and similarly of compositions of the artist's own invention.[4] Attributions of paintings have in the past proved more complicated, Hermann Voss crediting him in publications of 1928 and 1966 with some of the early views by Francesco Guardi,[5] while in more recent decades he has sometimes been identified as the author of work by the rather older 'Master of the Langmatt Foundation Views'.[6] The drawings provide some assistance in the attribution of paintings,[7] however, as do a few works signed with the initials 'F T', notably *San Cristoforo, San Michele and Murano from the Sacca della Misericordia* (plate 51). A pair showing *The Isola di San Giorgio Maggiore* and *The Molo looking West*, which surfaced recently on the market, are both signed with initials,[8] and correspond precisely with descriptions of a pair offered for sale in Venice in 1785, the earliest known reference to paintings by Tironi.[9]

From these secure works a significant group of paintings in the same distinctive style can be established, including views of Dolo[10] and of the Palazzo Recanati-Zucconi-Vendramin on the Brenta Canal,[11] and a *capriccio* of the Doge's Palace and other prominent Venetian buildings set on a canal.[12] Although certainly not of the first rank, Tironi is an original and interesting figure. While his drawing style and compositional structure recall Canaletto's methods to the point that one wonders if he might have worked in Canaletto's studio, his mannered figures are closer to Francesco Guardi's mature types. His palette, dominated by greens and browns and sombre often almost to the point of monochromy, finds parallels in much of the late work of both painters. The group of paintings currently given to Tironi, while not approaching the size of that attributed to the 'Langmatt Master', is too large and varied in quality to be the work of a single hand, and is in urgent need of better definition.[13]

51

Francesco Tironi (active about 1745–1797)
San Cristoforo, San Michele and Murano from the Sacca della Misericordia, about 1775?

Oil on canvas, 56.5 x 102 cm
Staatliche Kunsthalle, Karlsruhe (425)

Francesco Guardi
(Venice 1712–1793)

Originally from the Val di Sole in the Trentino near the Swiss and Austrian borders, the Guardi family had been granted a patent of nobility in 1643.[1] Francesco's father Domenico (1678–1716) trained as a painter in Vienna, remaining there until around 1700 when he moved to Venice. Almost nothing is known of Domenico's work and he died when Francesco was a child. A far more significant influence on Francesco was his elder brother Giovanni Antonio (1699–1760), who presumably took over his father's studio in 1716. (Giovanni) Antonio was a highly gifted and original figure painter on a very wide range of scale. From 1729 until 1747 he was part of the retinue of Johann Matthias von der Schulenburg and resident with him at Palazzo Loredan dell'Ambasciatore on the Grand Canal, executing portraits and copies of works by other artists, including most of a series of 43 Turkish scenes after Jean-Baptiste van Mour. This salaried employment was not, however, exclusive and during this period Antonio also, for instance, provided the figures in a number of Venetian views by Michele Marieschi. Among the brothers' siblings were a sister Cecilia, who married in 1719 Venice's greatest figure painter Giambattista Tiepolo (1696–1770), and a brother Nicolò (1715–86), who was also a painter and may have been responsible for some of the Venetian views traditionally given to Francesco, but by whom not a single certain work is known.

Domenico Guardi was intimately associated with the very rich Giovanelli brothers of Noventa Padovana by 1702, and it was they who commissioned his only certain work, a *San Zeno* of 1716 in the parish church of Valtrighe.[2] Montecuccoli degli Erri has established that

Antonio took over his father's role of executing copies for the Giovanelli and remained in their employment until his adoption by Schulenburg in 1729.[3] The will of Giovanni Benedetto Giovanelli of 1731, which mentions copies 'by the Guardi brothers', is the earliest mention of work by Francesco, and suggests that he had, in turn, replaced Antonio in the brothers' employment in 1729, when he was 17 years old.[4] These observations of Montecuccoli degli Erri are particularly significant, as they establish that Francesco would have become very familiar in his formative years with the collection of paintings at the Villa Giovanelli, which included Carlevarijs's spectacular *Allegories of Peace and War*,[5] and Canaletto's magnificent pair of *capricci*, of 1723.[6] Francesco was, however, to remain in the family business of figure painting and executing copies for nearly three decades.

Of the few figure paintings certainly by Francesco, most are datable to the later decades of his career. These include *A Miracle of Saint Hyacinth* (Kunsthistorisches Museum, Vienna),[7] probably of the mid-1760s, and an altarpiece of *Saints Peter and Paul with the Trinity* (Parish Church, Roncegno),[8] which must be of about 1782. *A Bishop Saint in Ecstasy* (Museo Provinciale, Trent)[9] is signed on the reverse, and one of two large panels of personifications of *Abundance* and *Hope* (John and Mable Ringling Museum of Art, Sarasota)[10] was formerly signed. Discussion continues over the attribution of other figure paintings. *The Madonna of the Seven Sorrows with Saints* and *The Trinity with Saints* (Gemäldegalerie der Akademie der Bildenden Künste, Vienna), which were given by Morassi to Antonio, are now considered

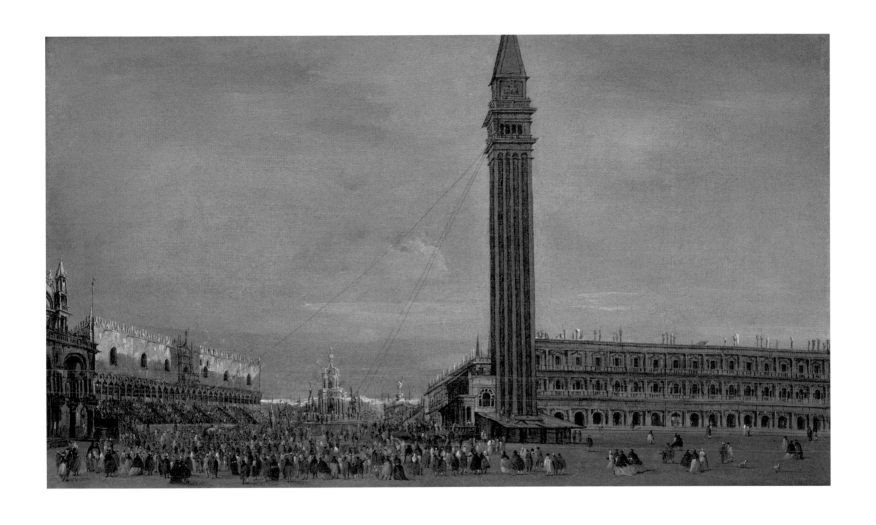

52

Francesco Guardi (1712–1793)
The Festival of Giovedì Grasso in the Piazzetta, 1758
Oil on canvas, 32 x 54 cm
From the collection of Ann and Gordon Getty
Washington only

to be Francesco's.[11] It is generally felt, however, that Francesco was distinctly less able as a figure painter than his brother.

It seems likely that Francesco Guardi was first tempted to try his hand at view painting before Canaletto's return from England in 1755, executing copies of engravings by and after Canaletto. Copying was, after all, his normal *modus operandi*, although from the start his views are distinguished by his own highly individual colouring. His marriage in 1757, followed by increasing responsibilities (two sons who survived beyond infancy were born in 1760 and 1764), may well have encouraged him in this new direction, before the death of his brother Antonio in 1760. His first – and indeed, only – dated painting is of 1758, a depiction of *The Festival of Giovedì Grasso in the Piazzetta*, of which a close version must be of similar date (plate 52). The dated version and *The Giudecca Canal and the Zattere* (plate 53) were both owned, along with three other paintings, by Sir Brook Bridges, who is recorded in Padua in June 1757.[12] Eight other paintings in Guardi's first style as a view painter must have been acquired by John Montagu, Lord Brudenell, the great patron of Antonio Joli,[13] who was in Venice by 21 September 1758, and left on 24 February 1760.[14] Evidence provided by such details of Grand Tours is particularly useful in establishing Guardi's chronology, as, although he was prolific both as a painter of *capricci* and views, the variety of his manners of painting makes his work difficult to date with any precision. Where the circumstances of patronage are unknown and the paintings do not depict specific events, dating may often depend on the costumes of the sprightly figures.

The reference to Francesco of 1764 in Gradenigo's *Notatori*[15] has given rise to much discussion, not least because of his description of the painter as a 'good pupil of the renowned Canaletto'. More surprising is his statement that Guardi owed his success to the camera obscura, since of all the Venetian view painters who have been accused of relying on mechanical aids, he can surely have benefited from their use the least. At this stage in his development, however, the predominant interest in atmosphere which characterises his later production was yet to overtake a concern for the structure of the man-made element in his views. One of the two paintings which Gradenigo mentions as exhibited on the Procuratie Nuove in the Piazza San Marco in April 1764 has been thought to be one of the pair of large views of the Rialto in an English private collection, *The Rialto Bridge from the North and the Palazzo dei Camerlenghi* (plate 56). As Francis Russell has pointed out, however, those must have been acquired by Chaloner Arcedeckne, who arrived in Venice on 20 August 1768, which should thus be considered a *terminus post quem*.

Probably of around 1776–8 is the celebrated set of 12 depictions of ceremonies involving the Doge,[16] based on prints by Brustolon, probably published in the early 1770s,[17] after drawings by Canaletto.[18] These herald the half-decade when Guardi was at the very height of his powers (see plates 57–63). *The Piazza San Marco during the Feast of the Ascension* (plate 59) and *A Regatta on the Grand Canal* (plate 60) are from a set of four which is datable in or after 1777, since the first painting shows the stalls in the form first used on Ascension Day in that year.[19] In January 1782 Venice was visited by the 'Conti del Nord', the Grand Duke Paul and Duchess Maria Feodorovna (later Tsar and Tsarina of Russia), which inspired a series of six representations of the festivities,[20] of which *The Concert of Girl Musicians in the Sala dei Filarmonici* is particularly delightful.[21] In May of the same year the painter was commissioned by Pietro Edwards, Inspector of Fine Arts of the Venetian Republic, to execute four views recording the visit to Venice of Pope

Pius VI, for which he received in all 48 zecchini. Two complete sets are known, and additional versions of *The Campo Santi Giovanni e Paolo with the Temporary Tribune erected for the Benediction of Pope Pius VI*.[22] Guardi was finally elected to the Venetian Accademia in 1784, 28 years after his brother Antonio. A fire which broke out in the oil depot near San Marcuola on 28 November 1789 inspired a highly atmospheric view (Alte Pinakothek, Munich) which demonstrates that he was still able to produce a masterpiece at the age of nearly 80.[23]

Guardi's son Giacomo (1764–1835) was very much his disciple, and discerning his work from his father's less inspired products is often very difficult. Giacomo perpetuated Francesco's style well into the nineteenth century.

53

Francesco Guardi (1712–1793)
The Giudecca Canal and the Zattere, about 1758
Oil on canvas, 72.2 x 119.3 cm
Carmen Thyssen-Bornemisza Collection, on loan to the Museo Thyssen-Bornemisza, Madrid (CTB.1995.1)

54

Francesco Guardi (1712–1793)

The Lagoon towards Murano from the Fondamenta Nuove, about 1762–5

Oil on canvas, 31.7 x 52.7 cm

The Fitzwilliam Museum, Cambridge (NO.0189)

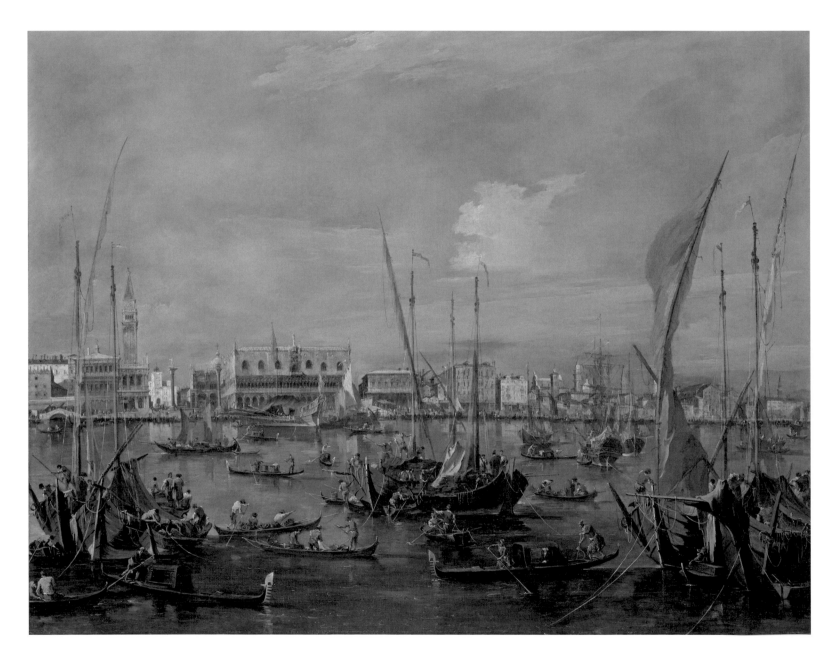

55

Francesco Guardi (1712–1793)
The Molo and the Riva degli Schiavoni from the Bacino di San Marco, about 1765–7
Oil on canvas, 121.9 x 152.4 cm
The Metropolitan Museum of Art, New York. Bequest of Adele L. Lehman, in memory of Arthur Lehman, 1965 (65.181.8)

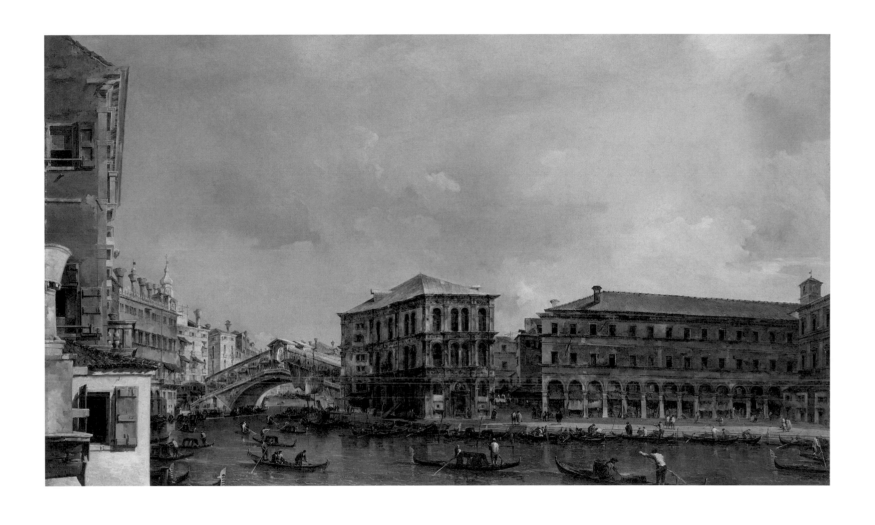

56

Francesco Guardi (1712–1793)
The Rialto Bridge from the North and the Palazzo dei Camerlenghi, about 1768–9
Oil on canvas, 116 x 199.5 cm
Private collection

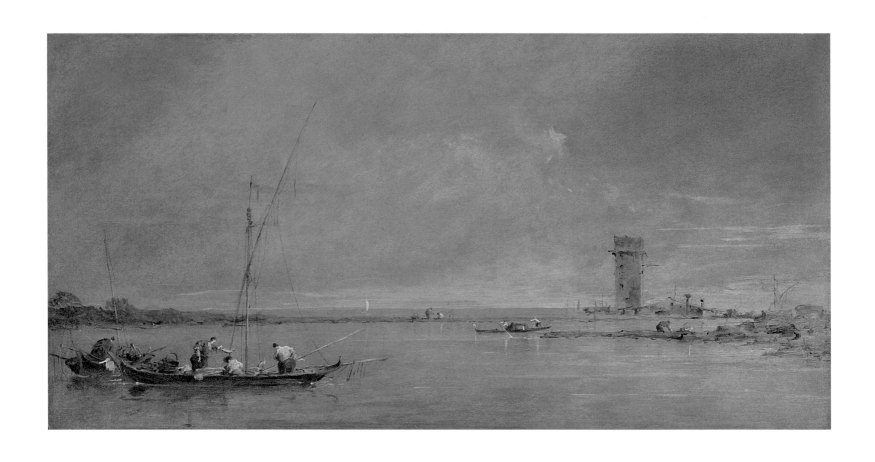

57

Francesco Guardi (1712–1793)
The Lagoon with the Torre di Malghera, probably 1770s
Oil on panel, 21.3 x 41.3 cm
The National Gallery, London. Salting Bequest, 1910 (NG2524)
London only

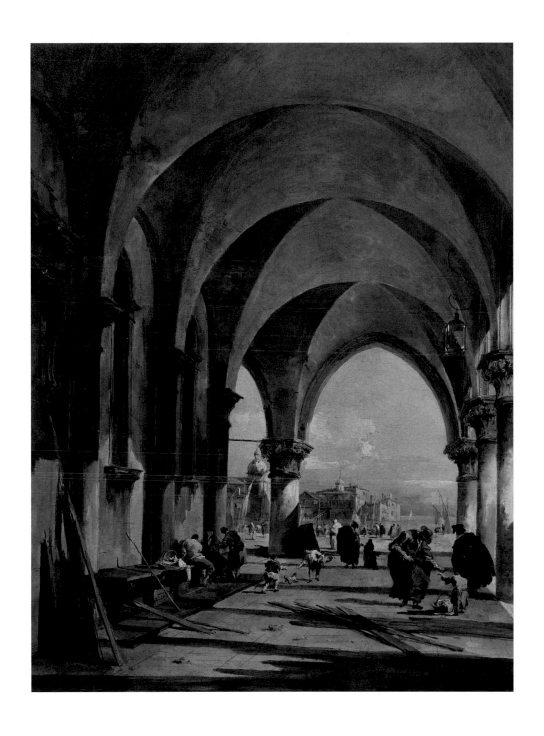

58

Francesco Guardi (1712–1793)
San Giorgio Maggiore from the Arcade of the Doge's Palace, about 1775–8
Oil on canvas, 49.5 × 36.2 cm
Private collection
London only

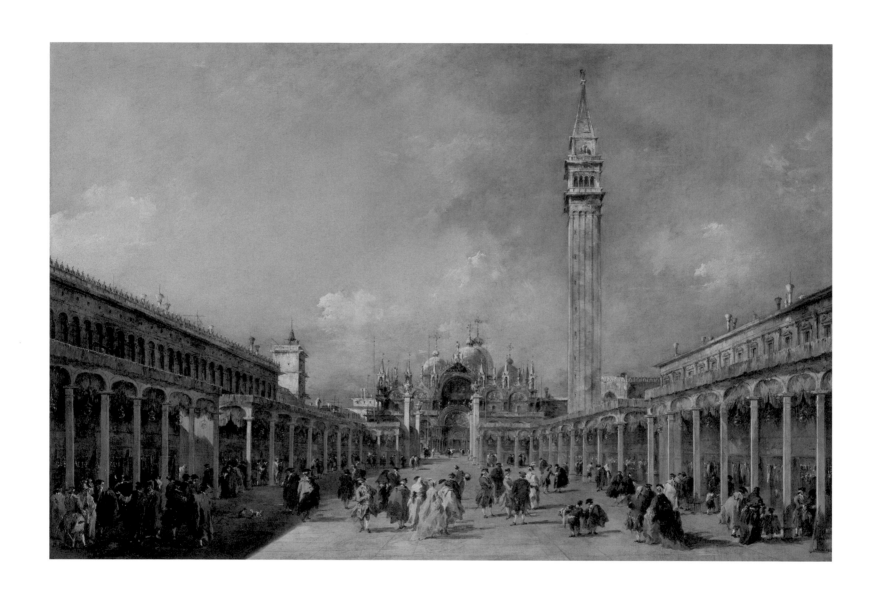

59

Francesco Guardi (1712–1793)
The Piazza San Marco during the Feast of the Ascension, about 1777
Oil on canvas, 61 x 91 cm
Calouste Gulbenkian Museum, Lisbon (390)

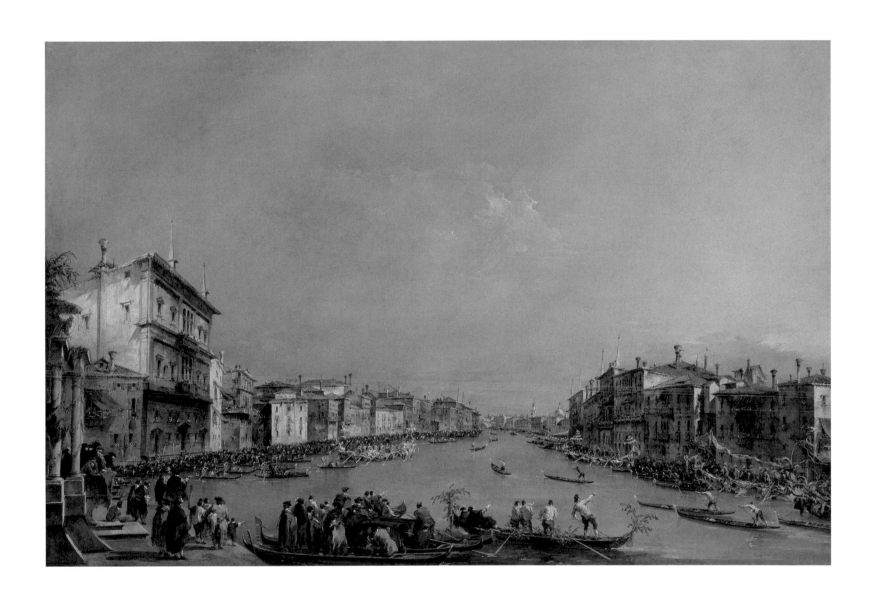

60

Francesco Guardi (1712–1793)
A Regatta on the Grand Canal, about 1777
Oil on canvas, 61 x 91 cm
Calouste Gulbenkian Museum, Lisbon (391)

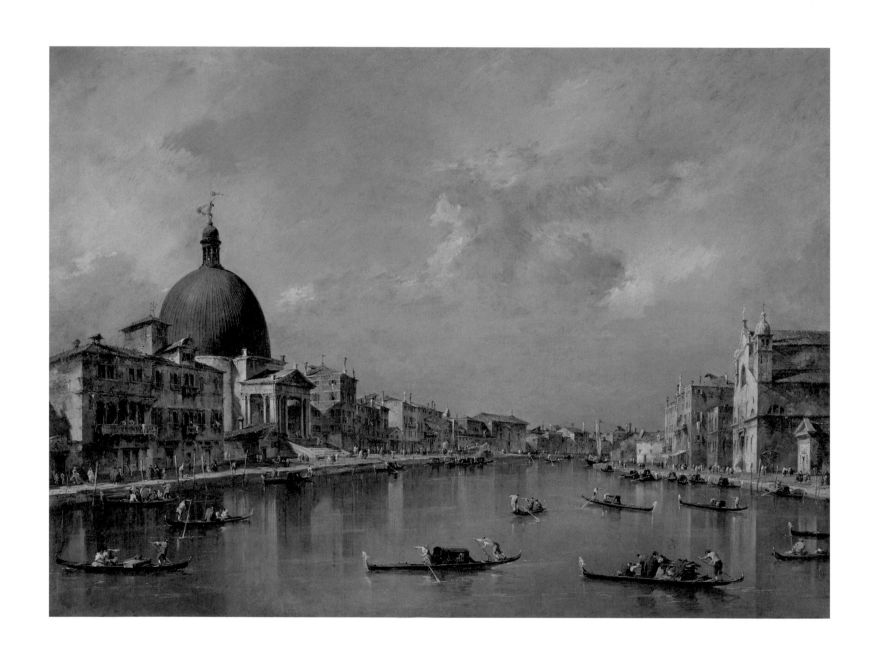

61

Francesco Guardi (1712–1793)
The Grand Canal with San Simeone Piccolo and Santa Lucia, about 1780
Oil on canvas, 67.3 x 91.5 cm
Philadelphia Museum of Art, PA. The John G. Johnson Collection, 1917 (303)

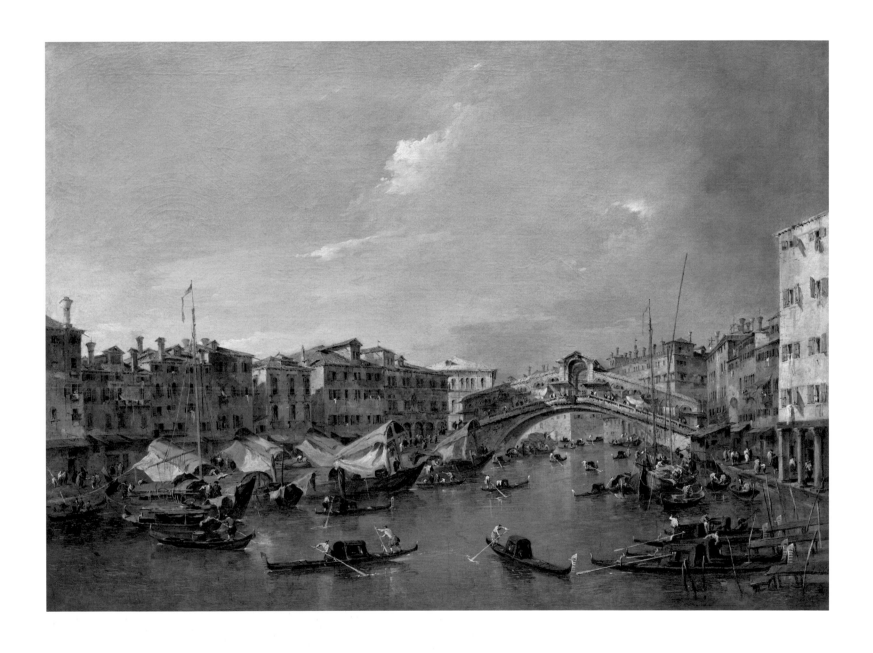

62

Francesco Guardi (1712–1793)
The Grand Canal with the Rialto Bridge from the South, about 1780
Oil on canvas, 68.5 x 91.5 cm
National Gallery of Art, Washington. Widener Collection (1942.9.27)

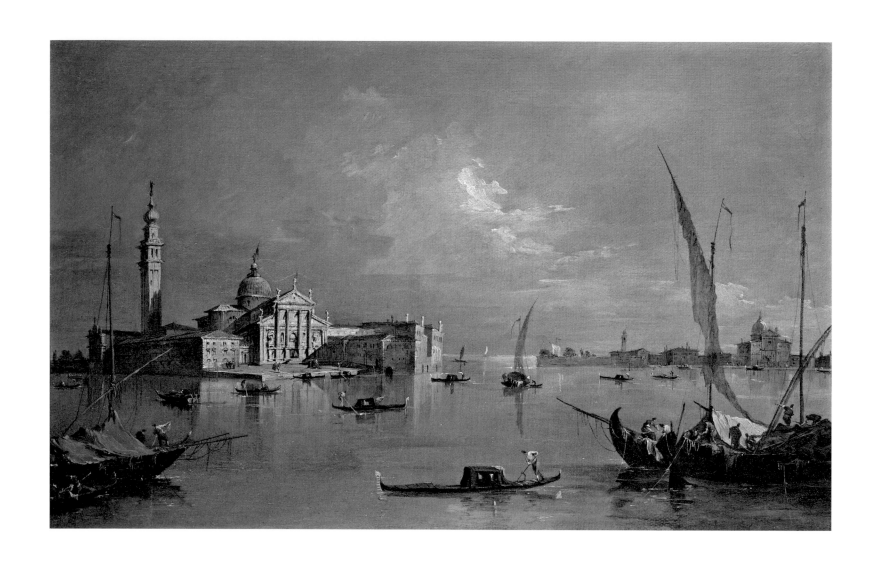

63

Francesco Guardi (1712–1793)
San Giorgio Maggiore and the Giudecca, about 1780
Oil on canvas, 33 x 51.5 cm
Private collection, courtesy of Simon C. Dickinson Ltd

64

Francesco Guardi (1712–1793)
The Isola della Madonetta in the Lagoon, about 1780–90
Oil on canvas, 35.6 x 55.2 cm
Harvard Art Museum, Fogg Art Museum, Cambridge, MA. Gift of Charles E. Dunlap (1959.185)

NOTES

Gaspare Vanvitelli

1 Notable among these is his immense *Panoramic View of Amersfoort* of 1671 (Amersfoort Town Hall).
2 Briganti 1996, pp. 424–7.
3 Briganti 1996, illus. p. 53.
4 Briganti 1996, p. 132, no. 1, illus.
5 Many of these remain in the Colonna collection.
6 Vanvitelli was certainly in Bologna on 10 December 1694, when he inscribed and dated a drawing there (Briganti 1996, no. D 345; Rome and Venice 2002–3, no. D 14).
7 Briganti 1996, nos D 103, 112, 337, 339–41 and 343 (for four of which see also Rome and Venice 2002–3, nos D 15–18).
8 The latest dated painting is of 1722, see San Diego 2001, pp. 12–13, fig. 10.
9 The next dated examples are of 1706 (Briganti 1996, nos 288 and 309).
10 Briganti 1996, nos 285–6; Rome and Venice 2002–3, no. 59, illus. in colour (the illustration in the Venice edition is far superior). Even these include a glimpse of the Bacino in the background, so that Vanvitelli seems never to have executed a painting of Venice which does not show water.
11 Briganti 1996, nos 293, 301.
12 See p. 16.
13 For the similarities between Vanvitelli's composition of *The Piazza San Marco looking South* and an early work by Canaletto, see p. 22. To that may be tentatively added the composition of Canaletto's view of *The Entrance to the Grand Canal, looking West* (plate 14), which is anticipated by no fewer than four of Vanvitelli's surviving drawings (Briganti 1996, nos D 112, 337, 341 and 343), and the resemblance between a very early Roman drawing by Canaletto of *The Pyramid of Cestius and the Porta San Paolo* (Constable 1962, I, pl. 131; II, no. 713[230]) and one of the same subject by Vanvitelli (Briganti 1996, pp. 334–5, no. D 134).

Luca Carlevarijs

1 'non ha avuto positivo maestro, ma ha studiato or qua or là' (Orlandi 1704, p. 226).
2 *Joseph sold by his Brethren* and *Moses striking the Rock*, see Rizzi 1967, p. 95, pls 9, 10; Padua 1994, nos 15, 16. These are the only known paintings by the artist with religious subjects.
3 Rizzi 1967, p. 95, pls 11–16; Padua 1994, nos 14–16. The Zenobio were said to be the richest family in the city. These landscapes were evidently painted for Carlevarijs's neighbour Conte Pietro Zenobio, who was a witness at the painter's marriage in 1699 and godfather to his first child, born in 1700. The patron and painter must have had a close relationship, as Carlevarijs came to be nicknamed 'Luca da Ca' Zenobio'.
4 Coronelli 1700.
5 It should be noted also that painting and engraving were by no means Carlevarijs's only interests. He was consulted about architectural projects at Conegliano in 1712 and Udine in 1714. In a portrait of him by Bartolomeo Nazzari (Ashmolean Museum, Oxford), he is shown with a globe and dividers, and in the caption to an engraving after it of 1724 he is described as an able mathematician (illus. Rizzi 1967, p. 15, and Padua 1994, pp. 14, 301).
6 With Galleria Cesare Lampronti, Rome, *Cento Capolavori di Pittura dal XVI al XVIII Secolo*, 22 October – 22 November 2009, nos 84–5.
7 Delneri 1999, pp. 191–6.
8 Padua 1994, no. 26.
9 Padua 1994, no. 36; Treviso 2008–9, no. 10.
10 Padua 1994, no. 66; Treviso 2008–9, no. 17.
11 Treviso 2008–9, no. 11.

12 Kragelund 2009, p. 3.
13 San Diego 2001, nos 3–6; Treviso 2008–9, nos 14–15. Almost certainly painted for Edward Leigh, 3rd Baron Leigh of Stoneleigh, this is the only set of four views by Carlevarijs to have remained together.
14 For *The Molo, looking West*, sold at Sotheby's, London, 7 July 2005, lot 46, and now in a Swiss private collection, see San Diego 2001, no. 9. The two other paintings were sold at Christie's, London, 26 November 1971, lots 73–4 (San Diego 2001, figs 22–3); for *The Molo from the Bacino di San Marco*, see Padua 1994, no. 64.
15 A pair of views of the Molo, looking east and west, sold at Christie's, London, 3 December 1997, lot 84, and since in a private collection (San Diego 2001, figs 19–20, and a larger view of *The Molo, looking West* in a private collection (San Diego 2001, no. 7).
16 Padua 1994, no. 65; Treviso 2008–9, no. 16.
17 Two, views of *The Piazza San Marco, looking East* and *The Rialto Bridge from the North* (one of only two views of the bridge by the artist) were sold at Christie's, London, 10 December 2003, lot 116; *The Molo, looking West* is in the Seattle Art Museum, and *The Piazzetta from the Waterfront*, de-accessioned by the Los Angeles County Museum of Art at Sotheby's, New York, 17 January 1986, lot 26, is now in an English private collection (San Diego 2001, fig. 25).
18 He may well have foreseen this when he made a will on 26 May 1727.

Johan Richter

1 Pallucchini 1995–6, p. 193, figs 298–9. It is frequently stated that Richter is recorded in Venice in or around 1710, without evidence for this being offered.
2 'quadretti ... fatti con tutto amore ... professando particular propensione alla sua compiutezza' and 'il genio suo'; Bottari and Ticozzi 1822, pp. 124–5.
3 None of the Venetian views given to Bernardo Canal (Venice 1664?–1744) has been established as of such early date.
4 'Disegno compagno, fatto a penna e acquerello con veduta di Venezia, e quantità di figurette, di mano di monsieur Gio. Richter, svezzese, scolare di Luca Carlevarijs' ('Identical drawing, in pen and watercolour, with a view of Venice, and a profusion of small figures, by the hand of M. Gio. Richter, Swedish, a pupil of Luca Carlevarijs'), (Campori 1870, p. 527).
5 Vertue 1934 edn, p. 64.
6 This is not the pair in the Nationalmuseum, Stockholm, which was owned by the Queen Consort of Sweden Lovisa Ulrika (1720–82).
7 I. Reale, 'Gio. Richter, svezzese, scolare di Luca Carlevarijs', in Padua 1994, p. 115, fig. 3; Berlin 2002–3, no. 17, pp. 110–12, 127. The other was destroyed during the Second World War but is known from a copy. For Streit, see p. 46.
8 Martini 1994, pp. 230, 232, note 8, figs 5–6.
9 For illustrations of seven of these, see I. Reale in Padua 1994, pp. 119, 121–3, figs 6–8, 12–15.
10 Martini 1994, p. 230, fig. 10.
11 A pair of views of the Piazza San Marco in the John and Mable Ringling Museum of Art, Sarasota, Florida, was included in the recent exhibition Sarasota and Memphis 2009–10, pp. 70–5, nos 7–8, as by Carlevarijs, despite having been published as the work of Richter (I. Reale in Padua 1994, p. 116, fig. 2, and p. 126), and the fact that one of the views is a close variant of one of the Sirén pair (ibid., fig. 1).
12 Fiocco 1932, pp. 3–15.
13 Richter's propensity for female staffage was such that in one instance a later owner felt it preferable to have two of the four girls in the foreground overpainted as men (Constable 1962, I, pl. 10b).
14 They are often strikingly similar in character to those (on a much larger

scale) of the figure painter Giovanni Antonio Pellegrini (Venice 1675–1741).

15 C.C. Cunningham expressed his belief in Richter's authorship of the painting in a letter of 15 October 1948 in the painting file at the Wadsworth Atheneum, but the attribution to Carlevarijs was retained in Amsterdam 1990–1, pp. 122–3, no. 15, and it is proposed as a (unique) work of collaboration between the two painters in Pallucchini 1995–6, pp.189, 194, pls 295, 297.

16 Rizzi 1967, p. 88: '*costituisce uno dei più alti raggiungimenti del Carlevarijs*'.

17 See p. 171 below.

18 Sotheby's, New York, 22 January 2004, lot 67; private collection, Crema (I. Reale in Padua 1994, p. 125, fig. 19); and Bonhams, London, 11 December 2002, lot 311, subsequently with Maison d'Art, Monte Carlo (showing the construction of the bridge barely begun).

19 The campanile with the onion-shaped cap fell in 1774 and was replaced with one of pyramid shape in 1775–91.

20 One of Canal's paintings after a Richter composition engraved by Vogel was included in the exhibition Amsterdam 1990–1, p. 124, no. 16, as the work of Richter.

Canaletto

1 The artist called himself most often 'Antonio Canal', but several variations are known, including 'Antonio da Canal', 'Antonio Canal il Canaleto' and 'Antonio Canaleto'. The use of the diminutive was presumably to differentiate him from his father.

2 His brother Cristoforo is last recorded in 1722. His eldest sister was to be the mother of Bernardo Bellotto (q.v.). The other two never married.

3 Bernardo Canal's birth date is usually given as 1664, although his *atto di morto* gives his age as 70 in 1744. Venice 2001, p. 38, states that he was born in 1675.

4 This is one of a series of 23 drawings of Rome, 22 of them in the British Museum and one (with a provenance from the painter's great-nieces) at Darmstadt, all apparently signed (all under Constable 1962, no. 713; the date on *The Arch of Constantine* was first published by Hugo Chapman in Venice 2001, no. 3).

5 His profession is given simply as 'painter' in documents of 1696 and 1697.

6 See, for instance, Venice 2001, nos 28–33.

7 Their companions are *The Grand Canal, looking North-East from the Palazzo Balbi* (Museo del Settecento Veneziano, Ca' Rezzonico, Venice; Constable 1962, no. 210; Venice 2001, no. 50), and *The Grand Canal from the Campo San Vio* (Museo Thyssen-Bornemisza, Madrid; Constable 1962, no. 182; Venice 2001, no. 51).

8 Constable 1976, nos 479** and 479***; Rome 2005, nos 4–5.

9 The others are Constable 1962, nos 12, 32, 33, 55 and 63.

10 Kowalczyk 1998, pp. 73–8.

11 Pinacoteca Gianni e Marella Agnelli, Turin; New York 1989–90, nos 8–11; Venice 2001, nos 62–5.

12 All were included in New York 1989–90, nos 14–22.

13 McSwiny wrote of the painter on 28 November 1727: 'The fellow is whimsical and vary's his prices every day; and he that has a mind to have any of his work, must not seem to be too fond of it, for he'l be ye worse treated for it, both in the price and the painting too. He has more work than he can doe, in any reasonable time, and well; but by the assistance of a particular friend of his, I get once in two months a piece sketch'd out and a little after finished, by force of bribery' (letter to the Duke of Richmond, West Sussex Records Office, Chichester).

14 Smith may well have also acted as intermediary in the purchase by George Proctor of Langley Park, Norfolk, of two pairs of views, a large pair now split between Memphis and El Paso (Constable 1962, nos 187 and 88; Sarasota and Memphis 2009–10, nos 20–1) and a smaller pair in a private collection (Constable 1962, nos 106 and 190). Proctor made a

large payment to Smith in August 1730 (see Sarasota and Memphis 2009–10, p. 30, note 12), but this would seem to be rather late to include the larger pair and is certainly too early for the smaller.

15 For the pendant, also at Houston, see Constable 1962, no. 220; New York 1989–90, no. 36; Venice 2001, no. 75.

16 Tatton Park (National Trust); Constable 1962, nos 111 and 97; New York 1989–90, nos 33–4; Rome 2005, nos 15–16.

17 Several of the components of this series are difficult to date with precision, some because of condition issues, others because Smith subsequently took the very unusual step of asking Canaletto to repaint the skies in a more mature style and to update certain details. All were included in London and Edinburgh 2005–7, nos 1–14.

18 The frontispiece also provides the only known likeness of Canaletto, after a drawing by Giovanni Battista Piazzetta.

19 The set for the Duke of Bedford followed the pattern of the series for Smith in culminating in two larger festival paintings, although here the difference in scale is far more pronounced.

20 Constable 1962, no. 331; Rome 2005, no. 27.

21 Constable 1962, nos 36 and 80; Rome 2005, nos 57 and 56.

22 'Of late few persons travel to Italy from hence during the wars', recorded George Vertue in his notebook in October 1746.

23 Vertue recorded in his notebook: 'Latter end of May came to London from Venice the Famous Painter of Views Cannalletti … of Venice, the Multitude of his works done abroad for English noblemen & Gentlemen has procured him great reputation & his great merrit & excellence in that way, he is much esteemed and no doubt but what Views and works He doth here, will give the same satisfaction – though many persons already have so many of his paintings'.

24 See, for instance, Beddington 2006, nos 54–7.

25 Beddington 2006, nos 9–10.

26 This was first established by F. Montecuccoli degli Erri, *Canaletto incisore*, Venice 2002, pp. 6–7.

27 For the other, see New York 1989–90, no. 82, and Treviso 2008–9, no. 45.

28 Constable 1976, no. 54*; New York 1989–90, no. 84.

29 Constable 1962, no. 509; New York 1989–90, no. 85.

30 His name had been proposed in January but on that occasion the three vacant spaces were filled by the landscape painter Francesco Zuccarelli, an obscure figure painter and a portraitist. No doubt a *capriccio* was preferred as his *morceau de réception* because of the perceived superior intellect required in its execution.

31 Constable 1962, no. 558; New York 1989–90, no. 127.

32 Its exact location, then Castello no. 5484, is shown by two drawings made by Canaletto from its windows, see Links 1973 and Constable 1976, nos 625 and 625*, pl. 218.

33 For the posthumous inventory, see Constable 1962 (and later editions), I, pp. 177–9.

Giovanni Battista Cimaroli

1 Private collection, UK; Constable 1962 (and subsequent editions rev. J.G. Links), I, pl. 94, II, no. 516; New York, 1989–90, no. 13; London and Washington 1994–5, no. 135. Cimaroli's contribution was here restricted to the foliage.

2 Private collection, UK; Constable 1962 (and subsequent editions rev. J.G. Links), I, pl. 94, II, no. 517; New York 1989–90, no. 12; Crema 2002, pp. 108–9, no. 6, illus. in colour.

3 Guarienti 1753, p. 272.

4 '20 Cimaroli: peint dans le meme goût, mais n'est pas encore arrivé au bout de l'échelle, du reste gâté par les anglois, qui lui ont imaginé que le plus petit de ses tableaux vaut 30 sequins' (Bettagno and Magrini 2002, p. 81).

5 For instance, Pallucchini 1996, II, pp. 292–7.

6 Three of these remain in the Royal Collection.

7 Padua 1994, nos 92–3; Milan 2008–9, p. 258, nos 25–6, illus. in colour p. 56. For the patronage of the Earl of Carlisle, see p. 45.

8 Spadotto 1999. The Venetian views listed include notably the pair of *The Molo from the Bacino* and *The Molo, looking West* de-accessioned by the Fine Arts Museums of San Francisco at Butterfield & Butterfield, San Francisco, 9 June 1999, lots 8003–4 (Spadotto 1999, nos 59–60, figs 39–40; Pedrocco 2001, illus. pp. 182–3).

9 Notably a pair sold by Eve, Paris, 13 December 2004, lot 27, as '*Ecole Venitienne, vers 1750*' and subsequently with Richard Green, London; a view of *The Piazza San Marco, looking East* in a private collection, Washington; and a view of *The Grand Canal at the Entrance to the Cannaregio* sold at Sotheby's, London, 11 December 2003, lot 239, as 'Follower of Canaletto' and later with Galleria Cesare Lampronti, Rome.

10 New York 1989–90, no. 56. It was subsequently exhibited again as Canaletto at Amsterdam 1990–1, no. 26, and is Links 1994, p. 126, pls 105–6.

11 Constable 1962, no. 254. This probably dates from before 1742 as it does not include Marchiori's statue of Saint John Nepomuk on the *traghetto* of San Geremia which was erected in that year.

12 Binion 1990a, pp. 147, 148 and 151.

13 Dodsley and Dodsley 1761, II, p. 313.

14 It may be remembered that Dodsley is also the source for the attribution to Canaletto of the pair of views by Bellotto now at Ottawa (plates 45 and 46).

15 Constable 1962, no. 361.

16 Venice 1987, no. 27; Gorizia 2008, no. 85; Madrid 2009, no. 42.

17 It was one of the last purchases by the great collector, who died in October 2009.

18 See pp. 170–1.

19 Gorizia 2008, no. 112.

20 Padua 1994, no. 95; Spadotto 1999, pp. 156–7, no. 37; Pedrocco 2002, pp. 181–2; Milan 2008–9, no. 28.

21 '*Ultimamente era presso il Negoziante Gaspare Craglietto un grande quadro di quel pittore colla Caccia de' Tori fatta nel 1740 …; ma tale quadro oggi non è più fra noi, sendo stato venduto a carissimo prezzo a un forastiere dal suo possessore. Il Craglietto pero ne aveva fatta fare una copia della stessa grandezza, e assai somigliante all'originale, la quale copia oggi (anno 1844) si possiede dal signor Abate Angelo Fornasieri in Venezia*' (Cicogna 1842, p. 345).

22 Magani 1996, pp. 144–5.

23 It is stated in Milan 2008–9, p. 259, that the Terruzzi painting was already in England in the possession of its first recorded owner, C. Morland Agnew, 'around the middle of the 19th century', but Agnew was not born until 1855 and may have acquired it not long before his death in 1931.

24 London 1849, no. 3, as 'Antonio Canal, called Canaletti'.

Antonio Joli

1 Tiraboschi 1786.

2 See, for instance, Arisi 1986, nos 52–5 and 104–7.

3 In 1738–9 he also designed sets for productions in Padua, Modena and Reggio Emilia.

4 Binion 1990a, pp. 147, 150. The paintings remained in the Schulenburg family until sold at Christie's, London, 23 April 1993, lot 53, and at Sotheby's, London, 28 February 1990, lot 85, respectively (Toledano 2006, nos v.v.I and N.I.1).

5 Quoted by Toledano 2006, p. 26.

6 Joli's arrival in England thus precedes by two years that of Canaletto, with whom he was to find himself again, as in Venice, in fairly direct competition for three years.

7 Toledano 2006, pp. 274–80, no. v.v.vII. The house is privately owned and sadly inaccessible.

8 Toledano 2006, no. s.I.1.

9 See Toledano 2006, no. N.XXXVI. Although Joli is described as 'napoletano' in inventories of the Schulenburg collection from 1738 onwards (Binion 1990a, p. 211), there is no evidence that he had visited Naples before this date.

10 Letter of 9 November 1762 to King Charles VII of Naples (from 1759 also Charles III of Spain), '*Il Pittor Iolli, che tuttavia dimora in Napoli, ed è da me conosciuto per espertissimo in dipingere, specialmente in piccolo …*'.

11 Toledano 2006, nos. v.I.2 and v.II; the third painting, a *Piazza San Marco* in an English private collection, is not in Toledano.

12 Toledano 2006, no. v.I.1; Treviso 2008–9, no. 61.

13 Toledano 2006, nos v.III, v.IV.1-2, and v.VI.1.

14 Ticozzi 1836, pp. 7–8.

15 A *terminus ante quem* is provided by the absence of the upper storeys of the wings of the Torre dell'Orologio, added by Giorgio Massari between March 1755 and 1757.

16 Letters from Morassi of 7 January 1958 and Succi of 10 February 1993 in the gallery's picture files: D. Succi in Padua 1994, pp. 81–5.

17 Marieschi also made an etching of the courtyard of the Doge's Palace, but its viewpoint is slightly to the right.

Michele Marieschi

1 By far the most complete source of biographical information on the painter is Montecuccoli degli Erri in Montecuccoli degli Erri and Pedrocco 1999.

2 Guarienti 1753, p. 380.

3 The gilding of the frame for the painting was paid for on 21 May.

4 Pedrocco in Montecuccoli degli Erri and Pedrocco 1999, no. 17; Treviso 2008–9, no. 48.

5 Montecuccoli degli Erri in Montecuccoli degli Erri and Pedrocco 1999, pp. 50 and 111.

6 Montecuccoli degli Erri in Montecuccoli degli Erri and Pedrocco 1999, pp. 58 and 61.

7 '*La troppa assiduità alla fatica e allo studio gli causò la morte*' (Guarienti 1753, p. 380).

8 Pushkin Museum, Moscow; Pedrocco in Montecuccoli degli Erri and Pedrocco 1999, no. 76.

9 Two of Marieschi's four children were stillborn and this one only survived 15 days (Montecuccoli degli Erri in Montecuccoli degli Erri and Pedrocco 1999, p. 59).

10 '*J'ay plaisir que vous avez receu les Tableaux … Je crois que Les avez placés dans votre Maison de Campagne …*' (Castle Howard archive J12/11/18).

11 See Pedrocco in Montecuccoli degli Erri and Pedrocco 1999, nos 21–4, 31–2, 74, 88–9, 99–100 and 113.

12 For instance, at the time of writing Christie's, London, have just announced that they are due to sell on 6 July 2010 two missing components of the Castle Howard series, hitherto only known from old monochrome photographs (Passariano 2003, figs 151–2).

13 '*Il se fit nommer il secondo Marieschi …*' (Mariette 1856, p. 264; quoted by Montecuccoli degli Erri in Montecuccoli degli Erri and Pedrocco 1999, p. 26).

14 Sotheby Parke-Bernet, 18 May 1972, lot 137; Sotheby's, London, 6 December 2006, lot 52; Treviso 2008–9, no. 57.

Bernardo Bellotto

1 His birthdate, given by Constable as 1720 and Kozakiewicz as 30 January 1721, has only recently been established (Marini 1993, pp.129–30).

2 Kozakiewicz 1972, II, p. 19, no. 20, illustrated. The drawing forms part of an important group of early drawings, many of which relate to surviving

3 paintings which have an unbroken provenance from Bellotto's descendants at Vilnius at the beginning of the nineteenth century and are now in the Hessischen Landesmuseum, Darmstadt.

3 Turin 2008, no. 2. It was sold by the 6th Earl of Malmesbury at Christie's, London, 11 April 1986, lot 57, as 'attributed to Bernardo Bellotto'.

4 Succi 1999, fig. 9 (colour); sold at Sotheby's, New York, 24 January 2008, lot 114.

5 The other two were by Michele Marieschi, *The Piazza San Marco, looking East* and *The Grand Canal with the Entrance to the Cannaregio*, which remain in the Malmesbury family collection, along with the panoramic view of *The Bacino di San Marco*, also acquired by Harris, which is one of Marieschi's masterpieces (Montecuccoli degli Erri and Pedrocco 1999, p. 388, no. 160, and p. 415, no. 185). Harris also owned Canaletto's magnificent view of *The Old Horse Guards, London, from St James's Park*, which was bequeathed to him by the Earl of Radnor in 1757; sold by his descendant at Christie's, London, 15 April 1992 (lot 59), it is now on loan to Tate Britain from the collection of the Lord Lloyd-Webber Art Foundation (Constable 1962, p. 415).

6 Both are now in the Royal Collection (Constable 1962, nos 161, 236).

7 For an old photograph showing five of these see Succi 1999, fig. 34.

8 For two of these see Venice and Houston 2001, nos 3–4, and Treviso 2008–9, nos 66–7.

9 Lyon Bequest. Succi 1999, figs 46–7.

10 Succi 1999, figs 41, 43, 44.

11 Kozakiewicz 1972, no. 25.

12 Kozakiewicz 1972, no. 24; Venice and Houston 2001, no. 7.

13 Turin 2008, no. 4.

14 Kowalczyk 1999, p. 200.

15 This is one of the rare instances in which the prototype is larger than Bellotto's version.

16 Kozakiewicz 1972, no. 23; Venice and Houston 2001, no. 5.

17 Kozakiewicz 1972, no. 105; Venice and Houston 2001, no. 6.

18 Dodsley and Dodsley 1761, II, p. 315.

19 '… *un grande intendimento ricercasi in chi vuole distinguerle da quelle del Zio*' (Orlandi 1753). Guarienti clearly knew Bellotto well, as he was godfather to his second daughter in 1746.

20 Binion 1990a, p. 173; Binion 1990b, p. 27.

21 Kozakiewicz 1972, no. 77; Venice and Houston 2001, no. 20.

22 Kozakiewicz 1972, nos 92–3; Venice and Houston 2001, nos 33–4; for one, see also Turin 2008, no. 64.

23 Kozakiewicz, 1972, nos 98, 101; for the first, see also Venice and Houston 2001, no. 37.

24 A *capriccio* in the Smith College Museum of Art, Northampton, MA (Kozakiewicz 1972, no. 316).

25 Five of his other eight children had died in infancy.

26 Bellotto is still to this day known as 'Canaletto' in Poland and German-speaking countries.

27 The views of Warsaw were – famously – used in the reconstruction of the city after the Second World War.

Pietro Bellotti

1 Bernardo and his descendants in Poland seem to have been the only members of the family to spell their name with a final 'o', for reasons which one can only surmise.

2 Kozakiewicz 1972, no. 60.

3 '*LES PLAISIRS DE LA COUR: OU THÉÂTRE SANS PAREIL. AVIS AUX AMATEURS DES BEAUX ARTS. La Peinture Architectorique & Prospective arrivée à son plus haut dégré de perfection. Le Sieur CANALETY, Peintre Venitien, convie les Curieux des Beaux Arts & de Peinture à voir son Théâtre sans pareil, composé des plus belles Vûes de l'Europe, comme Venise, Rome, Florence, Milan, Turin, Londres, Versailles, Strasbourg, plusieurs Ports de Mer, & autres morceaux d'Architecture antique & moderne, le tout peint à l'huile & de sa grandeur naturelle, les ayant vûs & tirés sur les lieux d'après nature, les ayant rendus susceptibles par la légéreté & la delicatesse du pinceau, s'étant acquis de la réputation par tout où il passe: il n'avoit dessein de les faire voir qu'à des personnes de l'Art & connoisseurs, afin de s'attirer leur estime ainsi que leur conseil; mais ces Amateurs sentant le plaisir que cela pourroit procurer aux personnes de la Ville, l'ont engagé de les faire voir au Public.*
 '*Le sieur CANALETY avertit ceux qui sont charmés de voir son Ouvrage, qui surement leur plaira, par la beauté, le choix & la variété des objects, qu'il le fera voir à toute heure en Foire, dans la Loge de la Veuve BERNARD, en entrant par la Porte de Tournon.*
 '*Cette Piéce a été vue par Sa Majesté, Monsieur le Dauphin, Madame la Dauphine & de toute la Cour, avec beaucoup de succès & d'applaudissemens.*
 '*Il se transportera dans les Maisons de ceux qui lui feront l'honneur de l'appeler.*
 '*Le sieur Canalety apprend le Dessein.*
 Le prix est de 24 sols par personne'

4 Barber 1988.

5 Constable 1989, I, pp. lxxx–lxxxii.

6 Marini 1993, p. 134.

7 Van de Sandt 2002, p. 96.

8 Van de Sandt 2002, p. 110, figs 14–16, 18–20, 22, 24 and 26.

9 Most of the signed works are *capricci* (see Beddington 2007, p. 682, figs 24–7), presumably because Bellotti took more pride in these works of the imagination. Only two signed views are known, one of *The Lock at Dolo* (Succi 2003, fig. 139) and an unpublished one of *The Castel S. Angelo and the Vatican* with an inscription apparently identifying it as having been executed for a patron in Amsterdam, in an English private collection. This last, and a pair of *capricci* in an English private collection, are the only known dated works, all of 1771.

10 Paul Mellon Collection, Yale Center for British Art, New Haven; Beddington 2007, fig. 21. This is datable on topographical grounds between 1763 and 1767.

11 The Mercers' Company, London; Beddington 2007, fig. 22.

12 Beddington 2007, fig. 24.

Francesco Tironi

1 L. Moretti, 'Francesco Tironi', in Treviso 2008–9, p. 206.

2 '*È da compiangersi il nostro Francesco Tironi, che morto sia in troppo fresca età da qualche anno, poiché i Porti di Venezia e le Isole disegnati da lui, ed incisi poi dal nostro Antonio Santi [sic], ci fanno scorgere quant'oltre sarebbe arrivato*' ('Our poor Francesco Tironi is much to be mourned, who died too young a few years ago, for the compositions of the harbour in Venice and the Islands, designed by him and subsequently engraved by Antonio Santi, show how much he would have achieved'), Moschini 1806, III, p. 78, note 1; quoted by Moretti in Treviso 2008–9, p. 206.

3 The *Ventiquattro Prospettive delle Isole della Laguna* in fact include views of the ports of Chioggia, Malamocco and the Lido, and of the *Murazzi* (sea walls). Tironi's drawings are in the Albertina, Vienna (6), the Robert Lehman Collection in the Metropolitan Museum of Art, New York (2), the Whitworth Art Gallery, Manchester, and the National Gallery of Art, Washington. One is in the former collection of Franz Koenigs and six others are in private collections.

4 For instance, a group of six in the Victoria and Albert Museum (Ward-Jackson 1980, pp. 180–2, nos 1185–90). An unpublished variant of the right section of the first of these was sold from the estate of Madame Carlo Broglio at the Palais Galliera, Paris, 20 March 1974, lot 2, as by Canaletto, and was subsequently with Agnew's, London, *Master Drawings and Prints*, 11 March – 25 April 1975, no. 17, with the same attribution.

5 Voss 1927–8, p. 270; Voss 1966, pp. 100–4.
6 The painter who headed this prolific workshop may, as Dario Succi has proposed, be Apollonio Domenichini (1715 – about 1770), who was inscribed in the Venetian painters' guild in 1757 (see, for instance, Succi 2003, pp. 103–7), but evidence is lacking.
7 For instance a painting by Tironi of *The Island of Portosecco* sold (from a house built in 1775) at Christie's, South Kensington, 21 April 2004, lot 306, as 'Follower of Francesco Guardi', and now in a private collection, is closely related to, but by no means a slavish repetition of, the composition of Sandi's print.
8 Bonhams, London, 3 December 208, lot 49; Galleria Cesare Lampronti, Rome, *Cento Capolavori di Pittura dal XVI al XVIII Secolo*, 22 October – 22 November 2009, nos 62–3. The initials are not mentioned in either catalogue. The paintings are now in a private collection, Monte Carlo.
9 *Catalogo di quadri raccolti dal fu signor Maffeo Pinelli ed ora posti in vendita in Venezia*, p. 106: '*Tironi Francesco – Bella Veduta dell'Isola di San Giorgio Maggiore di Venezia. In tela, alt. p[iedi] 1 onc. 8 – l[argo] p. 2. onc. 4 – Quadro simile, Veduta di Venezia dalla parte della Pescaria di S. Marco. In tela, di grandezza simile, e in ambedue sta scritto F.T*' ('Tironi Francesco – beautiful views of the Isola di San Giorgio Maggiore in Venice, height 1 ft 8 in, width 2 ft 4 in [= 58 x 81 cm] – similar picture, view of Venice from the Pescaria di San Marco. Canvas, of similar dimensions, and both bearing the initials F.T.'), (quoted by Moretti in Treviso 2008–9, p. 206). Maffeo Pinelli (1735–85) was a printer.
10 Christie's, South Kensington, 23 April 2008, lot 203, as Tironi, subsequently with Galleria Cesare Lampronti, Rome, *Cento Capolavori di Pittura dal XVI al XVIII Secolo*, 22 October – 22 November 2009, no. 44, as Cimaroli; Bonhams, London, 9 July 2008, lot 63, as follower of Giuseppe Zocchi.
11 Sotheby's, London, 23 March 1973, lot 52, as Giovanni Migliara; and Succi 2004, fig. 23.
12 Private collection, Italy.
13 The only monograph on the artist, Succi 2004, includes many works at the lower end of the quality scale.

Francesco Guardi

1 Proud of his status in a very class-conscious society, Guardi sometimes signed his drawings 'Francesco de Guardi'.
2 Montecuccoli degli Erri in Montecuccoli degli Erri and Pedrocco 1992, pp. 19–20, illus. p. 75.
3 Montecuccoli degli Erri in Montecuccoli degli Erri and Pedrocco 1992, pp. 25–8.
4 'fatte da li fratelli Guardi', see Montecuccoli degli Erri in Pedrocco and Montecuccoli degli Erri 1992, p. 15.
5 See p. 59.
6 See p. 69.
7 Morassi 1973, no. 203, figs 220–2, pl. XXXII; Succi 1993, fig. 50. The painting has been reduced in size.
8 Morassi 1973, no. 207, figs 225–6, pl. XXXIII; Succi 1993, fig. 237.
9 Morassi 1973, no. 202, fig. 224; Gorizia 1987, no. 9, fig. 16; Succi 1993, fig. 239.
10 Morassi 1973, no. 214, figs 229–31; Succi 1993, figs 233–4.
11 Morassi 1973, nos 44–5, figs 49–50; Succi 1993, figs 245–6.
12 Russell 1996, p. 8.
13 See pp. 103–6.
14 Russell 1996, p. 8. The pair only mentioned by Russell as a postscript, p. 11, note 38, was offered at Christie's, New York, 12 January 1996, lot 36.
15 See p. 52, note 25.
16 Eleven are now in the Louvre, one in the Musées Royaux des Beaux-Arts de Belgique, Brussels; Morassi 1973, nos 243–54, figs 268–84; Succi 1993, figs 80–3.
17 Succi 1993, p. 87.
18 Constable 1962, II, nos 630–41.
19 Succi 1993, pp. 90–1.
20 Morassi 1973, nos 255–61, figs 285–90, pl. XXXVI.
21 Alte Pinakothek, Munich (Succi 1993, fig. 116). *The Dinner and Ball in the Teatro San Benedetto* is now in a private collection, USA (ex Christie's, London, 9 December 1994, lot 62).
22 Morassi 1973, nos 262–76, figs 291–304.
23 Morassi 1973, no. 313, fig. 338; Succi 1993, fig. 142.

City and Ceremony

City and Ceremony

AMANDA BRADLEY

The Republic of Venice

The Venetian Republic was headed by an elected figure known as the Doge – the name adapted into Venetian dialect from the Latin *dux* (leader). The first to be given this title was Orso Ipato (r. 726–37), when in 726 the Byzantine Emperor Leo III ordered the destruction of all holy images and icons, provoking a rebellion throughout Byzantine Italy, and at which time each community chose its own leader. Thereafter the post was to be passed down through 117 successors over more than a thousand years.

Aided by its unique geography, Venice became largely independent of the mainland provinces, resisting attacks, particularly by the Lombards and, in 810, by King Pepin (777–810), second son of Charlemagne. The memory of the victory endured for centuries, and Venetian independence was a source of pride, eulogised by numerous authors, notably Marin Sanudo (1466–1536). Venice's location was not without its problems, however: during times of shortage, fresh water had to be imported on barges from the River Brenta on the mainland, and the devastation of the plague towards the end of the sixteenth century was surely exacerbated by the density of population.

'La Serenissima' – the Most Serene Republic – took from its isolation in the Lagoon a strong sense of identity, conveyed, as in other powerful Italian city states, through public iconography, patron saints, festivals and feast days. Unlike its counterparts on the mainland, however, Venice did not have a Roman ancestry from which to cultivate a self-image. This was rectified in some literary accounts, which presented Venice as the 'new Rome', and in the seventeenth century particularly, classical gods and goddesses came to feature prominently in public sculpted and painted displays. Still, however, the collective identity was harnessed to the surroundings of Venice: Venus, having also been born of the sea, featured prominently (note the similarity of the two names), as did Neptune, Nereids and other maritime figures, although this did not preclude other less nautical gods and goddesses. During festivals, lavish displays and floats featuring state-approved deities were staged. The Lagoon and canals made for dynamic backdrops for such festivities, as well as for regattas and comparatively sedate state ceremonials.

Venice was an empire *da mar*: up until the end of the sixteenth century her dominions were extensive, reaching also into the *terraferma* (the Italian mainland). As a hub for trade routes to the north and east, her fortunes were built on mercantile profit. This also meant that the city saw a large influx of foreign visitors. Set against such commercial aspirations, however, was the Venetian notion of *mediocritas*, which – appropriately enough for a republic – denied self-promotion and encouraged a sense of equality (in theory if not in practice). Indeed, the Venetian governmental system was complicated and quite unlike any other. Although by no means without inherent problems, it did manage to escape – at least in the public eye – the perpetual discord experienced by such other Italian city states as Florence.[1]

The Doge was elected by a complicated balloting system from a large, closed body of men called the Great Council, representing some 150 families, who constituted the ruling caste (in 1500 it had more than two thousand members; by 1797 about a thousand). From 1506 legitimate patrician birth, which ensured entry to the Great Council, was recorded in the 'Book of Gold'. The Great Council was subdivided into various other offices, notably the Senate (itself subdivided into advisory bodies called *savii*) and the Council of Ten. The *cittadini* (citizen class) was a subpatriciate, composed of an elite of families. Although members could not sit on the Great Council, they could assist with the running of the government, for example as secretaries. The government was, therefore, a kind of oligarchy, whereby power effectively rested within a small segment of society.

The End of the Republic

It has been argued that the 1570s marked the beginning of the end of the 'Imperial Age' of Venice.[2] It was a complex and gradual process, the causes including the loss of much of Venice's Mediterranean territory to the Turks, the city's continuing susceptibility to plague, and its displacement by Portugal as the key centre for international trade. The culmination came on 17 May 1797, when General Baraguay d'Hilliers entered Venice with some seven thousand French troops.[3] Lodovico Manin (r. 1789–97), the 118th and last Doge of Venice, surrendered unconditionally to Napoleon, and the Council declared the end of the republic. France and Austria subsequently signed the Treaty of Campoformio, under which Venice and her territories were granted to the Austrian allies, and the Austrians entered the city state a year later. There began a systematic looting of Venice, which targeted politically charged works of art, most notably the four bronze horses on the façade of the Basilica di San Marco, although they were returned in 1815 after the Battle of Waterloo and replaced with replicas in the 1980s (when the originals were moved in to the museum). In 1805 Napoleon seized control of Austria's territories in Italy, and Venice spent the next eight years under Napoleonic rule. This prompted a grand scheme for urban renewal, which – although not as drastic as at first envisaged – was to change parts of the cityscape forever.

1 For a thorough account see Chambers 1970, pp. 73ff.
2 Chambers 1970, p. 187.
3 For a full account see Norwich 1982, chap. 46, pp 605ff.

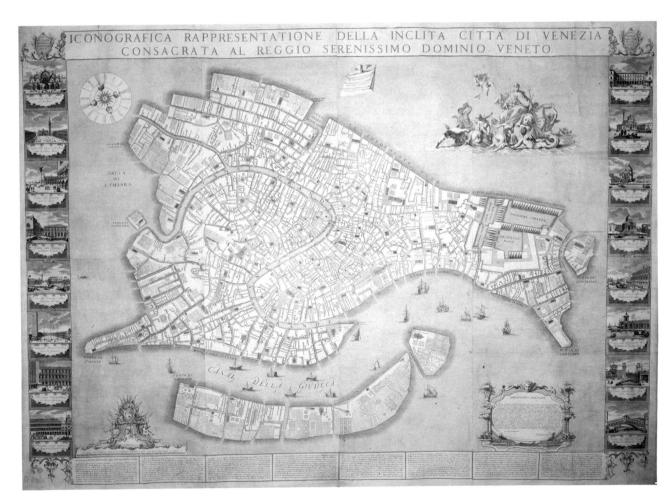

Fig. 55 Ludovico Ughi
Map of Venice, with 16
views of buildings in the
borders, 1729
Copper engraving,
152 x 215 cm
The British Library,
London

Places and Architecture

The Arsenale

Established under Doge Ordelafo Falier (r. 1102–18) in the parish of San Martino in the eastern part of the city, the Arsenale (from which the English word derives) united in one place the various aspects of shipbuilding, which had previously been dispersed throughout Venice. Praised by Marin Sanudo (1466–1533) in his *Laus urbis Venetae* in 1493, the labourers of the Arsenale manufactured ships primarily for war – Sanudo mentions that one of the ships was called 'No More Words' – although the maritime needs of war and trade were inextricably linked.[1]

Next to the twin towers of the Arsenale's watergate is the Porta Magna, or landgate, probably – although there is no documentary evidence to support this – designed by Antonio Gambello (d. 1481), and dated 1460 on the pedestals of the columns.[2] This is in the form of a triumphal arch, based in part on the classical Arch of the Sergii in the Dalmatian town of Pola (now Pula), then under Venetian rule. One of the earliest examples of the use of the classical style in Venice, the gateway served to symbolise the city's dominion over the seas. The late sixteenth century saw the addition of winged victories and an inscription commemorating victory over the Turks at Lepanto in 1571, as well as the crowning *Saint Justina* by Girolamo Campagna (about 1549–1625) of 1578. Further embellishments date from the time of Doge Francesco Morosini (r. 1688–94), including the replacement in 1692 of the drawbridge with a raised enclosure punctuated by pedestals with statues of mythological gods and goddesses and personifications. The large lions flanking this were looted from Athens in 1687, when Morosini retook the Morea from the Ottomans,[3] while the bronze flagstaff base in the centre of the square was erected in 1693 to commemorate the Doge's victories. A fourth lion was placed here to commemorate the successful defence of Corfu by Johann Matthias von der Schulenburg (1661–1747) against the Turks in 1716. On the east side of the Rio dell'Arsenale stood the oratory of Santa Maria dell'Arsenale, demolished in 1809.
Figs 56 and 57, and see plate 45.

ALTRA VEDVTA DELLE PORTE DEL ARSENALE

Luca Carlevarijs delin: et inc:

Fig. 56 Luca Carlevarijs (1663–1730)
Altra Veduta delle Porte dell'Arsenale, from *Le Fabriche, e Vedute di Venetia, disegnate, poste in Prospettiva, et intagliate da Luca Carlevariis* (Venice 1703)
Etching, 20.7 x 29.2 cm
The British Museum, London (1928,1016.82)

Fig. 57 Antonio di Natale
Seventeenth-century plan of the Arsenale and dockyard in Venice
Watercolour
Museo Correr, Venice

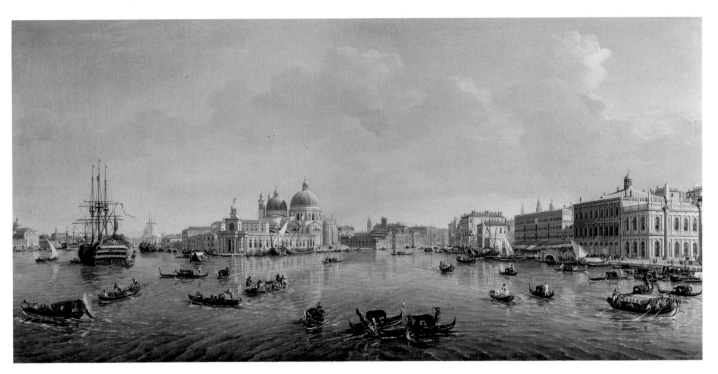

Fig. 58 Gaspar van Wittel, called Gaspare Vanvitelli (1652/3–1736)
View of the Bacino looking West, 1710
Oil on canvas, 55.5 x 109 cm
Menarini Fittipaldi collection, Florence

The Bacino di San Marco

Venice's 'inner harbour',[4] this irregularly shaped body of water is bordered by the Molo and the Riva degli Schiavoni to the north, by the islands of San Giorgio Maggiore and the Giudecca to the south, and by the Punta della Dogana (Customs House Point) and the entrance to the Grand Canal to the west. Thus not only is it adjacent to the Piazzetta and the civic and religious heart of the city, but it is also surrounded by many of Venice's most important buildings, from the Mint, the Library, the Doge's Palace and the prisons to the churches of San Giorgio Maggiore, the Zitelle (Santa Maria della Presentazione) and Santa Maria della Salute. The Bacino was the most impressive point of arrival for visitors, who alighted at the Piazzetta, where they were confronted by the twin columns of Saint Theodore and Saint Mark, symbolising the guardianship of the Eastern and Western churches.[5] Before the construction of ships was centralised at the Arsenale, ships were moored at the Molo or the Riva degli Schiavoni, but the loading and discharging of ballast and making of repairs were forbidden in 1303 to clear the Bacino for the ever-increasing volume of traffic.[6]
Fig. 58; see plates 24, 34 and 42, and especially plates 22 and 41.

The Campo Santi Giovanni e Paolo

Called in Venetian dialect the Campo San Zanipolo, this square is dominated by the Dominican church of Santi Giovanni e Paolo, one of the two largest Gothic churches in Venice. Begun probably in 1333, it was not consecrated until 1430, and the façade remains unfinished. Its deep recesses must have been intended for tombs, and indeed one is occupied by the tomb of Doge Jacopo Tiepolo (d. 1249) – one of 25 doges interred at this church. The portal was added in 1458–63 by Bartolomeo Bon (active 1421–64). The church is flanked to the north by the Scuola Grande di San Marco, begun after 1485 by Pietro Lombardo (1435–1515) and Giovanni Buora (1450–1513) and completed by 1495 by Mauro Codussi (1440–1504). Tullio Lombardo (1460–1532), Pietro's son, was responsible for the *trompe l'oeil* recession on either side of both doorways. The other notable feature of the square, standing to the south of the façade of the church on a high base, is Andrea del Verrocchio's magnificent equestrian statue of the *condottiere* Bartolomeo Colleoni.
See plates 12 and 49.

The Campo Santa Maria Formosa

This is one of the largest squares in Venice, and being situated in one of the city's more prosperous *sestieri*, it was the home of numerous *palazzi*. A public well at its centre provided fresh water, since the water in the canals was both saline and polluted. The wealth of the inhabitants meant that their parish church was built on a grander scale than some, and thus its unusual, free-standing form has come to dominate the square it occupies. Building began in 1492 and the church was substantially complete by 1504, when its architect, Mauro Codussi, died. It was centrally planned, although its triple nave was slightly elongated to allow for processions (this was particularly necessary as the Doge visited each year on the Feast of the Purification of the Virgin (2 February, otherwise known as Candlemas). The three apsed chapels at the east end – projecting into the *campo* – must, like the rest of the plan, be indebted to those in the Basilica di San Marco. Little is known of Codussi's intentions for the exterior: the façade on the south side is datable to the mid-sixteenth century and the west façade and *campanile* to the seventeenth.[7] The church was damaged by a bomb during the First World War and its appearance subsequently altered, most notably in the dome, which was rebuilt without its high drum.

See plates 18 and 44.

The Campo San Salvador

This was the meeting point of two important pedestrian thoroughfares, one leading to the Piazza San Marco, the other to the Campo San Bartolomeo, the Rialto and the Fondaco dei Tedeschi.[8] While the church of San Salvador (San Salvatore, the Holy Saviour, in Venetian dialect) was begun in about 1505 to the designs of Giorgio Spavento (about 1440–1509) and completed in the 1520s, its façade was added in 1660–6 by Antonio (about 1580–1661) and Giuseppe Sardi (1624–99). The same father-and-son team had earlier been responsible for the less inventive façade of the adjacent Scuola Grande di San Teodoro (about 1654–7). Both façades, which are the earliest known works by Giuseppe Sardi and the last by his father, were funded by bequests from a wealthy merchant, Jacopo Gallo.[9] Adjoining the church is the former monastery of Augustinian canons.

Fig. 59, and see plate 21.

CHIESA DI S. SALVATORE
Canonici Regolari Architettura di Giuseppe Sardi *Luca Carleuarijs delin:et inc:*

Fig. 59 Luca Carlevarijs
(1663–1730)
Chiesa di S. Salvatore, from
*Le Fabriche, e Vedute di Venetia,
disegnate, poste in Prospettiva,
et intagliate da Luca Carlevariis*
(Venice 1703)
Etching, 20.6 x 29.1 cm
The British Museum, London
(1928,1016.36)

The Campo San Vidal

The Campo San Vidal is situated across the Grand Canal from the church, monastery and *scuola grande* of Santa Maria della Carità. Now the busy approach to the Accademia Bridge, the small square was an obscure cul-de-sac until the first bridge was erected in 1854. The façade of the church of San Vidal was designed by Andrea Tirali (1657–1737), and modelled on the façade of Andrea Palladio's San Francesco della Vigna.

See plate 11.

The Canale di Santa Chiara

This small canal joins the Grand Canal in its furthest reaches to the north-west, after its final bend and just before its effluence into the Lagoon.

See plate 20.

The Doge's Palace (Palazzo Ducale)

While the Basilica di San Marco is the foremost Byzantine building in Venice, the Doge's Palace is the supreme Gothic edifice, and is as remarkable in terms of secular architecture as its neighbour is in ecclesiastical. The site of the palace must have been established early in the ninth century,[10] when Doge Agnello Partecipazio (r. 811–27) transferred the ducal seat from Malamocco on the Lido to the islands then known as 'Rialto' and now known collectively as 'Venice', which were more easily defended. It now consists of three wings: the first, the south, constructed in the 1340s, housing the Sala del Maggior Consiglio (the Hall of the Great Council); the west, an extension of 1422, which housed the law courts; and the east, which contained the Doge's apartments, built by Mauro Codussi in 1484. The initial architect is not known, although the later addition of a balcony in around 1404 on the south wall (along the Molo) was by the renowned sculptors Pierpaolo (d. about 1403) and Jacopo dalle Masegne (d. 1409).[11] The Porta della Carta, added to the west wing, was contracted to Giovanni and Bartolomeo Bon in 1438.

The palace's blend of Roman, Lombard and Arab details

Fig. 60 Canaletto (1697–1768)
The Piazzetta, looking East, with the Palazzo Ducale, about 1740–1, detail
Oil on canvas, 20 x 40 cm
Private collection

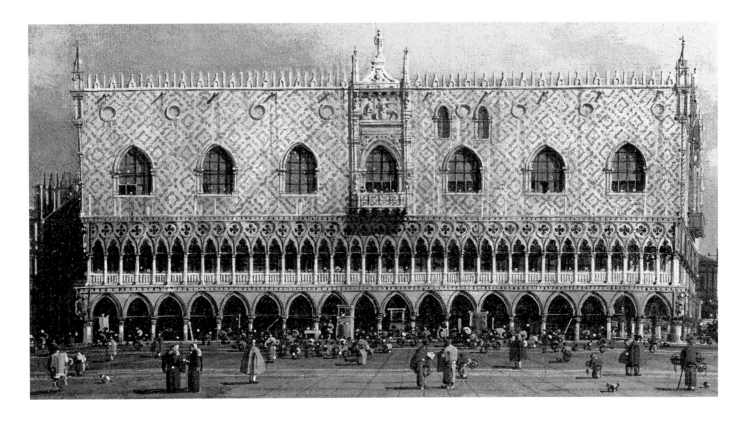

led John Ruskin to describe it as 'the central building of the world'.[12] It differs considerably from other contemporary Italian governmental buildings, not only in that the Doge's residence, the palace of justice and the town hall were combined in one building, but also – in contrast to such fortress-like exteriors as that of the Palazzo Vecchio in Florence – in being unfortified. Its unique position made possible its unique character, with arcades at street level, balconies fronted by delicate filigree tracery around the *piano nobile*, and the whole surface of the flat walls above articulated by lozenge patterns in pink Verona marble. The crowning crenellations are purely decorative. Both the courtyard and arcades were open to the public, this transparency intended to reflect the moral rectitude of the oligarchic state, further emphasised in the iconography of the capitals and sculpture. Particularly significant is the iconographic adaptation of *Justicia*, who features on a sculpted roundel of around 1422 and on the Porta della Carta, where she has become a personification of Venice herself.[13]

Fig. 60, and see plates 1, 28, 35, 46 and 58.

The Giudecca Canal

Wider than the Grand Canal, this was to become Venice's main route for heavy transport in the nineteenth century. It runs between the Zattere, which borders Dorsoduro to the south, and the island of the Giudecca, notable for Palladio's churches of the Redentore (begun in 1577) and the Zitelle (Santa Maria della Presentazione, about 1570–86). *See plate 53.*

The Grand Canal

This was – and remains – the main thoroughfare through Venice. It winds in a reverse 'S'-shape from the Bacino di San Marco in the south-east to the railway station (Stazione di Santa Lucia) and Piazzale Roma in the north-west. It is bordered by most of the grandest Venetian private palaces, as well as several notable churches. *Fig. 61.*

Fig. 61 Nineteenth-century aerial photograph of the Grand Canal

The Isola della Madonetta

This small island, also known as the Anconetta, sits in the Lagoon near Marghera. It formerly had a small church of Santa Maria, from which it took its popular name.
See plate 64.

The Lagoon

Venice and its numerous subsidiary islands stand in an enclosed bay of the Adriatic Sea. This was called in Venetian dialect the Laguna Veneta, from which the English word 'Lagoon' derives. With a surface area of approximately 340 square miles, it is the largest wetland in the Mediterranean. Originally (before AD 600) there was little land mass in the Lagoon, but islands were gradually formed by silt from the rivers and drainage, and these now make up about 8 per cent of the whole. The Roman statesman Cassiodorus (about 485–585) described the early Venetians as 'like aquatic birds, now on sea, now on land'.[14] A painting by Vittore Carpaccio of about 1495 (fig. 62) shows how the Lagoon was – as it still is – used for hunting birds and fishing.[15]
See plates 54 and 57.

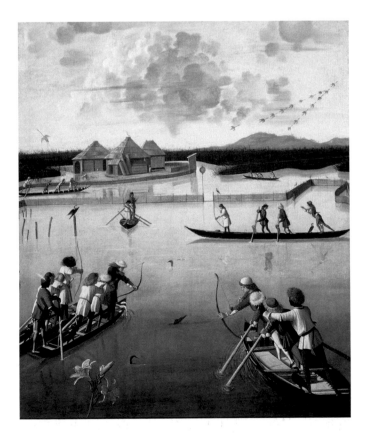

The Library of San Marco

The Biblioteca Nazionale Marciana extends along the west side of the Piazzetta, opposite the Doge's Palace, and is flanked on the south by the Zecca (Mint). It was begun in 1537 to accommodate some thousand manuscripts bequeathed to the republic by the Greek Cardinal Bessarion of Trebizond (1403–72) in 1468.[16] The books had remained in boxes, susceptible to thieves, until the scholar Pietro Bembo (1470–1547) was appointed librarian in 1532 and embarked upon initiatives to begin work on the Library. Designed by the state architect Jacopo Sansovino (1486–1570) – hence its original name, the Libreria Sansoviniana – it is made of Istrian stone, which is naturally resistant to damp. It was constructed on two floors, the lower articulated with the Doric order, and the *piano nobile* with the Ionic, surmounted by a frieze and statues of gods and heroes, with obelisks at each corner. The use of classical Roman architectural language served to emphasise the Venetian desire to be perceived as heirs to the Roman Republic, and fittingly, on 3 February 1587 (1586 m.v.), the Senate accepted the gift of the collection of antiquities belonging to Giovanni Grimani (Patriarch of Aquiliea, † 1593), which were housed – along with the donation of antiquities from his uncle, the Cardinal Domenico Grimani († 1523) – in the Library's *antisala* (entrance hall) some years later.[17] The building was angled to facilitate views of both the Basilica di San Marco and the Doge's Palace – a piece of planning that served to create a powerful visual expression of wisdom, faith and justice.
Fig. 64, and see plates 8, 43 and 46.

Fig. 62 Vittore Carpaccio (active 1490; died 1525/6)
Hunting on the Lagoon, about 1490–5
Oil on panel, 75.6 x 63.8 cm
The J. Paul Getty Museum, Los Angeles, CA (79.PB.72)

The Molo

The Molo is the broad stone quay along the waterfront of the Piazzetta. The landing stages here were used not only for ceremonial purposes but also for visitors. The Molo was lined with taverns and shops, as seen in Jacopo de' Barbari's woodcut of 1500 showing an aerial view of Venice.[18] Permanently moored at the Molo was the *Fusta*, a galley with a striped awning. Not to be confused with the much larger *bucintoro* (see Ascension Day), this was used for the temporary confinement of prisoners after trial.

Fig. 63, and see plates 34 and 55.

Fig. 63 Erhard Reuwich (active late 15th century)
Detail of the Molo, from Bernhard von Breydenbach's *Description of a Journey to the Holy Land* (*Peregrinatio in terram sanctam*) (Mainz 1486)
Woodcut
Private collection

The Piazza San Marco

The Piazza San Marco was the main processional and civic space in Venice, into which the Piazzetta opened at the south-east corner. It takes the form of an elongated trapez-ium, widening at the east end to encompass the façade of the Basilica di San Marco. To the north is Mauro Codussi's Torre dell'Orologio (Clock Tower), which was finished in 1499, although the top storeys of its wings date from 1755. It leads to the Mercera (the main commercial thoroughfare), and demarcates the transition between civic and commercial Venice. This north side continues with Bartolomeo Bon the Younger's Procuratie Vecchie, begun in 1513, comprising a long arcade of shops and two storeys of apartments, which were let to the Procurators of San Marco (whose status was second only to that of Doge).[19] Extra bays on the west side of the square were added in the 1530s by Jacopo Sansovino but were demolished by Napoleon in 1807. The Procuratie Nuove on the south side of the square formed an extension of Sansovino's Libreria and, although begun by Vincenzo Scamozzi (1548–1616), were completed by Baldassare Longhena (1598–1682), who was also responsible for the section connecting the Procuratie Nuove with the church of San Geminiano (also now destroyed).

To the south-east stands the Campanile (Bell Tower), with Jacopo Sansovino's Loggetta on its east side. Dating from the ninth century, the Campanile owes its present form to Bartolomeo Bon the Younger (*proto* or director of works to the Procurators of San Marco since 1505), who restored and redesigned it after an earthquake of 1511. The tower collapsed completely in 1902, crushing the Loggetta, but they were both rebuilt in their original form, using – where possible – original materials. The Loggetta, begun in 1538 and completed by 1545, was an instrumental backdrop to civic events, and was adorned with iconographically complex reliefs and figures propagating the 'myth' of Venice. Its bronze gates, by Antonio Gai (1686–1769), were erected in 1742, and their depiction (or absence) is often useful in dating views of the square.

See plates 5, 10, 15, 31 and 59.

The Piazzetta di San Marco

The Piazzetta leads from the Bacino di San Marco to the Piazza San Marco, flanked to the east by the Doge's Palace and to the west by Jacopo Sansovino's Library. Its role as the gateway to the city from the Molo is emphasised by monumental twin columns, surmounted respectively by statues of Saint Theodore and the lion of Saint Mark, Venice's patron saints. Like the Piazza San Marco, the Piazzetta is trapezoid in shape, opening up to the north to provide a view of the south flank of the Basilica di San Marco. While the Piazzetta was used, on occasion, for processional purposes, it was more generally a place for social gatherings and political gossip.[20]

Fig. 64, and see plates 8, 43 and 46.

The Rialto Bridge

Until the 1850s, people usually crossed the Grand Canal on *traghetti* (ferries), and the Rialto Bridge provided the only pedestrian route.[21] This had long been a crossing point, gradually assuming ever more permanent structures. In 1264 a wooden bridge was constructed, which can be seen in Vittore Carpaccio's *The True Cross healing a Possessed Man*

Fig. 64 Canaletto (1697–1768)
The Piazzetta di San Marco, looking West, with the Libreria,
about 1740, detail
Oil on canvas, 47 x 78.2 cm
Private collection

(Gallerie dell'Accademia, Venice). The bridge was twice destroyed, once by the conspirator Bajamonte Tiepolo (d. after 1329) in his uprising of 1310, and again in 1444, under the weight and crush of crowds straining to see the wedding procession of the Marquis of Ferrara. The structure in stone that survives today was designed and built between 1588 and 1591 by Antonio da Ponte (1512–95) and his nephew Antonio Contin (about 1566–1600). His involvement is somewhat surprising given the illustrious names who participated in the competition for the design: Michelangelo, Jacopo Sansovino, Giacomo Vignola, Vincenzo Scamozzi and Andrea Palladio. However, prolonged delays following fires in the Doge's Palace meant that they were unable to participate in the final project. The resulting bridge, supporting two rows of shops, is not entirely harmonious in conception, and heavy in design. It is adorned with a memorial inscription to Doge Pasquale Cicogna (r. 1585–95)

Fig. 65 Late nineteenth-century photograph of the Rialto Bridge

and relief sculptures propagating Venice's heritage and the notion of her divine protection: *The Annunciation* (the republic's mythical 'birthday', 25 March 421, was on the Feast of the Annunciation); and *Saint Mark* and *Saint Theodore*.
Fig. 65, and see plates 23, 38, 39, 56 and 62.

The Rio dei Mendicanti

This small canal is something of a backwater, running past the Campo Santi Giovanni e Paolo northwards into the Lagoon. On its east side is the Scuola Grande di San Marco

and the hospital and church of San Lazzaro dei Mendicanti. The façade of the hospital church was built in 1665–73 by Giuseppe Sardi and was funded by a bequest from the same Jacopo Gallo who had paid for Sardi's two earlier façades in the Campo San Salvador. A *squero* (gondola building yard) still operates on the opposite side of the canal, as depicted by Canaletto in one of the very few works of art to take the Rio as its subject (plate 9).
Figs 66 and 67, and see plate 9.

Fig. 66 The Rio dei Mendicanti as it is today

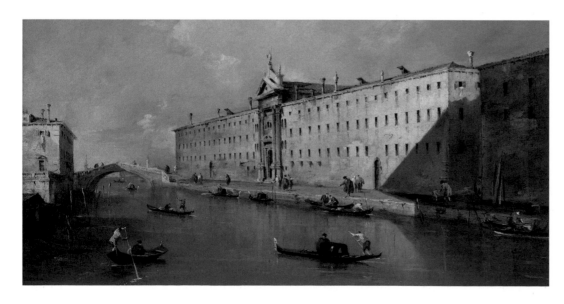

Fig. 67 Francesco Guardi (1712–1793) *A View of the Riva dei Mendicanti*, about 1780, detail Oil on canvas, 50.8 x 76.2 cm Private collection, California

The Riva degli Schiavoni

This quayside abutting the Molo stretches some 500 yards along the northern rim of the Bacino di San Marco towards the Rio dell'Arsenale. It was here that larger sailing boats used to moor, and it derives its name from the sailors from Dalmatia (Schiavonia) who anchored there. Originally the buildings, including a house where the poet Petrarch (1304–74) stayed, gave directly onto the waterfront, but the narrow quay has gradually been widened into a promenade, most notably in the 1780s.[22]

See plates 19 and 55.

San Cristoforo della Pace

This island formerly lay adjacent to the island of San Michele.[23] During Napoleonic rule, burial on mainland Venice was deemed unsanitary, and in 1807 Giannantonio Selva (1751–1819) was commissioned to design a cemetery on the island of San Cristoforo. His plan was never realised owing to lack of funding, but in 1836, under the direction of Annibale Forcellini, the canal separating San Cristoforo from its neighbour was filled in. The island's imposing fifteenth-century church and monastery, typical of Mendicant churches in Venice of this date, with a tripartite façade, plain brick masonry with Istrian stone sculptural details, buttressing piers, lancet windows and a rose window in the centre, had already been destroyed around 1810.[24]

Fig. 68, and see plates 7 and 51.

Fig. 68 Antonio Sandi (1733–1817)
San Cristoforo della Pace, engraving after Francesco Tironi, after 1779
Engraving
Private collection

San Giorgio Maggiore

Originally known as the Isola dei Cipressi (Island of the Cypresses) and used for the cultivation of vegetables and vines, the island of San Giorgio Maggiore lies in the Bacino di San Marco, just off the tip of the island of the Giudecca, facing the Molo and the Riva degli Schiavoni. Its skyline is dominated by the Benedictine church of San Giorgio, begun by Andrea Palladio (1508–80) in 1566. Government dispensation had to be granted to fell oak on Benedictine property in Treviso for the foundations, since the wood here was usually reserved for shipbuilding. By 1576 the church, which combines central and cruciform plans, was mostly finished, with the exception of the façade, which was completed to Palladio's model between 1607 and 1611, after his death. This is arguably Palladio's ecclesiastical masterpiece, combining Benedictine and Venetian conventions with classicising architectural language.[25] The façade, made from Istrian stone, takes the form of a projected temple front, articulated with columns of the Composite order, joined with swags, as on the Loggetta in the Piazza San Marco. The view of San Giorgio from the Molo was originally obscured by a row of houses on the waterfront of the island, but those were removed in 1609.

Fig. 69, and see plates 58 and 63.

Fig. 69 Luca Carlevarijs (1663–1730)
Chiesa di S. Giorgio Maggiore, de Monaci Benedettini, Architettura di Andrea Palladio, from *Le Fabriche, e Vedute di Venetia, disegnate, poste in Prospettiva, et intagliate da Luca Carlevariis* (Venice 1703)
Etching, 20.7 x 29.1 cm
The British Museum, London (1928, 1016.33)

The Basilica di San Marco

The Basilica di San Marco was without equal, both in form and function, in any other Italian medieval church.[26] Initially its primary function was to serve as a reliquary for the remains of Saint Mark, which were brought to Venice from Alexandria in 828/9, the first church being built in 830 under Doge Giovanni Partecipazio I (r. 829–36). Following a fire during a rebellion against the Doge, the church was rebuilt in 976 as a replica of the first. A third phase of redevelopment took place between 1084 and 1094, under Doges Contarini, Selvo and Falier. It was then that the church, based on the model of Justinian's Holy Apostles in Constantinople, assumed its complex role as reliquary, private chapel to the Doge, coronation hall and backdrop to political and ceremonial events, thus becoming an iconic expression of religious and secular power.[27] Ironically, by this time, the remains of Saint Mark – which had assumed a political relevance of their own but had not hitherto been placed in the church – had been lost; they were supposedly miraculously rediscovered inside a column.

It was not until the efforts of Venetian looters during the Fourth Crusade of 1202–4, culminating in the sack of Constantinople, that the brick building with its five domes assumed the dazzling internal and external veneer we see today.[28] The south façade, embellished with some of the most impressive treasures, was important as the focal point from the Molo and the Piazzetta, where visitors to Venice would alight. Here are displayed spoils from Constantinople – a porphyry sculpture thought to represent four Roman emperors (the Tetrarchs), polychromatic marble *paterae*, two pillars carved with vegetal reliefs – and the Pietra del Bando – a squat porphyry column from Acre, where the heads of executed traitors were displayed. The west façade was dominated by four bronze horses on pedestals in front of the window, gleaming against the intercolumniations, reminiscent of the *quadrigas* that crowned triumphal arches.[29] The rest of the façade is interspersed with iconographically pertinent sculptures by Venetian masters, which

Fig. 70 Gentile Bellini (active about 1460; died 1507)
Procession in the Piazza San Marco, 1496, detail of fig. 2
Oil on canvas, 367 × 745 cm
Gallerie dell'Accademia, Venice

integrate easily with – and in some cases emulate – looted works.[30] The façade culminates in ogival gables adorned with prophet busts and leafy ornament, but it is the mosaic cycle – not finished until the nineteenth century[31] – that indicates the true function of the church as a martyrium and provides a foretaste of the riches of the mosaic-covered interior. *Fig. 70, and see plates 5, 10, 15, 28, 31 and 59.*

Santa Maria della Carità

The Scuola Grande di Santa Maria della Carità, founded in 1260, was probably the first of the great Venetian *scuole* (guilds), and in 1294 it obtained its own hall above the portico of the monastery of Santa Maria della Carità. The Lateran canons rebuilt the church in 1442–52, and new buildings for the *scuola* were begun at the same time (the *scuola*'s façade, at a right angle to that of the church, dates from 1461). The *campanile* of the earlier church was retained and survived until 1741, when it collapsed, fortunately towards the Grand Canal, destroying only the two adjoining houses and propelling two *traghetti* (small ferries) into the Campo San Vidal on the other side of the canal. The church was suppressed in 1807 and all of the buildings of Santa Maria della Carità were made over to the Accademia di Belle Arti and the Gallerie dell'Accademia, which they still house. *See plate 11.*

Santa Maria della Salute

Supported on no fewer than 1,156,627 wooden piles, the church of Santa Maria della Salute is the pre-eminent Baroque church in Venice. The masterpiece of Baldassare Longhena, it was begun following a Senate decree of 22 October 1630, in the hope that its construction would help to deliver the city from the plague, to which Venice was particularly susceptible, losing more than 46,000 people in 16 months in 1630–1 – hence the church's name, 'Salute', meaning 'health' or 'salvation'. Longhena was fortunate to live just long enough to see the church's completion in 1681. The site was chosen partly because of its proximity to the churches of San Marco, San Giorgio Maggiore and the Redentore. Standing close to the point where the Grand Canal enters the Bacino di San Marco, its towering domes are the focal point of any view down the last stretch of the Grand Canal, as well as for many vistas from the Bacino. *See plates 8, 26, 29, 36, 43, 47 and 50.*

Santa Maria degli Scalzi

Although the church is by Baldassare Longhena, its opulent façade, begun in 1672, is by Giuseppe Sardi and was commissioned by the newly ennobled diplomat Gerolamo Cavazza (about 1588–1681), who paid the enormous sum of 74,000 ducats for its construction. *See plate 25.*

San Michele

San Michele is now the cemetery island of Venice. Situated between Venice and Murano, it was originally adjacent to, but then joined with, the island of San Cristoforo. It is dominated by the church of San Michele in Isola, begun in 1468 for the Camaldolese branch of the Benedictines and the earliest known work by the adopted Venetian architect Mauro Codussi (1440–1504).[32] Its gleaming façade, made of white limestone from Istria (increasingly favoured as the prime building material in Venice, and later used for Andrea Palladio's Redentore and San Giorgio Maggiore), is embellished with porphyry disks around an oculus, shell mouldings on the quadrants and radial fluting on the semicircular pediment. The use of rustication – which unusually runs over the pilasters, creating a striking visual effect – perhaps drew upon the work of the Florentine architect Leon Battista Alberti (1404–72), but also the rusticated foundations of the

Fig. 71 Antonio Sandi (1733 1817)
San Michele, engraving after Francesco Tironi, after 1779
Engraving
Private collection

(unfinished) Ca' del Duca on the Grand Canal. The compartmentalised façade, united by the use of classical details, is an exercise in restraint and serenity and formed the touchstone for early Renaissance architecture in Venice. *Fig. 71, and see plate 7.*

San Simeone Piccolo
Situated in the upper reaches of the Grand Canal on the south side, opposite the railway station, this church dedicated to Saint Simeon and Saint Jude was built by Giovanni Scalfarotto (1670–1764) between 1718 and 1738. Its façade was inspired by the Pantheon, with adjusted scale and proportion, although the heightened dome must owe something to Baldassare Longhena's Santa Maria della Salute.
See plate 25.

The Torre di Malghera
Malghera (now called Marghera), at the mainland end of the causeway from Venice (the Ponte della Libertà), is now best known for the Porto Marghera, the controversial industrial zone developed between 1919 and 1935. The Torre di Malghera was a relic of the fifteenth-century fortifications of Venice. Such defences on the nearest part of the mainland were important for the protection of the city: on numerous occasions the shores of the Lagoon were reached by enemies of the republic, from the Frankish Italian King Pepin in 810 to the army of the Holy League under Ramón de Cardona in 1513, when Malghera was burned and shots fired across the water towards Venice itself. The tower survived into the nineteenth century, being destroyed sometime before 1842.[33]
Fig. 52, and see plate 30.

1 Chambers and Pullan 1992, p. 19.
2 For further information see Goy 2006, pp.141 ff.
3 Morosini's visit to Athens was perhaps most notable for his blowing up of the Parthenon.
4 Lane 1973, pp. 13–15.
5 For a full analysis of the two saints and their relevance, see Fenlon 2009, pp. 14ff.
6 Lane 1973, pp. 13–14.
7 Howard 2002, p. 139.
8 The importance of the *campo* and church of San Salvador are fully discussed in Tafuri 1995, pp. 15–50.
9 Howard 2002, pp. 228–9.
10 Howard believes the date to be 810 (1980, p. 90); Susan Wallington (Connell) believes it to have been a little later, in 811–13 (private communication, 1997).
11 Howard believes the date to be 1404 (2002, pp. 92–3).
12 John Ruskin, cited in Howard 2002, p. 90.
13 For a detailed account of the Palazzo Ducale see Franzoi, Pignatti and Wolters 1990.
14 Cassiodorus, cited in Lane 1973, p. 3.
15 Hunting on the Lagoon has been memorably described more recently by Ernest Hemingway in *Across the River and into the Trees* (1950). Carpaccio's painting is called *Hunting on the Lagoon.*
16 Bessarion's bequest document – a panegyric to the Republic of Venice – is translated in Chambers and Pullan 1992, pp. 357–8.
17 The implications and complexities of the use of Roman features on the Library are discussed in Howard 2002, pp. 175–8. For the Grimani bequest see Perry 1978.
18 Noted in Fenlon 2009, p. 113.
19 It is possible that the design owed something, at least in part, to a model submitted by a Tuscan architect called 'il Celestro'. See Howard 2002, p. 151.
20 Fenlon 2009, p. 76.
21 A useful summary of the history of the Rialto Bridge can be found in Norwich 1982, pp. 504–5.
22 Links 1998b, p. 24.
23 See Zorzi 1977, vol. 2, pp. 401–3.
24 For more on Mendicant churches in Venice, see Howard 2002, pp. 75ff.
25 A thorough discussion of the church can be found in Howard 2002, pp. 196ff.
26 For an analysis of the various stages of the Basilica, see Demus 1960, and for further up-to-date details and discussion of iconography, see Fenlon 2009, pp. 20ff.
27 It did not become the Cathedral of Venice until 1807.
28 The north and west atria were also added at that date.
29 The original horses are now displayed in the Basilica's museum. They were looted from Constantinople, and it is still a matter of debate whether they are of Greek or Roman origin.
30 For more on the sculpture, see Goldner 1978.
31 Fenlon 2009, p. 25.
32 Howard 2002, pp. 133–5.
33 Referred to as destroyed in Cicogna 1842,V, p. 345.

Ceremonies and Events

Ascension Day

The Feast of the Ascension of Christ (the Festa della Sensa), which took place on the fortieth day after Easter, was the greatest of Venetian annual festivals. The Ascension season ran from May to June and was the culmination of the standard theatre season, which began in mid-November.[1] The state ceremonial galley, the *bucintoro*, was brought out of the Arsenale for the day and rowed to the Molo, where the Doge and Senate embarked. They were transported to San Nicolò di Lido, a church on the Lido dedicated to Saint Nicholas of Myra, patron of those who sailed the seas. There, with grandees of the republic and foreign envoys looking on, the Doge cast a golden ring into the sea to symbolise the marriage of the city with its greatest asset. There are thought to have been four incarnations of the *bucintoro*: the vessel used from 1606 to the first quarter of the eighteenth century is thought to have been the third. What was to prove the last was built in the 1720s to the designs of Michele Stefano Conti, and inaugurated in 1729.[2] Certainly the most

magnificent, it was described by the English visitor Richard Pococke in 1734 as 'without doubt the finest ship in the world'.[3]

The ceremony evolved from events of 1177, as recorded around 1320 by Bonincontro da Bori, a notary in the Ducal Chancery, and thereafter expanded upon by various state-appointed historians and panegyrists.[4] Fleeing Frederick I Barbarossa (1122–90), Pope Alexander III (r. 1159–81) had taken refuge in Venice – at that time under the leadership of Doge Sebastiano Ziani (r. 1172–78) – and in gratitude had granted the city state lordship of the Adriatic. This was symbolised by a gold ring 'to marry the sea ... in a sign of perpetual dominion'.[5] Legend had it that Barbarossa was subsequently defeated by the Venetian fleet and forced to supplicate before the Pope in Venice. No such naval victory actually took place, but Doge Ziani did preside over a peace treaty between Barbarossa and the Pope in 1177. It has also been suggested that the ceremony evolved from a pagan tradition of making an offering to Neptune, which may have developed into the magnificent Christian ceremonial.[6] Aspects of the ceremony may have served as an embodiment of the Venetian political system, representing the tripartite

Fig. 72 Canaletto
(1697–1768)
Ascension Day, about 1731–2
Oil on canvas, 86 x 137 cm
Private collection

division of the Venetian state – the Doge, the Senate and the people, here the oarsmen.

While the main ceremonial action took place on the water, the Piazza San Marco was overwhelmed by an influx of visitors and merchants' booths, even on one occasion prostitutes selling their daughters to the highest bidder.[7] Alongside these secular scenes, some orders, notably the Dominicans, added high drama by displaying miraculous relics.[8]

In 1702, with the French fleet operating in the Adriatic against the Austrians, the ceremony of the marriage of the sea was cancelled for the first time – an event that arguably 'symbolised the end of Venetian pretensions to control the operations of foreign warships in the Adriatic'.[9] The ceremony perished along with the republic itself in 1797. *Fig. 72, and see plates 3, 16, 24 and 42.*

Bull Chasing in the Piazza San Marco to Celebrate the Visit of Frederick Christian of Saxony, 16 February 1740

The chasing and baiting of bulls was an ancient tradition of uncertain origin in Venice.[10] The bulls were restrained with ropes by *tiratori* – famed for their bravery and strength – and baited by dogs, while the populace played an elaborate ducking game. Such events bore comparison to the sentencing to death of a bull and 12 pigs on the morning of Giovedì Grasso (p. 173), following a spectacular chase, which served to symbolise the myth of Venetian indomitability.[11] This bloody spectacle, in which the animals were sometimes tortured and decapitated, has also been interpreted as a perverse reference to the renewal of life, whereby the old dying body is cast aside in a revival of youth.[12]

Bull chasing was described by both Marin Sanudo (1466–1533) and Jacopo Sansovino (1486–1570) in the fifteenth and sixteenth centuries, but achieved the height of its popularity in the eighteenth century. Chases took place during carnival time – which usually ran from the Feast of Saint Stephen on 26 December until the first day of Lent, but could be extended to up to six months – and were usually staged in some of the larger *piazze*. The chase laid on for Frederick Christian of Saxony (1722–1763) was an exception, and was just one aspect of a rich programme of entertainment that included jousting and a concert at the Ospedale

della Pietà of concertos specially composed for the occasion by Antonio Vivaldi.[13] For the bull chasing a huge barrier had to be erected around the Piazza San Marco, and some 'forty-eight of the most expert youths, masked in European, Asiatic, African, and American styles, and attended by upwards of fifty dogs, were engaged in the sport for three hours'.[14]

Frederick Christian, later very briefly Prince-Elector of Saxony, was the eldest surviving son of Frederick Augustus II (1696–1763), Prince-Elector of Saxony and King of Poland. He arrived in Venice on 19 December 1739, proceeding to his lodgings in the Palazzo Foscari on 21 December under the name of Count Lusazia.[15] A painting by Bernardo Bellotto (1720–1780) (Nationalmuseum, Stockholm) shows the paraplegic Frederick at the water door of the *palazzo*, supported by burly attendants.[16] Despite the pretence of travelling incognito – which would have been difficult given that his visit lasted six months – he soon befriended the writer Lady Mary Wortley Montagu (1689–1762), who lived opposite him on the Grand Canal.[17] He was accompanied by the

Fig. 73 Giovanni Battista Cimaroli (1687–1771)
The Piazza San Marco with the Populace chasing Bulls in Celebration of the Visit of Friedrich Christian of Saxony, 16 February 1740, about 1740
Detail of plate 33

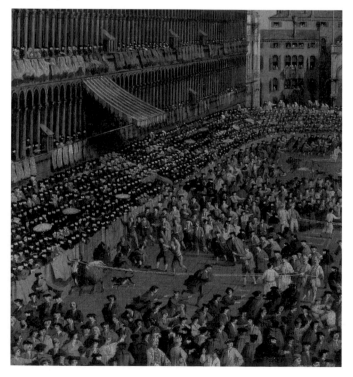

German statesman Joseph Anton Gabaleon, Count Wackerbarth-Salmour (1685–1761), who served as his mentor and governor.
Fig. 73, and see plate 33.

The Feast of Santa Maria della Salute

Venice's deliverance from the plague epidemic of 1630–1, which lasted some 16 months and killed 46,490 people, and the subsequent foundation of the church of Santa Maria della Salute (p. 167), were celebrated on 21 November, the Feast of the Salvation and of the Presentation of the Virgin. The cult of the Virgin held particular relevance to Venetians, who were themselves – before the arrival of Napoleon – inviolate to invasion.

This Andata Ducale (ducal procession) – one of 36 in the Venetian ritual calendar – began at the Doge's Palace, whence the Doge would process to the church with the *signoria* (the dogal councillors and the Heads of the Forty – the principal government authority).[18] The ceremony was closely modelled on the annual procession to Andrea Palladio's Redentore, another, earlier state church com-

memorating deliverance from the plague.[19] The Doge and his attendants arrived from the Piazzetta by boat, but other participants, including members of the *scuole* (guilds) and priests, arrived via a specially constructed pontoon bridge from the Campo Santa Maria Zobenigo (also known as Santa Maria del Giglio). Low Mass was said at Santa Maria della Salute, then the protagonists proceeded to the Basilica di San Marco where the main liturgy was performed, the occasion being marked by the opening of the Pala d'Oro – the Basilica's gold altarpiece encrusted with enamels and precious stones. Logistics for the event must have been complicated, with some five thousand participants pouring in and out of the church of the Salute. Baldassare Longhena's interior facilitated this to some extent, as the ambulatory on the rotunda was designed to accommodate processional movement. In addition, unlike the Redentore, which was similarly a votive church and in some ways Longhena's model, the Salute had three doors rather than one, easing the flow to and from its magnificent steps.
Fig. 74, and see plate 6.

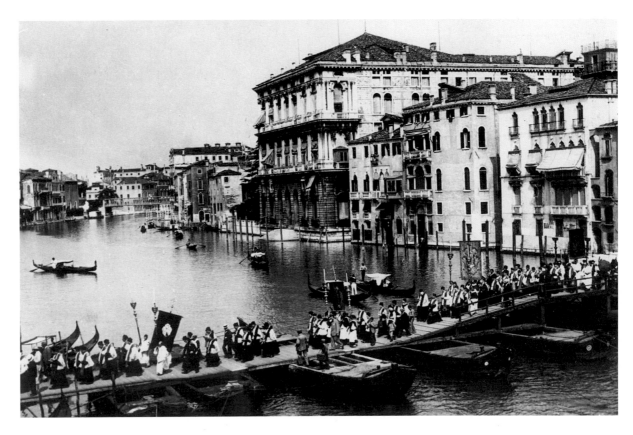

Fig. 74 1890s photograph of the Feast of Santa Maria della Salute, with pontoon

The Reception of the British Ambassador Charles Montagu, 4th Earl of Manchester, at the Doge's Palace, 22 September 1707

Charles Montagu (about 1662–1722), 4th Earl and later 1st Duke of Manchester, was twice British ambassador extraordinary to Venice.[20] His second term (which lasted from July 1707 until 12 October 1708; the first was in 1697–8) was undertaken with the aim of persuading the republic to ally with Britain against the French and the Spanish.[21] He soon discovered, however, that the Venetian government was merely 'an outward show, and their neutrality has been suffered … knowing they are not in a condition of being serviceable in any manner'.[22] Grand receptions such as that laid on for the Earl, were, by the eighteenth century, empty displays, serving only to disguise the political inertia and decline that had befallen 'La Serenissima' – no longer a great European power. Although he returned home bereft of political trophies, the Earl was by no means empty-handed, taking with him not only the great mezzo-soprano castrato Nicolo Grimaldi (1673–1732), or 'Nicolini', the leading male singer of his age, but also the prominent Venetian painters Giovanni Antonio Pellegrini (1675–1741) and Marco Ricci (1676–1730), who subsequently enjoyed fruitful periods working in England.

See plate 2.

The Reception of the French Ambassador Jacques-Vincent Languet, Comte de Gergy, at the Doge's Palace, 4 November 1726

Whilst Charles Montagu, 4th Earl of Manchester, had travelled to Venice with the intention of rallying support against the French (see above), the visit of the Comte de Gergy (1667–1734) was made with the opposite intention. A *chevalier de l'ordre de Wirtemberg*, the count was appointed the French King's ambassador to Venice in 1723, arriving there on 5 December.[23] As often happened, his state reception did not take place until nearly three years later, which must have given the Venetian government ample time to organise the event, and the Comte de Gergy enough time to find suitably renowned painters to record it (the reception was painted by both Carlevarijs and Canaletto).[24] It is possible that the Count shared the sentiments of his compatriot the political philosopher Charles-Louis de

Secondat, Baron de Montesquieu (1689–1755), who proclaimed that, though his eyes were 'very pleased by Venice', his 'heart and mind [were] not'.[25]

See plate 13.

The Regatta on the Grand Canal in Honour of Frederick IV, King of Denmark and Norway, 4 March 1709

The topography of Venice has always lent itself to dramatic spectacles, and of these none more so than 'regattas' or gondola races. Frederick IV (1671–1730), King of Denmark and Norway from 1699 until his death, arrived in Venice on 30 December 1708 during a famously bitter winter when the Lagoon had frozen over.[26] He stayed for nine weeks, lodging in the Palazzo Foscarini Giovanelli di Sant'Eustachio, the residence of Charles Montagu, 4th Earl of Manchester (see above), who had by then left for England.[27] Known to lack any interest in academic knowledge, the King was nevertheless a patron of culture, and his main weaknesses of pleasure-seeking and womanising must have been well catered for in Venice. The regatta in his honour was organised for the day before the King's departure by Alvito Foscari (head of the noble Foscari family), who entertained him afterwards with a banquet at Ca' Foscari (from which the two views of the regatta by Luca Carlevarijs are taken: plate 4 and one at Frederiksborg Castle, Denmark).

The boats in the race were richly decorated, the King's gondoliers wearing the gold and red livery of the House of Oldenburg (a North German dynasty which rose to prominence when it was elected to the thrones of Denmark and Norway in the mid-fifteenth century). An elaborate temporary structure – *una macchina della regatta* – was erected next to the Palazzo Balbi at the *volta del Canal* to mark the finishing line.

The Venetian calendar was – and is – peppered with regular boat races, as would be expected of a maritime republic. The main regatta – the Regata Storica (Historical Regatta) – on the first Sunday of September, began with a ceremonial parade along the Grand Canal, followed by rowing races between the various *sestieri* (districts) of Venice. Regattas were made up of races for various kinds of boats, with younger rowers and women in their own categories. These latter was probably quite exciting for the

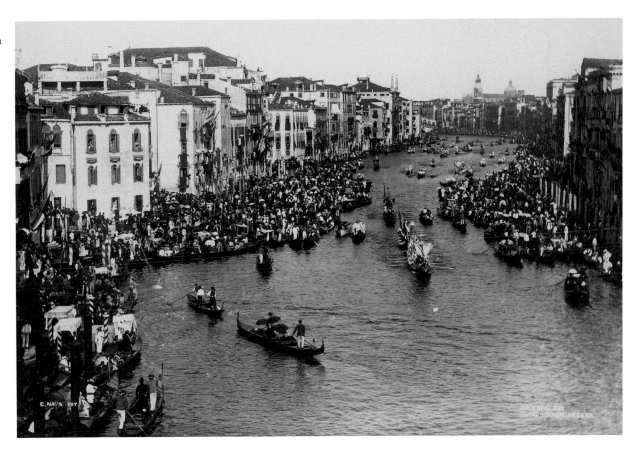

Fig. 75 Late nineteenth-century
photograph of the Regata Storica

Venetian male, leading one sixteenth-century friar to tell –
or fantasise – how he had 'been a spectator at a women's
race, [and] that they had been nude and had their fronts half
uncovered'.[28]

Fig. 75, and see plate 4.

The Festival of Giovedì Grasso

Giovedì Grasso, the last Thursday before the beginning of
Lent, was a major festival in Venice, a city whose populace
rarely overlooked an opportunity for public celebration. It
was initiated in 1162, following the seizure of the Venetian
vassal Grado by the German-born Patriarch Ulrich of
Aquileia at the instigation of Frederick Barbarossa, Emperor
of the West. Doge Vitale II Michiel immediately retaliated,
recapturing the city on the day coinciding with Giovedì
Grasso, destroying a number of Friulian castles and taking
700 prisoners, including Ulrich. The latter were released on
condition that every year on the Wednesday before Lent the
Patriarch of Aquileia would deliver to Venice a tribute of a
bull, 12 pigs and 300 loaves of bread. The following day, the
animals, which symbolised Ulrich and the twelve Friulian
canons who had accompanied him, were formally
condemned to death before being chased around the
Piazzetta and decapitated there, in front of the Doge's
Palace where public executions generally took place. By
1420, when the temporal domain of Aquileia was abolished,
the spectacle had become so popular that the government
found it necessary to continue it with animals provided from
the public purse. Following a decree of 1525 the 12 pigs were
spared but the beheading of the bull continued, accompa-
nied by other, more decorous entertainments, until the fall
of the Republic in 1797.

Guardi's representation of the subject of around 1758
(fig. 76; plate 52) shows three bulls about to be executed in
front of the Doge, who watches from the centre of the loggia
of the Doge's Palace. In the centre of the Piazzetta is the tall
wooden structure used to launch fireworks, which appears
to bear the arms of the reigning Doge, Francesco Loredan
(r. 1752–62). This is flanked by members of the Castellani
and Nicolotti factions, drawn from the parishes of San Pietro

di Castello and San Nicolò dei Mendicoli, competing to form pyramids, a gymnastic feat known as the *Forze d'Ercole*. The scene is dominated, however, by the most spectacular feature of the festivities, the *Svolo del Turco*, so named because in the sixteenth century Turkish daredevils were employed to perform it. In this a youth descended on a wire from the top of the Campanile to present the Doge with a bunch of flowers and complimentary verses. After being recompensed with a purse of money, he would then retrace his path back up the Campanile. Often there was more than one acrobat, the *Gazzetta Veneta* of 16 February 1760 recording that in that year there were no fewer than four.[29]

1 M. Feldman, 'Opera, Festivity, and Spectacle in "Revolutionary" Venice: Phantasms of Time and History', in Martin and Romano 2000, p. 257, note 71.

2 Not to be confused with the Lucchese Stefano Conti, an important patron of Carlevarijs and Canaletto (see pp. 60, 69).

3 Richard Pococke, cited in Redford 1996, p. 61. After the Napoleonic occupation this last *bucintoro* was burned, but not before the gilding had been removed.

4 For a full assessment and details of the legend see Fortini Brown 1988, pp. 38–9.

5 The indulgence, granted by Pope Alexander III for all perpetuity, began on the eve of Ascension Day and is noted by Francesco Sansovino, cited by B. Pullan in Chambers and Pullan 1992, p. 191.

6 Lane 1973, p. 57.

7 R.C. Davis, 'Slave Redemption in Venice', in Martin and Romano 2000, p. 478.

8 D. Pincus, 'Hard Times and Ducal Radiance', in Martin and Romano 2000, p. 129, note 27.

9 Lane 1973, p. 417.

10 Tamassia Mazzarotto 1980, p. 37, note 7. Chapter 1, 'La Caccia Dei Tori e Dell'Orso', gives a thorough account of bull chasing and its complexities. For ancient precedents, see Crooke 1917, pp. 141–63.

11 Muir 1981, pp. 160–1.

12 Mikhail Bakhtin, cited in Muir 1981, p. 178: 'The Rabelasian images fix the very moment of this transfer which contains the two poles. Every blow dealt to the old helps the new to be born.'

13 Vivaldi was employed in the Conservatory at the Ospedale della Pietà from 1703 until his departure from Venice later in 1740.

14 London 1849, under no. 3.

15 Kowalczyk 1999, p. 199ff.

16 First identified by Kowalczyk in Kowalczyk 1999.

17 Grundy 1999, p. 407.

18 A good overview of the ceremony can be found in Hopkins 2000, pp. 144ff.

19 A contemporary account can be found in Sansovino 1663 edn, p. 525.

20 See entry in Ingamells 1997, pp. 633–4.

21 During the war of the Spanish succession (1701–14), Venice had been wooed by Spain and France but had evaded both.

22 Manchester, *Court and Society*, 298 (2 March 1708), quoted in Ingamells 1997, pp. 633–4.

23 Aubert de la Chenaye-Desbois 1774, VIII, p. 457.

24 See also *Repertorium der diplomatischen Vertreter aller Länder seit dem Westfälischen Frieden (1648)*, Zürich 1950, vol. 2, p. 132; cited in Haskell 1956, p. 298, note 14.

25 Montesquieu, cited in Levey 1994, p. 2.

26 The Venetians consequently joked that the King had brought Scandinavian weather with him.

27 Kragelund 2009, pp. 1–2.

28 Laven 2002, p. 200.

29 For more on the subject, see Tamassia Mazzarotto 1980, pp. 31–9, and Muir 1981, pp. 160–71.

Facing:
Fig. 76 Francesco Guardi (1712–1793)
The Festival of Giovedì Grasso in the Piazzetta, 1758
Detail of plate 52

Bibliography

Ackroyd 2009
P. Ackroyd, *Venice: Pure City*, London 2009

Amsterdam 1990–1
B. Aikema and B. Bakker, *Painters of Venice: The Story of the Venetian 'Veduta'*, trans. A. McCormick, exh. cat., Amsterdam (Rijksmuseum), The Hague 1990–1

Arisi 1986
F. Arisi, *Gian Paolo Panini e i fasti della Roma del '700*, Rome 1986

Aterido et al. 2004
A. Aterido, J.M. Cuesta, J.J. Pérez Preciado with D. Blanca, *Inventarios reales: Colecciones de pinturas de Felipe V e Isabel Farnesio*, 2 vols, Madrid 2004

Atlanta, Seattle and Minneapolis 1995–6
Treasures of Venice: Paintings from the Museum of Fine Arts, Budapest, eds G. Keyes, I. Barkóczi and J. Satkowski, exh. cat., Atlanta (High Museum of Art), Seattle (Art Museum), Minneapolis (Institute of Arts), New York 1995–6

Aubert de la Chenaye-Desbois 1774
François-Alexandre Aubert de la Chenaye-Desbois, *Dictionnaire de la Noblesse*, 2nd edn, Paris 1774

Barber 1988
G. Barber, 'From Canaletto to the Ostrich: Parisian Popular Entertainments in 1755', *Bodleian Library Record*, XII, no. 6 (April 1988), pp. 453–70

Barcelona 2001
D. Succi and A. Delneri, *Canaletto. Una Venècia Imaginària*, exh. cat., Barcelona (Centre de Cultura Contemporània), 2001

Beddington 2004
C. Beddington, 'Bernardo Bellotto and his circle in Italy. Part 1: Not Canaletto but Bellotto', *The Burlington Magazine*, CXLVI, no. 1219 (October 2004), pp. 665–74

Beddington 2005
C. Beddington, 'Bernardo Bellotto and his circle in Italy, Part 2: The Lyon Master and Pietro Bellotti', *The Burlington Magazine*, CXLVII, no. 1222 (January 2005), pp. 16–25

Beddington 2006a
C. Beddington, *Canaletto in England: A Venetian Artist Abroad 1746–1755*, New Haven and London 2006

Beddington 2006b
C. Beddington, 'Some little-known Venetian views by Canaletto of the 1720s', *The Burlington Magazine*, CXLVIII, no. 1244 (November 2006), pp. 772–8

Beddington 2007
C. Beddington, 'Pietro Bellotti in England and elsewhere', *The Burlington Magazine*, CXLIX, no. 1255 (October 2007), pp. 678–84

Belluno 1993
Marco Ricci e il paesaggio veneto del Settecento, eds D. Succi and A. Delneri, exh. cat., Belluno (Palazzo Crepadona), Milan 1993

Berlin 1974
Venedig im 18. Jahrhundert: Bilder aus der Streit'schen Stiftung, ed. E. Schleier, exh. cat., Berlin (Gemäldegalerie), 1974

Berlin 2002–3
Blick auf den Canal Grande: Venedig und die Sammlung des Berliner Kaufmanns Sigismund Streit, ed. N. Hartje, exh. cat., Berlin (Gemäldegalerie), 2002

Bettagno 1983
A. Bettagno, 'In margine a una mostra', *Notizie da Palazzo Albani*, XII, nos 1–2 (1983), pp. 222–8

Bettagno and Magrini 2002
A. Bettagno and M. Magrini (eds), *Lettere artistiche del Settecento veneziano*, I, Vicenza 2002

Binion 1990a
A. Binion, *La galleria scomparsa del maresciallo von der Schulenburg: Un mecenate nella Venezia del Settecento*, Milan 1990

Binion 1990b
A. Binion, 'I Bellotto di Schulenburg', in *Bernardo Bellotto: Verona e le città europee*, ed. S. Marinelli, exh. cat., Verona (Museo di Castelvecchio), Milan 1990, pp. 27–9

Bomford and Roy 1993
D. Bomford and A. Roy, 'Canaletto's "Stonemason's Yard" and "San Simeone Piccolo"', *National Gallery Technical Bulletin*, XIV (1993), pp. 34–41

Bottari and Ticozzi 1822
G. Bottari and S. Ticozzi, *Raccolta di lettere sulla pittura, scultura ed architettura …*, II, Milan 1822

Briganti 1970
G. Briganti, *The View Painters of Europe*, London 1970

Briganti 1996
G. Briganti, *Gaspar van Wittel*, 2nd edn, eds L. Laureati and L. Trezzani, Milan 1996

Browning 1905
H.E. Browning, 'The Canaletto Collection at Castle Howard', *Art Journal*, LXVIII (1905), pp. 340–5

Camesasca 1974
E. Camesasca, *L'opera completa del Bellotto*, Milan 1974

Campori 1870
G. Campori, *Raccolta di Cataloghi ed Inventarii …*, Modena 1870

Chambers 1970
D. Chambers, *The Imperial Age of Venice 1380–1580*, London 1970

Chambers and Pullan 1992
D. Chambers and B. Pullan (eds), *Venice: A Documentary History 1450–1630*, Oxford 1992

Cicogna 1840, 1842
E. Cicogna, *Delle Inscrizioni Veneziane*, 6 vols, Venice 1824–53

Constable 1929
W.G. Constable, 'Canaletto at the Magnasco Society', *The Burlington Magazine*, LV, no. 316 (July 1929), pp. 46–50

Constable 1962, 1976 and 1989
W.G. Constable, *Canaletto: Giovanni Antonio Canal 1697–1768*, 2 vols, London 1962 (2nd edn rev. J.G. Links, Oxford 1976, reissued with supplement and additional plates Oxford 1989)

Contini 2002
R. Contini, *The Thyssen-Bornemisza Collection: Seventeenth and Eighteenth Century Italian Painting*, London 2002

Corboz 1985
A. Corboz, *Canaletto: Una Venezia immaginaria*, 2 vols, Milan 1985

Coronelli 1700
V. Coronelli, *Guida de' forestieri*, 2nd edn, Venice 1700

Crema 2002
Officina Veneziana: Maestri e Botteghe nella Venezia del Settecento, eds F. Magani and F. Pedrocco, exh. cat., Crema (Centro culturale Sant'Agostino), Milan 2002

Crooke 1917
W. Crooke, 'Bull-Baiting, Bull-Racing and Bull Fights', *Folklore*, XXVIII, no. 2 (1917), pp. 141–63

Delneri 1999
A. Delneri, "Non vedo l'ora di vedere li due quadri lodati universalmente", in *Pittura Veneziana dal Quattrocento al Settecento: Studi di storia dell'arte in onore di Egidio Martini*, ed. G.M. Pilo, Venice 1999, pp. 191–6

Demus 1960
O. Demus, *The Church of San Marco in Venice: History, Architecture, Sculpture*, Cambridge, MA, 1960

Dodsley and Dodsley 1761
R. and J. Dodsley, *London and Its Environs Described. Containing an Account of Whatever is Most Remarkable for Grandeur, elegance, Curiosity or Use, in the City and in the Country Twenty Miles round it*, 6 vols, London 1761

Dresden 2008
Canaletto: Ansichten vom Canal Grande in Venedig, Das restaurierte Meisterwerk, exh. cat., Dresden (Gemäldegalerie Alte Meister), 2008

Eglin 2001
J. Eglin, *Venice Transfigured: The Myth of Venice in British Culture, 1660–1797*, New York 2001

Fenlon 2009
I. Fenlon, *Piazza San Marco*, London 2009

Fiocco 1932
G. Fiocco, 'Giovanni Richter', *L'Arte* (January 1932), pp. 3–15

Fortini Brown 1988
P. Fortini Brown, *Venetian Narrative Painting in the Age of Carpaccio*, New Haven 1988

Franzoi, Pignatti and Wolters 1990
U. Franzoi, T. Pignatti and W. Wolters, *Il Palazzo Ducale di Venezia*, Treviso 1990

Goldner 1978
G. Goldner, *Niccolò and Piero Lamberti*, New York 1978

Gorizia 1987
P. Casadio et al., *Guardi, metamorfosi dell'immagine (Problemi critici per Antonio, Francesco, Nicolò e Giacomo)*, exh. cat., Gorizia (Castello di Gorizia) 1987

Gorizia 1988
Capricci veneziani del Settecento, ed. D. Succi, exh. cat., Gorizia (Castello di Gorizia) 1988

Gorizia 1989
Marieschi tra Canaletto e Guardi, ed. D. Succi, exh. cat., Gorizia (Castello di Gorizia), Turin 1989

Gorizia 2008
Le Meraviglie di Venezia: Dipinti del '700 in collezioni private, eds D. Succi and A. Delneri, exh. cat., Gorizia (Palazzo della Torre), Venice 2008

Gorizia and Venice 1983
Da Carlevarijs ai Tiepolo: Incisori veneti e friulani del Settecento, ed. D. Succi, exh. cat., Gorizia (Musei Provinciali, Palazzo Attems), Venice (Museo Correr), 1983

Goy 2006
R. Goy, *Building Renaissance Venice: patrons, architects and builders, c.1430–1500*, New Haven and London 2006

Gradenigo 1942
Notizie d'Arte tratte dai Notatori e dagli Annali del N.H. Pietro Gradenigo, ed. L. Livan, Venice 1942

Greenwich and Amsterdam 2006–7
P.C. Sutton, *Jan van der Heyden*, exh. cat., Greenwich, CT (Bruce Museum) and Amsterdam (Rijksmuseum), 2006–7

Grundy 1999
I. Grundy, *Lady Mary Wortley Montagu: Comet of the Enlightenment*, Oxford 1999

Guarienti 1753
P. Guarienti in P.A. Orlandi and P. Guarienti, *Abecedario Pittorico*, Venice 1753

Hanover and Düsseldorf 1991–2
Venedigs Ruhm im Norden. Die großen venezianischen Maler des 18 Jahrhunderts, ihre Auftraggeber und ihre Sammler, exh. cat., Hanover (Forum des Landesmuseums), Düsseldorf (Kunstmuseum), Hanover 1991–2

Hartford 1991
Wadsworth Atheneum Paintings II: *Italy and Spain*, ed. J.K. Cadogan, Hartford, CT, 1991

Haskell 1960
F. Haskell, 'Francesco Guardi as a Vedutista and Some of his Patrons', *Journal of the Warburg and Courtauld Institutes*, XXIII, nos 3–4 (1960), pp. 256–76

Haskell 1963
F. Haskell, *Patrons and Painters: A Study in the Relations between Italian Art and Society in the Age of the Baroque*, London 1963

Hopkins 2000
A. Hopkins, *Santa Maria della Salute: Architecture and Ceremony in Baroque Venice*, Cambridge 2000

Howard 1980 and 2002
D. Howard, *The Architectural History of Venice*, 1st edn 1980; rev. edn New Haven and London 2002

Ingamells 1997
J. Ingamells, *A Dictionary of British and Irish Travellers in Italy 1701–1800 compiled from the Brinsley Ford Archive*, New Haven and London 1997

Kowalczyk 1995
B.A. Kowalczyk, 'Il Bellotto veneziano nei documenti', *Arte Veneta*, XLVII (1995), pp. 68–77

Kowalczyk 1996
B.A. Kowalczyk, 'Il Bellotto veneziano: grande intendimento ricercasi', *Arte Veneta*, XLVIII (1996), pp. 71–89

Kowalczyk 1998
B.A. Kowalczyk, 'I Canaletto della National Gallery di Londra', *Arte Veneta*, LIII (1998), pp. 73–100

Kowalczyk 1999
B.A. Kowalczyk 'I primi sostenitori Veneziani di Bernardo Bellotto', *Saggi e memorie di storia dell'arte*, 23 (1999), pp. 191–218

Kozakiewicz 1972
S. Kozakiewicz, *Bernardo Bellotto*, trans. M. Whittall, 2 vols, London 1972

Kragelund 2009
P. Kragelund, 'Popes, kings and the Medici in the eighteenth-century *fasti* of the Palazzo Mocenigo di S. Stae in Venice', *Journal of the History of Collections* (September 2009)

Lane 1973
F. Lane, *Venice. A Maritime Republic*, Baltimore and London 1973

Laven 2002
M. Laven, *The Virgins of Venice*, London 2002

Levey 1971
M. Levey, *National Gallery Catalogues: The Seventeenth- and Eighteenth-Century Italian Schools*, London 1971

Levey 1973
M. Levey, *The Venetian Scene*, London 1973

Levey 1991
M. Levey, *The Later Italian Pictures in the Collection of Her Majesty the Queen*, 2nd edn, Cambridge 1991

Levey 1994
M. Levey, *Painting in Eighteenth-Century Venice*, 3rd edn, New Haven and London 1994

Links 1971
J.G. Links, *Views of Venice by Canaletto Engraved by Visentini*, New York 1971

Links 1973
J.G. Links, 'Canaletto at Home', *The Burlington Magazine*, CXV, no. 843 (June 1973), pp. 390–3

Links 1977
J.G. Links, *Canaletto and his patrons*, London 1977

Links 1981
J.G. Links, *Canaletto: The Complete Paintings*, St Albans 1981

Links 1994
J.G. Links, *Canaletto*, 2nd edn, London 1994

Links 1998a
J.G. Links, *A Supplement to W.G. Constable's Canaletto*, London 1998

Links 1998b
J.G. Links, *The Soane Canalettos*, London 1998

London 1849
Catalogue of the Marquess of Westminster's Collection of Pictures at Grosvenor House, London 1849

London 1980–1
O. Millar, *Canaletto: Paintings & Drawings*, exh. cat., London (The Queen's Gallery), 1980–1

London 2004
George III & Queen Charlotte: Patronage, Collecting and Court Taste, ed. J. Roberts, exh. cat., London (The Queen's Gallery), 2004

London and Edinburgh 2005–7
M. Clayton, *Canaletto in Venice*, exh. cat., London (The Queen's Gallery), Edinburgh (The Queen's Gallery, Palace of Holyroodhouse), 2005–7

London and Washington 1994–5
The Glory of Venice: Art in the Eighteenth Century, eds J. Martineau and A. Robison, exh. cat., London (Royal Academy of Arts), Washington, DC (National Gallery of Art), New Haven and London 1994–5

London, York and Swansea 1998–9
D. Bomford and G. Finaldi, *Venice through Canaletto's Eyes*, exh. cat., London (National Gallery), York (York City Art Gallery), Swansea (Glynn Vivian Art Gallery), London and New Haven 1998–9

Lorenzetti 1975 edn
G. Lorenzetti, *Venice and its Lagoon*, Trieste 1975

Madrid 2001
D. Succi and A. Delneri, *Canaletto. Una Venecia Imaginaria*, exh. cat., Madrid (Museo Thyssen-Bornemisza), 2001

Madrid 2009
A. Scarpa, *Settecento Veneziano: Del Barroco al Neoclasicismo*, exh. cat., Madrid (Real Academia de Bellas Artes de San Fernando), 2009

Magani 1996
F. Magani, review of Padua 1994 in *Arte Veneta*, XLVIII (1996), pp. 144–5

Mahon 1947
D. Mahon, *Studies in Seicento Art and Theory*, London 1947

Manzelli 1991 and 2002
M. Manzelli, *Michele Marieschi e il suo alter-ego Francesco Albotto*, Venice 1991 (2nd edn 2002)

Manzelli 1999
M. Manzelli, *Antonio Joli: opera pittorica*, Venice 1999

Mariette 1856 edn
P.-J. Mariette, *Abecedario de P.J. Mariette et autres notes inédites de cet amateur sur les arts et les artistes*, eds P. de Chennevières and A. de Montaiglon, III, Paris 1856

Marini 1993
G. Marini: '"Con la propria industria e sua professione". Nuove documenti sulla giovinezza di Bellotto', *Verona illustrata*, VI (1993)

Martin and Romano 2000
J. Martin and D. Romano, *Venice Reconsidered: the history and civilisation of an Italian city-state 1297–1797*, Baltimore 2000

Martini 1994
E. Martini, 'Note e precisazioni sul vedutista Johann Richter', *Arte Documento*, VIII (1994)

Martyn 1766
T. Martyn, *The English Connoisseur: Containing an Account of Whatever is Curious in Painting, Sculpture, etc., in the Palaces and Seats of the Nobility and Principal Gentry of England, both in Town and Country*, 2 vols, Dublin 1766

Mesuret 1952
R. Mesuret, 'Pietro Bellotti un veneziano di Tolosa', *Arte Veneta*, VI (1952), pp. 170–2

Michiel 1829
G.R. Michiel, *Le origini delle feste veneziane*, 6 vols, Milan 1829

Milan 2008–9
Da Canaletto a Tiepolo: Pittura veneziana del Settecento, mobili e porcellane dalla collezione Terruzzi, ed. A. Scarpa, exh. cat., Milan (Palazzo Reale), 2008–9

Mirano 1999
Bernardo Bellotto detto il Canaletto, ed. D. Succi, exh. cat., Mirano (Barchessa di Villa Morosini), Venice 1999

Montecuccoli degli Erri 2002
F. Montecuccoli degli Erri, *Canaletto incisore*, Venice 2002

Montecuccoli degli Erri and Pedrocco 1999
F. Montecuccoli degli Erri and F. Pedrocco, *Michele Marieschi: La vita, l'ambiente, l'opera*, Milan 1999

Morassi 1973
A. Morassi, *Guardi: L'opera completa di Antonio e Francesco Guardi*, 2 vols, Venice 1973

Moschini 1806
G. Moschini, *Della letteratura veneziana del secolo XVIII fino a nostri giorni*, Venice 1806

Muir 1981
E. Muir, *Civic Ritual in Renaissance Venice*, Princeton 1981

Muraro 1993
M. Muraro, *Os Guardi da Colecção C. Gulbenkian*, Lisbon 1993

New Haven and London 2006–7
C. Beddington, *Canaletto in England: A Venetian Artist Abroad, 1746–1755*, exh. cat., New Haven (Yale Center for British Art), London (Dulwich Picture Gallery), New Haven 2006–7

New York 1983
C. Whitfield, *Views from the Grand Tour*, exh. cat., New York (Colnaghi), 1983

New York 1989–90
K. Baetjer and J.G. Links, *Canaletto*, exh. cat., New York (Metropolitan Museum of Art), 1989–90

Norwich 1982
J.J. Norwich, *A History of Venice*, London 1982

Orlandi 1704
P.A. Orlandi, *Abecedario pittorico*, Bologna 1704

Ottawa 1987
Catalogue of the National Gallery of Canada, Ottawa: European and American Painting, Sculpture, and Decorative Arts, 1: *1300–1800*, eds M. Laskin, Jr, and M. Pantazzi, Ottawa 1987

Padua 1994
Luca Carlevarijs e la veduta veneziana del Settecento, eds I. Reale and D. Succi, exh. cat., Padua (Palazzo della Ragione), Milan 1994

Pallucchini 1995–6
R. Pallucchini, *La pittura nel Veneto: Il Settecento*, 2 vols, Milan 1995–6

Passariano 2003
Da Canaletto a Zuccarelli: il paesaggio veneto del Settecento, eds A. Delneri and D. Succi, exh. cat., Passariano (Villa Manin), Tavagnacco 2003

Pedrocco 2001
F. Pedrocco, *Visions of Venice: Paintings of the 18th Century*, London and New York 2001

Pedrocco and Montecuccoli degli Erri 1992
F. Pedrocco and F. Montecuccoli degli Erri, *Antonio Guardi*, Milan 1992

Perry 1978
M. Perry, 'Cardinal Domenico Grimani's legacy of Ancient Art to Venice', *Journal of the Warburg and Courtauld Institutes*, XLI (1978), pp. 215–44

Pignatti 1966
T. Pignatti, 'Gli inizi di Bernardo Bellotto', *Arte Veneta*, XX (1966), pp. 218–29

Pignatti 1967
T. Pignatti, 'Bernardo Bellotto's Venetian Period (1738–1743)', *Bulletin of The National Gallery of Canada*, IX–X (1967), pp. 1–17

Puppi 1968
L. Puppi, *L'opera completa del Canaletto*, Milan 1968

Redford 1996
B. Redford, *Venice and the Grand Tour*, New Haven and London 1996

Rizzi 1967
A. Rizzi, *Luca Carlevarijs*, Venice 1967

Rome 2005
Canaletto: Il trionfo della Veduta, ed. B.A. Kowalczyk, exh. cat., Rome (Palazzo Giustiniani), Cinisello Balsamo 2005

Rome and Venice 2002–3
Gaspare Vanvitelli e le origini del vedutismo, ed. F. Benzi, exh. cat., Rome (Chiostro del Bramante), Venice (Museo Correr), Rome 2002–3

Rossi Bortolatto 1974
L. Rossi Bortolatto, *L'opera completa di Francesco Guardi*, Milan 1974

Russell 1996
F. Russell, 'Guardi and the English tourist', *The Burlington Magazine*, CXXXVII, no. 1114 (1996), pp. 4–11

Russell 1999
F. Russell, review of Links 1998a, *The Burlington Magazine*, CXLI, no. 1152 (March 1999), pp. 180–1

Russell 2005
F. Russell, review of Rome 2005, *Apollo*, CLXI, no. 520 (June 2005), pp. 99–100

San Diego 2001
C. Beddington, *Luca Carlevarijs: Views of Venice*, exh. cat., San Diego (Timken Museum of Art), 2001

Sansovino 1663 edn
F. Sansovino, *Venetia città nobilissima et singolare*, Venice 1581; ed. G. Martinioni, Venice 1663

Sarasota and Memphis 2009–10
Venice in the Age of Canaletto, eds A. Libby, M. Pacini, S. Thomas, exh. cat., Sarasota (John and Mable Ringling Museum of Art), Memphis (Memphis Brooks Museum of Art), 2009–10

Sarasota, Fort Worth, Omaha, Nashville and Charlotte 2004–6
Renaissance to Rococo: Masterpieces from the Wadsworth Atheneum Museum of Art, ed. E. Zafran, exh. cat., Sarasota (John and Mable Ringling Museum of Art), Fort Worth (Kimbell Art Museum), Omaha (Joslyn Art Museum), Nashville (Frist Center for the Visual Arts), Charlotte (Mint Museum of Art), New Haven and London 2004–6

Shapley 1979
F.R. Shapley, *National Gallery of Art, Washington, Catalogue of the Italian Paintings*, 2 vols, Washington, DC, 1979

Sloman 2002
S. Sloman, *Gainsborough in Bath*, New Haven and London 2002

Spadotto 1999
F. Spadotto, 'Un artista dimenticato: Giovan Battista Cimaroli', *Saggi e memorie di storia dell'arte*, XXIII (1999), pp. 129–87

Succi 1993
Dario Succi, *Francesco Guardi: Itinerario dell'avventura artistica*, Milan 1993

Succi 2004
D. Succi, *Francesco Tironi: ultimo Vedutista del Settecento veneziano*, Mariano del Friuli 2004

Tafuri 1995
M. Tafuri, *Venice and the Renaissance*, Cambridge, MA, and London 1995

Tamassia Mazzarotto 1980
B. Tamassia Mazzarotto, *Le Feste Veneziane: i giochi popolari, le cerimonie religiose e di governo*, 2nd edn Florence 1980

The Hague and Washington 2008–9
A. van Suchtelen and A.K. Wheelock, Jr, *Dutch Cityscapes of the Golden Age*, exh. cat., The Hague (Mauritshuis) and Washington, DC (National Gallery of Art), 2008–9

Ticozzi 1836
S. Ticozzi, *Lettera intorno a due quadri di vaste dimensioni di Antonio Canal detto il Canaletto*, Milan 1836

Tiraboschi 1786
G. Tiraboschi, *Notizie de' Pittori, Scultori, Incisori e Architetti natii degli stati del Serenissimo Signor Duca di Modena*, Modena 1786

Toledano 1988
R. Toledano, *Michele Marieschi: L'opera completa*, Milan 1988

Toledano 1995
R. Toledano, *Michele Marieschi: Catalogo ragionato*, 2nd edn, Milan 1995

Toledano 2006
R. Toledano, *Antonio Joli*, Turin 2006

Toronto, Ottawa and Montreal 1964–5
W.G. Constable, *Canaletto: Giovanni Antonio Canal 1697–1768*, exh. cat., Toronto (Art Gallery), Ottawa (National Gallery of Canada), Montreal (Musée des Beaux-Arts), 1964–5

Treviso 2008–9
Canaletto: Venezia e i suoi splendori, eds G. Pavanello and A. Craievich, exh. cat., Treviso (Casa dei Carraresi), 2008–9

Turin 2008
Canaletto e Bellotto: L'arte della veduta, ed. B.A. Kowalczyk, exh. cat., Turin (Palazzo Bricherasio), Milan 2008

Urrea Fernández 1977
J. Urrea Fernández, *La pintura italiana del siglo XVIII en España*, Valladolid 1977

Van de Sandt 2002
A. and U. van de Sandt, 'Alla ricerca di "Pietro Bellotti, un veneziano di Tolosa"', *Saggi e memorie di storia dell'arte*, XXV (2002), pp. 91–120

Venice 1937
G. Lorenzetti, *Le feste e le maschere veneziane*, exh. cat., Venice (Ca' Rezzonico), 1937

Venice 1965
P. Zampetti, *Mostra dei Guardi*, exh. cat., Venice (Palazzo Grassi), 1965

Venice 1967
P. Zampetti, *I Vedutisti Veneziani del Settecento*, exh. cat., Venice (Palazzo Ducale), 1967

Venice 1969
A. Bettagno, *Caricature di Anton Maria Zanetti*, exh. cat., Venice (Fondazione Cini), 1969

Venice 1982
Canaletto: Disegni-Dipinti-Incisioni, ed. A. Bettagno, exh. cat., Venice (Fondazione Giorgio Cini), Vicenza 1982

Venice 1986–7
Canaletto & Visentini, Venezia & Londra, ed. Ca' D. Succi, exh. cat., Venice (Pesaro), Padua 1986

Venice 1987
Vedute italiane del '700 in collezioni private italiane, eds M. Magnifico and M. Utili, exh. cat., Venice (Museo Diocesano d'Arte Sacra, Sant'Apollonia), Milan 1987

Venice 1993
Francesco Guardi: Vedute, Capricci, Feste, ed. A. Bettagno, exh. cat., Venice (Isola di San Giorgio Maggiore), 1993

Venice 1995
Splendori del Settecento Veneziano, eds G. Nepi Sciré and G. Romanelli, exh. cat., Venice (Ca' Rezzonico, Gallerie dell'Accademia and Palazzo Mocenigo), Milan 1995

Venice 2001
Canaletto prima maniera, ed. B.A. Kowalczyk with C. Ceschi and S. Guerriero, exh. cat., Venice (Fondazione Giorgio Cini), Milan 2001

Venice and Houston 2001
Bernardo Bellotto 1722–1780, Italian language edn ed. B.A. Kowalczyk and M. da Cortà Fumei, English language edn ed. E.P. Bowron, exh. cat., Venice (Museo Correr), Houston (Museum of Fine Arts), Milan 2001

Vertue 1934 edn
G. Vertue, *Notebooks*, III, The Walpole Society, XXII (1934)

Vivian 1971
F. Vivian, *Il Console Smith: mercante e collezionista*, Vicenza 1971

Voss 1927–8
H. Voss, 'Francesco Tironi. Ein Vergessener venezianischer Vedutenmaler', *Zeitschrift für Bildende Kunst*, LXI (1927–8), pp. 266–70

Voss 1966
H. Voss, 'Francesco Guardi und Francesco Tironi', *Pantheon*, XXIV (1966), pp. 100–4

Waagen 1838
G.F. Waagen, *Works of Art and Artists in England*, London 1838

Waagen 1854
G.F. Waagen, *Treasures of Art in Great Britain*, 3 vols, London 1854

Waagen 1857
G.F. Waagen, *Galleries and Cabinets of Art in Great Britain*, London 1857

Walpole 1928 edn
H. Walpole, *Journal of Visits to Country Seats*, The Walpole Society, XVI (1928)

Ward-Jackson 1980
P. Ward-Jackson, *Victoria and Albert Museum Catalogues: Italian Drawings*, II: *17th–18th century*, London 1980

Washington 1996
D. De Grazia and E. Garberson with E.P. Bowron, P.M. Lukehart and M. Merling, *The Collections of the National Gallery of Art Systematic Catalogue: Italian Paintings of the Seventeenth and Eighteenth Centuries*, Washington, DC, 1996

York 1994
Masterpieces from Yorkshire Houses: Yorkshire Families at Home and Abroad 1700–1850, exh. cat., York (York City Art Gallery), 1994

Zanetti 1771
A.M. Zanetti, *Della pittura veneziana e delle opere pubbliche de' veneziani maestri*, Venice 1771

Zorzi 1977
A. Zorzi, *Venezia Scomparsa*, 2 vols, Milan 1977

List of Works

COMPILED WITH THE ASSISTANCE OF SCOTT NETHERSOLE AND JULIET CHIPPINDALE

1

Gaspar van Wittel, called Gaspare Vanvitelli (1652/3–1736)

The Molo from the Bacino di San Marco, 1697

Signed and dated 'Gas: V: W: 1697' (on ship on right)
Oil on canvas, 98 x 174 cm
Museo Nacional del Prado, Madrid (P-475)

PROVENANCE
Elisabetta Farnese (1692–1766), wife of King Philip V of Spain, Palacio de La Granja de San Ildefonso, near Segovia, Spain, by 1746; Museo Nacional del Prado, Madrid, 1868

SELECTED LITERATURE
Venice 1967, no. 7, pp. 16–19; Links 1977, p. 3, pl. 5; Urrea Fernández 1977, p. 403; Amsterdam 1990–1, no. 10, pp. 111–12; Links 1994, pl. 9; D. Succi in Padua 1994, p. 36, fig. 1; Briganti 1996, no. 287, p. 241; A. Corboz in Barcelona 2001, p. 25, fig. 4; A. Corboz in Madrid 2001, p. 33, fig. 4; Rome and Venice 2002–3, no. 60, pp. 190–1; Aterido et al. 2004, p. 295; Treviso 2008–9, no. 1, p. 242

2

Luca Carlevarijs (1663–1730)

The Reception of the British Ambassador Charles Montagu, 4th Earl of Manchester, at the Doge's Palace, 22 September 1707, about 1707–8

Signed with initials 'L.C.' (on last column to right)
Oil on canvas, 132 x 264 cm
Birmingham Museums & Art Gallery (1949P36)

PROVENANCE
Commissioned by Charles Montagu, 4th Earl of Manchester (about 1662–1722), created Duke of Manchester in 1719; by descent at Kimbolton Castle, Huntingdonshire, to Alexander Montagu, 10th Duke of Manchester, by whom sold, Kimbolton Castle sale (Knight, Frank & Rutley on the premises), 18 July 1949 (= 1st day), lot 29 (as Canaletto); with Colnaghi; acquired by Birmingham Museums & Art Gallery, 1949

SELECTED LITERATURE
Rizzi 1967, pp. 14, 39, 51, 87–8, pls 28–30, col. pls III–IV; Venice 1967, no. 19, pp. 40–1; Briganti 1970, pls 36–7 (details); Hanover and Düsseldorf 1991–2, no. 20, pp. 128–9; Links 1994, p. 14, pl. 11; Padua 1994, no. 37, p. 206; Pallucchini 1995–6, I, p. 181, fig. 278; San Diego 2001, p. 16, fig. 15

3

Luca Carlevarijs (1663–1730)

The Molo from the Bacino di San Marco on Ascension Day, 1710

Signed with initials and dated 'LC MDCC X [= 1710]' (on boat lower right)
Oil on canvas, 134.8 x 259.4 cm
The J. Paul Getty Museum, Los Angeles, CA (86.PA.600)

PROVENANCE
With Baron Michele Lazzaroni, Paris and Rome, by 1922; Gina Lollobrigida (b. 1927), Rome, until 1986; with Agnew's, London; purchased by the J. Paul Getty Museum, 1986

SELECTED LITERATURE
Rizzi 1967, p. 93, pls 43–4; London and Washington 1994–5, no. 23, p. 444; Redford 1996, pl. 8; San Diego 2001, p. 19, fig. 4

4

Luca Carlevarijs (1663–1730)

The Regatta on the Grand Canal in Honour of Frederick IV, King of Denmark and Norway, 4 March 1709, 1711

Signed with initials and dated 'MDCCXI [= 1711] L.C.' (on stern of boat lower centre)
Oil on canvas, 134.9 x 259.7 cm
The J. Paul Getty Museum, Los Angeles, CA (86.PA.599)

PROVENANCE
See previous entry

SELECTED LITERATURE
Rizzi 1967, pp. 51, 88, 93, pls 39–40; San Diego 2001, no. 2, p. 47

5

Luca Carlevarijs (1663–1730)

The Piazza San Marco, looking East, about 1710–15

Oil on canvas, 86 x 163.5 cm
Accepted by HM Government in lieu of inheritance tax and allocated to the Trustees of Kiplin Hall, North Yorkshire, 2007. Loaned from Kiplin Hall with agreement of the Museums, Libraries and Archives Council

PROVENANCE
Presumably acquired by Christopher Crowe (1682–1749), British Consul at Leghorn 1705–16, and thereafter at Kiplin Hall, near Scorton, North Yorkshire

SELECTED LITERATURE
Constable 1962 (and subsequent edns rev. J.G. Links), I, pl. 7c; Rizzi 1967, pp. 14–16, 63, 89, pls 119–20; Links 1977, pl. 2; York 1994, no. 36, pp. 74–5; Pallucchini 1995–6, I, p. 187, fig. 291; Ingamells 1997, p. 258; San Diego 2001, no. 8, pp. 50–1

6

Johan Richter (1665–1745)

The Entrance to the Grand Canal, looking East, with the Bridge of Boats for the Feast of the Madonna della Salute, before 1728

Oil on canvas, 120.6 x 151.4 cm
Wadsworth Atheneum Museum of Art, Hartford, CT. The Ella Gallup Sumner and Mary Catlin Sumner Collection Fund (1939.268)

PROVENANCE
Anon. sale ('removed from a Mansion House in the West of Scotland'), Christie's, London, 11 April 1924, lot 10 (as 'J. Marieschi' [sic]) to Rothschild; with the Sackville Gallery London, 1925; Gonse, Paris, 1939?; with D'Atri, Paris; with Wildenstein, New York, from whom purchased by the Wadsworth Atheneum, 1939

SELECTED LITERATURE
Rizzi 1967, pp. 60–3, 88–9, pls 115–16, col. pl. VIII, detail (as Carlevarijs); Venice 1967, no. 20, pp. 42–3 (as Carlevarijs); Amsterdam 1990–1, no. 15, pp. 122–3 (as Carlevarijs); J. Cadogan in Hartford 1991, p. 98 (as Carlevarijs); D. Succi and I. Reale in Padua 1994, pp. 16, 127, 243–7 (under no. 70), 124, fig. 17; Pallucchini 1995–6, I, pp. 189, 194, figs 295, 297; San Diego 2001, pp. 23–5

7

Canaletto (1697–1768)

San Cristoforo, San Michele and Murano from the Fondamenta Nuove, about 1722

Oil on canvas, 143.5 x 151.1 cm
Dallas Museum of Art, TX. Foundation for the Arts Collection, Mrs John B. O'Hara Fund (1984.51.FA)

PROVENANCE
Giovanni Berzi, Padua, 1765 and 1783; Alexandre Maria Aguado, Marquis de las Marismas del Guadalquivir; his sale, Paris, 20–8 March 1843, lot 269 (as Canaletto with figures by Tiepolo); J.H. Hutchinson, London, by 1877 (as Guardi); Edward Montagu-Stuart-Wortley-Mackenzie, 1st Earl of Wharncliffe (1827–99), Wortley Hall, Sheffield, by 1884; thence by descent to Alan Montagu-Stuart-Wortley-Mackenzie, 4th Earl of Wharncliffe, by whom sold Sotheby's, London, 23 June 1982, lot 68; acquired by the Dallas Museum of Art, 1984

SELECTED LITERATURE
Rossetti 1765, p. 312; Constable 1962, II, no. 365(a) (as 'perhaps by Canaletto'); New York 1983, no. 4, pp. 14–17; Corboz 1985, II, no. P37, p. 574; Constable 1989, II, p. 736, no. 365*; New York 1989–90, no. 30, pp. 138–9; D. Succi in Belluno 1993, p. 68, fig. 26; Links 1998a, no. 365*, p. 34, pl. 236; Venice 2001, no. 40, pp. 108–9

8

Canaletto (1697–1768)

The Entrance to the Grand Canal and Santa Maria della Salute from the Piazzetta,

about 1723

Oil on canvas, 172.4 x 135.6 cm
Lent by Her Majesty The Queen (RCIN 405073)
London only

PROVENANCE
Commissioned from the artist by Joseph Smith (about 1674–1770), Palazzo Balbi (now Mangilli-Valmarana), Venice; bought from Smith by King George III in 1762; thence by descent

SELECTED LITERATURE
Constable 1962 (and subsequent edns rev. J.G. Links), I, pl. 34, II, no. 146; Puppi 1968, no. 47A; Vivian 1971, p. 177; London 1980–1, no. 5, p. 36; Links 1981, no. 27; Corboz 1985, II, no. P29, p. 571; New York 1989–90, no. 29, pp. 136–7, fig. 23; Levey 1991, no. 383, pp. 24–5, pl. 27; D. Succi in Belluno 1993, p. 15, fig. 1, pp. 56–8, fig. 6; Links 1994, pp. 68–9, pl. 48; Pallucchini 1995, I, p. 379, fig. 612; B. Kowalczyk in Venice 2001, pp. 22–4; London 2004, no. 145, p. 172; London and Edinburgh 2005–7, p. 93, fig. 15

9

Canaletto (1697–1768)

The Rio dei Mendicanti, looking South,

about 1723

Oil on canvas, 143 x 200 cm
Ca' Rezzonico, Museo del Settecento Veneziano, Venice

PROVENANCE
Joseph Wenzel, Fürst von und zu Liechtenstein (1696–1772), Vienna and by descent to Franz Joseph II, Fürst von und zu Liechtenstein (1906–89), until 1956, when acquired by Senatore Mario Crespi, Milan; acquired by the Ca' Rezzonico, 1983

SELECTED LITERATURE
Constable 1962 (and subsequent edns rev. J.G. Links), I, pl. 56, II, no. 290; Venice 1967, no. 45, pp. 104–5; Puppi 1968, no. 14A; Links 1977, pp. 22–3, pl. 19; Links 1981, no. 10; Venice 1982, no. 81, pp. 20–1, 56–8; Bettagno 1983, pp. 222–5; Corboz 1985, II, no. P4, p. 560; F. Pedrocco in Venice 1986–7, pp. 27–32; New York 1989–90, no. 4, pp. 76–9; V. Pemberton-Pigott in New York 1989–90, pp. 53–4; Amsterdam 1990–1, no. 18, pp. 146–7; D. Succi in Belluno 1993, pp. 61–3, fig. 13; Links 1994, pp. 32, 34, 36, pl. 22; London and Washington 1994–5, no. 134, pp. 219–20, 434; Pallucchini 1995–6, I, pp. 376–7, figs 603, 605; Venice 2001, no. 48, pp. 130–3

10

Canaletto (1697–1768)

The Piazza San Marco, looking East,

about 1723

Oil on canvas, 141.5 x 204.5 cm
Museo Thyssen-Bornemisza, Madrid (75 [1956.1])

PROVENANCE
Joseph Wenzel, Fürst von und zu Liechtenstein (1696–1772), Vienna and by descent to Franz Joseph II, Fürst von und zu Liechtenstein (1906–89), until 1956, when acquired by Baron Hans Heinrich Thyssen-Bornemisza, Lugano; acquired by the Museo Thyssen-Bornemisza, Madrid, 1993

SELECTED LITERATURE
Constable 1962 (and subsequent edns rev. J.G. Links), I, pl. 11, II, no. 1; Toronto, Ottawa and Montreal 1964–5, no. 4, pp. 38–9; Puppi 1968, no. 11A; Links 1977, pp. 21–2, pls 15–17; Links 1981, no. 7; Venice 1982, no. 79, pp. 13, 20–1, 56–7; Corboz 1985, I, pp. 41–2, 178, II, no. P1, p. 559, fig. 1; F. Pedrocco in Venice 1986–7, pp. 27–32; New York 1989–90, no. 1, pp. 3, 66–9; V. Pemberton-Piggott in New York 1989–90, pp. 53–4; Amsterdam 1990–1, no. 17, pp. 128, 144–5; D. Succi in Belluno 1993, pp. 61–3, fig. 14; Links 1994, pp. 28, 32, 34, pl. 23; Pallucchini 1995–6, I, pp. 376–7, 379, figs 599, 601; Links 1998a, p. 5, pl. 241; Barcelona 2001, no. 37, pp. 58–9, 112–13; Madrid 2001, no. 38, pp. 84–5, 140–1, 143; Venice 2001, no. 49, pp. 27–8, 134–7; Contini 2002, no. 54, pp. 256–9

11

Canaletto (1697–1768)

Campo San Vidal and Santa Maria della Carità ('The Stonemason's Yard'),

about 1725

Oil on canvas, 123.8 x 162.9 cm
The National Gallery, London. Sir George Beaumont Gift, 1823; passed to the National Gallery, 1828 (NG127)

PROVENANCE
Sir George Beaumont, London, by June 1808; deposited by him at the British Museum in 1823 for the National Gallery; passed to the National Gallery in 1828

SELECTED LITERATURE
Constable 1962 (and subsequent edns rev. J.G. Links), I, pl. 43, II, no. 199; Puppi 1968, no. 33; Briganti 1970, pl. 41 (detail); Levey 1971, pp. 18–22; Links 1977, pp. 35–6, 41, pls 41–3; Levey 1973, pp. 28, 36, pl. 2 (detail); Links 1981, no. 53; Corboz 1985, I, pp. 94, 97, fig. 92, II, no. P54, p. 580; New York 1989–90, no. 32, pp. 142–4; V. Pemberton-Piggott in New York 1989–90, p. 56; Amsterdam 1990–1, p. 53, fig. 57; D. Succi in Belluno 1993, pp. 49–51, fig. 25; Bomford and Roy 1993, pp. 35–41; Links 1994, pp. 77–8, 112, pl. 61; Pallucchini 1995–6, I, pp. 476–7, fig. 752; Kowalczyk 1998; Links 1998a, no. 199, p. 21; London, York and Swansea 1998–9, fig. 42; Venice 2001, no. 60, pp. 160–3

12

Canaletto (1697–1768)

The Campo Santi Giovanni e Paolo,

about 1725

Oil on canvas, 125 x 165 cm
Gemäldegalerie Alte Meister, Staatliche Kunstsammlungen Dresden (3465)
Washington only

PROVENANCE
Conte Giambattista Colloredo (1656–1729), the Imperial Ambassador, by whom purchased on St Roch's day 1725; Prince-Elector Frederick Augustus II, Elector of Saxony, also King Augustus III of Poland, Dresden, by 1754

SELECTED LITERATURE
Constable 1962 (and subsequent edns rev. J.G. Links), I, pl. 58, II, no. 305; Venice 1967, no. 46, pp. 106–7; Puppi 1968, no. 18; Briganti 1970, pl. 44; Links 1977, p. 14, pl. 11; Links 1981, no. 16; Corboz 1985, II, no. P41, p. 576; New York 1989–90, no. 5, pp. 80–2; V. Pemberton-Pigott in New York 1989–90, p. 56; Amsterdam 1990–1, p. 46, fig. 52; D. Succi in Belluno 1993, pp. 35–6, fig. 11; Links 1994, pp. 42–3, pl. 25; Pallucchini 1995–6, I, p. 477, fig. 748; Kowalczyk 1998, p. 98; Links 1998a, pl. 262; Venice 2001, pp. 150–1, 166; Rome 2005, no. 9, pp. 68–71; Russell 2005, p. 99; Beddington 2006b, fig. 48; Dresden 2008, no. 12, p. 82

13

Canaletto (1697–1768)

The Reception of the French Ambassador Jacques-Vincent Languet, Comte de Gergy, at the Doge's Palace, 4 November 1726,

about 1727

Oil on canvas, 181 x 259.5 cm
The State Hermitage Museum, St Petersburg (GE-175)

PROVENANCE
Empress Catherine II of Russia (1729–96), by 1774

SELECTED LITERATURE
Constable 1962 (and subsequent edns rev. J.G. Links), I, pl. 66, II, no. 356; Puppi 1968, no. 31; Links 1981, no. 75; Venice 1982, no. 83; Corboz 1985, II, no. P53, p. 579; D. Succi in Belluno 1993, p. 43, fig. 16; D. Succi in Padua 1994, pp. 68–72, fig. 5; Venice 1995, no. 70, pp. 290–1; Pallucchini 1995–6, I, pp. 478–81, fig. 753; Treviso 2008–9, no. 32, pp. 260–1

14

Canaletto (1697–1768)

The Entrance to the Grand Canal, looking West, with Santa Maria della Salute,

about 1729

Oil on canvas, 49.5 x 73.7 cm
The Museum of Fine Arts, Houston, TX. The Robert Lee Blaffer Memorial Collection, gift of Sarah Campbell Blaffer (56.2)

PROVENANCE
Hugh Howard, 1730; thence by descent through the Earls of Wicklow (withdrawn from the Wicklow Sale 1950); with E. Speelman, London; with Knoedler, New York, 1955; Sarah Campbell Blaffer; her gift to The Museum of Fine Arts, Houston, 1956

SELECTED LITERATURE
Constable 1962 (and subsequent edns rev. J.G. Links), I, pl. 37, II, no. 166; Toronto, Ottawa and Montreal 1964–5, no. 11, p. 48; Venice 1967, no. 62, pp. 138–9; Puppi 1968, no. 70B; Briganti 1970, pl. 65 (detail); Links 1977, p. 34, pl. 33; Links 1981, no. 52; Corboz 1985, II, no. P49, p. 578; New York 1989–90, no. 35, pp. 149–51; V. Pemberton-Piggott in New York 1989–90, p. 57; D. Succi in Belluno 1993, p. 59, fig. 11; Links 1994, p. 79, pl. 63; Pallucchini 1995–6, I, p. 484, fig. 755; Venice 2001, no. 74, pp. 202–3

15
Canaletto (1697–1768)
The Piazza San Marco, looking South and West, about 1731

Oil on canvas, 66.3 x 103.5 cm
Wadsworth Atheneum Museum of Art, Hartford, CT. The Ella Gallup Sumner and Mary Catlin Sumner Collection Fund, endowed by Mr and Mrs Thomas R. Cox, Jr (1947.2)

PROVENANCE
(Possibly) Johann Matthias von der Schulenburg (1661–1747), Venice; with Martin H. Colnaghi, London; Louis Costa Torro, Château des Iris, Lormont, Gironde, France; sold Anderson Galleries, New York, 20 January 1927, lot 36; bought by Knoedler & Co., New York; with Gaston Neumans, Paris, 1928; with Julius Böhler, Munich, 1929 (as Bellotto); Rosenbaum, Berlin; Mr and Mrs Hugo Moser, Berlin, Amsterdam and New York, by whom acquired about 1929–30; sold Parke-Bernet, New York, 20 April 1946, lot 32; bought by Schoeneman Galleries, New York, from whom purchased by the Wadsworth Atheneum, 1947

SELECTED LITERATURE
Constable 1962 (and subsequent edns rev. J.G. Links), I, pl. 20, II, no. 54; Toronto, Ottawa and Montreal 1964–5, no. 25, p. 65; Puppi 1968, no. 190A; Kozakiewicz 1972, II, no. Z 26; Links 1981, under no. 135; Corboz 1985, I, pp. 80–1, fig. 69, II, no. P305, p. 650; J. Cadogan in Hartford 1991, pp. 78–81; Links 1994, p. 229, pl. 200; Links 1998b, pp. 42–4, fig. 21; San Diego 2001, no. 11, pp. 52–3; Sarasota, Fort Worth, Omaha, Nashville and Charlotte 2004–6, no. 22, p. 82

16
Canaletto (1697–1768)
The Molo from the Bacino di San Marco on Ascension Day, about 1733–4

Oil on canvas, 76.8 x 125.4 cm
Lent by Her Majesty The Queen (RCIN 404417)

PROVENANCE
Commissioned from the artist by Joseph Smith (about 1674–1770), Palazzo Balbi (now Mangilli-Valmarana), Venice; bought from Smith by King George III in 1762; thence by descent

SELECTED LITERATURE
Constable 1962 (and subsequent edns rev. J.G. Links), I, pl. 64, II, no. 335; Puppi 1968, no. 67A; Links 1971; Vivian 1971, p. 179; Links 1977, p. 40, pls 52, 54; London 1980–1, no. 20, pp. 51–2; Links 1981, no. 85; Corboz 1985, II, no. P82, p. 587; D. Succi in Venice 1986–7, pp. 33–44, 235; New York 1989–90, no. 44, pp. 171–6; Levey 1991, no. 397, pp. 35–6; Links 1994, p. 86, pls 65, 70; Pallucchini 1995–6, I, pp. 482–5, 491, fig. 760; Redford 1996, pls 1, 6–7, 10; London and Edinburgh 2005–7, no. 14, pp. 78–81; New Haven and London 2006–7, fig. 54.1

17
Canaletto (1697–1768)
A Regatta on the Grand Canal, about 1733–4

Oil on canvas, 77.2 x 125.7 cm
Lent by Her Majesty The Queen (RCIN 404416)

PROVENANCE
See previous entry

SELECTED LITERATURE
Constable 1962 (and subsequent edns rev. J.G. Links), I, pl. 65, II, no. 347; Venice 1967, no. 64, pp. 142–3; Puppi 1968, no. 68A; Vivian 1971, p. 179; Links 1977, p. 40, pl. 53; London 1980–1, no. 19, pp. 50–1; Puppi 1968, no. 68A; Links 1981, no. 86; Corboz 1985, II, no. P83, p. 588; D. Succi in Venice 1986–7, pp. 33–44, 234; New York 1989–90, no. 43, pp. 166–71; Levey 1991, no. 396, pp. 34–5, pl. 42; Links 1994, p. 86, pl. 69; London and Washington 1994–5, no. 136, pp. 224, 435; Pallucchini 1995–6, I, pp. 482–5, fig. 759; London and Edinburgh 2005–7, no. 13, pp. 74–7

18
Canaletto (1697–1768)
The Campo Santa Maria Formosa, about 1733–4

Oil on canvas, 47 x 80 cm
Lent by His Grace the Duke of Bedford and the Trustees of the Bedford Estates
London only

PROVENANCE
Commissioned by John Russell, 4th Duke of Bedford (1710–71), Bedford House, Bloomsbury Square, London; his grandson Francis Russell, 5th Duke of Bedford (1765–1802), by whom removed to Woburn Abbey, Bedfordshire, shortly after 1792 in preparation for the demolition of Bedford House, and by descent at Woburn

SELECTED LITERATURE
Constable 1962, I, pl. 54, II, no. 278; Venice 1967, no. 57, pp. 130–1; Puppi 1968, no. 101A; Briganti 1970, pl. 59 (detail); Links 1981, no. 105; Corboz 1985, II, no. P147, p. 610; Pallucchini 1995–6, I, pp. 485–7, fig. 765

19
Canaletto (1697–1768)
The Riva degli Schiavoni, looking West, about 1735–6

Oil on canvas, 126.2 x 204.6 cm
The Trustees of Sir John Soane's Museum, London
London only

PROVENANCE
Commissioned by Johann Matthias von der Schulenburg (1661–1747), Palazzo Loredan a San Trovaso, Venice; bequeathed to his nephew Christian Günther von der Schulenburg; Schulenburg sale, Christie's, London, 13 April 1775 (= 2nd day), lot 60 (unsold); Charles-Alexandre, Vicomte de Calonne (1734–1802); sold Skinner, London, 23 March 1795, lot 85; William Beckford (1759–1844), Fonthill Splendens, Wiltshire; his sale Phillips, London, 24 August 1807, lot 605; bought by Sir John Soane, consecutively at Chelsea Hospital, London, 12 Lincoln's Inn Fields (1819–25), and 14 Lincoln's Inn Fields (1825–89); since then at 12 Lincoln's Inn Fields

SELECTED LITERATURE
Waagen 1854, II, p. 321; Constable 1962 (and subsequent edns rev. J.G. Links), I, pl. 30, II, no. 122; Puppi 1968, no. 39B; Links 1981, under no. 73; Corboz 1985, II, no. P60, p. 581; Binion 1990a, pp. 118–19, 148, 207, 234, 285, 295, fig. 39; Binion 1990b, p. 29; Links 1994, pp. 98–100, pl. 76; London and Washington 1994–5, no. 139, pp. 229–30, 436; Links 1998b, pp. 24–32, pl. 1; New Haven and London 2006–7, p. 8, fig. 1

20
Canaletto (1697–1768)
The Grand Canal, looking South-East along the Fondamenta di Santa Chiara, about 1736

Oil on canvas, 47 x 77.7 cm
Private collection, London

PROVENANCE
Commissioned by Charles Spencer, 3rd Duke of Marlborough (1706–58), Langley Park, near Slough, Buckinghamshire; his son George Spencer, 4th Duke of Marlborough (1739–1817), by whom sold with Langley Park in 1788 to Robert Bateson (d. 1825), who took the additional surname of Hervey in 1788 and was created Sir Robert Bateson-Harvey in the baronetage of Ireland in 1789; by descent at Langley Park to his great-grandson Sir Robert Grenville Harvey, 2nd Bt (1856–1931); his widow Lady Emily Grenville Harvey (1872–1935); sold by the Harvey Trustees, about 1956/7; private collection from May 1957

SELECTED LITERATURE
Constable 1962 (and subsequent edns rev. J.G. Links), I, pl. 53, II, no. 267; Puppi 1968, no. 113; Corboz 1985, II, no. P155, p. 612; Russell 1999, p. 181; Russell 2005, p. 11

21

Canaletto (1697–1768)

The Campo San Salvador, about 1736

Oil on canvas, 46.8 x 77.5 cm
Private collection, London

PROVENANCE
See previous entry

SELECTED LITERATURE
Constable 1962 (and subsequent edns rev.
J.G. Links), I, pl. 55, II, no. 283; Puppi 1968, no. 127;
Links 1971, p. 72; Links 1977, p. 45; Links 1981,
no. 127; Venice 1982, no. 88, p. 64; Corboz 1985,
II, no. P169, p. 617; New York 1989–90, no. 47,
pp. 184–5; Links 1998a, no. 283, p. 29; D. Succi and
A. Delneri in Barcelona 2001, p. 15, fig. 4; D. Succi
and A. Delneri in Madrid 2001, p. 22, fig. 4; Russell
1999, p. 181; Rome 2005, no. 32, pp. 148–51, 154;
Russell 2005, p. 100

22

Canaletto (1697–1768)

The Bacino di San Marco, about 1738–9

Oil on canvas, 124.5 x 204.5 cm
Museum of Fine Arts, Boston, MA. Abbott Lawrence
Fund, Seth K. Sweetser Fund, and Charles Edward
French Fund, 1939 (39.290)

PROVENANCE
Acquired by Henry Howard, 4th Earl of Carlisle
(1694–1758), and by inheritance at Castle Howard,
Yorkshire, to the Hon. Geoffrey William Algernon
Howard (1877–1935); sold by his Trustees through
Spink & Son, London, to the Museum of Fine Arts,
Boston, 1939

SELECTED LITERATURE
Waagen 1838, III, p. 206, no. 64; Waagen 1854, III,
p. 323, no. 64; Browning 1905, p. 344; Constable
1929, p. 46; Constable 1962 (and subsequent edns
rev. J.G. Links), I, pl.32, II, no. 131; Toronto, Ottawa
and Montreal 1964–5, no. 18, pp. 56–7 (exhibited at
Toronto and Ottawa only); Venice 1967, no. 71,
pp. 158–61; Puppi 1968, no. 161A; Briganti 1970,
pl. 60 (detail); Links 1977, pp. 42, 50, pl. X; Links
1981, no. 146; Venice 1982, no. 85, p. 61; Bettagno
1983, pp. 225–8, figs 4–5, 7; Corboz 1985, I, pp. 101,
104, 160, figs 108, 153, II, no. P278, p. 643; New York
1989–90, no. 51, pp. 192–6; Links 1994, pp. 95, 98,
100, 112, pls X, 78; London and Washington 1994–5,
no. 140, pp. 230–1, 437; Pallucchini 1995–6, I,
pp. 489–91, figs 770, 773; Redford 1996, pl. 24;
D. Succi in Mirano 1999, pp. 49, 51, fig. 30

23

Canaletto (1697–1768)

*The Grand Canal with the Rialto Bridge from
the South*, about 1740

Oil on canvas, 45 x 76 cm
Institut de France, Musée Jacquemart-André, Paris
(MJAP-P 577-1)

PROVENANCE
Édouard André, 1865; Mme Édouard André (née
Nélie Jacquemart), by whom bequeathed to the
Institut de France, 1912

SELECTED LITERATURE
Constable 1962, II, no. 228(a)1 (in subsequent edns
rev. J.G. Links also I, pl. 199); Puppi 1968, no. 242C;
Links 1981, under no. 43; Corboz 1985, II, no. P399,
p. 657

24

Canaletto (1697–1768)

The Bacino di San Marco on Ascension Day,
about 1739

Oil on canvas, 57 x 93 cm
MNAC. Museu Nacional d'Art de Catalunya, Barcelona.
On permanent loan from the Colección Thyssen-
Bornemisza (MNAC 212851)

PROVENANCE
(Possibly) George Reveley (1699–1766); his son
Henry Reveley (1737–98), Bryn-y-Gwyn, Dolgelley,
Merionethshire, North Wales; his grandson Hugh
John Reveley by 1876; Mrs A.L. Snapper, London;
her posthumous sale Sotheby's, London, 14 June
1961, lot 52; bought Agnew's, London, from whom
purchased in 1962 by Baron Hans Heinrich
Thyssen-Bornemisza, Lugano; acquired by the
Museo Thyssen-Bornemisza, Madrid, 1993

SELECTED LITERATURE
Constable 1976, I, pl. 204, II, no. 340(aa) (as
'perhaps by Canaletto'); Links 1981, under no. 115;
Corboz 1985, II, no. P206, p. 628; Barcelona 2001,
no. 44, pp. 126–7; Madrid 2001, no. 46, pp. 158–9;
Contini 2002, no. 55, pp. 260–3; New Haven and
London 2006, p. 79

25

Canaletto (1697–1768)

*The Grand Canal with San Simeone Piccolo
and the Scalzi*, about 1740

Oil on canvas, 124.5 x 204.6 cm
The National Gallery, London. Bequeathed by
Lord Farnborough, 1838 (NG163)

PROVENANCE
Charles Long (1760–1838), created Baron
Farnborough in 1826, by 1832; his bequest to the
National Gallery, 1838

SELECTED LITERATURE
Constable 1962 (and subsequent edns rev.
J.G. Links), I, pl. 52, II, no. 259; Puppi 1968,
no. 170A; Levey 1971, pp. 22–4; Levey 1973, pp. 28, 36,
pl. 7 (detail); Links 1977, pp. 41–2, pls 50–1; Links
1981, no. 147; Corboz 1985, I, p. 252, figs 316–17, II,
no. P285, p. 646; Bomford and Roy 1993, pp. 35–41;
Links 1994, pp. 105, 112, pls 91–3; Kowalczyk 1998,
pp. 79–81; Links 1998a, p. 18; London, York and
Swansea 1998–9, fig. 15; Turin 2008, no. 29,
pp. 110–11

26

Canaletto (1697–1768)

*The Entrance to the Grand Canal, looking
East, with Santa Maria della Salute*,
about 1741

Oil on canvas, 54.6 x 101.6 cm
The Fitzwilliam Museum, Cambridge (PD.106-1992)

PROVENANCE
Commander David Heber-Percy (1909–71); his
sale, Christie's, London, 25 June 1971, lot 24; with
Leggatt Brothers, London; Dr Daniel McClean
McDonald (1905–91); his bequest to the
Fitzwilliam Museum, Cambridge, 1991

SELECTED LITERATURE
Constable 1976, II, no. 180(aa); Links 1981,
under no. 134; Links 1998a, p. 19, pls 252, 254;
B. Kowalczyk in Venice and Houston 2001, p. 66

27

Canaletto (1697–1768)

*The Entrance to the Grand Canal and Santa
Maria della Salute from the Molo*, about 1743

Signed with initials 'A.C.F.' (on the wall to left of centre)
Oil on canvas, 114.5 x 153.5 cm
National Gallery of Art, Washington. Gift of
Mrs Barbara Hutton (1945.15.4)
Washington only

PROVENANCE
Acquired by Henry Howard, 4th Earl of Carlisle
(1694–1758), and by inheritance at Castle Howard,
Yorkshire, to the Hon. Geoffrey William Algernon
Howard (1877–1935); sold by his Trustees to
Barbara Hutton, Countess Hangwitz Reventlow,
Winfield House, London; her gift to the National
Gallery of Art, Washington, 1945

SELECTED LITERATURE
Browning 1905, pp. 342–4; Constable 1929, p. 46;
Constable 1962, I, pl. 35, II, no. 154; Puppi 1968,
no. 142A; Links 1977, p. 42, pl. 60; Shapley 1979, I,
p. 103, II, pl. 70; Links 1981, no. 140; Corboz 1985,
II, no. P250, p. 636; Links 1994, p. 95, pl. 77; E.P.
Bowron in Washington 1996, pp. 25–31; D. Succi in
Mirano 1999, p. 51, fig. 29; Rome 2005, no. 49,
pp. 194–201

28

Canaletto (1697–1768)

*The Piazza San Marco and the Piazzetta,
looking South-East*, about 1743

Signed with initials 'A.C.F.' (lower left)
Oil on canvas, 114.6 x 153 cm
National Gallery of Art, Washington. Gift of
Mrs Barbara Hutton (1945.15.3)
Washington only

PROVENANCE
See previous entry

SELECTED LITERATURE
Browning 1905, p. 342; Constable 1929, p. 46;
Constable 1962, I, pl. 19, II, no. 50; Puppi 1968,
no. 141; Links 1977, p. 42, pl. 58; Shapley 1979, I,
pp. 101–3, II, pl. 69; Links 1981, no. 139; Venice 1982,
no. 86, p. 62; Corboz 1985, II, no. P249, p. 636; Links
1994, p. 95, pl. 75, p. 97; E.P. Bowron in Washington
1996, pp. 24–31; D. Succi in Mirano 1999, p. 51,
fig. 28; Rome 2005, no. 48, pp. 194–200

29

Canaletto (1697–1768)

*The Entrance to the Grand Canal, looking
East, with Santa Maria della Salute*, about

1742–4

Signed and dated 'ACanal F. 1744' (AC in monogram;
lower centre)
Oil on canvas, 127 x 203 cm
Lent by Her Majesty The Queen (RCIN 404397)
London only

PROVENANCE
Commissioned from the artist by Joseph Smith
(about 1674–1770), Palazzo Balbi (now Mangilli-
Valmarana), Venice; bought from Smith by King
George III in 1762; thence by descent

SELECTED LITERATURE
Constable 1962 (and subsequent edns rev.
J.G. Links), I, pl. 38, II, no. 174; Puppi 1968, no. 237A;
Vivian 1971, p. 178; London 1980–1, no. 26, p. 58;
Links 1981, no. 199; Corboz 1985, II, no. P116, p. 602;
Levey 1991, no. 407, pp. 42–3, pl. 53; Links 1994,
pls 122–3, p. 147

30

Canaletto (1697–1768)

The Torre di Malghera, about 1760

Oil on canvas, 31.5 x 46.2 cm
Private collection

PROVENANCE
Dimitri Tziracopoulo, Berlin, before 1939, and
subsequently Athens, and by descent; with
Agnew's, London, 1984; Jaime Ortiz-Patiño; with
Agnew's, London, 1987; Robert H. Smith, Crystal
City, Virginia; sold through Simon Dickinson Ltd
to the present owner 2004

SELECTED LITERATURE
Constable 1962 (and subsequent edns rev.
J.G. Links), I, pl. 67, II, no. 369 (with incorrect
width measurement); Puppi 1968, no.198; Turin
2008, no. 68, pp. 180–1

31

Canaletto (1697–1768)

*The Piazza San Marco from the Western
Arcade*, about 1758

Oil on canvas, 46.4 x 37.8 cm
The National Gallery, London. Salting Bequest, 1910
(NG2515)

PROVENANCE
George Salting, by whom purchased in 1886; his
bequest to the National Gallery, 1910

SELECTED LITERATURE
Constable 1962 (and subsequent edns rev.
J.G. Links), I, pl. 15, II, no. 21; Puppi 1968, no. 319;
Levey 1971, p. 31; Links 1981, no. 312; Corboz 1985,
II, no. P440, p. 726; Links 1994, p. 233, pl. 204;
London, York and Swansea 1998–9, fig. 48; Treviso
2008–9, no. 44, pp. 268–9

32

Canaletto (1697–1768)

*The Grand Canal looking South-East from
the Campo Santa Sofia to the Rialto Bridge*,
between 1758 and 1762

Oil on canvas, 119 x 185 cm
Staatliche Museen zu Berlin, Gemäldegalerie, on loan
from the Streitsche Stiftung (1653)
London only

PROVENANCE
Commissioned from the artist by Sigismund Streit
(1687–1775), by whom sent to Berlin in 1763; his gift
to the Gymnasium zum Grauen Kloster, Berlin,
about 1763

SELECTED LITERATURE
Constable 1962 (and subsequent edns rev.
J.G. Links), I, pl. 50, II, no. 242; Puppi 1968,
no. 228A; Berlin 1974, no. 1, pp. 16–19; Links 1977,
p. 72, pl. 104; Links 1981, no. 293; Venice 1982,
no. 111, pp. 83–4; Corboz 1985, II, no. P486, p. 748;
M. Levey in New York 1989–90, p. 20, fig. 8;
Hanover and Düsseldorf 1991–2, no. 17, pp. 122–3;
Links 1994, pp. 225–9, pl. 197; Pallucchini 1995–6, I,
p. 507, fig. 797; Berlin 2002–3, no. 7, pp. 75–9, 81,
88, 129

33

Giovanni Battista Cimaroli (1687–1771)

*The Piazza San Marco with the Populace
chasing Bulls in Celebration of the Visit of
Friedrich Christian of Saxony, 16 February
1740*, about 1740

Oil on canvas, 153 x 202.5 cm
Private collection, England

PROVENANCE
Gasparo Craglietto (1772–1838), Ponte della Ca' di
Dio no. 3838, near San Giovanni in Bragora, Venice,
from whom purchased in 1836 by Richard, 2nd
Marquess of Westminster; thence by inheritance

SELECTED LITERATURE
Cicogna 1840, III, p. 469; Cicogna 1842, V, p. 345;
Quadreria di Gasparo Craglietto, Venice 1838,
Appendix, 1843, pp. 4–5, no. 4; London 1849,
pp. 1–2, no. 3

34

Antonio Joli (about 1700–1777)

*The Bacino di San Marco and the Molo with
the Formal Entrance of the Apostolic Nuncio
Monsignor Giovanni Francesco Stoppani,
17 April 1741*, about 1742

Oil on canvas, 160.7 x 221.6 cm
National Gallery of Art, Washington. Gift
of Mrs Barbara Hutton (1945.15.2)

PROVENANCE
Cardinal Giovanni Francesco Stoppani, Rome;
bequeathed to Marchese Schiucchinelli, Cremona;
Giuseppe Castagna and Felice Ponzio, 1836; Lady
Mary Baillie of Polkemmet, née Stewart (d. 1910);
Admiral Johnston Stewart of Polkemmet, perhaps
nephew of the preceding; Christie's, London,
21 June 1912, lot 140, to Arthur Tooth & Sons; sold
14 July 1925 to Viscount Gabriel Chabert; with
Arnold Seligmann, London, early 1930s; sold to
Barbara Hutton; her gift to National Gallery of Art,
Washington, 1945, as Canaletto

SELECTED LITERATURE
Ticozzi 1835, pp. 7–8; Constable 1962 (and
subsequent edns rev. J.G. Links), II, no. 358;
Shapley 1979, I, pp. 108–9, II, pl. 75 (as Follower of
Canaletto); D. Succi in Padua 1994, pp. 81–5, fig. 17;
E. Garberson in Washington 1996, pp. 334–40 (as
Venetian eighteenth-century); Manzelli 1999,
no. V.1, pp. 32–5, 99; Crema 2002, no. 26, pp. 140–2
(as attributed to Antonio Joli and Gaspare
Diziani); Toledano 2006, no. V.IX, pp. 204–5;
Treviso 2008–9, no. 59, p. 278

35

Antonio Joli (about 1700–1777)

*The Courtyard of the Doge's Palace with the
Apostolic Nuncio Monsignor Giovanni
Francesco Stoppani and Senators in
Procession, 17 April 1741*, about 1742

Oil on canvas, 160.7 x 221.6 cm
National Gallery of Art, Washington. Gift
of Mrs Barbara Hutton (1945.15.1)
Washington only

PROVENANCE
See previous entry

SELECTED LITERATURE
Ticozzi 1835, pp. 7–8; Constable 1962 (and
subsequent edns rev. J.G. Links), II, nos 83a and
358; Shapley 1979, I, pp. 108–9, II, pl. 74 (as Follower
of Canaletto); D. Succi in Padua 1994, pp. 81–5, fig.
18; E. Garberson in Washington 1996, pp. 334–40
(as Venetian eighteenth-century); Manzelli 1999,

no. v.2, pp. 32–5, 99; Pedrocco 2001, pp. 176–7; Crema 2002, no. 27, pp. 140–3 (as attributed to Antonio Joli and Gaspare Diziani); Toledano 2006, no. v.x, pp. 204–6; Treviso 2008–9, no. 60, p. 278

36 (not exhibited)
Michele Marieschi (1710–1743)
The Entrance to the Grand Canal, looking East, with Santa Maria della Salute, about 1735

Oil on canvas, 124 x 213 cm
Musée du Louvre, Paris (162)

PROVENANCE
General Michel-Marie, Comte de Claparède (1770–1842), Paris, from whom acquired by the Musée du Louvre, 1818 (as Canaletto)

SELECTED LITERATURE
Constable 1962 (and subsequent edns rev. J.G. Links), I, pl. 37, II, no. 169 (as Canaletto); Venice 1967, no. 122, pp. 262–3; Puppi 1968, no. 23B; Links 1977, p. 56, pl. 87 (as Attributed to Marieschi); Corboz 1985, I, no. 36, pp. 272–3; Toledano 1988, no. v.17, pp. 90–1; D. Succi in Gorizia 1989, pp. 121, 123, fig. 127; Amsterdam 1990–1, no. 30, pp. 173–4; Manzelli 1991, no. M.32.1, p. 60; Toledano 1995, no. v.23, p. 87; Links 1998a, pp. 17–18, pl. 251; Montecuccoli degli Erri and Pedrocco 1999, no. 115, pp. 340–1; Manzelli 2002, no. M.32.01, p. 89

37
Michele Marieschi (1710–1743)
The Courtyard of the Doge's Palace, 1736

Oil on canvas, 118.5 x 180.7 cm
Private collection, Italy
London only

PROVENANCE
Johann Matthias von der Schulenburg (1661–1747), Palazzo Loredan a San Trovaso, Venice; bequeathed to his nephew, Christian Gunther von der Schulenburg, by whom removed to Hehlen, Germany; Schulenburg Sale, Christie's, London, 13 April 1775 (= 2nd day), lot 58, to Chapman; by descent to Sir Walter Bromley-Davenport MP, Capesthorne Hall, Macclesfield, Cheshire; his son, William Bromley-Davenport, by whom sold Christie's, London, 2 July 1976, lot 45; private collection, Paris; Christie's, London, 13 December 1996, lot 78; private collection, London; Christie's, London, 7 July 2009, lot 66, to Naumann

SELECTED LITERATURE
D. Succi in Gorizia 1988, p. 95, fig. 11; Toledano 1988, p. 68, under no. v.4.1; D. Succi in Gorizia 1989, p. 90, figs 87–8; Binion 1990a, pp. 119, 122, 152, 210, 234, 248, 285, 295; Manzelli 1991, no. A.4.2, p. 75 (as Albotto); Toledano 1995, no. v.4.b, p. 56; Montecuccoli degli Erri and Pedrocco 1999, no. 78, pp. 299–300; Manzelli 2002, no. A.04.01, pp. 112–14 (as Albotto); F. Pedrocco in Treviso 2008–9, p. 273

38
Michele Marieschi (1710–1743)
The Rialto Bridge from the South, about 1736

Oil on canvas, 55.9 x 85 cm
Philadelphia Museum of Art, PA. The John G. Johnson Collection, 1917 (298)
Washington only

PROVENANCE
John G. Johnson by 1913; his bequest to the Philadelphia Museum of Art, 1917

SELECTED LITERATURE
Toledano 1988, no. v.9.3, p. 80; Toledano 1995, no. v.11.b, p. 72; Montecuccoli degli Erri and Pedrocco 1999, no. 26, p. 245; Manzelli 2002, no. M.09.02, p. 80

39
Michele Marieschi (1710–1743)
The Rialto Bridge from the Riva del Vin, about 1737

Oil on canvas, 131 x 196 cm
The State Hermitage Museum, St Petersburg (GE-176)

PROVENANCE
Count Andrei Italinsky, St Petersburg; received by the Hermitage, 1829

SELECTED LITERATURE
Constable 1962, I, pl. 47, II, no. 229 (as Canaletto); Puppi 1968, no. 53 (as Canaletto); Kozakiewicz 1972, no. z189, pp. 434–7 (as Canaletto); Links 1981, no. 30 (as Canaletto); Corboz 1985, I, p. 219, fig. 265, II, no. P73, p. 584 (as Canaletto); Gorizia 1989, no. 27, pp. 122–5, 253; Amsterdam 1990–1, no. 31, pp. 175–6, 193; Manzelli 1991, no. M.38.1, p. 61; Toledano 1995, no. v.16, p. 77; Venice 1995, no. 65, pp. 268–9; Pallucchini 1995–6, II, p. 308, fig. 459; Links 1998a, p. 24, pl. 258; Montecuccoli degli Erri and Pedrocco 1999, no. 75, pp. 295, 297; Crema 2002, no. 29, pp. 146–7; Manzelli 2002, no. M.38.01, pp. 90–1

40
Michele Marieschi (1710–1743)
The Grand Canal with San Simeone Piccolo and the Scalzi, about 1742

Oil on canvas, 55.6 x 84.8 cm
Philadelphia Museum of Art, PA. Purchased with the W.P. Wilstach Fund, 1900 (W1900-1-14)
Washington only

PROVENANCE
Purchased for the Philadelphia Museum of Art with the W.P. Wilstach Fund, 1900

SELECTED LITERATURE
Toledano 1988, no. v.19.2, p. 93; D. Succi in Gorizia 1989, pp. 160, 255, fig. 184; Manzelli 1991, no. M.12.1, p. 55; Toledano 1995, no. v.25.b, p. 89; Montecuccoli degli Erri and Pedrocco 1999, no. 159, p. 387; Manzelli 2002, no. M.12.01, p. 82

41
Michele Marieschi (1710–1743)
The Bacino di San Marco, about 1739–40

Oil on canvas, 95.2 x 178.7 cm
Private collection

PROVENANCE
The London dealer William Hayter, by whom bequeathed to James Harris, MP (1709–80) of The Close, Salisbury, Wiltshire, and the Manor House, Great Durnford, Wiltshire; his son Sir James Harris, created Baron Malmesbury in 1788 and Viscount FitzHarris and Earl of Malmesbury in 1800, and by descent

SELECTED LITERATURE
Constable 1962 (and subsequent edns rev. J.G. Links), II, under no. 144; P. Zampetti in Venice 1967, p. 264; Puppi 1968, no. 36c; Toledano 1988, no. v.37, pp. 16, 116–17; D. Succi in Gorizia 1989, pp. 98, 100, figs 92–4; Manzelli 1991, no. M.25.1, pp. 58–9, Toledano 1995, no. v.45, pp. 18, 125–6; Links 1998a, p. 16, pl. 248; Montecuccoli degli Erri and Pedrocco 1999, no. 107, pp. 330–1; Manzelli 2002, no. M.25.01, pp. 87–8; Rome 2005, no. 31, pp. 144–7; Russell 2005, p. 100

42
Bernardo Bellotto (1722–1780)
The Bacino di San Marco on Ascension Day, about 1739

Oil on canvas, 108 x 152.5 cm
From the Castle Howard Collection

PROVENANCE
Acquired by Henry Howard, 4th Earl of Carlisle (1694–1758), and by inheritance at Castle Howard

SELECTED LITERATURE
Browning 1905, p. 344 (as Canaletto); Constable 1962, II (and subsequent edns rev. J.G. Links), no. 334 (as Canaletto; erroneously described as destroyed by fire in 1940); Puppi 1968, no. 107B (as Canaletto; incorrectly described as destroyed); H. Brigstocke in York 1994, p. 72 (as Canaletto); Links 1998a, p. 33, pl. 270; D. Succi in Mirano 1999, pp. 47–9, fig. 32

43
Bernardo Bellotto (1722–1780)
The Entrance to the Grand Canal and Santa Maria della Salute from the Piazzetta, about 1742

Oil on canvas, 150 x 122 cm
Private collection

PROVENANCE
In the present collection since the nineteenth century

SELECTED LITERATURE
Constable 1929, p. 49 (as Canaletto); Constable 1962, II, no. 147 (in subsequent edns rev. J.G. Links also I, pl. 195), Toronto, Ottawa and Montreal 1964–5,

no. 17, p. 55 (as Canaletto); Pignatti 1967, pp. 2–3, pl. 14; Puppi 1968, no. 361; Kozakiewicz 1972, I, pp. 65–7, II, no. Z111, pp. 404, 419 (as Canaletto); Camesasca 1974, no. 7; Links 1981, no. 168 (as Canaletto); D. Succi in Padua 1994, p. 51; B.A. Kowalczyk in Venice 1995, pp. 300–1; Pallucchini 1995–6, II, p. 494, fig. 778; Kowalczyk 1996, p. 85; B. Kowalczyk in Venice and Houston 2001, p. 68

44
Bernardo Bellotto (1722–1780)
The Campo Santa Maria Formosa,
about 1742
Oil on canvas, 92 x 150.5 cm
From a private European collection

PROVENANCE
British private collection since the early nineteenth century

SELECTED LITERATURE
Constable 1962, I, pl. 55, II, no. 279 (as Canaletto); Puppi 1968, no. 101B (as Canaletto); Links 1981, under no. 105 (as Canaletto); Corboz 1985, II, no. P212, p. 629 (as Canaletto); B. Kowalczyk in Venice and Houston 2001, pp. 46–8, illus.; Turin 2008, no. 12, pp. 78–9

45
Bernardo Bellotto (1722–1780)
The Arsenale, about 1743
Oil on canvas, 151.1 x 121.5 cm
National Gallery of Canada, Ottawa. Purchased 1930 (3719)

PROVENANCE
Bouchier Cleeve (1715–60), Foot's Cray Place, Kent; his daughter, Elizabeth Cleeve, who married Sir George Yonge, Bt, 1765; his sale, White's, London, 24 March 1806, lot 28; John Parker, 2nd Baron Boringdon, later 1st Earl of Morley, Saltram, Devon; his son Edmund Parker, 2nd Earl of Morley; sold Christie's, London, 1 June 1860, lot 111; Sir John Hardy, 1st Bt, Dunstall Hall, Burton-on-Trent, Staffs; thence by descent to Major Bertram Hardy; sold Christie's, London, 1 August 1929, lot 41; with the Savile Gallery, London; acquired by the National Gallery of Canada, 1930

SELECTED LITERATURE
Dodsley and Dodsley 1761, II, p. 315; Martyn 1766, I, p. 36; Constable 1962 (and subsequent edns rev. J.G. Links), I, pl. 54, II, no. 272 (as Canaletto); Toronto, Ottawa and Montreal 1964–5, no. 27, p. 67 (as Canaletto); Pignatti 1966, pp. 222–3, 226–7, 229; Pignatti 1967, pp. 2–3, pls 16, 26; Puppi 1968, no. 358; Kozakiewicz 1972, I, pp. 65–7, II, no. Z261, pp. 449–50 (as Canaletto); Camesasca 1974, no. 9; Links 1981, no. 170; Ottawa 1987, pp. 19–23, fig. 80; Binion 1990b, p. 29; D. Succi in Padua 1994, p. 51; B.A. Kowalczyk in Venice 1995, pp. 300–1; Pallucchini 1995–6, II, p. 494, fig. 780; Kowalczyk

1996, p. 85; Mirano 1999, pp. 23–4, 71; Venice and Houston 2001, no. 9, pp. 70–3; Rome 2005, no. 59, pp. 226–9

46
Bernardo Bellotto (1722–1780)
The Piazzetta, looking North, about 1743
Oil on canvas, 151.5 x 121.5 cm
National Gallery of Canada, Ottawa. Purchased 1930 (3720)

PROVENANCE
Bouchier Cleeve (1715–60), Foot's Cray Place, Kent; his daughter, Elizabeth Cleeve, who married Sir George Yonge, Bt, 1765; his sale, White's, London, 24 March 1806, lot 29; John Parker, 2nd Baron Boringdon, later 1st Earl of Morley, Saltram, Devon; his son Edmund Parker, 2nd Earl of Morley; sold Christie's, London, 1 June 1860, lot 112; Sir John Hardy, 1st Bt, Dunstall Hall, Burton-on-Trent, Staffs; thence by descent to Major Bertram Hardy; sold Christie's, London, 1 August 1929, lot 42; with the Savile Gallery, London; acquired by the National Gallery of Canada, 1930

SELECTED LITERATURE
Dodsley and Dodsley 1761, II, p. 313; Martyn 1766, I, p. 36; Constable 1962 (and subsequent edns rev. J.G. Links), I, pl. 23, II, no. 67 (as Canaletto); Toronto, Ottawa and Montreal 1964–5, no. 26, p. 66 (as Canaletto); Pignatti 1966, pp. 222–3, 226–7, 229; Pignatti 1967, pp. 2–3, pls 15, 21–2, 29, 31, 33; Venice 1967, no. 85, pp. 188–9; Puppi 1968, no. 359; Kozakiewicz 1972, I, pp. 65–7, II, no. Z41, p. 404 (as Canaletto); Camesasca 1974, no. 8; Links 1981, no. 169; Corboz 1985, I, p. 325, fig. 393; Ottawa 1987, pp. 19–24, fig. 81; Binion 1990b, p. 29; D. Succi in Padua 1994, p. 51; London and Washington 1994–5, p. 361; B.A. Kowalczyk in Venice 1995, pp. 300–1; Pallucchini 1995–6, II, p. 494, fig. 779; Kowalczyk 1996, p. 85; Mirano 1999, pp. 23–4, 71; Venice and Houston 2001, no. 10, pp. 74–7; Rome 2005, no. 58, pp. 222–5

47
Bernardo Bellotto (1722–1780)
The Entrance to the Grand Canal, looking East, with Santa Maria della Salute, about 1743
Oil on canvas, 72 x 96.5 cm
Private collection/care of the Richard Green Gallery

PROVENANCE
Mrs Danby Harcourt, Swinton Park, Masham, North Yorkshire; Sir Robert Affleck, 8 Cornwall Mansions, London, and Dalham Hall, Newmarket; his posthumous sale Christie's, London, 25 July 1891, lot 104 (as Canaletto), unsold and reoffered 11 June 1892, lot 65, to Vokins; Edward Steinkopff, 47 Berkeley Street, London; his posthumous sale Christie's, London, 24 May 1935, lot 69 (as Canaletto), to A.H. Buttery; Mrs J.A. Stewart, New

York, and by descent until sold Christie's, New York, 11 January 1995, lot 25; bought by Richard Green, from whom purchased by the present owner 1997

SELECTED LITERATURE
Constable 1962 (and subsequent edns rev. J.G. Links), II, no. 180(a) (as Canaletto); Puppi 1968, no. 134B (as Canaletto); Kozakiewicz 1972, II, under no. 7, p. 13 (as Canaletto); Links 1981, under no. 134 (as Canaletto); Links 1998a, p. 19, pl. 253; B. Kowalczyk in Venice and Houston 2001, p. 66, illus. p. 68

48
Bernardo Bellotto (1722–1780)
The Torre di Malghera, about 1744
Oil on canvas, 37.3 x 62.2 cm
Bristol's Museum, Galleries & Archives (K5269)

PROVENANCE
(Possibly, according to Commander William Crutchley) General Sir John Murray, 8th Bt (about 1768–1827); Admiral Sir Victor Crutchley (1893–1986), Mappercombe Manor, near Bridport, Dorset (by whom, according to Wikipedia, purchased in 1945); given by his estate to the Bristol City Museum and Art Gallery in lieu of tax, 1987

SELECTED LITERATURE
Kowalczyk 1996, p. 86, fig. 25; B. Kowalczyk in Turin 2008, p. 180, fig. 68.1

49
Bernardo Bellotto (1722–1780)
The Campo Santi Giovanni e Paolo, about 1745
Oil on canvas, 70.8 x 111 cm
National Gallery of Art, Washington. Widener Collection (1942.9.7)
Washington only

PROVENANCE
The Hon. Marmaduke Constable-Maxwell, Dumfriesshire; his sale, Christie's, London, 1 March 1873, lot 132; purchased by William Ward, 1st Earl of Dudley, London; his sale, Christie's, London, 25 June 1892, lot 51, to Agnew's, London; Peter A.B. Widener, Pennsylvania, 1892; his son Joseph E. Widener; his gift to the National Gallery of Art, Washington, 1942

SELECTED LITERATURE
Constable 1962, II, no. 307 (as Canaletto; in subsequent edns rev. J.G. Links also I, pl. 202); Pignatti 1967, p. 1; Puppi 1968, no. 110B (as Canaletto); Kozakiewicz 1972, II, no. Z256, p. 449; Camesasca 1974, no. 5A; Shapley 1979, I, pp. 99–101, II, pl. 67 (as Canaletto); Links 1981, no. 114 (as Canaletto); Corboz 1985, II, no. P221, p. 631 (as Canaletto); E.P. Bowron in Washington 1996, pp. 9–14; Kowalczyk 1996, pp. 84–5, figs 20–1; Links 1998a, pp. 30–1, pl. 264; D. Succi in Mirano 1999, p. 29,

fig. 8; B. Kowalczyk in Venice and Houston 2001, pp. 60–2, illus.; D. Succi in Barcelona 2001, pp. 46–7, fig. 6; D. Succi in Madrid 2001, p. 68, fig. 6

50

Pietro Bellotti (1725–about 1800)
The Entrance to the Grand Canal, looking East, with Santa Maria della Salute, about 1743–4

Oil on canvas, 56.5 x 84 cm
Private collection, Canada

PROVENANCE
Private collection, Belgium; with Charles Beddington Ltd, from whom purchased by the present owner 2006

SELECTED LITERATURE
Beddington 2005, p. 23, fig. 15; Beddington 2007, p. 679

51

Francesco Tironi (active about 1745–1797)
San Cristoforo, San Michele and Murano from the Sacca della Misericordia, about 1775?

Signed with initials 'F.T.'
Oil on canvas, 56.5 x 102 cm
Staatliche Kunsthalle, Karlsruhe (425)

PROVENANCE
Leopold I, Grand Duke of Baden, by 1833 (as Canaletto)

SELECTED LITERATURE
Pedrocco 2001, pp. 186–7, illus. (detail); Succi 2004, p. 27, fig. 26 (detail)

52

Francesco Guardi (1712–1793)
The Festival of Giovedì Grasso in the Piazzetta, 1758

Signed with initials 'F.G.' (on the yellow awning in an arch of the arcade of the Procuratie Nuove)
Oil on canvas, 32 x 54 cm
From the collection of Ann and Gordon Getty
Washington only

PROVENANCE
Private collection, London; Senatore Mario Crespi (1879–1962), Milan; private collection, Switzerland; acquired by the present owner in 1989

SELECTED LITERATURE
Morassi 1973, I, no. 280, pp. 189, 362, II, fig. 309; Rossi Bortolatto 1974, no. 137; D. Succi in Gorizia 1987, pp. 42, 47, 55 (note 3), fig. 19; Succi 1993, pp. 26–7, fig. 7

53

Francesco Guardi (1712–1793)
The Giudecca Canal and the Zattere, about 1758

Signed 'Fran.co Guardi' (lower left)
Oil on canvas, 72.2 x 119.3 cm
Carmen Thyssen-Bornemisza Collection, on loan to the Museo Thyssen-Bornemisza, Madrid (CTB.1995.1)

PROVENANCE
Sir Brook Bridges, 3rd Bt (1733–91); by descent at Goodnestone Park, Kent to Henry Fitzwalter Plumptre, 20th Baron FitzWalter; sold Christie's, London, 17 July 1931, lot 15, to Rothschild; Sir George Leon, Bt; R.F. Heathcoat-Amory; sold Sotheby's, London, 27 June 1962, lot 87, to Leonard Koetser; sold by Paul Wallraf to Francesco Genova, 1962; sold by Genova to Miss Alice Tully, Hampshire House, New York, 1962; her posthumous sale, Christie's, New York, 11 Jan 1995, lot 50; purchased after the sale by Carmen Thyssen-Bornemisza

SELECTED LITERATURE
Morassi 1973, I, no. 622, pp. 220, 426, II, fig. 590; Rossi Bortolatto 1974, no. 142; D. Succi in Gorizia 1987, pp. 60, 80 (note 3); Russell 1996, pp. 4–8, fig. 2; Barcelona 2001, no. 47, pp. 132–3; Madrid 2001, no. 49, pp. 164–5; Contini 2002, no. 62, pp. 294–9

54

Francesco Guardi (1712–1793)
The Lagoon towards Murano from the Fondamenta Nuove, about 1762–5

Oil on canvas, 31.7 x 52.7 cm
The Fitzwilliam Museum, Cambridge (No.0189)

PROVENANCE
Rev. Charles Lesingham Smith (1806–78), The Rectory, Little Canfield, Essex; his bequest to the Fitzwilliam Museum, 1878

SELECTED LITERATURE
Morassi 1973, I, no. 658, p. 432, II, fig. 613; Rossi Bortolatto 1974, no. 530; Amsterdam 1990–1, no. 41, p. 221; Succi 1993, p. 45, fig. 35

55

Francesco Guardi (1712–1793)
The Molo and the Riva degli Schiavoni from the Bacino di San Marco, about 1765–7

Oil on canvas, 121.9 x 152.4 cm
The Metropolitan Museum of Art, New York. Bequest of Adele L. Lehman, in memory of Arthur Lehman, 1965 (65.181.8)

PROVENANCE
Sir Sigmund Neumann, 1st Bt (1857–1916), London, by 1904; his son Sir Cecil Newman, 2nd Bt, Royston, Hertfordshire; with Knoedler, New York, 1958; sold to Adele Lehman, New York; her bequest to the Metropolitan Museum of Art, New York, 1965

SELECTED LITERATURE
Morassi 1973, I, no. 392, p. 384, II, fig. 416; Rossi Bortolatto 1974, no. 165, p. 199; D. Succi in Gorizia 1987, p. 65, fig. 54; Amsterdam 1990–1, no. 40, pp. 219–20; Succi 1993, p. 49, fig. 47

56

Francesco Guardi (1712–1793)
The Rialto Bridge from the North and the Palazzo dei Camerlenghi, about 1768–9

Signed 'F.co Guardi' (lower left)
Oil on canvas, 116 x 199.5 cm
Private collection

PROVENANCE
Chaloner Arcedeckne (1741–1809), Glevering Park, Suffolk; by inheritance either through his daughter Frances Catherine (d. 1815), who married in 1810 Joshua Vanneck, later 2nd Baron Huntingfield (1778–1844), or through his granddaughter Louisa Arcedeckne (d. 1898), who married in 1839 Charles Andrew Vanneck (1818–97), later 3rd Baron Huntingfield, both of Heveningham Hall, Yoxford, Suffolk; sold by the latter in 1891 through Christie's and Agnew's, London, to Sir Edward Guinness (1847–1927), 1st Bt and later 1st Earl of Iveagh; thence by descent

SELECTED LITERATURE
Morassi 1973, I, no. 555, pp. 234, 413, II, figs 529, 531; Rossi Bortolatto 1974, no. 234; D. Succi in Gorizia 1987, p. 60, figs 49–50; Succi 1993, pp. 47–8, fig. 42; London and Washington 1994–5, no. 210, pp. 315, 458; Russell 1996, p. 10

57

Francesco Guardi (1712–1793)
The Lagoon with the Torre di Malghera, probably 1770s

Oil on panel, 21.3 x 41.3 cm
The National Gallery, London. Salting Bequest, 1910 (NG2524)
London only

PROVENANCE
(Possibly) anon. sale, London, 2 June 1808, lot 22, to Seguier; C.H.T. Hawkins; his sale London, 11 May 1896, lot 41, to Agnew; George Salting, by whom purchased in 1896; his bequest to the National Gallery, 1910

SELECTED LITERATURE
Briganti 1970, pl. 79; Levey 1971, pp. 132–3; Levey 1973, pp. 31–3, 36, pls 1, 17 (details); Morassi 1973, I, no. 664, pp. 252, 433–4, II, fig. 620; Rossi Bortolatto 1974, no. 750

58

Francesco Guardi (1712–1793)
*San Giorgio Maggiore from the Arcade
of the Doge's Palace*, about 1775–8

Signed with initials 'F.G.P.' (lower left)
Oil on canvas, 49.5 x 36.2 cm
Private collection
London only

PROVENANCE
Welbore Ellis Agar, 2nd Earl of Normanton
(1778–1868), by whom purchased at a Phillips
auction before 1841, and by inheritance at
Somerley House, near Ringwood, Hampshire, to
Shaun James Christian Wellbor Ellis Agar, 6th Earl
of Normanton, by whom sold in 2000; art market,
London; with Simon C. Dickinson Ltd, London,
from whom purchased by present owner in
January 2001

SELECTED LITERATURE
Waagen 1857, p. 373; Morassi 1973, I, no. 776,
pp. 276 and 454, II, fig. 709; Rossi Bortolatto 1974,
no. 496; D. Succi in Gorizia 1987, p. 281; D. Succi in
Gorizia 1988, p. 368, fig. 58; Succi 1993, p. 149,
fig. 157

59

Francesco Guardi (1712–1793)
*The Piazza San Marco during the Feast of
the Ascension*, about 1777

Oil on canvas, 61 x 91 cm
Calouste Gulbenkian Museum, Lisbon (390)

PROVENANCE
Robert Haldane-Duncan, 3rd Earl of Camperdown
(1841–1918); sold Christie's, London, 8 March 1919,
to Calouste Gulbenkian

SELECTED LITERATURE
Venice 1965, no. 117, p. 256 (incorrectly illus.);
Morassi 1973, I, no. 277, pp. 188, 361–2, II, fig. 307;
Rossi Bortolatto 1974, no. 500; Muraro 1993, no. 7,
pp. 28–31, 95–6; Succi 1993, pp. 90–2, fig. 84

60

Francesco Guardi (1712–1793)
A Regatta on the Grand Canal, about 1777

Oil on canvas, 61 x 91 cm
Calouste Gulbenkian Museum, Lisbon (391)

PROVENANCE
See previous entry

SELECTED LITERATURE
Venice 1965, no. 119, pp. 232–3; Morassi 1973, I, no.
299, pp. 202, 366–7, II, fig. 326; Rossi Bortolatto
1974, no. 513; Muraro 1993, no. 9, pp. 36–9, 98–9;
Succi 1993, p. 90, fig. 85

61

Francesco Guardi (1712–1793)
*The Grand Canal with San Simeone Piccolo
and Santa Lucia*, about 1780

Oil on canvas, 67.3 x 91.5 cm
Philadelphia Museum of Art, PA. The John G. Johnson
Collection, 1917 (303)

PROVENANCE
(Possibly) John Ingram (1767–1841), Matsala (or
Marsala) House, England; thence probably by
inheritance to Ingram Fuller Godfrey (1827–1916);
John G. Johnson, Philadelphia; his bequest to the
Philadelphia Museum of Art, 1917

SELECTED LITERATURE
Morassi 1973, I, no. 579, pp. 250, 418, II, fig. 552;
Rossi Bortolatto 1974, no. 535

62

Francesco Guardi (1712–1793)
*The Grand Canal with the Rialto Bridge
from the South*, about 1780

Oil on canvas, 68.5 x 91.5 cm
National Gallery of Art, Washington. Widener Collection
(1942.9.27)

PROVENANCE
(Possibly) John Ingram (1767–1841), Matsala (or
Marsala) House, England; thence probably by
inheritance to Ingram Fuller Godfrey (1827–1916);
John G. Johnson, Philadelphia; Peter A.B. Widener,
Pennsylvania, by whom purchased in 1894; his son
Joseph E. Widener; his gift to the National Gallery
of Art, Washington, 1942

SELECTED LITERATURE
Morassi 1973, I, no. 529, pp. 408–9, II, fig. 512;
Rossi Bortolatto 1974, no. 406; Shapley 1979, I, pp.
240–1, II, pl. 161; Succi 1993, p. 107, fig. 107; E.
Garberson in Washington 1996, pp. 130–3

63

Francesco Guardi (1712–1793)
San Giorgio Maggiore and the Giudecca,
about 1780

Oil on canvas, 33 x 51.5 cm
Private collection, courtesy of Simon
C. Dickinson Ltd

PROVENANCE
Broglio Collection, Paris, 1946; Mme E. Bernt,
Paris; Schäffer Collection, Zurich

SELECTED LITERATURE
Morassi 1973, I, no. 431, pp. 242, 392, II, fig. 454;
Rossi Bortolatto 1974, no. 243

64

Francesco Guardi (1712–1793)
The Isola della Madonetta in the Lagoon,
about 1780–90

Oil on canvas, 35.6 x 55.2 cm
Harvard Art Museum, Fogg Art Museum, Cambridge, MA.
Gift of Charles E. Dunlap (1959.185)

PROVENANCE
R. Wallace, Paris; with Wildenstein, New York;
Charles E. Dunlap; his gift to the Fogg Museum,
1945

SELECTED LITERATURE
Haskell 1960, pp. 268–70; Morassi 1973, I, no. 659,
pp. 251, 433, II, fig. 618; Rossi Bortolatto 1974,
no. 771; London and Washington 1994–5, no. 215,
pp. 319 and 459; Venice 1995, no. 85, pp. 336–7

Index

Lenders

Barcelona: Museu Nacional d'Art de Catalunya

Berlin: Staatliche Museen zu Berlin, Gemäldegalerie, on loan from the Streitsche Stiftung

Birmingham: Birmingham Museums & Art Gallery

Boston, Massachusetts: Museum of Fine Arts, Boston

Bristol: Bristol's Museum, Galleries & Archives

Cambridge, Massachusetts: Harvard Art Museum/Fogg Art Museum

Cambridge, UK: The Fitzwilliam Museum

Dallas, Texas: Dallas Museum of Art

Dresden: Gemäldegalerie Alte Meister, Staatliche Kunstsammlungen Dresden

Hartford, Connecticut: Wadsworth Atheneum Museum of Art

Houston, Texas: The Museum of Fine Arts, Houston

Karlsruhe: Staatliche Kunsthalle Karlsruhe

Lisbon: Calouste Gulbenkian Museum

London: Her Majesty Queen Elizabeth II; Her Majesty's Government; National Gallery; Sir John Soane's Museum

Los Angeles, California: The J. Paul Getty Museum

Madrid: Carmen Thyssen-Bornemisza Collection; Museo Nacional del Prado; Museo Thyssen-Bornemisza

Newport, Virginia: The Mariners' Museum (ex catalogue; Washington only)

New York: The Metropolitan Museum of Art

Ottawa: National Gallery of Canada

Paris: Institut de France, Musée Jacquemart-André

Philadelphia, Pennsylvania: Philadelphia Museum of Art

St Petersburg: The State Hermitage Museum

San Francisco, California: Collection of Ann and Gordon Getty

Venice: Fondazione Musei Civici di Venezia, Ca' Rezzonico, Museo del Settecento Veneziano; Museo Correr (ex catalogue; Washington only)

Washington, DC: National Gallery of Art

Woburn: His Grace the Duke of Bedford, and the Trustees of the Bedford Estates

Yorkshire: Castle Howard; The Trustees of Kiplin Hall

And all those lenders and private collectors who wish to remain anonymous.

The exhibition in London has been made possible with the assistance of the Government Indemnity Scheme which is provided by DCMS and administered by MLA.

The exhibition in Washington is supported by an indemnity from the Federal Council on the Arts and the Humanities.

Photographic Credits

Barcelona MNAC. Museu Nacional d'Art de Catalunya, Barcelona © Colección Thyssen-Bornemisza, on loan to MNAC – Museu Nacional d'Art de Catalunya, Barcelona: plate 24; figs 10, 33. **Berlin** Staatliche Museen zu Berlin, Gemäldegalerie © 2005. Photo Scala, Florence / BPK, Bildagentur für Kunst, Kultur und Geschichte, Berlin. Photo Jörg P. Anders: plate 32; fig. 47. **Birmingham** © Birmingham Museums & Art Gallery: plate 2; fig. 17. **Boston, Massachusetts** © 2010 Museum of Fine Arts, Boston: plate 22. **Bristol** © By Permission of Bristol's Museums, Galleries & Archives: plate 48; fig. 54. **Cambridge** © The Fitzwilliam Museum, University of Cambridge: plate 26; figs 43, 45. Photo © Hamilton Kerr Institute, The Fitzwilliam Museum, University of Cambridge: plate 54. **Cambridge, Massachusetts** Harvard Art Museum, Fogg Art Museum, Cambridge. Imaging Department © President and Fellows of Harvard College, Cambridge: plate 64. **Castle Howard, Yorkshire** © courtesy of the owner: plate 42; figs 11, 27, 28, 31, 36. **Dallas, Texas** © Dallas Museum of Art, Texas: plate 7. **Dresden** Gemäldegalerie Alte Meister, Staatliche Kunstsammlungen Dresden © akg-images/Erich Lessing: plate 12. **Florence** Menarini Fittipaldi collection © 2010 Photo Scala, Florence: fig. 58. **Hartford, Connecticut** © 2009. Wadsworth Atheneum Museum of Art / Art Resource, NY / Scala, Florence: plates 6, 15; fig. 20. **Houston, Texas** © The Museum of Fine Arts, Houston, Texas: front cover, plate 14. **Karlsruhe** © Staatliche Kunsthalle Karlsruhe 2009. Photo by W. Pankoke: plate 51. **Lisbon** © Calouste Gulbenkian Museum, Lisbon: back cover, plates 59, 60. © Calouste Gulbenkian Museum, Lisbon. Photo Catarina Gomes Ferreira: fig. 49. **London** Photo © Sarah Quill / Venice Picture Library: fig. 66. Photo © Museums, Libraries and Archives Council: plate 5; fig 14. Osterley Park,

The National Trust © NTPL: fig. 25. The Royal Collection © 2010, Her Majesty Queen Elizabeth II: plates 8, 16, 17, 29; figs 9, 24, 29, 30, 32, 35, 50. © By Permission of The British Library, London: fig. 55. © The Trustees of The British Museum: figs 56, 59, 69. © The National Gallery, London: plates 11, 25, 31, 57; fig. 51. © By courtesy of the Trustees of Sir John Soane's Museum, London: plate 19; fig. 18. © V&A Images / Victoria and Albert Museum, London: fig. 12. Matthew Hollow, London: plates 30, 50; figs 46, 53, 60. **Los Angeles, California** © The J. Paul Getty Museum, Los Angeles: plates 3, 4; figs 8, 13, 62. **Madrid** © Museo Nacional del Prado, Madrid: plate 1; figs 4–7. © Museo Thyssen-Bornemisza, Madrid. Photo José Loren: plate 10; fig. 15. © Carmen Thyssen-Bornemisza Collection, on loan to the Museo Thyssen-Bornemisza, Madrid. Photo José Loren: plate 53; fig. 48. **New York** © 2009. The Metropolitan Museum of Art / Art Resource / Scala, Florence: plate 55. **Ottawa, Ontario** © National Gallery of Canada: plates 45, 46. **Paris** Institut de France, Musée Jacquemart-André, Paris © 2009. Photo Musée Jacquemart-André / Institut de France / Scala, Florence: plate 23. Musée du Louvre, Paris © RMN / Gérard Blot: plate 36, fig. 23. **Philadelphia, Pennsylvania** © Philadelphia Museum of Art: plates 38, 40, 61. **Private collections** © Photo courtesy of the owners: plates 30, 41; figs 21, 53, 60, 63, 64, 68, 71, 72. © Private collection 2010: plate 56. © Photo The National Gallery, London / courtesy of the owners: plate 43, fig. 22*. Private European Collection © Antonia Reeve 2010 / courtesy of the owner: plate 44; figs 37, 39–41. Collection of Ann and Gordon Getty © Photo 2009 Colin McRae / courtesy of the owner: plate 52; fig. 76. Private collection / care of Richard Green Gallery © Courtesy of the owner: plate 47; figs 42, 44. Private collection, courtesy of Simon Dickinson Ltd © Private collection: plate 63. Private collection, California © Photo 2009 Colin McRae /

courtesy of the owner: fig. 67. Private collection, Canada © Photo courtesy of the owner: plate 50; fig. 46. Private collection, England © Photo National Gallery, London / courtesy of the owner: plate 33; figs 26, 73. Private collection, Italy © Photo courtesy of the owner: plate 37. Private collection, London © Photo Nick Moss / Rodney Todd-White, August 2004 / Courtesy of the owner: plates 20, 21. Private collection, Spain © 2009 Photo Gonzalo de la Serna / courtesy of the owner: plate 58. **Springfield, Massachusetts** © Michele and Donald D'Amour Museum of Fine Arts, Springfield. Photo David Stansbury: fig. 3. **St Petersburg** The State Hermitage Museum, St Petersburg © 2010. Photo Scala, Florence: plate 39. © The State Hermitage Museum, St Petersburg. Photo Vladimir Terebenin, Leonard Kheifets, Yuri Molodkovets: plate 13; figs 16, 34. **Venice** © Photo Archivio Naya-Böhm, Venice: figs 61, 65, 74, 75. Ca' Rezzonico, Museo del Settecento Veneziano, Venice © courtesy Fondazione Musei Civici di Venezia: plate 9. Fondazione Giorgio Cini, Gabinetto dei Disegni e delle Stampe, Venice © Fondazione Giorgio Cini, Venice. Matteo De Fina: fig. 19. Gallerie dell'Accademia, Venice © Photo Francesco Turio Böhm: figs 2, 70. Museo Correr, Venice © The Art Archive / Museo Correr Venice / Alfredo Dagli Orti: fig. 57. **Washington, DC** Image courtesy of the Board of Trustees, National Gallery of Art, Washington: plates 27, 28, 34, 35, 49, 62; fig. 52. **Woburn Abbey** By kind permission of His Grace the Duke of Bedford and the Trustees of the Bedford Estates © 2010. Photo Scala, Florence: plate 18; fig. 38.

*Fig. 22: Infrared reflectography was carried out by Rachel Billinge, Research Associate in the Conservation Department at the National Gallery using the gallery's new digital infrared scanning camera SIRIS (Scanning InfraRed Imaging System) which uses a indium gallium arsenide (InGaAs) array sensor.